DATE DUE

36364

GAYLORD S

THE WATERCOLOR PAINTING BOOK

THE WATERCOLOR PAINTING BOOK

By Wendon Blake/Paintings by Claude Croney

WATSON-GUPTILL PUBLICATIONS/NEW YORK
PITMAN PUBLISHING/LONDON

Copyright © 1978 by Billboard Ltd.

Published in the United States and Canada by Watson-Guptill Publications,
1515 Broadway, New York, N.Y. 10036

Published in Great Britain by Pitman Publishing Ltd.,
39 Parker Street, London WC2B 5PB
ISBN 0-273-01217-7

Library of Congress Cataloging in Publication Data
Blake, Wendon.
 The watercolor painting book.
 1. Water-color painting—Technique
I. Croney, Calude II. Title.
ND2420.B56 1978 751.4'22 77-19322
ISBN 0-8230-5672-4

Manufactured in Japan

First Printing, 1978
Second Printing, 1978

CONTENTS

Painting in Watercolor. At first glance, watercolor looks like the simplest possible painting medium. You can paint a picture with just three or four brushes, a dozen tubes of color, a jar of water, and a piece of paper not much larger than the page you're now reading. Furthermore, a watercolor can take very little time to paint. It's rare for a watercolorist to spend more than a few hours on a picture—and many of the world's greatest watercolors have been painted in as little as an hour. But don't be deceived. Watercolor may *look* easy, but the professionals agree that it's the most challenging of all painting media.

Mastering Watercolor. There are two basic challenges in watercolor painting. First, because the liquid color flows across the paper as freely as a wave washing over a beach, it takes a lot of practice to learn how to control the fluid paint so it goes where you want it to go and *stays there*. Second, because watercolor dries so rapidly—as soon as the water evaporates—you must learn to plan every step before you touch brush to paper, so you can work quickly and decisively. Learning to paint in watercolor is like learning to play a musical instrument. The whole secret is frequent practice. You must be prepared to paint (and perhaps spoil) scores of watercolors before you'll feel the medium begin to obey your command.

Learning by Doing. In this book, you'll see every basic watercolor operation demonstrated step-by-step. You'll watch famed watercolorist Claude Croney execute a great variety of paintings, beginning with very simple subjects and then going on to much more complex ones. Each illustration shows a stage in the progress of the painting, while the accompanying text describes the exact painting procedure. Having watched "over the artist's shoulder," you should then try the process yourself. Don't copy the painting in the book, but find a similar subject and attempt a similar painting, using the same methods you've seen in the demonstration. If time and weather permit, go outdoors and paint directly from nature, which is really the best way to learn. If your time outdoors is limited, a good solution is to paint some small pictures on location and then bring them back home where you can develop the original idea into a larger picture. At your leisure, you can study the original painting, see what you've done right and where you've gone wrong, and then try again.

How this Book is Organized. You'll find that this book is divided into three parts: *Watercolor Painting*, *Landscapes in Watercolor*, and *Seascapes in Watercolor*. Although the first few demonstrations are still life and flower subjects—simple subjects that you can set up indoors to try out the basic techniques—most of the demonstrations show you how to paint the outdoor subjects that are the favorites of watercolorists around the world.

Watercolor Painting. Part One introduces the basic watercolor techniques, showing you how to apply and control areas of liquid color (called washes) and how to exploit the fascinating technique called drybrush. The first six demonstrations are indoor and outdoor still lifes—vegetables, a tree stump, fruit, flowers indoors, flowers outdoors, and a fallen tree—in which Croney shows all the different ways to handle the brush. Then he shows you how to put these techniques to work in painting the landscapes of spring, summer, autumn, and winter and finally, two coastal landscapes.

Landscapes in Watercolor. Part Two starts by reviewing the basic techniques, showing how to use them to paint specific landscape components such as mountains, a lake, rocks, and mist. Then there are ten step-by-step demonstrations in which Croney shows you how to paint ten popular landscape subjects: deciduous trees, evergreens, a meadow, mountains, hills, a lake, a stream, snow and ice, clouds, and a sunset.

Seascapes in Watercolor. Part Three begins by showing you how to use the basic wash and drybrush techniques to paint specific seascape components such as waves, headlands, cliffs, and the shoreline. Then Croney demonstrates how to paint ten popular seascape subjects, step-by-step: waves, surf, tidepools, a salt marsh, moonlight on the sea, fog, a storm, a rocky shore, dunes, and a headland.

Background Material. Throughout these three parts of *The Watercolor Painting Book*, you'll also find guidance about such problems as composition, lighting, perspective, and how to select suitable subjects. You'll learn not only how to handle the brush, but how to create special effects by scratching and scraping, sponging, and washing and scrubbing out color. You'll learn how brushwork "expresses" the character of the subject. And since every element of the landscape has its own "personality," there are close-ups of various rock, tree, cloud, and wave forms, all intended to sharpen your powers of observation. For the ultimate goal isn't merely to master the medium of watercolor, but to use that medium to express your personal response to the magic of nature.

Tubes and Pans. Watercolors are normally sold in collapsible metal tubes about as long as your thumb and in metal or plastic pans about the size of the first joint of your thumb. The tube color is a moist paste that you squeeze out onto the surface of your palette. The color in the pan is dry to the touch but dissolves as soon as you touch it with a wet brush. The pans, which lock neatly into a small metal box made to fit them, are convenient for rapid painting on location. But the pans are useful mainly for small pictures—no more than twice the size of this page—because the dry paint in the pans is best for mixing small quantities of color. The tubes are more versatile and more popular. The moist color in the tubes will quickly yield small washes for small pictures and big washes for big pictures. If you must choose between tubes and pans, buy the tubes. Later, if you want a special kit for painting small pictures outdoors, buy the pans.

Color Selection. All the pictures in this book were painted with just eleven tube colors. True, the colors of nature are infinite, but most professional watercolorists find that they can cope with the colors of nature with a dozen tube colors—or even less. Once you learn to mix the various colors on your palette, you'll be astonished at the range of colors you can produce. Six of these eleven colors are *primaries*—two blues, two reds, two yellows—which means colors that you can create by mixing other colors. Just two are *secondaries*—orange and green—which means colors that you *can* create by mixing two primaries. You can mix a rich variety of greens by combining various blues and yellows, plus many different oranges by combining reds and yellows. So you could really do without the secondaries. But it does save time to have them. The last three colors on your palette are what painters call neutrals: two shades of brown and a gray.

Blues. Ultramarine is a dark, soft blue that produces a rich variety of greens when blended with the yellows, and a wide range of grays, browns, and brown-grays when mixed with the neutrals. Cerulean blue is a light, bright blue that is popular for skies and atmospheric effects. At some point in the future, you might like to try substituting phthalocyanine blue for cerulean; phthalocyanine is more brilliant, but must be used in small quantities because it tends to dominate any mixture.

Reds. Alizarin crimson is a bright red with a hint of purple; it produces lovely oranges when mixed with the yellows, subtle violets when mixed with the blues, and rich darks when mixed with green. Cadmium red light is a dazzling red with a hint of orange, producing rich oranges when mixed with the yellows, coppery tones when mixed with the browns, and surprising darks (not violets) when mixed with the blues.

Yellows. Cadmium yellow light is bright and sunny, producing luminous oranges when mixed with the reds and rich greens when mixed with the blues. Yellow ochre is a much more subdued, tannish yellow that produces subtle greens when mixed with the blues and muted oranges when mixed with the reds. You'll find that both cadmiums tend to dominate mixtures, so add them just a bit at a time.

Orange. Cadmium orange is a color you really could create by mixing cadmium yellow light and cadmium red light. But it's a beautiful, sunny orange and convenient to have ready-made.

Green. Hooker's green is optional—you can mix lots of greens—but convenient, like cadmium orange. Just don't become dependent on this one green. Learn how many other greens you can mix by combining your various blues and yellows. And see how many other greens you can make by modifying Hooker's green with the other colors on your palette.

Browns. Burnt umber is a dark, subdued brown that produces lovely brown-grays and blue-grays when blended with the blues, subtle foliage colors when mixed with green, and warm autumn colors when mixed with reds, yellows, and oranges. Burnt sienna is a bright orange-brown that produces a very different range of blue-grays and brown-grays when mixed with the blues, plus rich coppery tones when blended with reds and yellows.

Gray. Payne's gray has a distinctly bluish tone, which makes it popular for painting skies, clouds, and atmospheric effects.

No Black, No White. You may be surprised to discover that this color list contains no black or white. Once you begin to experiment with color mixing, you'll find that you don't really need black. You can mix much more interesting darks—containing a fascinating hint of color—by blending such colors as blue and brown, red and green, orange and blue. And blue-brown mixtures make far more interesting grays than you can create with black. Your sheet of watercolor paper provides the only white you need. You lighten a color mixture with water, not with white paint; the white paper shines through the transparent color, "mixing" with the color to produce the exact shade you want. If some area is meant to be *pure* white, you simply leave the paper bare.

Round Brushes. When wet, a round brush should have a neat bullet shape and come to a sharp point. Here are five typical good round brushes. The two at left are expensive sables. The center brush is a less expensive oxhair. At right are two inexpensive oriental brushes with bamboo handles—worth trying if you're on a tight budget. A good substitute for sable is soft white nylon.

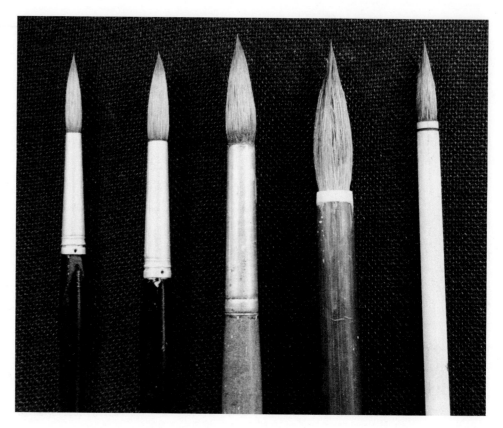

Flat Brushes. A good flat brush, when wet, should taper to a squarish shape that curves inward toward the working end. Here, from left to right, are a large oxhair, good for big washes; a small bristle brush like those used for oil painting, helpful for scrubbing out areas to be corrected; a large white nylon brush, a good substitute for the more expensive sable; and a nylon housepainter's brush, which you might like to try for painting or wetting big areas.

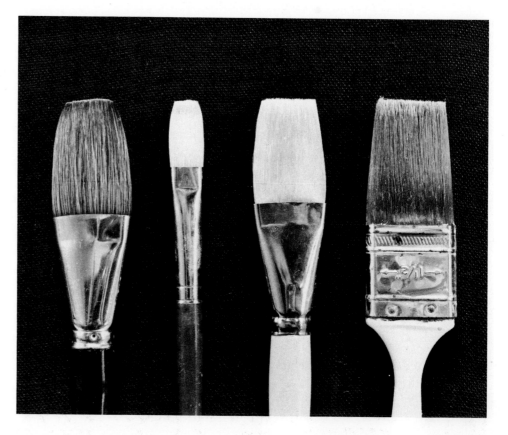

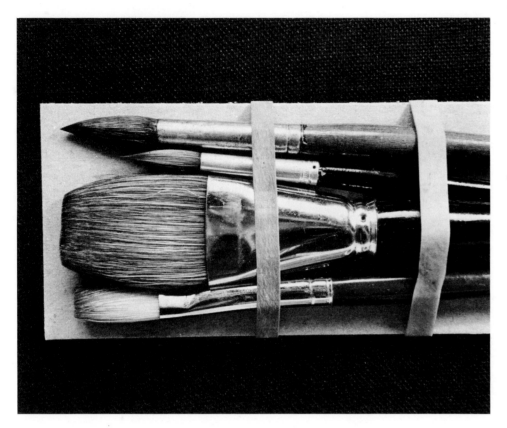

Carrying Your Brushes. When you're working on location and carrying your brushes from place to place, it's important to protect the delicate hairs from being squashed in your paintbox. One good way to do this is to cut a piece of stiff cardboard just a bit longer than the longest brush. Then arrange the brushes carefully on the board, making sure that they don't squash one another, then strap them down with a few rubber bands. For further protection, you can then slip the board into a sturdy envelope or wrap it in something flexible, like a cloth or bamboo placemat, secured with a couple of rubber bands.

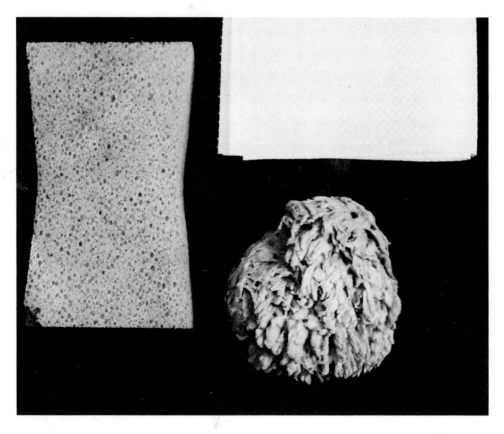

Sponges and Towels. For wetting your paper, sponging off areas you want to repaint, and cleaning up spills, it's worthwhile to buy an inexpensive synthetic sponge (left) or the more expensive natural sponge (lower right). The natural sponge has a silkier texture and will treat the surface of the paper more gently. Paper towels (upper right) are also good for cleaning up—and are handy for blotting up wet color from the surface of the painting when you want to lighten some passage that seems too dark.

Watercolor Palette. The most versatile type of watercolor palette is made of white molded plastic or lightweight metal coated with tough white enamel paint. Along the edges of this white plastic palette are compartments into which you squeeze your tube colors. The center of the palette is a large, flat mixing area. A "lip" prevents the tube colors from running out of the compartments into the central mixing area. At the end of the painting session, you can simply mop up the mixing area with a sponge or paper towel, leaving the color in the compartments for the next painting session.

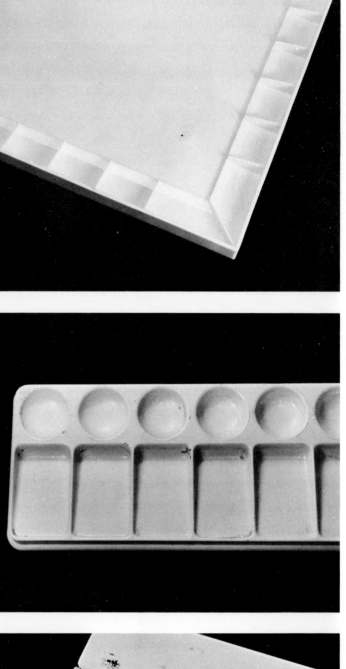

Studio Palette. Designed primarily for use indoors, this palette has circular "wells" into which you squeeze your tube colors, plus rectangular compartments for individual mixtures. The compartments slant down at one end so that the mixtures will run downward and form pools into which you can dip your brush.

Box for Pans. For painting small watercolors outdoors, many artists prefer to carry a metal box that holds little rectangular pans of dry color, rather than tubes. The dry colors liquefy as soon as you touch them with a wet brush. Buy an empty box and then buy separate pans of color, which you insert into the box. Notice that the box has two lids that open to give you four "wells" and one flat mixing surface.

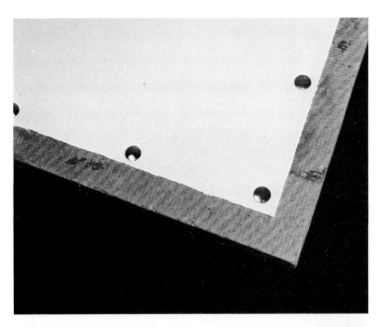

Fiberboard and Tacks. A simple way to support your watercolor paper when you're painting is to tack the sheet to a stiff piece of fiberboard. This particular piece of fiberboard is 3/4″ (about 18 mm) thick and soft enough to accept thumbtacks (drawing pins) or pushpins. Be sure to cut the board just a bit larger than the size of your watercolor paper.

Plywood and Tape. Another solution is to tape your watercolor paper to a sheet of wood—preferably plywood, which will resist warping when it gets wet. The wood will be too hard to take tacks, so use masking tape that's at least 1″ (25 mm) wide, or even wider if you can find it. A sheet of smooth hardboard will also do the job. If available, buy hardboard or plywood that's made for outdoor use; it's more resistant to moisture.

Pencil and Knife. To sketch your composition on the watercolor paper, carry a sharp pencil with a lead that's not too dark. HB is a good grade. A mechanical pencil with retractable lead is least apt to break. For cutting paper and tape, as well as for scratching lines into your painting, a sharp knife is handy. This knife is convenient and safe because it has a retractable blade, which you can replace when it gets dull.

Round Brushes. The basic tool for watercolor painting is a round softhair brush. A cluster of carefully selected animal hairs is cemented into a metal cylinder (called a ferrule) which, in turn, is clamped onto the end of a cylindrical wooden brush handle. The cluster of hairs is shaped something like a bullet: thick and round at the ferrule, then gradually tapering to a sharp point. It's important to have the biggest round brush you can afford. In most art supply catalogs, this is usually a number 12 sable, which is about 5/16″ (roughly 8 mm) in diameter at the point where the hairs enter the ferrule. Some dealers stock a number 14 sable, which is even bigger: roughly 3/8″ (about 10 mm) in diameter at the end of the ferrule. For detailed work, you should have another round sable that's about half the diameter of the big one—usually a number 7 in most art supply catalogs.

Saving Money. You'll probably be shocked by the price of a top-quality sable brush. The animal hairs are rare and costly; the brushes are made by hand; and the price seems to go up every year! For these reasons, the most expensive sables are generally bought by professionals. However, there are other softhair brushes which will do the job. First of all, there *are* less expensive grades of sable, which your art supply store may carry. Second, there are oxhair and squirrel hair brushes that are *far* less expensive; they're less springy than sable, but lots of artists like them just as well. And several manufacturers have now come up with soft, white nylon brushes—a kind of synthetic sable—that behave very much like natural sable, but cost a lot less.

Flat Brushes. For large areas of color such as skies and expanses of water, a large, flat brush is extremely useful. This is a flat, squarish body of soft hairs set into a broad metal ferrule at the end of a thick, cylindrical wooden handle. The most useful flat brush is at least 1″ (25 mm) wide where the hairs enter the ferrule; and if you're going to paint really big pictures, try to find a flat brush that's even bigger. For bold brushwork on a smaller scale, get a 1/2″ (12 or 13 mm) flat brush. Once again, don't be discouraged by the price of top-quality sable. Cheaper sable, oxhair, squirrel hair, or white nylon will do just as well.

Other Brushes. Many watercolorists carry one or two oil painting brushes—the kind made of white hog bristles—in their kits. Because these bristles are stiffer than the sables, oxhairs, and white nylons, the oil brushes make a bolder, rougher stroke. But bristle brushes are most commonly used for scrubbing out a passage that needs to be lightened or corrected. You might like to try working with a 1″ (25 mm) bristle brush, later adding another one that's half that size. For delicate line work, many watercolorists like a very slender sable called a rigger, originally developed for sign painters. And for wetting large areas with clear water, it's sometimes helpful to have a 2″ (50 mm) nylon housepainter's brush.

Testing Softhair Brushes. When you buy a softhair brush, it's important to test the brush before you walk out of the store. A good art supply store generally has a jar of water near the brush rack for just this purpose. A knowledgeable customer will test out several brushes before he makes his final choice. Dip the brush into the water and swirl the brush around carefully with a gentle circular motion. Make sure that you don't squash the hairs against the bottom of the jar. Then remove the wet brush from the jar, hold the handle at the far end, and make a quick whipping motion with a snap of your wrist. A good round brush should prove its worth by automatically assuming a smooth bullet shape, sharply pointed at the tip. A good flat brush should form a neat, squarish shape, tapering in slightly toward the forward edge. If the round brush assumes an irregular tip, rather than coming to a neat point, try another brush. If the hairs of the flat brush don't come neatly together after this test, but retain a ragged shape, don't buy the brush. Keep testing brushes until you find one that behaves properly.

How Many Brushes? Although a professional watercolorist often has a drawer full of brushes, accumulated over the years, you really need very few. You can paint watercolors for the rest of your life with just four brushes: the two round ones and the two flat ones described above. Others may be fun to have, but they're certainly optional. If you want to compare the handling qualities of the expensive, highly resilient brushes with the less expensive, softer brushes, there's a way to do this without spending too much money. When you buy your two biggest brushes—the large round and the large flat—these can be inexpensive oxhair or squirrel hair. After all, when you're working with big brushes, you're making bold, free strokes, so the brush doesn't need to have an absolutely perfect shape. Then, when you buy your two smaller brushes—one round and one flat—you might invest in top-quality sables, which are less expensive in this size. If you prefer, the small round brush can be sable and the small flat one might be white nylon. After a year of painting, you'll know whether you like a soft brush or a resilient one.

Watercolor Paper. You *can* paint a watercolor on any thick white drawing paper, but most artists work on paper made specifically for watercolor painting. The best watercolor papers have a texture—the professionals call it a *tooth*—that responds to the stroke of the brush as no ordinary paper can. Good watercolor paper also has just the right degree of absorbency to hold the liquid color, which is more apt to wander off in some unpredictable direction when you work on ordinary drawing paper. So stick to watercolor paper and buy the best you can afford.

Textures. Watercolor papers are manufactured in three surfaces: rough, cold pressed, and hot pressed. The rough surface has a very pronounced tooth, best for large pictures and bold brushwork. The cold pressed variety—which the British call a "not" surface—still has a distinct tooth, but a far more subtle texture, which most watercolorists prefer. The cold pressed surface is a lot easier to work on, particularly for beginners. Hot pressed paper is almost as smooth as the paper on which this book is printed. The surface has very little tooth, and the liquid color tends to run away from you. Hot pressed paper is mainly for experienced painters who've learned how to control it.

Paper Weights. When it gets wet, watercolor paper swells and tends to buckle—or cockle, as the British say. That is, the paper tends to develop bulges or waves. The thicker the paper, the less pronounced (and the less irritating) these waves or bulges will be. The *thinnest* paper that's convenient to paint on is designated as 140 pound. This is the weight of a very heavy drawing paper. The *thickest* paper you're likely to use is 300 pound, which is as stiff as cardboard. No, a single sheet of paper won't weigh 140 pounds or 300 pounds. That's the weight of a *ream* of paper, which means 500 sheets. In other words, a 140 pound sheet comes from a stack of 500 sheets weighing 140 pounds altogether.

Buying Paper. It's most economical to buy watercolor paper in individual sheets, which are most often 22″ × 30″ (55 cm × 75 cm). When a watercolorist talks about a "full sheet," this is usually the size he means. You can then cut this sheet into halves or quarters, which are all convenient sizes for painting. For small practice pictures and rapid sketches, you can even cut the sheet into eighths. You can also buy a small stack of watercolor paper in a pad, bound on one edge like a book. And you can buy a stack of paper in a block, which is bound along all four edges to keep the paper from curling up as you paint. But you pay a lot extra for the binding. You save a lot of money by buying sheets, cutting them up, and then tacking or taping them to your own drawing board.

Handmade Versus Machinemade. At one time, watercolor papers were normally made by hand. Such paper was called "100% rag" because it was made entirely of shredded rags. Today, all but a few of the great handmade paper mills have disappeared. Some art supply dealers stock rare, expensive handmade papers, which are still the best—if you can afford them. But most watercolorists now paint on machinemade papers that are chemically pure cellulose fiber, actually as permanent as the all-rag stock. The best machinemade papers are called *mouldmade*, a slow, careful process that produces a painting surface that comes reasonably close to the handmade stock. Mouldmade paper is still expensive, though not as costly as the handmade variety.

Testing Watercolor Paper. Assuming that you're not ready to invest in handmade paper—most people don't—it's best to work with mouldmade paper, which is still far better than the *ordinary* machinemade papers. If you look carefully at the surface, you'll see that the less expensive machinemade papers have a mechanical, repetitive texture that has much less "personality" than the more random texture of the mouldmade. But a good art supply store may have several brands of mouldmade paper, differing in absorbency, texture, and toughness. Buy one or two sheets of each (perhaps one cold pressed and one rough), cut them into quarters, label them so you know which is which, and paint pictures on them all. After a few months of experimentation, you'll know which sheet you like best.

What to Look for. See how absorbent the paper is. One sheet soaks up the liquid color, while another seems to resist it—the color seems to stay on the surface and need more stroking to force it into the hills and valleys of the sheet. At first glance, the more absorbent paper may look better, but some artists do like the less absorbent kind. (You can also make it a bit more absorbent by sponging the surface with clear water.) Speaking of toughness, you'll also find that some papers will take more punishment than others. The more absorbent papers are usually softer, which means that you can't scrub out and repaint easily. The tougher surfaces will take more vigorous brushwork and are easier to scrub out and correct. Watch the texture too. If you like to work on a large scale with big, ragged strokes, you may like the rough surface better than the cold pressed, which lends itself to smoother washes and more controlled brushwork.

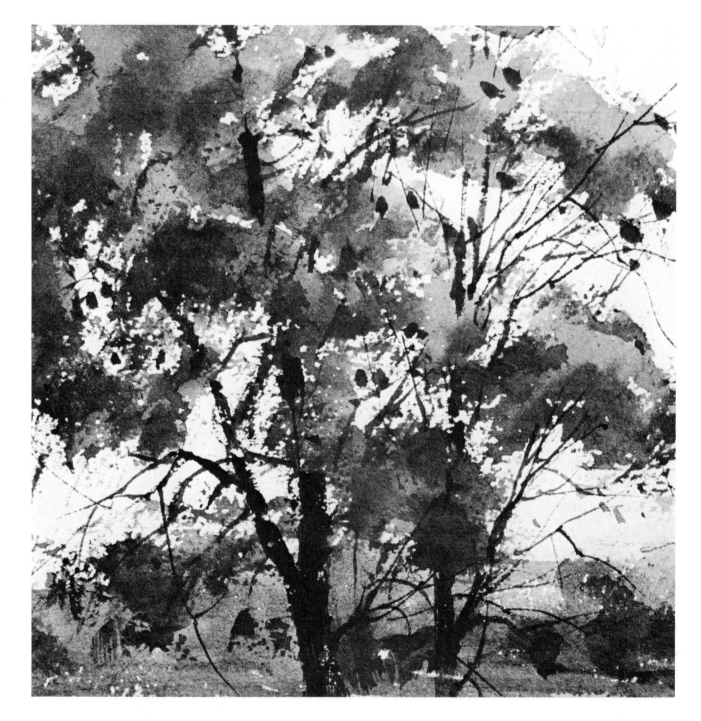

Rough Paper. The surface of your watercolor paper will have a strong influence on the character of your brushwork. On rough paper, the brushstrokes have a ragged, irregular quality that's just right for suggesting the rough texture of treetrunks and branches and the flickering effect of leaves against a light sky. In this life-size closeup of a section of a landscape, you can see how the texture of the paper literally breaks up the brushstrokes. If you like to work with bold, free strokes, you'll enjoy working on rough paper.

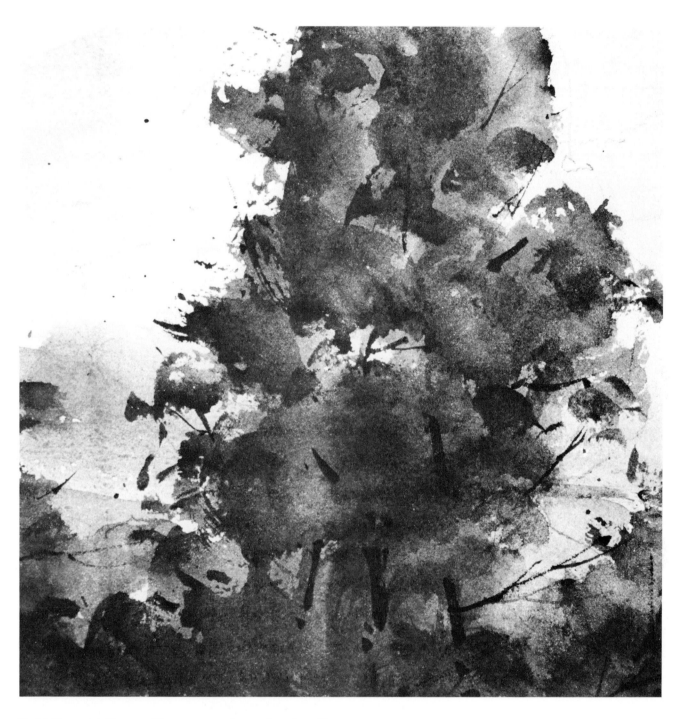

Cold Pressed Paper. The most popular surface is cold pressed—called "not" in Britain—which still has a distinct texture, but not nearly as irregular as the rough sheet. In this close-up of a tree from another painting, you can see that the liquid color goes on smoothly, and the brushstrokes don't look nearly as ragged. Cold pressed stock is the "all-purpose" paper that most watercolorists prefer because it's most versatile. It takes everything from big, smooth masses of color to tiny details. And you can still work with big, free strokes, if that's your style.

Studio Setup. Whether you work in a special room you've set aside as a studio or just in a corner of a bedroom or a kitchen, it's important to be methodical about setting up your painting equipment. Let's review the basic equipment you'll need and see how this equipment should be arranged.

Brushes. It's best to buy just a few brushes—and buy the best you can afford. You can perform every significant painting operation with just four softhair brushes, whether they're expensive sable, less costly oxhair or squirrel, soft white nylon, or some blend of inexpensive animal hairs. All you really need are a big number 12 round and a smaller number 7 round plus a big 1" (25 mm) flat and a second flat about half that size.

Paper. The best all-purpose watercolor paper is mouldmade 140 pound stock in the cold pressed surface (called a "not" surface in Britain), which you ought to buy in the largest available sheets and cut into halves or quarters. The most common sheet size is 22" × 30" (55 cm × 75 cm). Later, you may want to try the same paper in a rough surface.

Drawing Board. The simplest way to support your paper while you work is to tack or tape the sheet to a piece of hardboard, cut just a little bigger than a full sheet or half sheet of watercolor paper. You can rest this board on a tabletop, perhaps propped up by a book at the back edge, so the board slants toward you. You can also rest the board in your lap or even on the ground. Art supply stores carry more expensive wooden drawing boards to which you tape your paper. At some point, you may want to invest in a professional drawing table, with a top that tilts to whatever angle you find convenient. But you can easily get by with an inexpensive piece of hardboard, a handful of thumbtacks or pushpins, and a role of masking tape, 1" (25 mm) wide to hold down the edges of your paper.

Palette or Paintbox. Some professionals just squeeze out and mix their colors on a white enamel tray—which you can probably find in a shop that sells kitchen supplies. The palette made *specifically* for watercolor is white metal or plastic, with compartments into which you squeeze tube colors, plus a mixing surface for producing quantities of liquid color. For working on location, it's convenient to have a metal watercolor box with compartments for your gear. But a toolbox or a fishing tackle box—with lots of compartments—will do just as well. If you decide to work outdoors with pans of color, buy an empty metal box

equipped to hold pans, then buy the selection of colors listed in this book: don't buy a box that contains pans of color preselected by the manufacturer.

Odds and Ends. You'll need some single-edge razor blades or a knife with a retractable blade (for safety) to cut paper. Paper towels and cleansing tissues are useful, not only for cleaning up, but for lifting wet color from a painting in progress. A sponge is excellent for wetting paper, lifting wet color, and cleaning up spills. You'll obviously need a pencil for sketching your composition on the watercolor paper before you paint: buy an HB drawing pencil in an art supply store or just use an ordinary office pencil. To erase the pencil lines when the watercolor is dry, get a kneaded rubber (or "putty rubber") eraser, so soft that you can shape it like clay and erase a pencil line without abrading the delicate surface of the paper. Find three wide-mouthed glass jars big enough to hold a quart or a liter of water; you'll find out why in a moment. If you're working outdoors, a folding stool is a convenience—and insect repellent is a *must*!

Work Layout. Lay out your supplies and equipment in a consistent way, so everything is always in its place when you reach for it. Directly in front of you is your drawing board with your paper tacked or taped to it. If you're right-handed, place your palette and those three wide-mouthed jars to the right of the drawing board. In one jar, store your brushes, hair end up; don't let them roll around on the table and get squashed. Fill the other two jars with clear water. Use one jar of water as a "well" from which you draw water to mix with your colors; use the other for washing your brushes. Keep the sponge in a corner of your palette and the paper towels nearby, ready for emergencies. Line up your tubes of color someplace where you can get at them quickly—possibly along the other side of your drawing board—when you need to refill your palette. Naturally, you'd reverse these arrangements if you're left-handed.

Palette Layout. In the excitement of painting, it's essential to dart your brush at the right color instinctively. So establish a fixed location for each color on your palette. There's no one standard arrangement. One good way is to line up your colors in a row with the *cool* colors at one end and the *warm* colors at the other. The cool colors would be gray, two blues, and green, followed by the warm yellows, orange, reds, and browns. The main thing is to be consistent, so you can find your colors when you want them.

PART ONE

WATERCOLOR PAINTING

Why Paint in Watercolor? Artists who paint in watercolor are fanatical about their medium. Watercolor seems to inspire a kind of passion—once you master it—that unites watercolorists into a kind of unofficial worldwide "society," like people who are in love with wine or sailing or horseback riding. Ask the watercolorist to define the magic of his medium and he'll probably talk about three unique qualities: transparency, speed and spontaneity.

Transparency. As it comes from the tube, watercolor is a blend of finely powdered color, called pigment; a water-soluble adhesive called gum arabic, which will glue the pigments to the watercolor paper; and just enough water to make these ingredients form a thick paste. You squeeze a dab of this paste from the tube onto the palette, load a brush with water, touch the tip of your brush to the dab of color, and swirl the brush around on the mixing area of your palette to form a pool of liquid color. That pool is essentially tinted water, as clear and transparent as the water you drink, merely darkened by a touch of color. The color on your palette is like a sheet of colored glass. You can see right through it to the white surface of the palette. And when you brush the liquid color onto the paper, the light in your studio shines through the wash, strikes the white surface of the paper, and bounces back through that layer of color like sunlight passing through stained glass. A watercolor painting is literally filled with light. That's why watercolorists love to paint the effects of light and atmosphere in outdoor subjects such as landscapes and seascapes.

Speed. As soon as the water evaporates, a stroke or wash of watercolor is dry. But that stroke or wash actually *begins* to dry as soon as the liquid color hits the paper. For a minute or two—as long as the wet color remains shiny—you can push the paint around or blend in more liquid color. But as soon as the surface of the paper begins to lose its shine, the liquid color is beginning to "set up." At that stage, you'd better stop and let it dry. From that point on, you run the danger of producing unpleasant streaks or blotches if you keep working on the damp color. If you try to introduce a brushload of fresh color into that damp surface, you're most likely to produce a distinctive kind of blotch, which every watercolorist knows and dreads—called a *fan* because of its peculiar, ragged edge. In short, watercolor forces you to be quick. You have to plan your picture carefully: decide exactly what you want to do, work with decisive strokes, then stop. Every painting is exciting—a race against time, a challenge to your decisiveness and your control of the medium. Watercolor is for people who like speed and action.

Spontaneity. Because of this rapid drying time, you're forced to wield the brush quickly and freely. Like a general planning an attack, you must do all your thinking before you sound the charge. Once the action begins, there's no turning back. As soon as the brush touches the paper, the challenge is to get the job done with a few bold, rapid strokes. This is why a good watercolor has such a wonderfully fresh, lively, spontaneous feeling. A century after the picture was painted, the viewer can still share the artist's pleasure in the sweeping action of the brush.

Permanence. Yes, a watercolor *will* last a century or more, even though it's nothing more than tinted water on a fragile sheet of paper. If you work with non-fading color—such as the colors recommended in this book—and keep your painting away from moisture, that delicate veil of color on the paper will last just as long as a tough, leathery coat of oil paint on a canvas.

Wash Demonstrations. Following a brief survey of the colors, brushes, papers, and other equipment you need for watercolor painting, this book begins by demonstrating the four basic ways of applying liquid color to paper. First, you'll see how to paint a flat wash, which means a color area that's the same density from one edge to the other. Then you'll see how to paint a graded wash, which starts out dark at one edge and gradually lightens as it reaches the other edge. You'll learn the technique called drybrush, which means working with a brush that's merely dampened with color. And finally, you'll see a demonstration of the wet-in-wet technique, which means brushing color onto a wet surface so the strokes blur and fuse.

Painting Demonstrations. These wash demonstrations are followed by a series of painting demonstrations in which Claude Croney, a master of watercolor technique, puts these four basic wash techniques to work in a series of twelve complete paintings. He starts with simple, colorful still lifes of fruit, vegetables, and flowers, since still life is the easiest way to learn how to control any painting medium. Then Croney goes outdoors to paint a variety of landscapes and coastal subjects.

Special Effects. Finally, you'll learn various technical tricks such as creating lines and textures by scratching and scraping. You'll also learn how to alter a watercolor painting by the techniques called sponging, washing, scrubbing, and lifting. And you'll learn how to mat, frame, and preserve a finished picture.

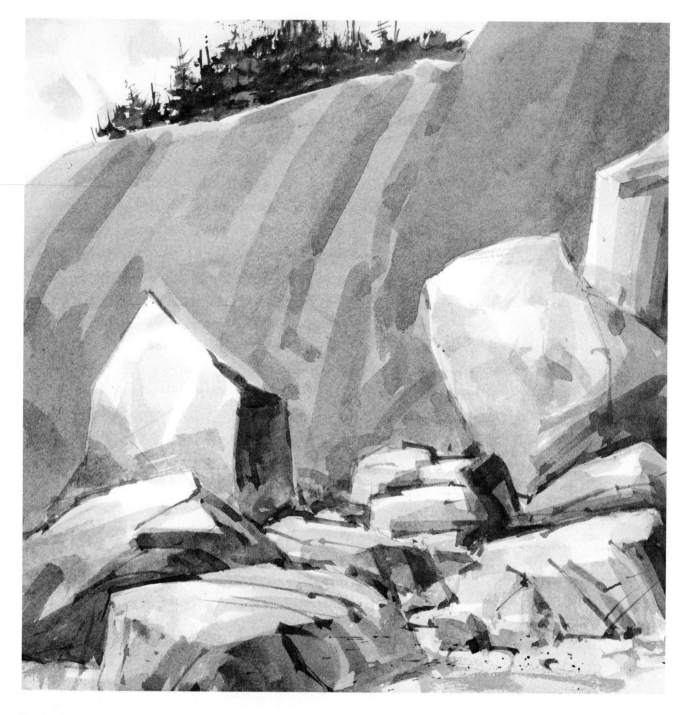

Rocks in Flat Washes. The basic way to apply water-color is called the *flat wash*. You mix up a small pool of color on your palette and paint an area that's the same tone from end to end. It's not darker at one end and lighter at the other—that's why it's called *flat*. This study of a cliff and rocks is composed entirely of flat washes, one laid over the other. You paint the light areas first and let them dry. Then you paint the darker areas right over the lighter ones. In this way, you build flat wash over flat wash until the picture is completed. It's helpful to work with your drawing board tilted up slightly at the back. Paint your flat washes from the top down, overlapping your strokes very slightly; the color will roll down the sheet toward you. If a pool of color forms at the lower end of the completed wash, quickly rinse your brush, flick out most of the water with a snap of your wrist, and use the tip of the brush as you would a sponge to soak up some of the excess color.

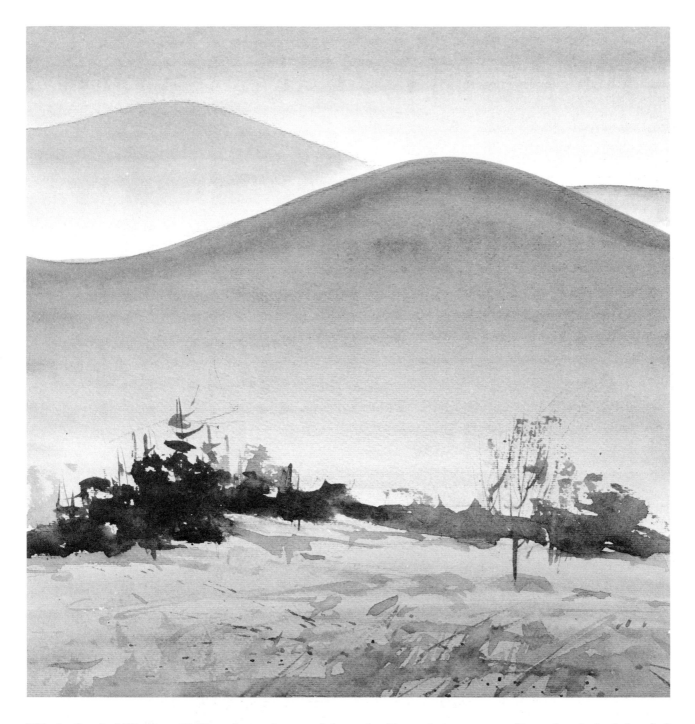

Hills in Graded Washes. Unlike a flat wash, a *graded wash* moves from dark at one end to light at the other. Once again, your drawing board should tilt up slightly at the back, so the color will roll toward you. Mix a pool of liquid color on your palette and paint each wash in a series of overlapping stripes, working fast enough so that one stroke doesn't dry before you apply the next. The strokes should be wet enough so that they blur together. However, in order to get the dark-to-light gradation, each successive stroke should contain more water and less color. At the dark end of the wash, the first strokes can be taken straight from the pool on the palette. Then begin to pick up a little water on your brush before you dip it into the pool. As you work down the wash, the brush will contain more water and less color. You can see how this works in the painting of sky and hills here. They all start out dark at the top, then grow lighter and lighter.

Step 1. This rock study is done in flat washes. Each wash is a series of horizontal strokes, one below the other. The strokes overlap just a bit, and you must work fast so that the strokes stay wet and blur into one another, forming an even tone. The picture begins with a pale pencil drawing. The sky and cliff are painted in a series of flat washes, each slightly darker than the one before. A pale wash covers the sky and the entire cliff area. When that's dry, a slightly darker wash covers just the cliff area. After that's dry, the darker areas are painted.

Step 2. Now the brush moves to the rocks in the foreground. A few very pale washes are painted over the light area and allowed to dry. Then the shadows are painted in with broad, straight strokes. As you'll see in a moment, the foreground shadows will eventually be much darker, but it's always best to work gradually from light to dark. One important tip: watercolor always dries paler than you expect— so get into the habit of making the liquid mixtures on your palette just a bit "too dark."

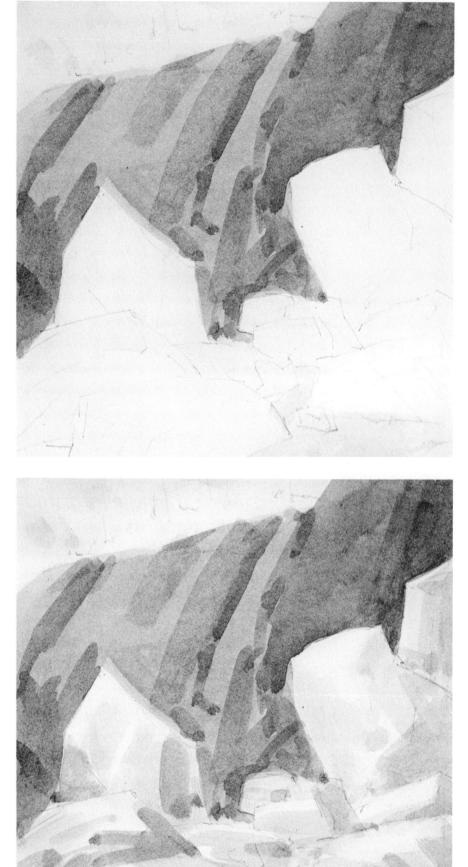

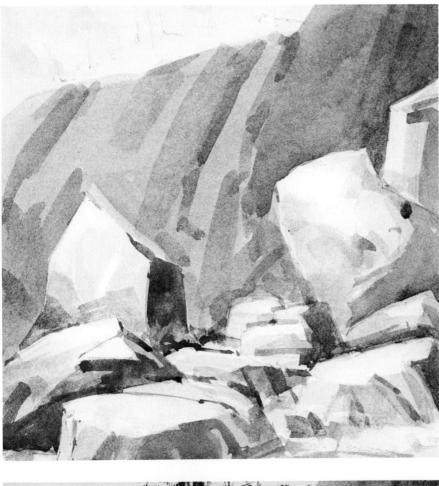

Step 3. Now the first real darks begin to appear on the shadow sides of the foreground rocks. They're still quick, straight, fairly broad strokes—no attention to precise detail yet. But these still aren't the strongest darks.

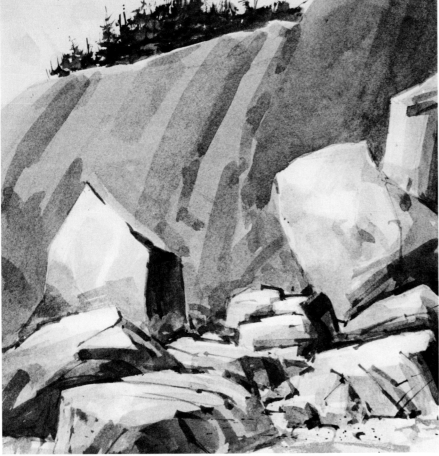

Step 4. Finally, the tip of the brush strikes in crisp, dark strokes to reinforce the shadows on the foreground rocks. This is the time to add details like the cracks in the rocks—but not too many. The tip of the brush is also used to suggest the trees at the top of the cliff, which are painted in a series of little touches to suggest the texture of the foliage.

Step 1. Here's how hills are done in graded washes. Once again, it's best to start from the top. The sky begins with one or two long strokes of dark color, followed by several strokes of paler color containing more water. The pale strokes are added while the dark strokes are still wet so that they blur together. When the sky is dry, the distant hills are done in exactly the same way. In the foreground and along the edge of the near hill, you can see traces of the very pale pencil drawing with which the picture began. So far, the near hill and the foreground are just bare paper.

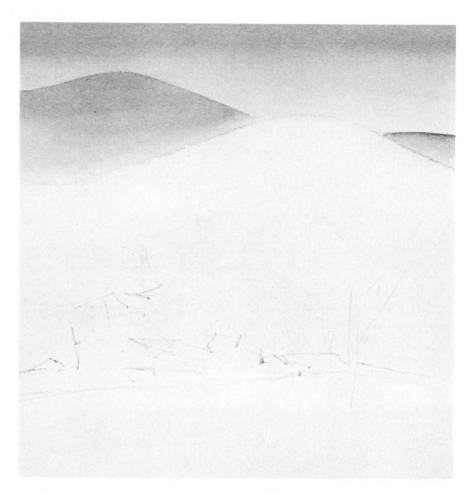

Step 2. Now the nearest, biggest hill is done in the same way as the sky and the far hill. The topmost strokes are quite dark; thus the more distant hill at the horizon seems farther away. The immediate foreground is still bare paper.

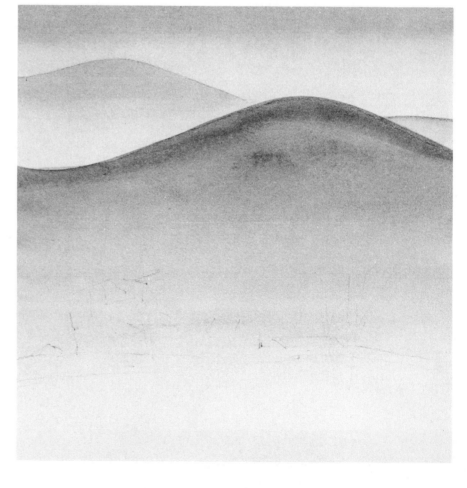

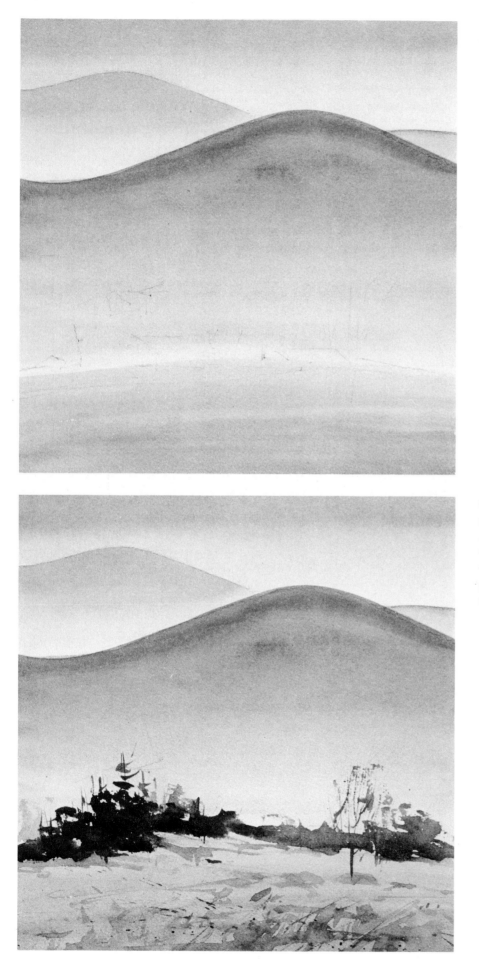

Step 3. At this point, work begins on the immediate foreground. You can see that it's a rather streaky, graded wash. The strokes are applied very freely so that they don't quite blend, and the strokes in the immediate foreground are only a little darker than those beyond. As you'll see in the next step, the entire foreground will have an irregular texture.

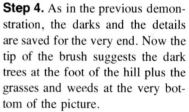

Step 4. As in the previous demonstration, the darks and the details are saved for the very end. Now the tip of the brush suggests the dark trees at the foot of the hill plus the grasses and weeds at the very bottom of the picture.

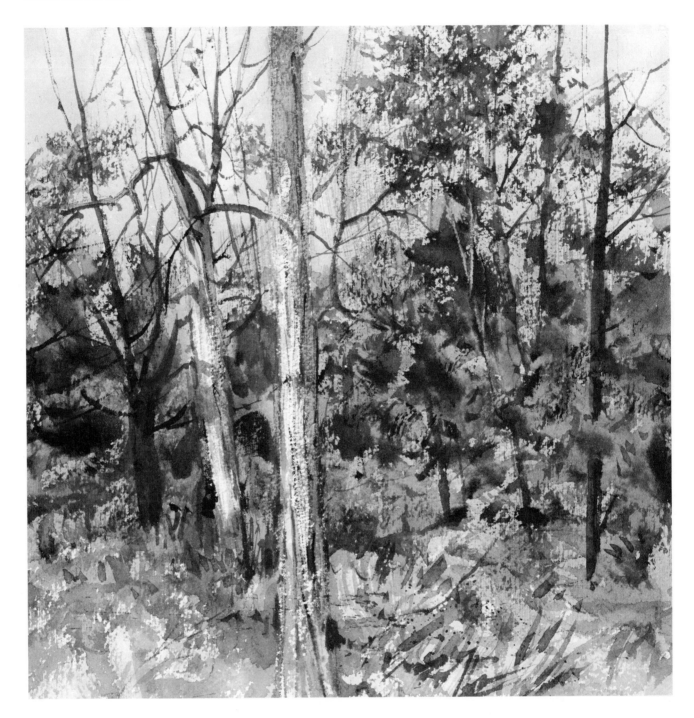

Woods Painted with Drybrush. Drybrush is a method of exploiting the texture of the paper to create rough-textured brushstrokes. The brush isn't literally dry, but just damp. You can dip the brush in liquid color and then wipe the hairs on a paper towel to remove some of the color, or you can just pick up a bit of color on the brush, not letting the hairs get too wet. You then skim the damp brush over the paper, hitting the ridges and skipping over the valleys. The color tends to be deposited on those ridges, leaving the valleys bare. The harder you press, the more color you deposit, but some paper always peeks through, and the strokes have a fascinating, ragged quality that is ideal for suggesting textures such as treetrunks, masses of leaves, and the flicker of sunlight on the ground below.

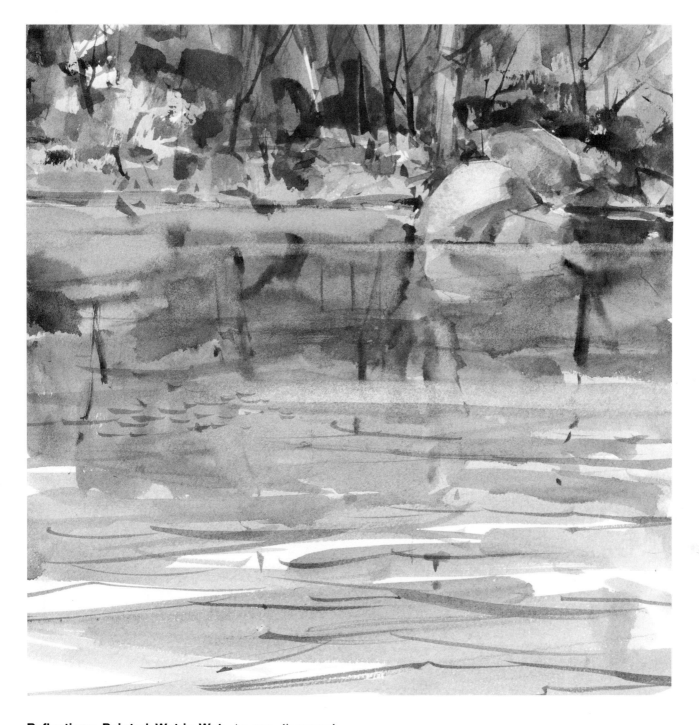

Reflections Painted Wet-in-Wet. As you discovered when you painted a series of overlapping strokes to create flat and graded washes, a stroke of watercolor blurs when it hits a wet area of the paper. The technique called wet-in-wet takes advantage of this phenomenon. If you wet the paper first—either with pure water or with liquid color—and then apply fresh strokes of color to this wet surface, those strokes will blur. You can see this happening in the reflections of the dark woods in the water just above the midpoint of this picture. The dark strokes blur into a paler undertone to suggest the mysterious shapes of the reflections.

Step 1. Now you'll see how drybrush is used to paint the rough texture of a forest scene. Over a simple pencil drawing of the main shapes, a pale tone is quickly brushed in for the distant sky, leaving bare paper for the two light treetrunks just left of center. While the sky wash is still wet, a few darker strokes are added to suggest the distant woods. These darker strokes blur into the wet sky wash.

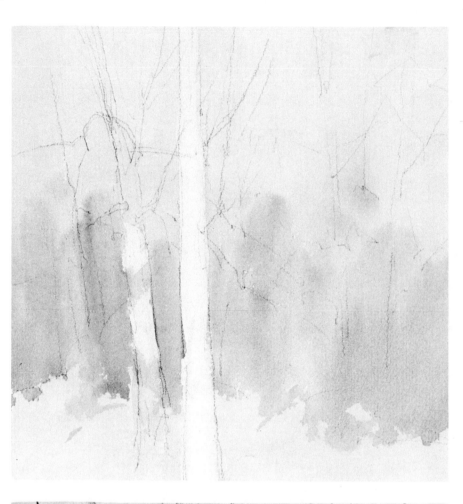

Step 2. The tip of the brush adds a few fast, decisive strokes for the darker treetrunks and also for some branches. It's a good idea to place these darks early so that you don't lose track of them among the mass of drybrush strokes that will come next.

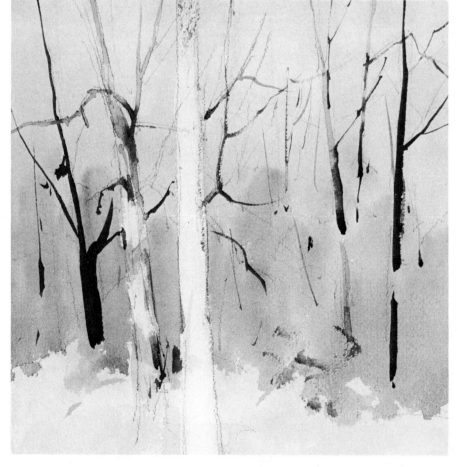

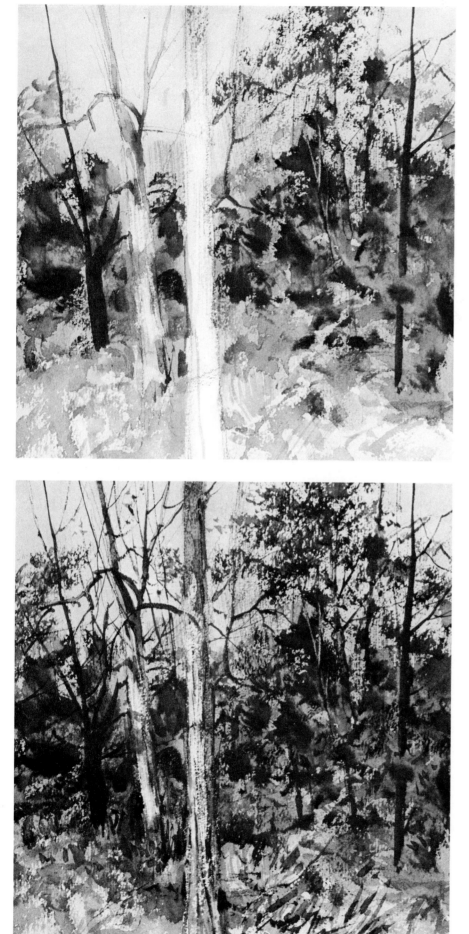

Step 3. Now the drybrush work begins. The brush is damp, not wet—lots of color, but not too much water. If the brush is too wet, wipe it on a paper towel. Now the brush is skimmed over the paper, leaving color on the ridges and skipping over the valleys. If you press harder, you'll deposit more color, but the strokes will still have a broken, irregular look, with flecks of paper showing through. The darks in the center are placed with quick, rough strokes. If some strokes look too dark and ragged, they can be softened with some strokes of liquid color, as you see in the center. Notice the pale drybrush strokes in the immediate foreground.

Step 4. Drybrush strokes gradually build up the darks of the woods, the foliage against the sky, and the grasses and weeds in the foreground. Finally, the tip of the brush suggests the texture of the central treetrunk with slender strokes—and adds details such as more branches, twigs, and foreground weeds.

Step 1. A wet-in-wet passage looks most effective when contrasted with more precise washes. So this picture begins with a series of flat washes for the woods at the top. This section is painted flat wash over flat wash, like the rock study you've already seen. Just a few big strokes suggest lights and shadows.

Step 2. Now the woods are completed with more precise, slender strokes to suggest treetrunks and more shadows. For precise work like this, you can either use a small brush or the very tip of a large brush. The water area is still bare paper.

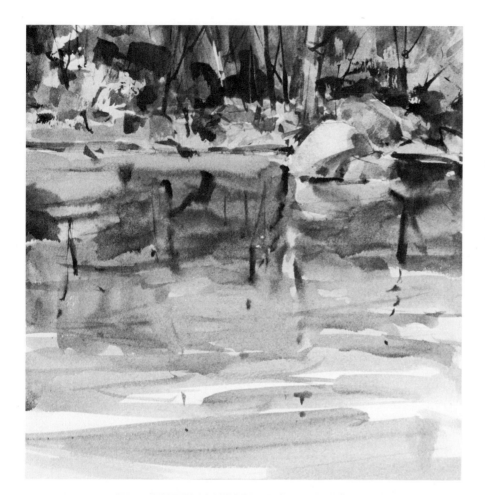

Step 3. At this point, the reflections are painted wet-in-wet. A series of pale horizontal strokes suggests the water. It's important to wait a moment to let that wash settle into the paper. Then, while the underlying wash is still wet and shiny, the brush goes back in with much darker strokes that blur and suggest the reflections just below the shoreline. Since a wet-in-wet passage always dries *much* lighter than you expect, the color on your brush should be quite dark.

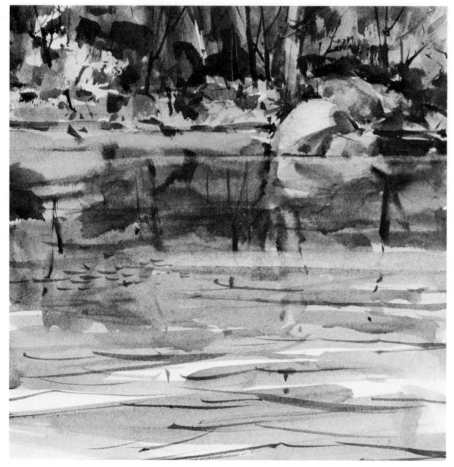

Step 4. When the water and reflections are dry, a few ripples and streaks are added with a small brush. Now you'll see that the dried color of the water is a lot paler than the wet wash.

Planning Your Colors. Watercolor, unlike oil paint, doesn't allow you to mix a batch of color, brush it over the painting surface, wipe it off, and try again. Once that mixture is on the watercolor paper, it's there to stay. As you'll see later, there *are* ways of washing off an unsuccessful color mixture, but these are strictly emergency measures. That first wash of color should be the right one. The only way to make sure it's the right one is to know what each color on your palette can do, so you can plan every color mixture in advance.

Testing Your Colors. The best way to find out what your colors will do is to plan a simple series of tests. If you use the color selection recommended in this book, you'll have eleven colors on your palette. Make a "test sheet" for each of these colors. Take three full-size sheets of watercolor paper and cut them into quarters, which will give you a dozen small sheets, one for each color on your palette—plus an extra sheet which you can put aside for a small painting later on. At the top of each sheet, write the name of one of the colors on your palette. Then, using one of your big brushes—either the large round or the large flat—paint a series of color patches about 1" (25 mm) square in several rows across the sheet.

Mixtures. Start with the color whose name is written at the top of the sheet. Mix it with a little water for the first patch, with more water for the second, and with a lot of water for the third. Then mix that color with each color on your palette. Label each mixture so you can go back to the "test sheet" later on and see how you got all those fascinating colors. It's particularly interesting to try each mixture two or three times, varying the proportions of the colors. In other words, if you're mixing ultramarine blue and cadmium yellow light, first try a mixture in which the blue and yellow are added in equal quantities; then try more blue and less yellow; finally, try more yellow and less blue. Painting these "test sheets" is the quickest way to learn about your colors. The whole job won't take you more than a few hours and will save you countless days of frustration when you're actually painting.

Color Charts. It's worthwhile to do these "test sheets" methodically. Label each mixture with some code that you'll be able to decipher months later. For example, if the mixture is ultramarine blue and cadmium yellow light, you might just use the initials UB-CYL. Now these are more than just "test sheets"; they're color charts that you can use for years, tacking them on your studio wall and referring to them when you're planning the color mixtures in a painting. Eventually, all these color mixtures will be stored in

your memory, and you can put the charts away in a drawer. But while you're learning, the charts are a great convenience. They also look very professional and will impress your friends!

Color Mixing. When the time comes to mix colors for a painting, here are a few tips to bear in mind. Dip your brush into the water first, then pick up a bit of moist color from the palette with the *tip* of the brush and stir the brush around on the palette until you get an even blend of color and water. Then pick up a bit of your second color on the tip of your brush and stir this into the mixture. If you need a third color, stir this into the mixture *after* you've blended the first two colors. The point is to add the colors to the mixture one at a time so you can judge how much you're adding and see the mixture change gradually. Try to stick with mixtures of just two or three colors. Mixtures of four or more colors tend to turn muddy.

Mixing on the Paper. Because watercolor is fluid and transparent, you'll discover interesting ways of mixing color right on the paper. One method is the wet-in-wet technique. You can wet the surface of the paper with clear water and quickly brush two or three colors onto the shiny surface; allow them to flow and merge by themselves, with just a little help from the brush. This produces lovely, irregular color mixtures, with one hue blurring into another like the interlocking blues and grays of a cloudy sky. Another way to mix directly on the paper is to put down one color, allow it to dry, then paint a second veil of color over the first. The underlying color will shine through the second wash, and the two will "mix" in the eye of the viewer. A wash of blue over a dry patch of yellow will produce green, but this will be quite a different green from a mixture of the same two colors on your palette. One transparent color over another produces an *optical* mixture.

Testing Optical Mixtures. Just as you've made "test sheets" to see what happens when you mix one color with another, it's worthwhile to make some more "test sheets" to see what kinds of *optical* mixtures you can create. The quickest way to do this is to take one of your flat brushes and make a long, straight stroke of one color. Let it dry. Then cross this long stroke with a short stroke of each color on your palette. Make each short stroke just long enough so that you can see how it looks on the bare white paper and then how it changes as it crosses the underlying stripe of color. Make one of these "stripe charts" for each color on your palette, and you'll discover a great variety of optical mixtures that you'd never find any other way.

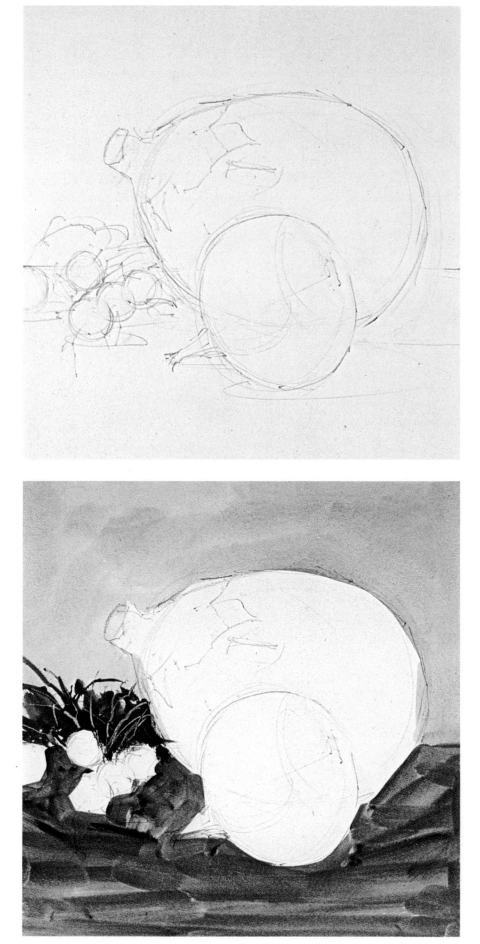

Step 1. To learn how to model forms—to get a sense of three-dimensional roundness—it's best to start out with some still-life objects from the kitchen, such as this arrangement of an eggplant, an onion, and some radishes. Begin with a simple drawing. You needn't be too precise in drawing your lines, since you're going to erase them with kneaded rubber (or putty rubber) after the complete painting is dry.

Step 2. The background and the tabletop are painted with big, free strokes. The background is ultramarine blue mixed with a touch of burnt sienna. The tabletop is mostly burnt umber, plus a bit of cerulean blue. The greens behind the radishes are Hooker's green and burnt sienna, painted with a small, round brush. The stems are scraped out with the tip of the brush handle while the color is still wet.

Step 3. The rounded form of the eggplant is brushed in with curving strokes—a blend of alizarin crimson, ultramarine blue, and burnt umber. Some strokes are darker than others and they all blur together, leaving a piece of bare paper for the highlight. The onion is painted with a mixture of yellow ochre, cadmium orange, and a touch of cerulean blue, with all the strokes blurring together, wet-in-wet. The dark spots on the onion are burnt umber, brushed in while the underlying color is still wet. The green on the eggplant is cadmium yellow, cerulean blue, and yellow ochre.

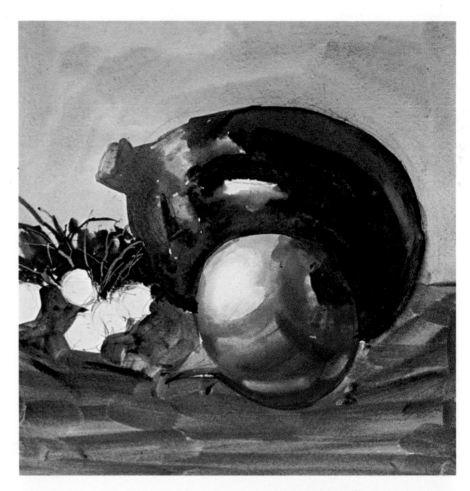

Step 4. The radishes are modeled with the short, curving strokes of a small, round brush—a blend of cadmium yellow, cadmium red, and alizarin crimson for the bright tones, then Hooker's green for the dark touches. The dark greens on the tip of the eggplant are also Hooker's green darkened with a touch of cadmium red.

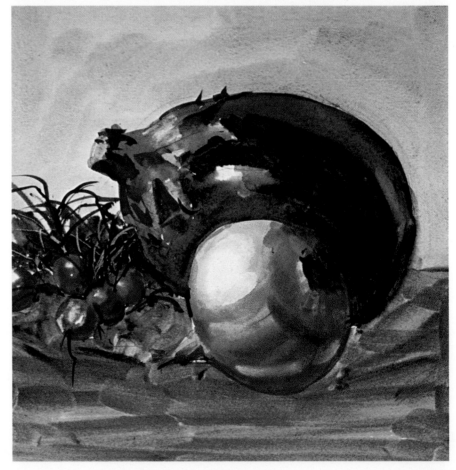

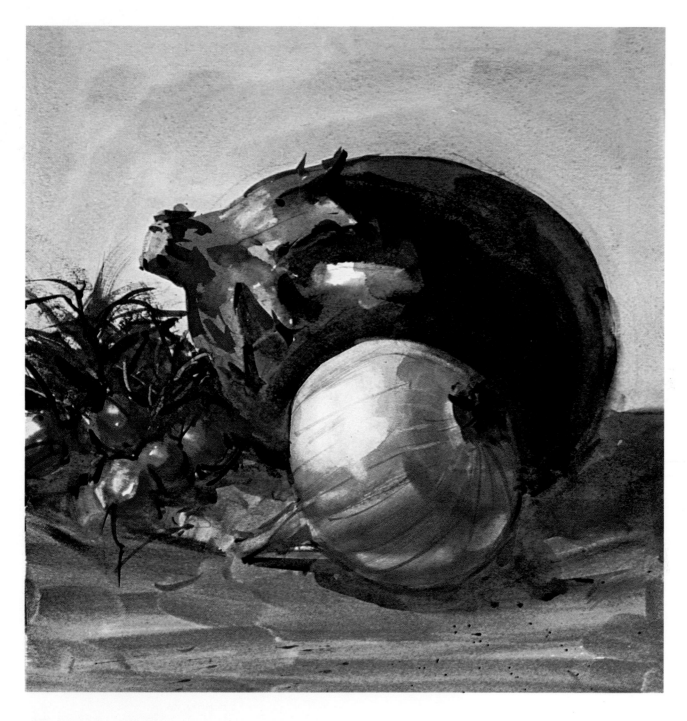

Step 5. Finally, cast shadows are added beneath the egg-plant, onion, and radishes in a dark mixture of burnt umber and ultramarine blue. Some dark touches are added to the green tip of the eggplant, at both ends of the onion, and behind the radishes with a mixture of Hooker's green and alizarin crimson. Some lines of burnt umber are added to the onion, and some light lines are scratched out with the corner of a sharp blade. Going back to the green mixture in Step 2, some drybrush strokes are added behind the radishes. As you can see, the main point is to follow the forms. The brushstrokes on the vegetables are rounded, like the shapes of the vegetables themselves. And the strokes of the table are horizontal, like the surface of the table.

Step 1. Some rough-textured object like this old, dead treestump is ideal for developing your skill with drybrush. This may also be a good opportunity to try out rough paper, in contrast to the cold pressed (or "not") paper used in the previous demonstration. The preliminary pencil drawing defines the general shape of the treestump, indicates some of the bigger cracks, and suggests some roots that will be painted out later because they're distracting.

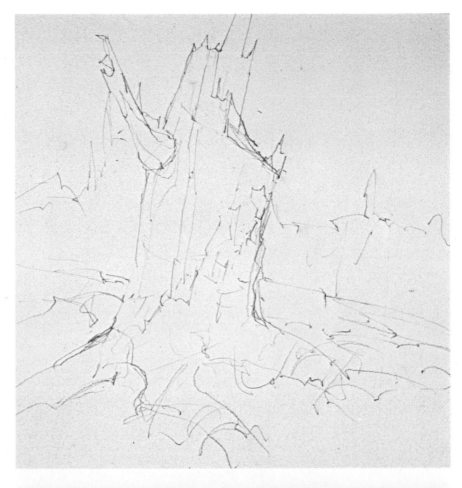

Step 2. In a landscape, it's usually best to start with the sky, painting it with a large flat or round brush. The sky mixture here is ultramarine blue, alizarin crimson, and yellow ochre. Then you can work on the shapes along the horizon, which happen to be trees in this case—a mixture of Hooker's green and burnt umber, with a bit of Payne's gray. The grass is Hooker's green, yellow ochre, and burnt sienna. This completes the background for the treestump. The lines in the distant trees are scratched with the tip of a brush handle while the color is wet.

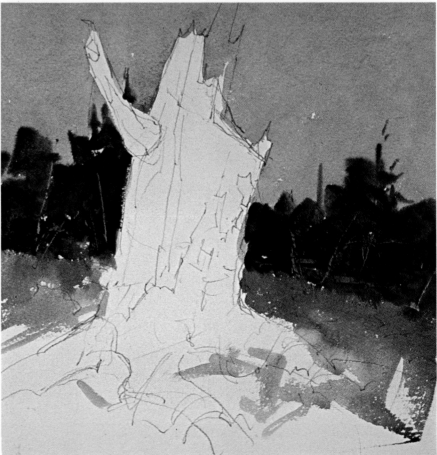

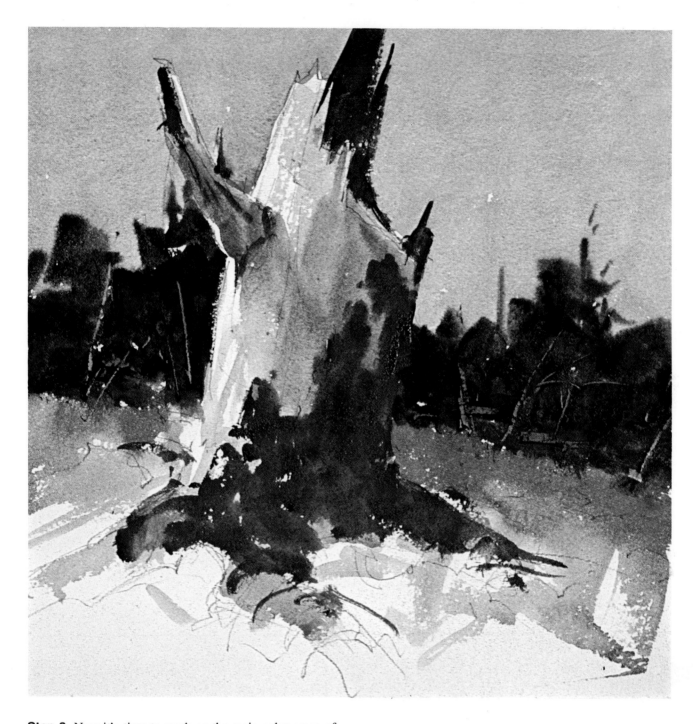

Step 3. Now it's time to work on the main color areas of the treestump itself. It's usually best to work from light to dark. The lighter tones of the wood are burnt sienna and ultramarine blue, leaving some bare paper on the left side of the stump for the lights. This same mixture is used for the shadow side of the broken branch. While the light tone is still damp, a dark mixture of Hooker's green and burnt umber is added to the right side of the stump, so the dark and light tones fuse slightly. This mixture is also used for the other darks on the stump. At this point, the brush carries a lot of color, but it's not too wet; thus the strokes have a drybrush feeling—particularly the darks at the top of the stump.

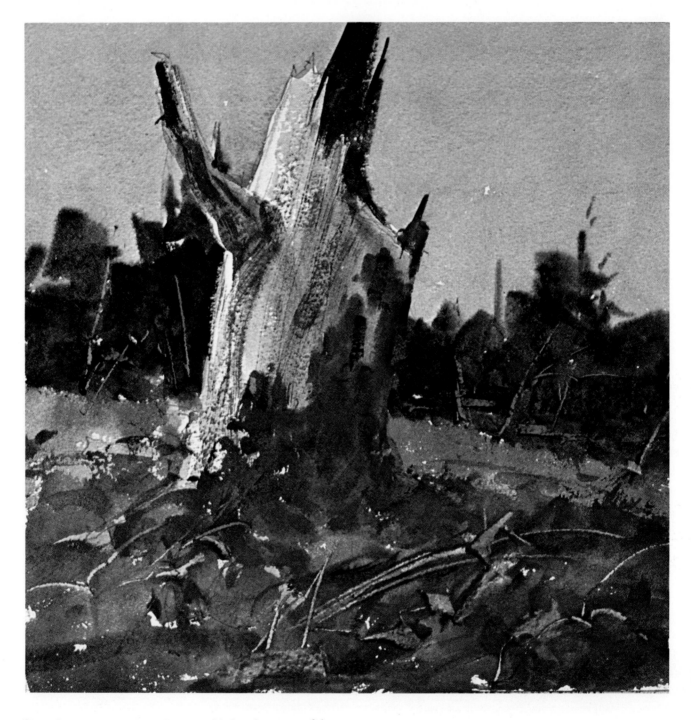

Step 4. Now drybrush strokes are added to the stump, following the upward direction of the form and suggesting the roughness of the dead, weathered wood. These strokes are a mixture of cerulean blue and burnt sienna. The dead weeds in the foreground are painted roughly with a big brush—a mixture of yellow ochre, burnt sienna, and burnt umber—with one wet stroke blurring into the next. While the foreground color is still wet, it's fun to scrape into the color with the tip of a brush handle to suggest individual weeds. If you look closely, you can see some drybrush strokes suggesting the rough texture of the ground.

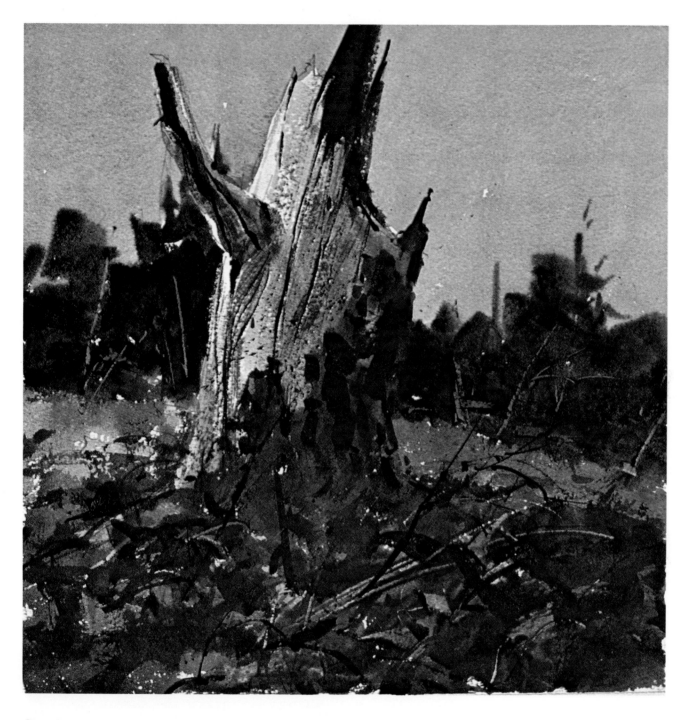

Step 5. Drybrush strokes of burnt umber are added to the foreground. More darks are added to the stump with a mixture of alizarin crimson and Hooker's green. This mixture is used for the very slender strokes and additional drybrush textures on the light part of the stump. The sharp corner of a blade is used to scrape out some light lines next to the dark ones, strongly emphasizing the texture of the wood. Finally, a few touches of cadmium red are added at the base of the stump, within the dark shadows at the top of the stump, and inside the cracked branch. The finished painting is actually a combination of many different effects. The sky is a flat wash. The distant trees are painted wet-in-wet into the sky. Drybrush is used selectively, mainly on the stump and in the foreground.

Step 1. The rounded forms of fruit always make an excellent subject for a still life—good practice for developing your skills with the brush. This casual arrangement of grapefruit, apples, and plums begins with a simple pencil drawing that indicates the rounded shapes of the fruit, plus the bowl and the dividing line between the tabletop and the background wall. The background is painted with a mixture of cerulean blue, yellow ochre, and burnt sienna, with more blue in some places and more brown or yellow in others. The same colors are used on the underside of the bowl, with more yellow ochre.

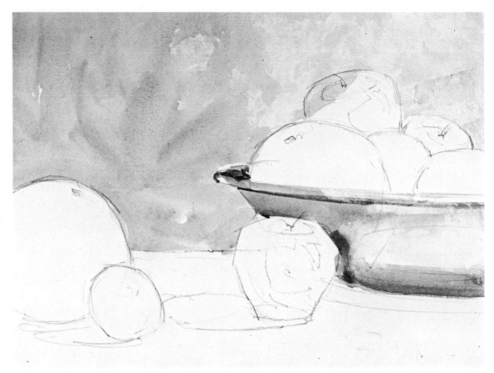

Step 2. The light side of the grapefruit is painted with cadmium yellow, plus some yellow ochre and a touch of cerulean blue on the shadow side. While the light washes are still wet, the dark strokes are added so that the dark and light strokes blur together a bit. Notice how the strokes curve to follow the rounded forms.

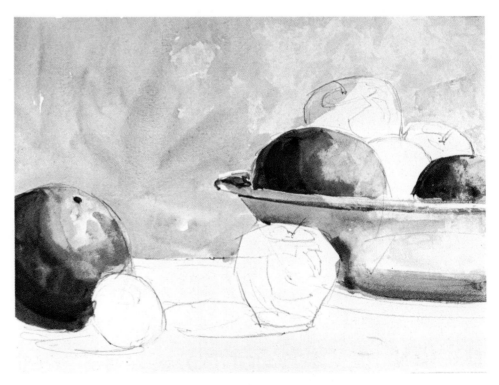

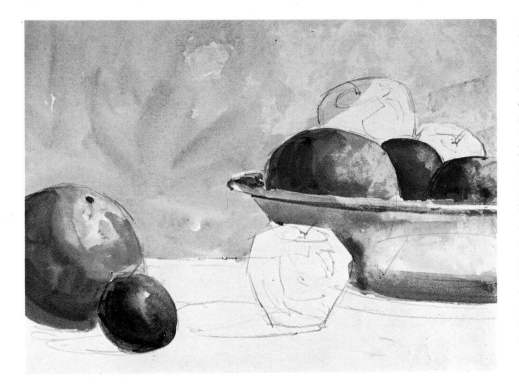

Step 3. The orange in the bowl, just behind the two grapefruit, starts with a mixture of cadmium yellow and cadmium orange. An extra dash of cadmium orange is added to the top while the first wash is still wet, and a little Hooker's green is brushed into the wet wash to suggest a shadow farther down. The plum is mainly ultramarine blue and alizarin crimson, with a hint of yellow ochre. A bit of bare paper is left for the highlight. The lighter side of the plum is painted with more water in the mixture, the shadow side with less. The two tones blend together, wet-in-wet.

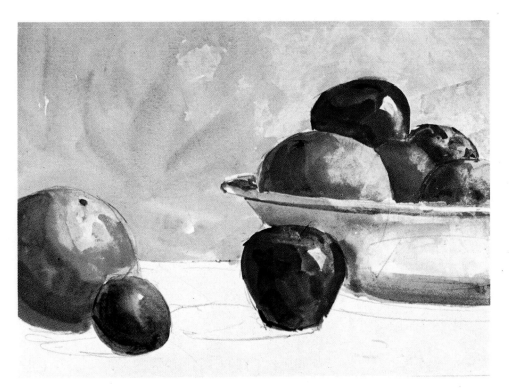

Step 4. The lighter sides of the apples are painted with cadmium red and a little cadmium yellow, adding more cadmium red and alizarin crimson to the shadow side. The darkest touches of shadow include a little Hooker's green. The dark touches are added while the lighter strokes are still slightly wet. The green at the top of the apple is Hooker's green plus a little cadmium yellow. The paler apple at the back of the bowl is painted with the same mixtures, but with more water.

Step 5. Now it's time to "anchor" the fruit to the horizontal surface of the table, which is painted with a large, flat brush carrying a fluid mixture of Hooker's green and burnt sienna. You can see that the brushstrokes are rather irregular, some containing more green and some containing more brown. More strokes are added to the background wall with the same big brush; the free, erratic strokes carry mixtures of cerulean blue, yellow ochre, and burnt sienna, some strokes bluer and some browner than others.

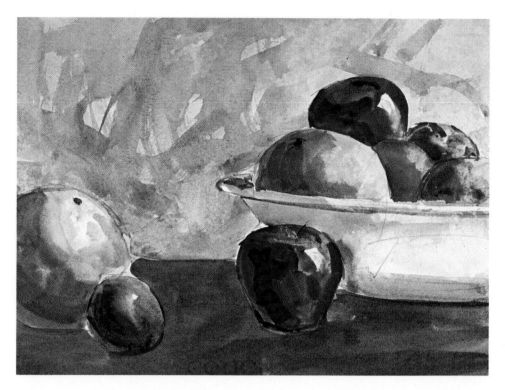

Step 6. Shadows on the table are added with a dark mixture of burnt umber and Hooker's green, carefully painted with a small, round sable. A few strokes are added to the tabletop to suggest the wood texture. Then more texture is added to the wall and the tabletop by a technique called spattering: the brush is dipped into wet color, which is then thrown onto the painting surface with a whipping motion of the wrist, spattering small droplets of paint. Stems are added to the apples—a blackish blend of Hooker's green and alizarin crimson.

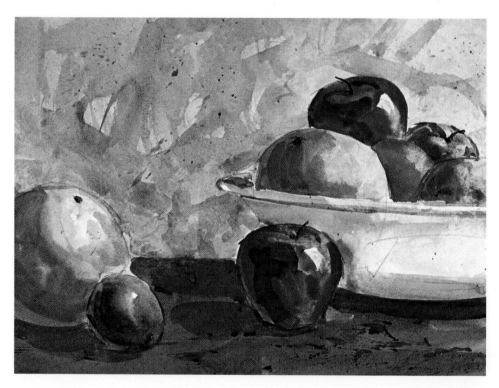

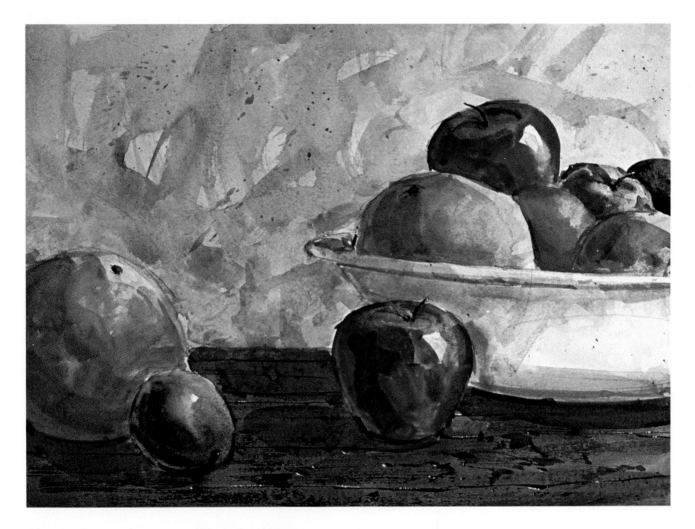

Step 7. The picture seems to need another dark note, so a second plum is added to the bowl, using the same mixtures as the plum painted in Step 3. Finally, details are added with the tip of a small, round brush. Lines are painted on the tabletop to suggest cracks. The same brush is used for the drybrush textures on the table. The corner of a sharp blade scratches some light lines next to the dark ones. Dark lines are added to sharpen the edges of the fruit in the bowl, beneath the bowl, and beneath the fruit on the table—to make them "sit" more securely. These darks aren't black, but a mixture of Hooker's green and alizarin crimson, like the apple stems. Finally, the shadow on the side of the bowl is darkened slightly with cerulean blue, yellow ochre, and burnt sienna. Notice the warm reflection of the apple in the shiny side of the bowl—painted all the way back in Step 1!

Step 1. Perhaps the most delightful indoor subject is a vase of flowers, preferably in some casual arrangement like this one. Here, the background tone is a mixture of ultramarine blue, yellow ochre, and a touch of alizarin crimson. When the background is dry, the general shapes of the flowers are painted in various mixtures of cadmium orange, cadmium red, and alizarin crimson, with the shapes blurring into one another, wet-in-wet. With the flowers just partially dry, the leaves are quickly added, sometimes blurring into the edges of the flowers. The leaves are Hooker's green and burnt umber.

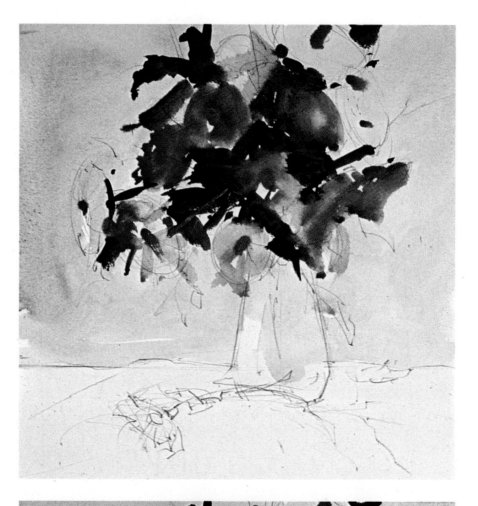

Step 2. Cooler flowers are added with a mixture of cerulean blue and alizarin crimson. The yellow centers of the flowers are yellow ochre and cadmium yellow. So far, the brushwork is broad and free, with no attention to detail—the flowers and leaves are just colored shapes.

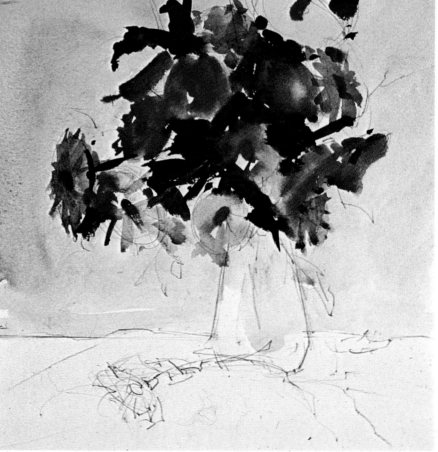

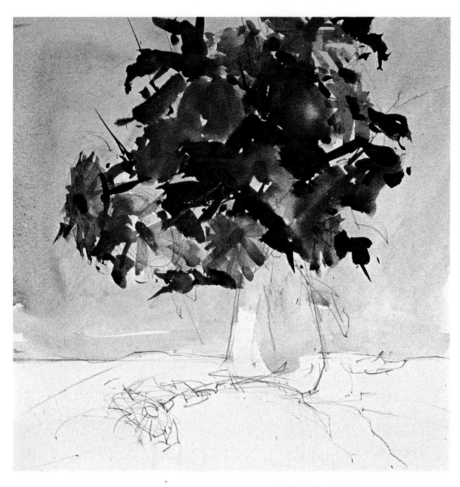

Step 3. With the main shapes of the flowers and leaves blocked in, less important shapes are added around the edges—more flowers at the top and bottom, more leaves at the bottom and the right. The leaves are the same mixture of Hooker's green and burnt umber. The new, pale flowers are yellow ochre and cerulean blue in the light areas, Hooker's green, yellow ochre, and ultramarine blue in the darker areas.

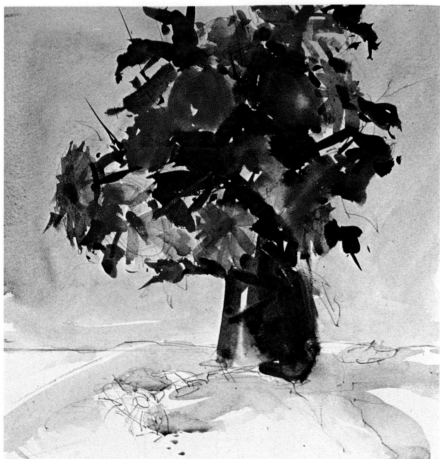

Step 4. Now it's time to begin work on the glass vase. The glass and the water within it have no color of their own, but simply reflect the color of their surroundings. Thus, the vase takes on the color of the dark stems in the water and the dark leaves above. The strokes on the vase are various mixtures of cerulean blue and burnt sienna, with a hint of Hooker's green, all painted into one another while they're still wet. A patch of light paper is left for a highlight, and a softer light is created by blotting up some wet color with a paper towel. The folds on the tabletop are suggested with a mixture of cerulean blue and burnt sienna.

Step 5. A flower and a leaf are added to the tabletop. The petals are a mixture of cadmium orange, cadmium red, and alizarin crimson, painted with a small, round brush. The light green is cadmium yellow, yellow ochre, and Hooker's green, while the dark green is Hooker's green and a touch of alizarin crimson. Cool shadows are added beneath the flower and under the leaves with cerulean blue and a little burnt sienna.

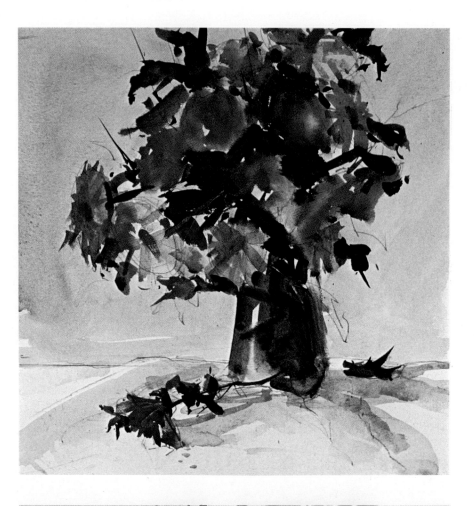

Step 6. The main colored shapes are completed. Now come the details. Alizarin crimson and Hooker's green make a good dark tone for painting the slender lines that suggest the petals of the flowers and the vase. The same mixture is used for adding more stems and a few more leaves.

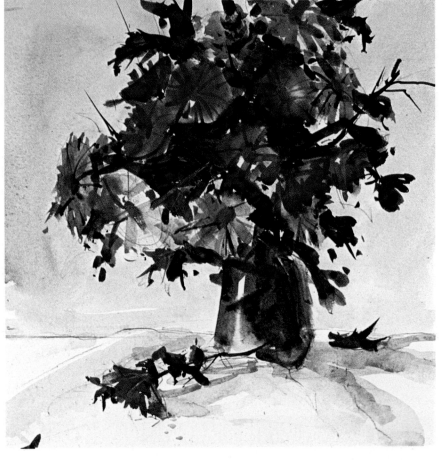

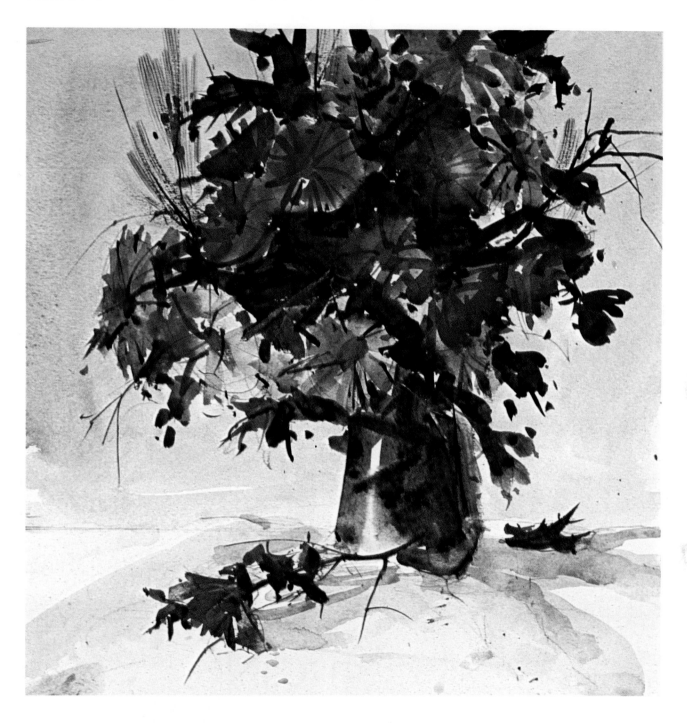

Step 7. In the final stage, you look carefully at the picture and add just a few more details, very selectively. Here you can see even more twigs at the right and left sides of the bouquet. More twigs are also added to the stem of the flower on the tabletop, and a fernlike shape is added at the upper left. All these dark notes are mixtures of Hooker's green and burnt umber or Hooker's green and alizarin crimson. Just a bit of spatter in the immediate foreground suggests some fallen petals or bits of bark from the twigs. In painting the delicate, graceful forms of flowers, it's important not to be *too* careful. Paint them as freely and broadly as you paint trees. And don't get carried away with too much detail. A little detail goes a long way.

Step 1. Having painted a bouquet of flowers indoors, why not try painting flowers in their natural outdoor setting? This demonstration begins with a fairly precise drawing of the main flower shapes, plus a few simple lines for the rocks and the lighter mass of flowers in the distance. The rock forms are painted in a series of flat washes—a mixture of alizarin crimson, ultramarine blue, and yellow ochre, with each successive wash getting a bit darker. The warm tone on the flowers is a liquid "mask" that repels paint and keeps the paper pure white. You'll see why later.

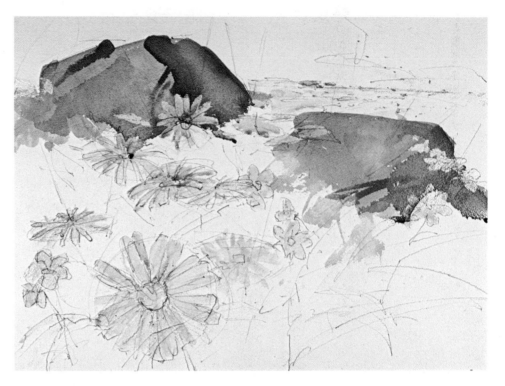

Step 2. Now the whole picture is covered with big, splashy strokes to indicate the large color areas. The lighter greens are mixtures of cadmium yellow, Hooker's green, and burnt sienna. The darker greens are Hooker's green and burnt umber. The splashes of hot color are mixtures of cadmium orange, cadmium red, and alizarin crimson. Some color overlaps the pale shapes of the flowers but doesn't soak into the paper because these areas are protected by the dried masking liquid—or frisket—which you can buy in an art supply store that specializes in materials for graphic designers.

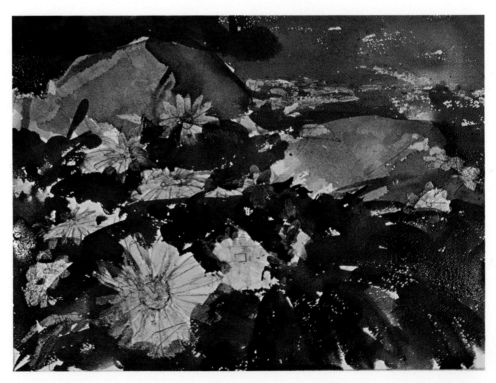

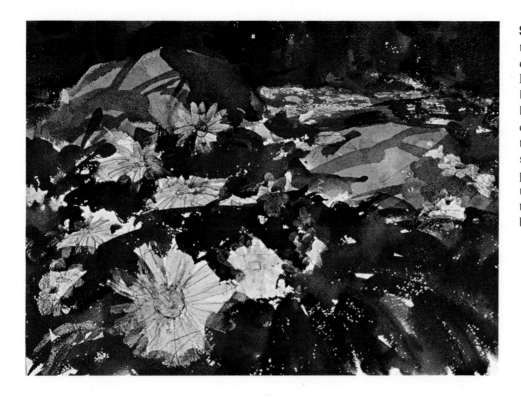

Step 3. The background at the top of the painting is darkened with strokes of Hooker's green blended with burnt umber and ultramarine blue. Notice how the various dark strokes overlap and blur together, wet-in-wet. The shadows on the rocks are painted with the same mixture used in Step 1. So far, everything has been done with a big, round brush.

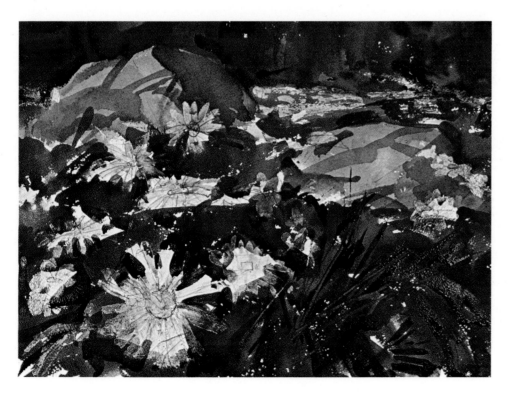

Step 4. Now more work is done in the foreground, where slender, dark strokes are added with a small, round brush to suggest grasses and weeds. You can see these in the lower right, where the dark strokes are a mixture of Hooker's green, burnt umber, and ultramarine blue. While the paint is still damp, the lighter lines in the lower right are scraped in with the tip of the brush handle.

Step 5. The time has come to remove the masking liquid from the flowers in the foreground and from the mass of flowers beyond the rocks. You can peel away the frisket with your fingers; it comes off like a thin sheet of rubber. The flowers are now ready for you to paint.

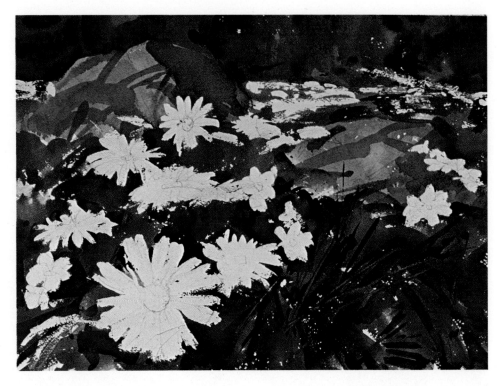

Step 6. The violet flowers are painted with a mixture of ultramarine blue and alizarin crimson. The shadows on the white flowers are a very pale mixture of yellow ochre and cerulean blue. The centers of the white flowers are yellow ochre with a touch of cadmium orange and cerulean blue. The brilliant reddish flower just left of center is cadmium red and alizarin crimson. Touches of these mixtures are added to the mass of flowers beyond the rocks.

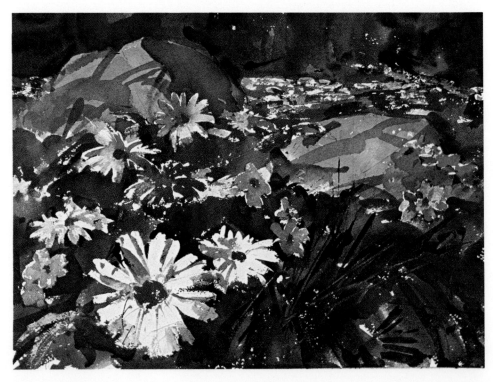

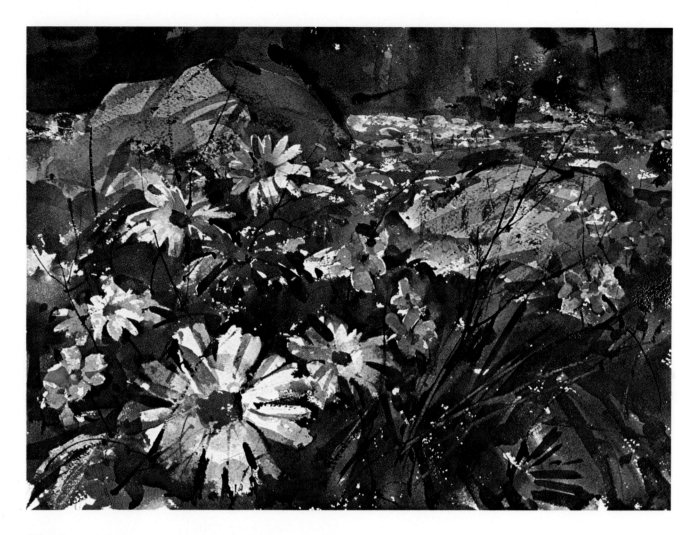

Step 7. Cool shadows are washed over the flowers in the foreground—a mixture of ultramarine blue, burnt sienna, and yellow ochre. The edges of some of the white flowers are softened and blurred by scrubbing them with a wet bristle brush, then blotting them with a paper towel. You can see this clearly in the smaller white flower at the center of the picture. With a small, round brush, dark strokes are added around the nearby flowers to sharpen their shapes—the darks are a mixture of Hooker's green and alizarin crimson. The same mixture is used to add crisp, slender strokes for blades of grass that stick up through the masses of flowers, particularly in the left side of the painting. The same dark mixture is used to add a few dark strokes to the rocks, and the brush is skimmed lightly over the rocks to add some drybrush textures. For these very slender lines, it's helpful to have a skinny brush used by signpainters—called a rigger. If you squint at the finished painting, you'll make an interesting discovery: the painting consists mostly of dark, rather subdued tones, and there are really very few bright colors. These bright colors have so much impact precisely because they're surrounded by more somber hues.

Step 1. Look for other outdoor "still lifes" like this tree-trunk fallen across a stream. The initial pencil drawing defines the shape of the trunk very carefully, indicates a couple of large cracks in the trunk, but simply suggests the shapes of the surrounding weeds and the reflection of the trunk in the water. These pencil lines shouldn't be followed *too* carefully when you start to paint.

Step 2. The background is painted first to define the shape of the tree as precisely as possible. The narrow strip of sky is painted right down to the trunk with Payne's gray and yellow ochre. Before the sky tone dries, the mass of distant trees is brushed in with a mixture of Hooker's green, burnt umber, and Payne's gray. The tone beneath the trunk is ultramarine blue and a little burnt umber. The whole job is done with a big, round brush, using the tip along the edge of the tree-trunk.

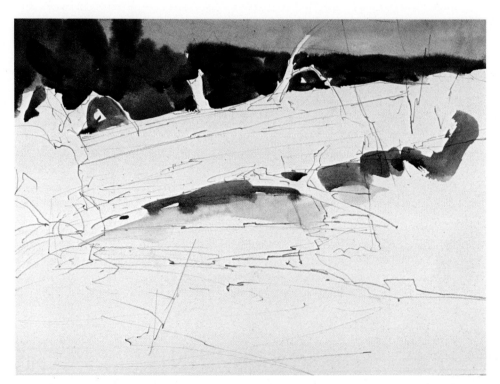

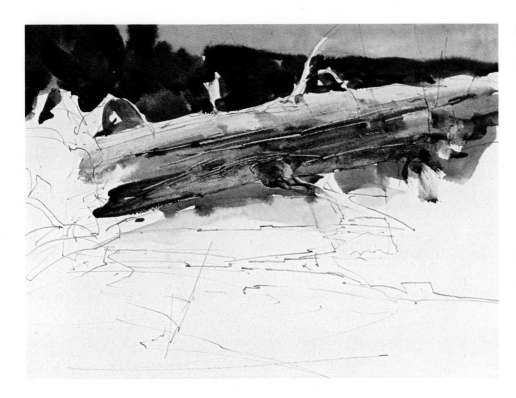

Step 3. Work begins on the top of the trunk, leaving bare paper at the edge and then starting with a very pale wash of cerulean blue and burnt sienna that is mostly water. The shadow on the trunk is a darker version of the same mixture, with more blue in some strokes and more brown in others. While the color is still wet, the white lines are scratched in with the tip of the brush handle.

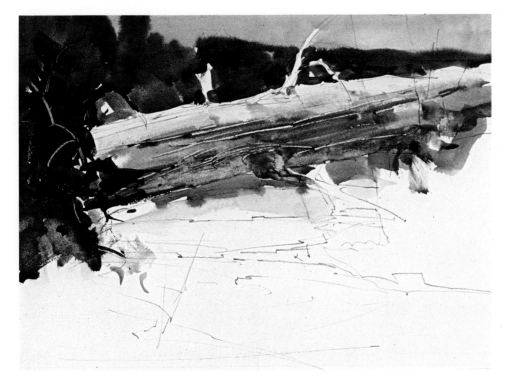

Step 4. The base of the tree (at your left) is painted with a dark mixture of alizarin crimson and Hooker's green, plus some extra strokes of cadmium red that melt away into the dark. You can see more scratches made in the wet color by the brush handle. You can also try doing this with your fingernail or with the corner of a discarded plastic credit card.

Step 5. The masses of weeds to the right are painted with various mixtures of Hooker's green, burnt sienna or burnt umber, Payne's gray, and sometimes a touch of cadmium yellow to brighten the green. You can see that it's not one uniform mixture, but a number of overlapping strokes of several mixtures. The same mixtures are used on the left. And more light scratches are made into the wet color. So far, everything has been done with a big, round brush.

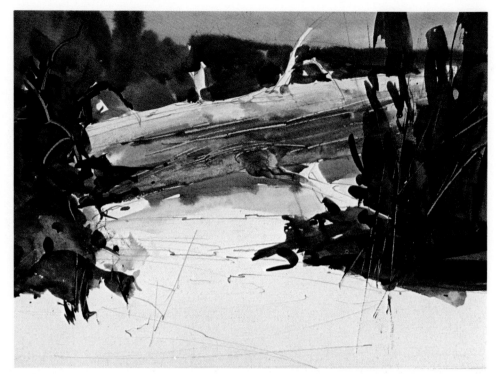

Step 6. The water comes next. First, the general tone of the water is indicated with streaky strokes of Payne's gray and yellow ochre. Then the dark reflection on the tree is painted with a mixture of burnt sienna and cerulean blue. The other reflections in the foreground are a mixture of Hooker's green, burnt umber, and Payne's gray. This mixture is also used for the ripples. Note that a bit of the paper is left bare to suggest the light on the water.

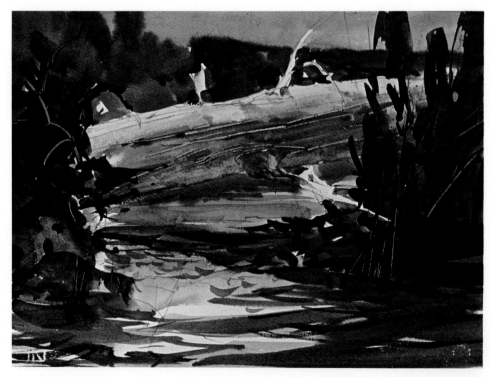

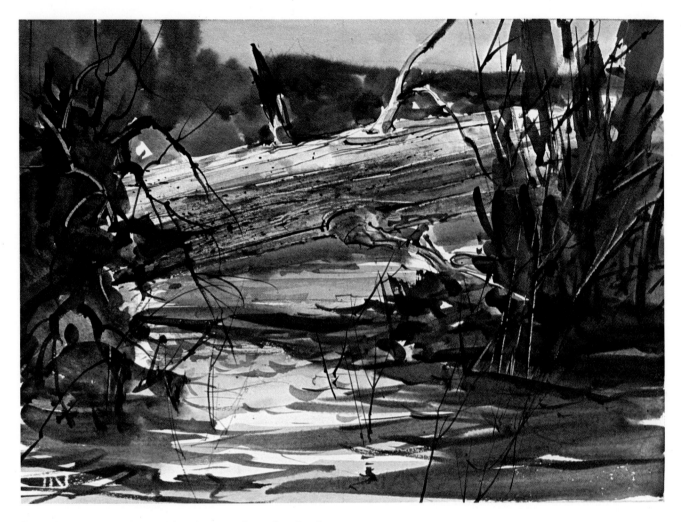

Step 7. Now a small round brush comes into play for the final textures and details. Drybrush strokes are run along the treetrunk, and slender lines define cracks and branches more distinctly—these darks are a mixture of alizarin crimson and Hooker's green. Twigs are added at the left, weeds at the right, and more weeds in the water, all with the tip of the brush. This is another case where the slender brush called a rigger does a particularly good job for those very thin strokes. Notice other touches such as the spatter on the treetrunk and the warm notes of cadmium red that are added to enliven the mass of weeds to the right. It's interesting to compare the finished painting with the pencil drawing in Step 1 just to see where the paint follows the drawing and where it doesn't. The lines of the treetrunk have been followed with considerable care. But the drawing does nothing more than indicate the *location* of the masses of weeds and the dark reflection in the water, which are brushed in so freely that the lines of the drawing disappear altogether.

Step 1. In spring, when leaves first appear on the trees, foliage is a delicate green, often with a hint of yellow—and the masses of leaves aren't as thick as they will be later on in midsummer. This spring landscape begins with a very simple pencil drawing that just indicates the general direction of the treetrunks and the overall shapes of the leafy masses. The sky is covered with a wash of yellow ochre. While this wash is still wet, ultramarine blue is painted in with a large, round brush.

Step 2. The same brush is used to paint the distant hills with a mixture of ultramarine blue and alizarin crimson. You can see that the individual strokes vary in color: some have more blue and some more crimson. The brushwork is rough because the hills will be partially covered by a mass of trees in the next step.

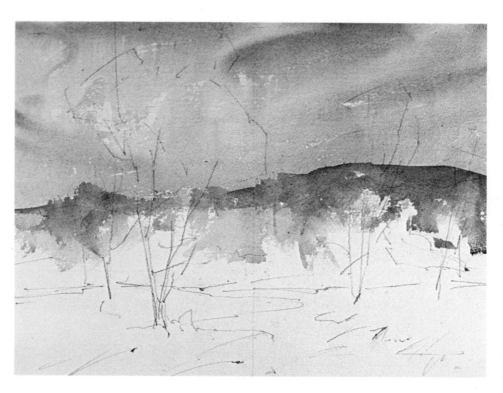

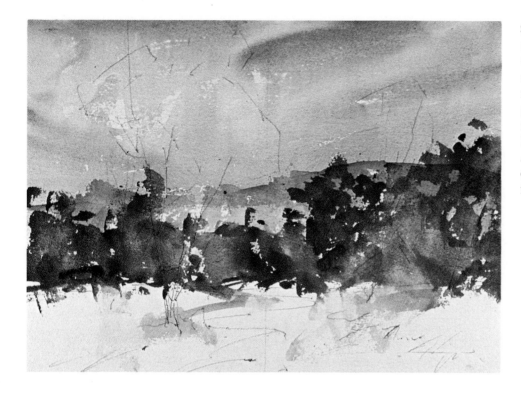

Step 3. Now the foliage in the middle distance is added with a big, round brush. The strokes are mixtures of cadmium yellow, Hooker's green, and cerulean blue. In many of the strokes, the yellow is allowed to dominate. And the strokes are applied over and into one another, fusing wet-in-wet.

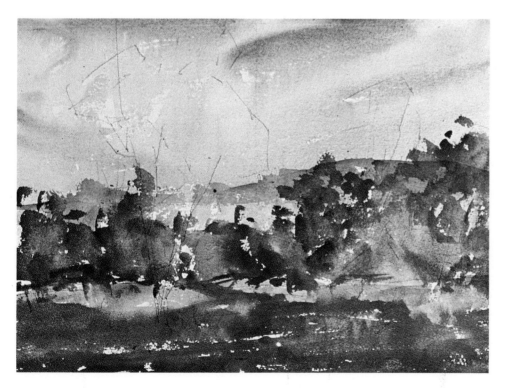

Step 4. The grass in the foreground is added with a big, round brush—the strokes are again mixtures of cadmium yellow, Hooker's green, and cerulean blue. Notice that a dark shadow has been added beneath the pencil lines of the tree on the left. In contrast with the short vertical and diagonal strokes used to suggest the trees in Step 3, the meadow is suggested mainly with long horizontal strokes.

Step 5. Now the small, round brush is used to indicate some treetrunks and branches with a dark mixture of alizarin crimson and Hooker's green. Never try to render every branch and twig. Just pick out a few. This dark tone could also be a mixture of burnt sienna and ultramarine blue, if you'd like to try a different combination.

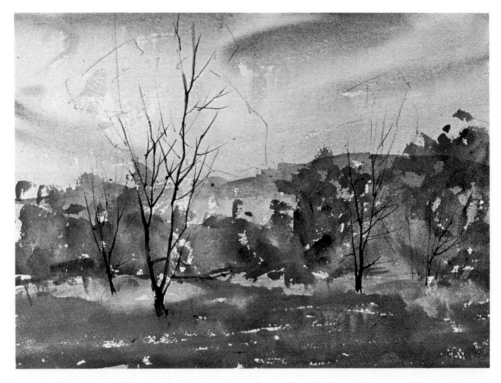

Step 6. Now, using the side of the same brush, the first foliage is drybrushed into the picture with a mixture of Hooker's green and cerulean blue, with just a hint of cadmium yellow. Working with the side of the brush, rather than the tip, you can make short, ragged strokes that are broken up by the texture of the paper, suggesting masses of leaves with patches of sky breaking through. The same method is used to drybrush a shadow under the larger tree.

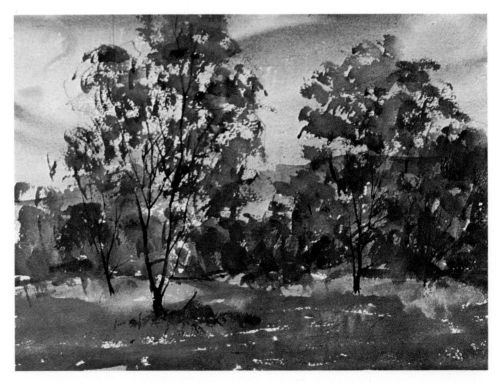

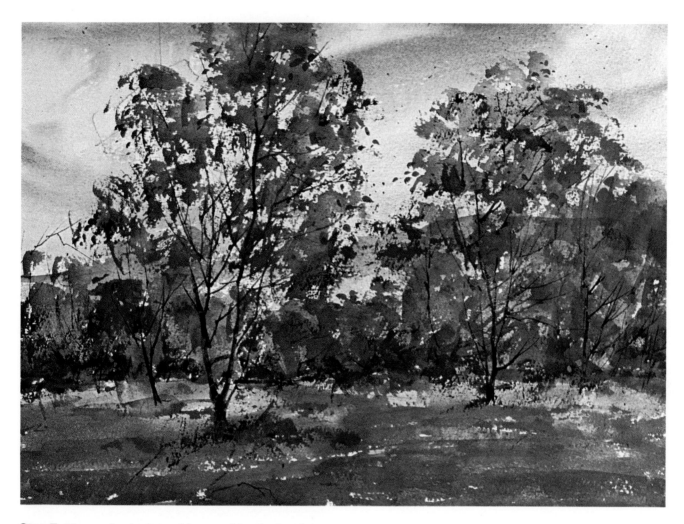

Step 7. Now, going back to a big, round brush, the picture is completed mainly with drybrush strokes—mixtures of ultramarine blue, cadmium yellow, and Hooker's green. Some darker patches are added to the trees in the foreground, suggesting shadow areas on the masses of leaves. Shadows are also suggested on the mass of trees in the middle distance, particularly along the lower edge. A shadow is suggested at the base of the tree on the right, and the shadow is darkened beneath the tree on the left. Darker horizontal strokes are added to the meadow, so there's now a gradation from dark green in the foreground to a lighter tone in the middle distance. Notice how bits of paper are allowed to show through the strokes on the ground, suggesting patches of sunlight. Some of the dark green mixture and a bit of cadmium yellow are spattered among the trees. And a rigger is used to add some more branches.

Step 1. In midsummer, trees are in full leaf and foliage tends to be darker and denser. Once again, this landscape begins with a very simple drawing, just suggesting the placement of the treetrunks, the leafy masses, some foreground shadows, and the shapes of the hills. The sky begins with a few strokes of a very pale yellow ochre, quickly followed by strokes of cerulean blue that fuse softly into the yellow. The strokes of the distant hills are mixtures of cerulean blue and cadmium orange.

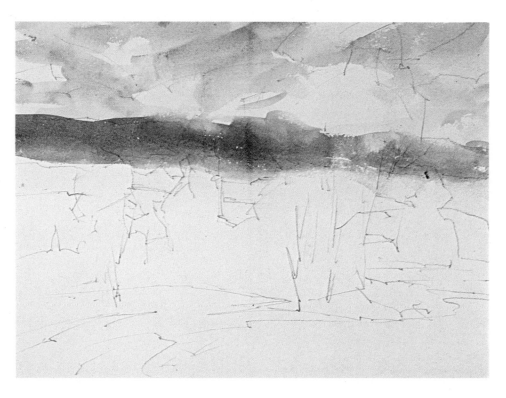

Step 2. The foreground is painted with a mixture of cadmium yellow, Hooker's green, cerulean blue, and an occasional hint of cadmium orange. The same mixtures are used for the green patches between the trees in the middle distance, but with a bit more blue and green in the strokes. The patches of color between the trees are brushed in very freely, paying little attention to their exact shapes, since a great deal of the middle distance will be covered by the bigger, darker shapes of the trees.

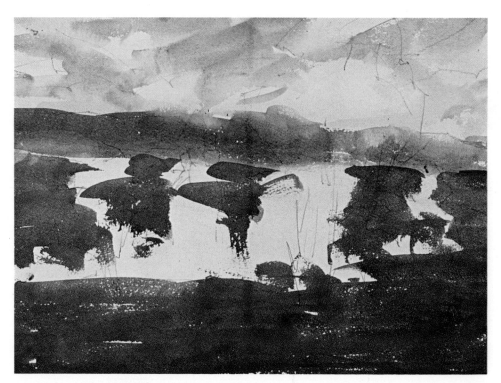

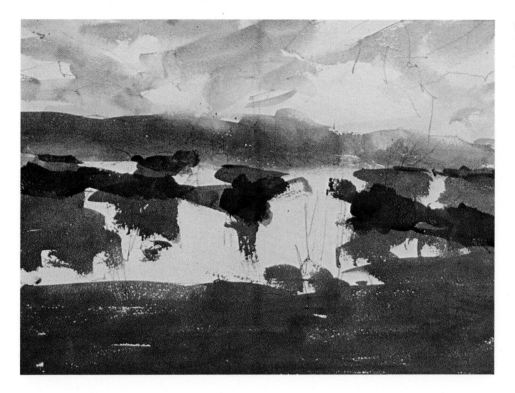

Step 3. Still working with a big, round brush, the darker patches in the middle distance are now painted with a mixture of Hooker's green and cerulean blue. You could actually use a small round brush at this point, but it's always best to use the biggest brush you can handle, since this forces you to work boldly.

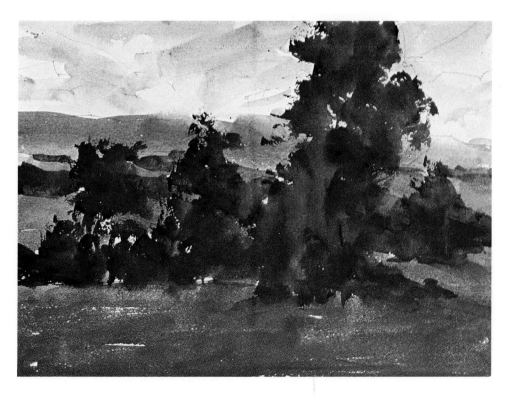

Step 4. The big masses of the foreground trees are now brushed in with a blend of Hooker's green, cadmium yellow, and burnt sienna. The darkest strokes contain more burnt sienna. The strokes are brushed over and into one another, so they tend to fuse wet-in-wet. Along the edges of the trees, the side of the brush is used so that the dry-brush effect suggests leafy edges. Where the leafy masses touch the ground, a damp brush (just water) is used to soften the transition.

Step 5. The foliage is darkened with a mixture of Hooker's green and burnt umber. Many of the leafy masses now appear to be in shadow. You can see a trunk beginning to show in the largest tree, beneath which a shadow has begun to appear. With a small, round brush, a few dark flecks are added around the edges of the trees to suggest some more leaves.

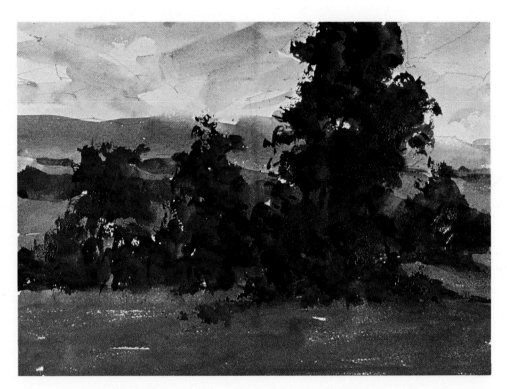

Step 6. The tree shadows in the foreground are painted with a mixture of Hooker's green and burnt sienna. The strokes curve slightly, suggesting the curve of the meadow. The sunlit patches are the wash that was applied in Step 2, which is allowed to break through the darker shadow strokes.

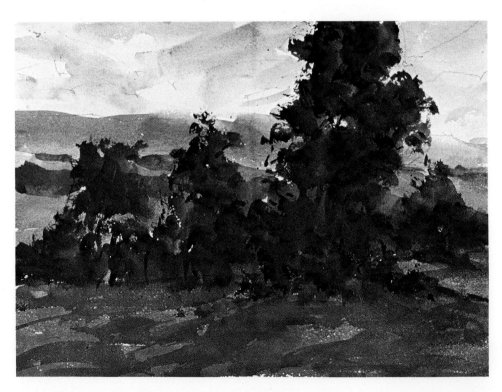

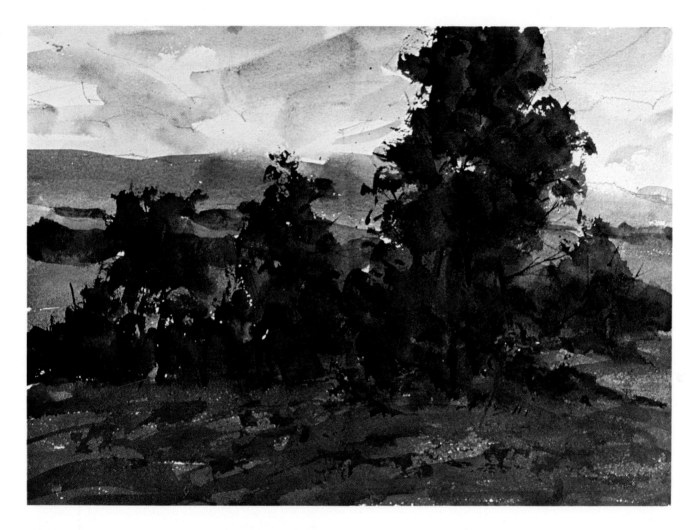

Step 7. As always, details are saved for the very end. A small, round brush is used to indicate trunks and branches among the trees. More dark strokes are added to the foreground, while the shadow under the largest tree is reinforced with some dark strokes too. Some tiny flecks of cadmium yellow are added to the grass and around the base of the largest tree. They're very unobtrusive, but they do make the painting look just a bit sunnier. This painting is a particularly good example of how few strokes you need to paint a convincing landscape. The trees consist almost entirely of large masses of color with just a few touches of a small brush to suggest trunk and branches. By the way, did you notice that the pencil lines in the sky haven't been erased? You can leave them there if you like. Or you can take them out with a kneaded (putty rubber) eraser. But wait until the painting is absolutely dry, or even this very soft eraser will abrade the surface.

Step 1. The hot colors of autumn trees look even richer if they're placed against a very subdued background such as a gray or overcast sky. So this autumn scene begins with a sky of Payne's gray, warmed with a bit of yellow ochre. The sky tone is brushed right over the pencil drawing, which will later disappear under masses of color. The distant hills are cerulean blue and a bit of cadmium red. A big sky like this can be painted quickly with a large, flat brush or a large, round brush.

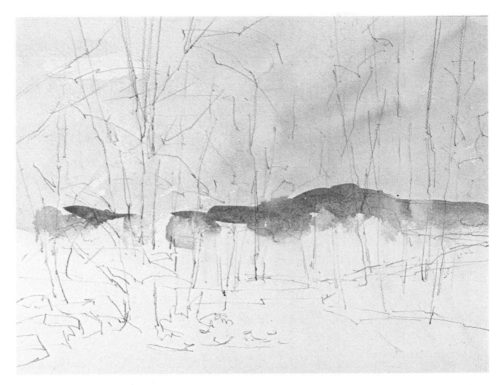

Step 2. The mass of foliage in the middle distance is painted with short strokes of a big round brush. The strokes are mixtures of cadmium orange, Hooker's green, and burnt sienna. The darker strokes contain more burnt sienna, and the hotter colors contain more cadmium orange.

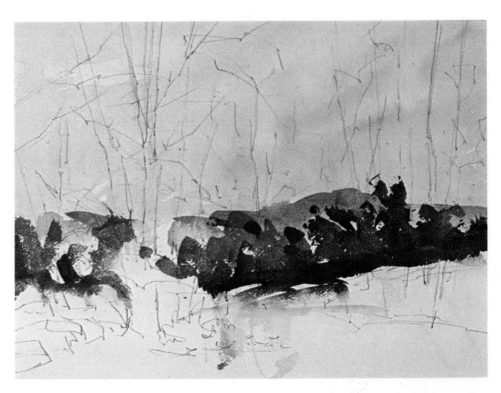

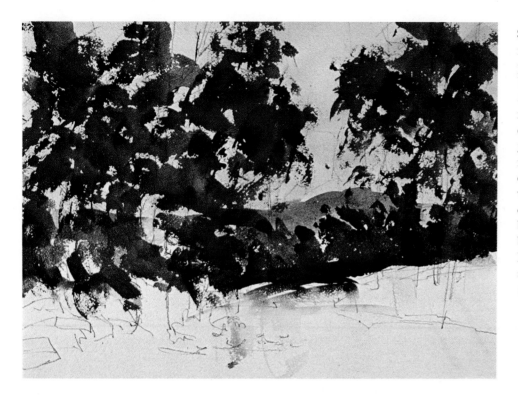

Step 3. Now the colorful masses of foliage are roughly painted with short strokes of a big, round brush. The strokes are various mixtures of cadmium yellow, yellow ochre, cadmium orange, Hooker's green, and burnt umber—never more than two or three colors in any mixture. The wet strokes tend to blur into one another. The side of the brush is often used for a drybrush effect that suggests leaves. Notice how patches of sky break through among the strokes.

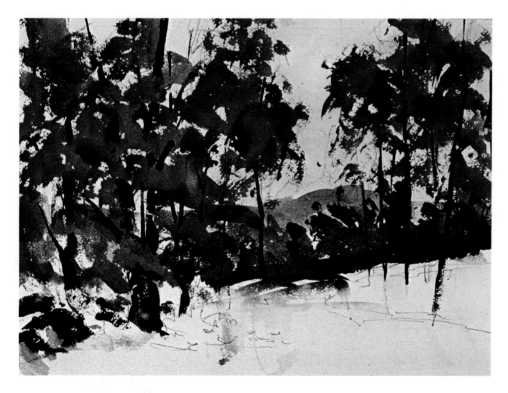

Step 4. The darks of the tree-trunks and the rocks at the left are added with a small, round brush, carrying a blend of alizarin crimson, Hooker's green, and just a touch of cadmium red. Observe how the trunks of the larger trees to the left are painted with short strokes so that the trunks are often concealed by the masses of leaves. The color on the rocks is rather thick—not too much water—so the strokes have a drybrush feeling that suggests the rough texture of the rocks.

Step 5. Going back to a big round brush, the foreground is painted with various mixtures of cadmium orange, cadmium red, alizarin crimson, and Hooker's green—never more than two or three colors to a given mixture. The darks, suggesting shadows on the ground, contain more Hooker's green. The strokes blend into one another, wet-in-wet, and curve slightly to suggest the contour of the ground.

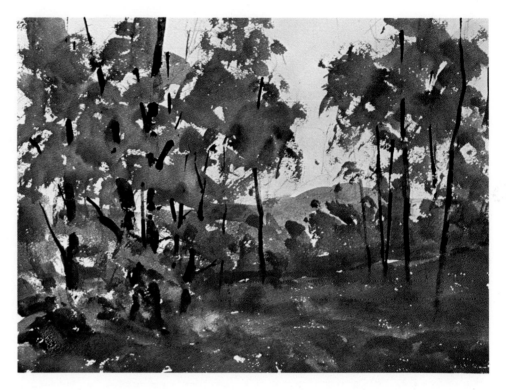

Step 6. To suggest individual leaves—some of them blowing in the autumn wind—a mixture of cadmium orange, cadmium red, and Hooker's green is spattered over the upper part of the picture with a small round brush. More trunks and branches are added with the tip of a small brush and a mixture of alizarin crimson, cadmium red, and Hooker's green, which makes a very rich dark. The tiniest branches can be done with a rigger.

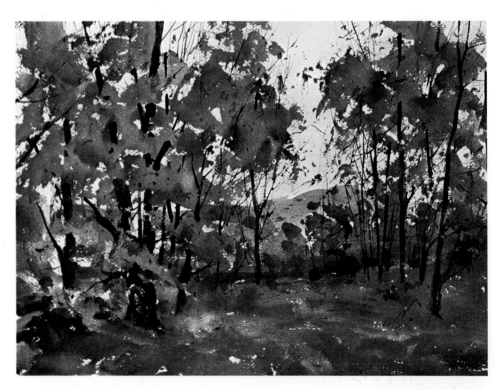

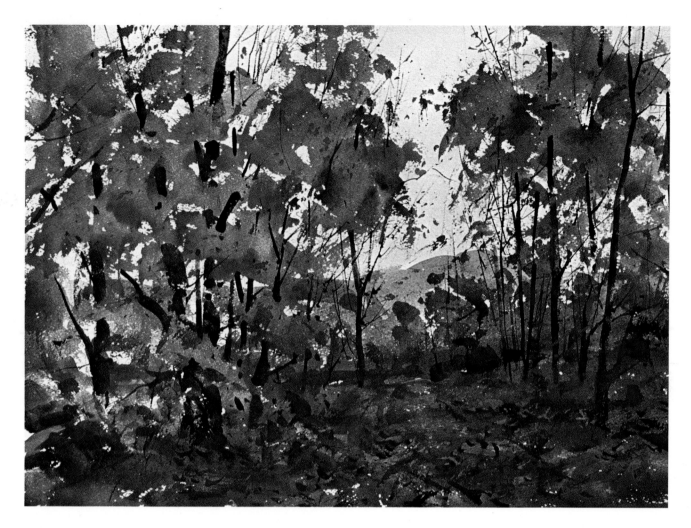

Step 7. The lively texture of the fallen leaves on the ground is suggested by drybrush strokes, made with the side of a small round brush and a mixture of alizarin crimson and Hooker's green. More touches of this mixture are added with the tip of the small brush. While the paint on the ground is still damp, some lighter areas are scratched in with the tip of the brush handle or a slender, blunt knife. If you look carefully at the ground area, all you'll see is a mass of rough brushwork and a few tiny strokes made with the tip of the brush. You don't really see any fallen leaves, but the brushwork makes you *think* you see them. Detail is suggested, never painted methodically. And look carefully at those hot autumn colors. They're not nearly as red and orange as you might think. If the whole painting were just red and orange, you'd find it terribly monotonous. You need that gray sky and those cool hints of green for relief. Besides, they make the warm colors look warmer by contrast.

Step 1. The pale tones of a snowy landscape often contrast dramatically with the dark, overcast skies of winter. The preliminary pencil drawing quickly indicates the shape of the main tree, the location of a few other trees, the shadows in the foreground, and the placement of the horizon. The dramatic cloud shapes aren't drawn in pencil, but just painted wet-in-wet. The sky begins with a pale wash of burnt sienna over the entire sky area. While this is still wet, the darker tones are brushed in—a mixture of ultramarine blue, burnt umber, and Payne's gray.

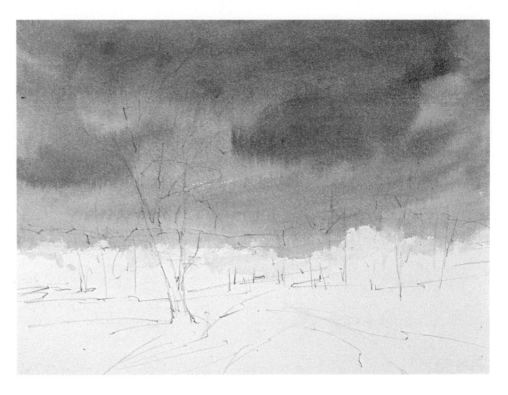

Step 2. When the sky tone is dry, the strip of landscape along the horizon is painted with a mixture of cerulean blue and burnt umber, using a small round brush. At the center of the horizon, you can see how a wet brush—just plain water—has been used to soften the dark edge to create a more atmospheric feeling.

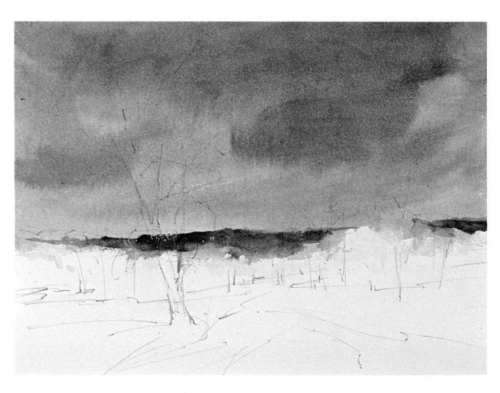

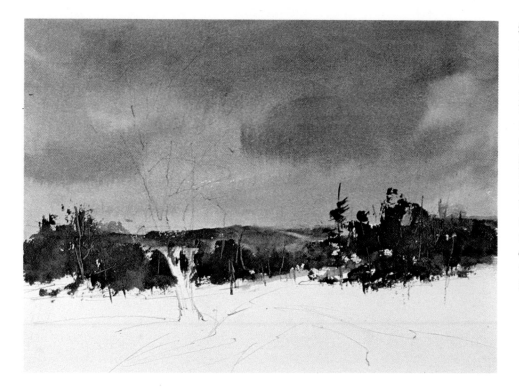

Step 3. With a blend of Hooker's green, burnt umber, and Payne's gray, the trees in the middle distance are painted with a small, round brush. The color is a bit thick—not too much water—so the paint isn't too fluid and goes on with a slightly dry-brush feeling. While the color is still wet, the tip of the brush handle scratches in some lighter lines for tree-trunks. Along the lower edge of this color area, the side of the brush is used to create an irregular drybrush texture.

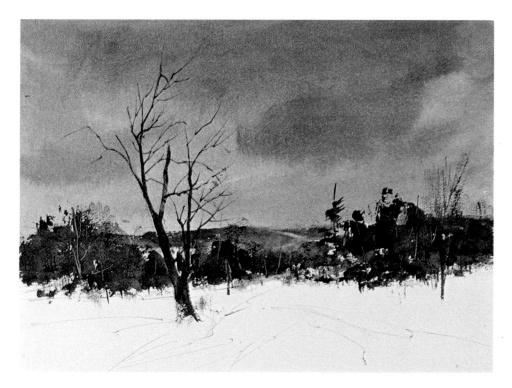

Step 4. The tall, bare tree is painted with the tip of a small round brush and a mixture of cerulean blue and burnt umber. The trees in the background are darkened with drybrush strokes of burnt umber and Hooker's green, which are also used to suggest a smaller tree at the right.

Step 5. The variations in the color of the snow are painted with a large, round brush and very pale mixtures of cerulean blue and burnt sienna. While these strokes are still wet, some of them are softened with clear water. Thus, some of the strokes have sharp, distinct edges, while others have soft edges. This mixture is also used to indicate some pale shadows under the distant trees. Here and there, these strokes are lightened with a quick touch of the paper towel.

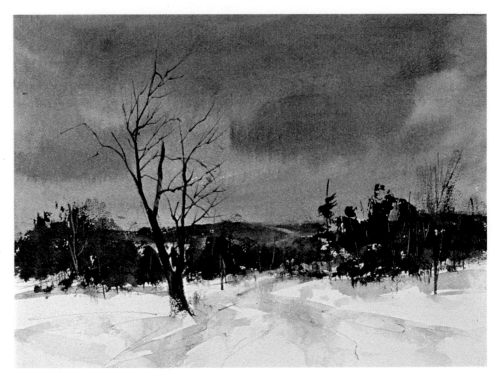

Step 6. The point of the smallest brush (or a rigger) can be used to suggest the slender lines of the dead weeds that break through the snow in the foreground. To indicate a few fallen leaves, blown by the wind, a small, round brush is used to spatter some dark specks across the foreground. These darks are all mixtures of burnt sienna and cerulean blue.

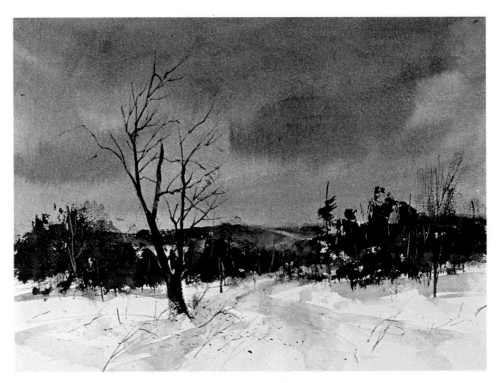

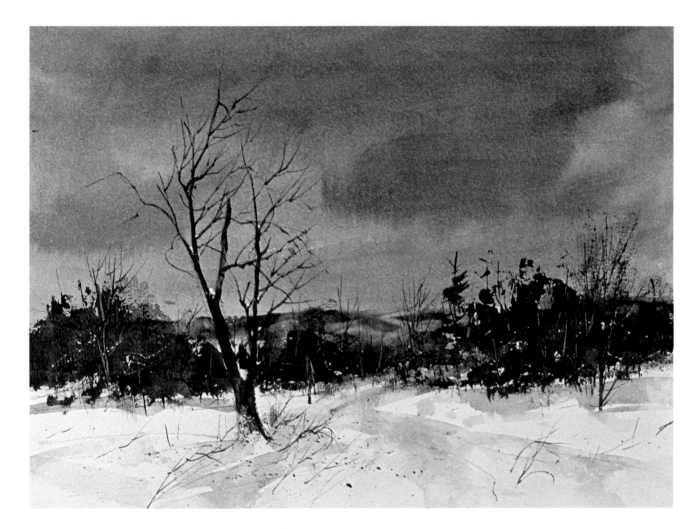

Step 7. The finishing touches are added with the tip of a small round brush. More branches appear at the tops of the trees along the horizon and on the big tree just left of center. A wet bristle brush is used to scrub out some color on the distant hills, suggesting that light is falling on them. The wet color is then blotted up with a paper towel. The corner of a sharp blade is used to scratch out a few whites on the main treetrunk, suggesting snow caught among the branches. This winter landscape is a good example of how much color you can suggest with subdued tones. The grayish sky is actually full of warm and cool color. The snow isn't a dead white, but also contains very delicate warm and cool notes. And the dark notes contain no black at all—they're actually mixtures of much brighter colors. Thus, even the darkest strokes have a hint of color.

Step 1. The forms of the distant headland, the nearby cliffs, the rocks, and the edge of the water are carefully drawn with light pencil lines. But the cloud shapes in the sky will be soft and blurry, so there's not much point in drawing them. The sky area is covered with a very pale wash of yellow ochre, applied with a big, flat brush. Then a big, round brush is used to brush long, curving strokes of ultramarine blue into the yellow ochre while it's still wet.

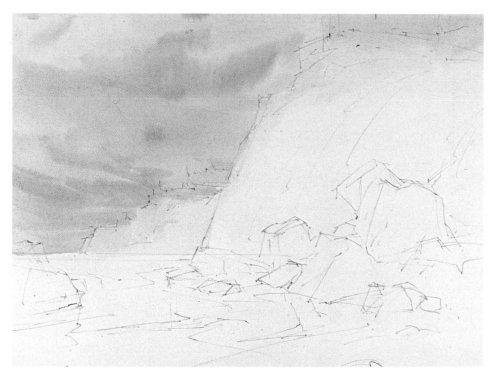

Step 2. A small, round brush is used to paint the distant headland with various mixtures of Payne's gray and yellow ochre—some pale, some dark—and some of these strokes are blotted with a paper towel while they're still wet. This use of the paper towel creates an irregular texture that suggests the roughness of the rocks and the trees at the top of the headland. These strokes will also look rougher if you use the side of the brush.

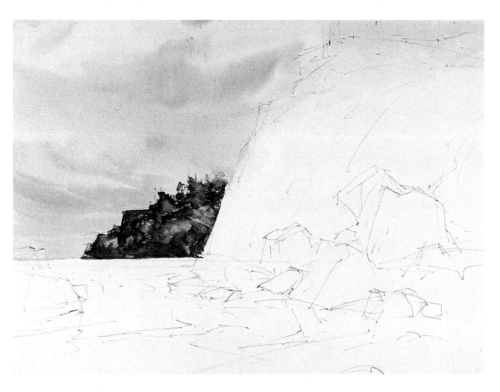

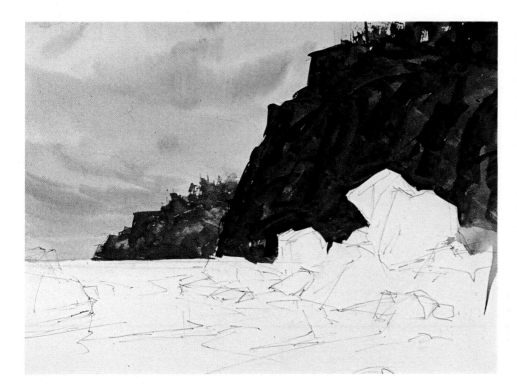

Step 3. The big, dark cliff is painted with a large, round brush and a mixture of burnt sienna, burnt umber, and Hooker's green. The darkest strokes contain very little water and are mainly burnt umber and Hooker's green. The tip of the brush is carefully worked around the shapes of the foreground rocks, following the pencil lines.

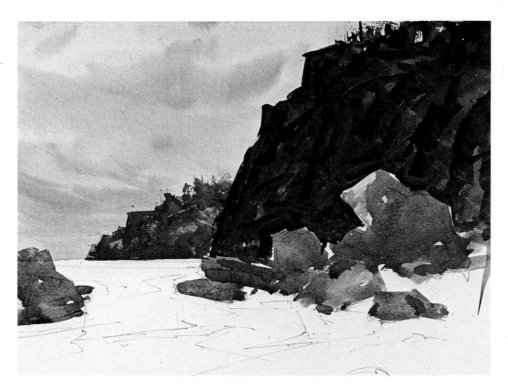

Step 4. The rocks are first painted with a pale wash of cadmium red, burnt sienna, and ultramarine blue, using a small, round brush. When this pale wash is dry, the shadow areas are painted with a mixture of ultramarine blue and burnt sienna. Notice that the strokes are very casual, leaving an occasional fleck of bare white paper to suggest a sunlit edge on the rock.

Step 5. The small, round brush is used to paint a strip of rich color in the water—a mixture of Hooker's green, ultramarine blue, and Payne's gray. More water is added to this mixture, which is carried toward the shore. At the right, the mixture is darkened with more Payne's gray to suggest the reflection of the distant headland. And a white strip of bare paper is left just under the headland to indicate light reflecting on the water. The sand is painted with a pale wash of yellow ochre and Payne's gray, plus a few strokes of Hooker's green and burnt sienna to suggest some seaweed.

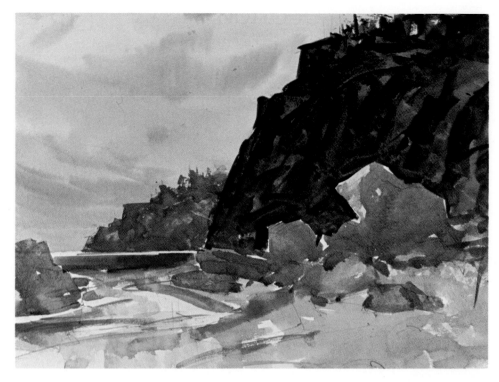

Step 6. With a small, round brush, dark shadows are painted on the rocks with a mixture of cadmium red, burnt sienna, and ultramarine blue. The strokes are sharp and distinct, not merging into one another, to emphasize the solid, blocky character of the rocks. Some smaller touches of the brush give the impression of pebbles scattered around the base of the rock formation.

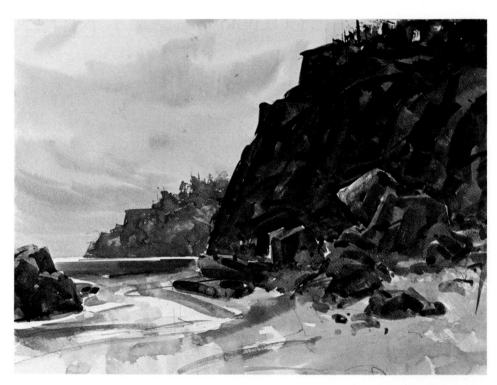

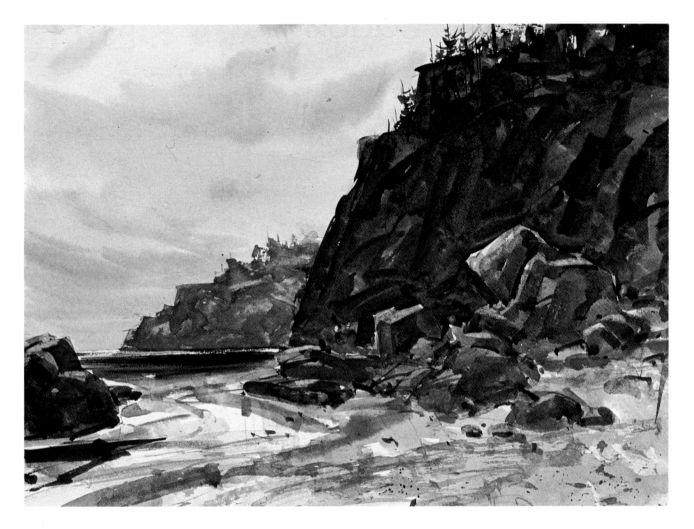

Step 7. The final touches are all put in with a small, round brush. A few trees are added at the top of the nearby cliff— a mixture of Hooker's green and burnt umber. Cracks, shadows, and other details are added to the rocks with a dark mixture of ultramarine blue, burnt sienna, and cadmium red. This mixture is used to dash in a few quick strokes for the reflection beneath the rock at the left. Free, scrubby strokes of Hooker's green and burnt umber are carried across the foreground to give the feeling of more seaweed and other beach debris. This effect is further enhanced by spattering this mixture across the sand. The distant water is darkened with ultramarine blue and a bit of burnt sienna. When this is dry, the strip of light is reinforced with a quick scratch of a sharp blade, guided by a ruler or by the straight handle of a brush.

Step 1. The rocks on the beach are very carefully drawn to record their shapes precisely. The silhouette of the distant headland is also traced carefully. The sky is covered by a series of horizontal strokes consisting of various mixtures of yellow ochre, cerulean blue, and burnt sienna, which partially fuse, wet-in-wet.

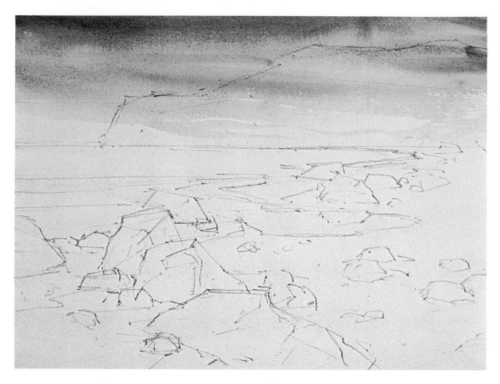

Step 2. The dark shape of the distant headland is painted with a mixture of burnt umber, ultramarine blue, and Hooker's green. Notice that it's not a smooth, even tone, but sometimes darker and sometimes lighter, depending on the proportions of the three ingredients in the stroke. At the extreme right, the lower edge of the headland is softened by pure water and fades away into the beach.

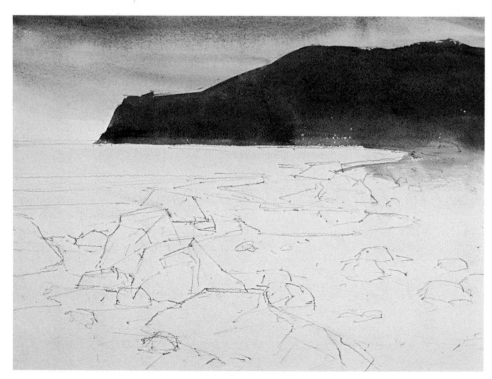

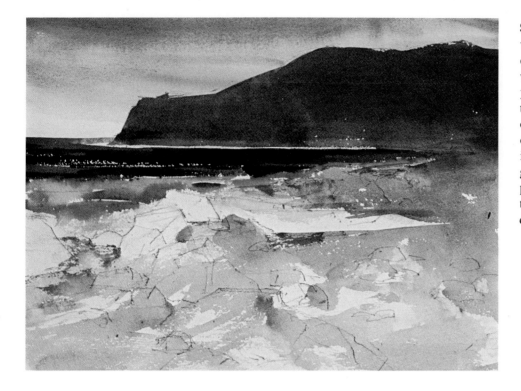

Step 3. The water is painted with ultramarine blue, Hooker's green, and burnt umber, with more water and a little yellow ochre added closer to the beach. The sand is yellow ochre, burnt sienna, and cerulean blue. The sand tone is brushed over the foreground very loosely, allowing patches of bare paper to show through. So far, everything is done with big brushes.

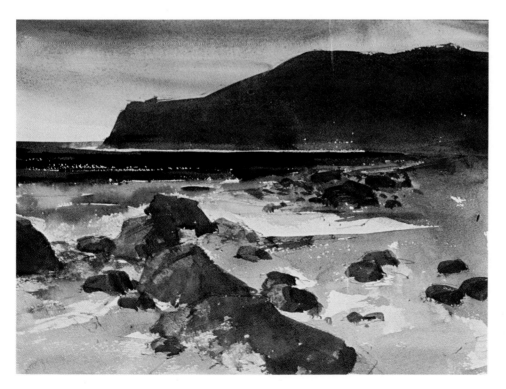

Step 4. The lighter tones of the rocks are painted with cadmium orange, burnt sienna, and cerulean blue. When these light tones are dry, the darks are added with burnt sienna, Hooker's green, and cerulean blue. The side of a small, round brush is used for the ragged textures of the rocks to the left. Now the patches of bare paper begin to look like areas of sunlight on the beach.

Step 5. With a mixture of burnt sienna, Hooker's green, and ultramarine blue, the tip of a small, round brush is used to add such dark details to the rocks as cracks, shadows, and edges. The same mixture is used to add some pebbles along the shoreline.

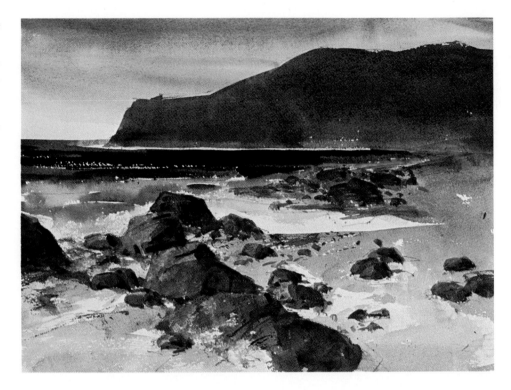

Step 6. To suggest pebbles, seaweed, and other debris, the side of a small brush is used for drybrush textures along the shoreline and in the lower left corner. Then the same brush is used to spatter dark flecks over the beach. This dark mixture is burnt sienna and ultramarine blue.

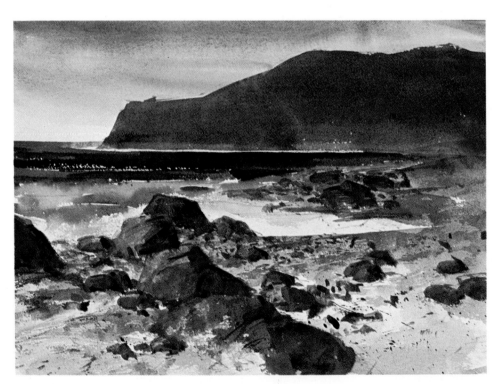

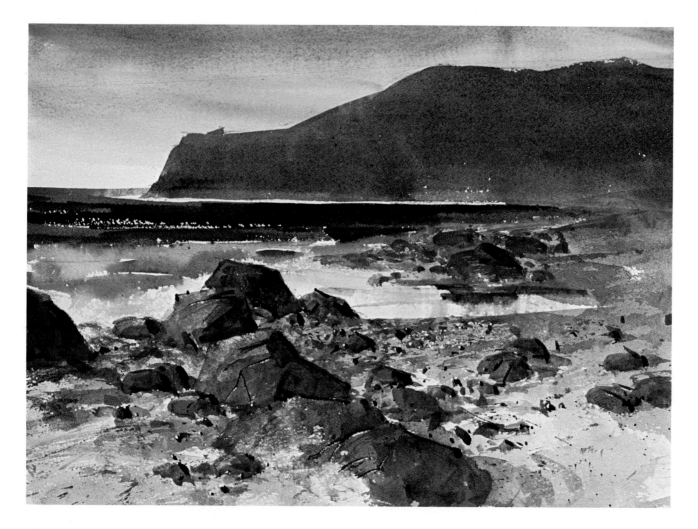

Step 7. The tip of a small, round brush and the sharp corner of a blade are used for the finishing touches. More dark cracks are added to the rocks. Then the blade is used to scratch some light lines along the cracks. The blade also picks up flecks of light on the pebbles at the edge of the water. A reflection is added in the tidepool just beneath the rock to the left of center—then blurred with clear water. Some cast shadows are added to the right of the rocks. These dark tones are mixtures of cerulean blue and burnt sienna or Hooker's green and burnt umber. Notice how bare paper has been left exposed at various stages in the painting process, creating the impression that light is flashing across the water and on parts of the beach.

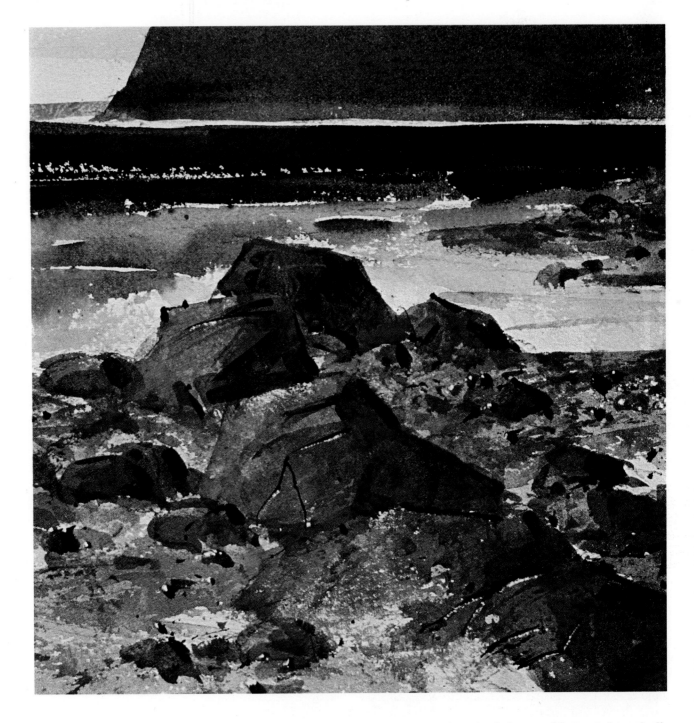

Step 7. (close-up). In this close-up of the rocks, a portion of the beach, and a portion of the water, you can see the brushwork in more precise detail. Notice how drybrush is used to suggest the sandy, pebbly texture of the beach. A dark line and a white scratch, side by side, make the cracks in the rocks look very convincing. Tiny flecks of white paper, picked off the tops of the pebbles with the corner of a blade, increase the feeling of sparkling light and shadow.

You can also see how the dark tone of the ocean is gradually lightened with more water toward the shore. If you work quickly, drawing your brush straight across the paper without pressing too hard, you can leave an occasional gap of white paper to suggest the broken strips of light across the dark water. You can also lighten the water—as in the area close to the shore—by pressing down hard with a paper towel while the color is still quite wet.

Technical Tricks. Although brushes are the primary tools of watercolor painting, watercolorists are always discovering new "technical tricks" that they can perform with other tools. Knives, razor blades, and the pointed end of the wooden brush handle are frequently used to create lines and textures. Surprising things can also be done with sandpaper, plastic credit cards, ice cream sticks, butter knives, and other implements from the kitchen or the toolbox.

Scratching Wet Paper. The easiest way to create a line, of course, is by drawing the pointed tip of your small, round brush across the surface of the dry paper. But another way is to take some pointed implement, such as the tip of the brush *handle*, and scratch into the paper while the wash is still wet. The color will settle into that groove and make a line that has a very different character from a brushstroke. The tip of the brush handle makes a sharp, slender line. A more ragged line is produced by scratching into the wet color with the tip of a sharp knife or the pointed corner of a razor blade. You'll find that these lines are always darker than the surrounding wash, so this technique is best for suggesting things such as dark branches, twigs, weeds, and grasses.

Scraping Wet Color. One of the hardest things to paint in watercolor is a light line surrounded by darker color. Because you have no opaque color, you can't paint the dark area first, then paint light lines over it. You have to paint the dark color around the light shape. However, a blunt tool such as the rounded corner of a plastic credit card, the rounded tip of a wooden ice cream stick, or the rounded blade of a butter knife will push aside a certain amount of wet color if you use the tool properly. The trick is to press the blunt instrument against the paper and push aside the wet color the way you'd scrape butter off a slice of bread—but don't dig in and create a groove, which could actually produce a darker line. Thus, you *can* create those light treetrunks by starting with a dark wash, then scraping away some lighter lines while the wash is still wet.

Scraping Dry Color. Once a wash is dry, you can use the tip of a knife or the sharp corner of a razor blade to scratch away the dried color and reveal the white paper beneath to create twigs, branches, weeds, and grasses in sunlight. Using the flat edge of a razor blade or a knife, you can also scrape away larger areas. For example, if you want to lighten the sunlit side of a treetrunk, a cloud, or a rock, you can gently scrape away *some* of the dry color so that the underly-

ing paper begins to peak through. Once you've scraped an area, don't paint over it—the fresh color will sink into the scrapes, and they'll come out darker than before!

Correcting Watercolors. By now, it should be clear that a watercolor painting is extremely hard to correct. Because your color is transparent, you can't simply cover up an unsuccessful passage with a fresh layer of paint. The underlying color always shines through. While the passage is still wet, you can blot off most of the color with a paper towel or a cleansing tissue. But once the color is dry, you can never restore the paper to its original whiteness and start again. However, there are several emergency measures for removing enough color to give yourself a second chance.

Sponging Out. A soft, silky natural sponge will often lighten a large, dried area—such as a sky. Soak the sponge in clear water until the fibers of the sponge are very soft, then work gently over the surface of the paper, washing out the sponge frequently. You can also start by brushing a wash of clear water over the offending passage, letting the water soak in a bit so the color loosens, and then working with the sponge. Don't scrub. Move the sponge very gently.

Washing Out. If the whole painting looks hopeless, the most drastic measure is to take the whole sheet straight to the bathtub and soak out as much color as you can in a tub full of cold water. Some colors will come off by themselves. Others will wash away under running tap water. Still others will need a gentle sponging. But don't be surprised if certain colors—such as alizarin crimson or phthalocyanine blue—stain the paper permanently and resist your efforts to remove them. When you've washed away all the color that will come loose, tack the wet paper to your drawing board so the sheet will stretch fairly smooth when it dries. At this point, you'll have a "ghost" of your original painting—you can rarely get out all the color—over which you can apply fresh strokes and washes, either while the paper is still wet or after it's dry as a bone.

Scrubbing and Lifting Out. The sponge and the bathtub are for large color areas, of course. To remove color from a smaller area, you can try scrubbing with a bristle brush—the kind used for oil painting. Work with the brush in one hand and a paper towel or cleansing tissue in the other. Dip the brush in clear water, scrub gently, and blot away the loosened color with the towel or tissue.

Step 1. If you want to make dark lines by scratching into wet color, you've got to work quickly. Let's say you want to add many little branches amid the foliage of a tree. Paint the large masses of the leaves rapidly with a sopping wet brush.

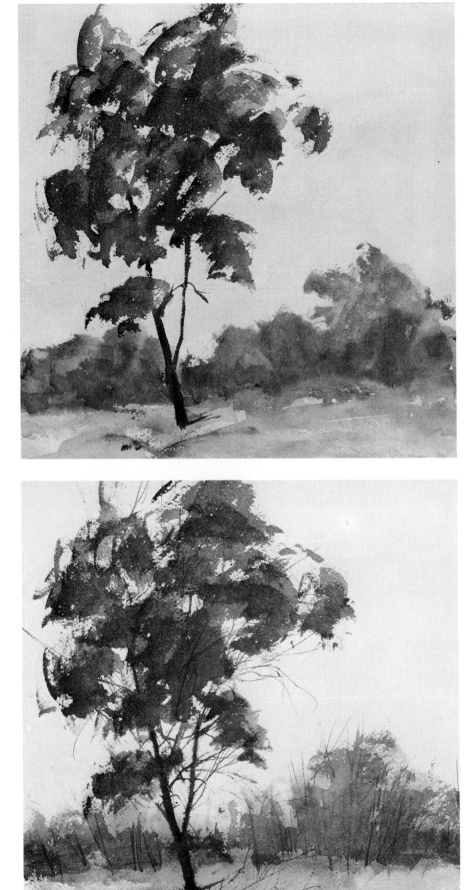

Step 2. While the masses of leaves are still wet and shiny, scratch into them with the corner of a sharp knife or razor blade. Make sure you abrade the surface so the dark color flows into the lines, which then become darker than the surrounding foliage. You can see many little lines scratched into the foreground tree and the other trees along the horizon. Then you can add more branches along the edges with the tip of a small, round brush.

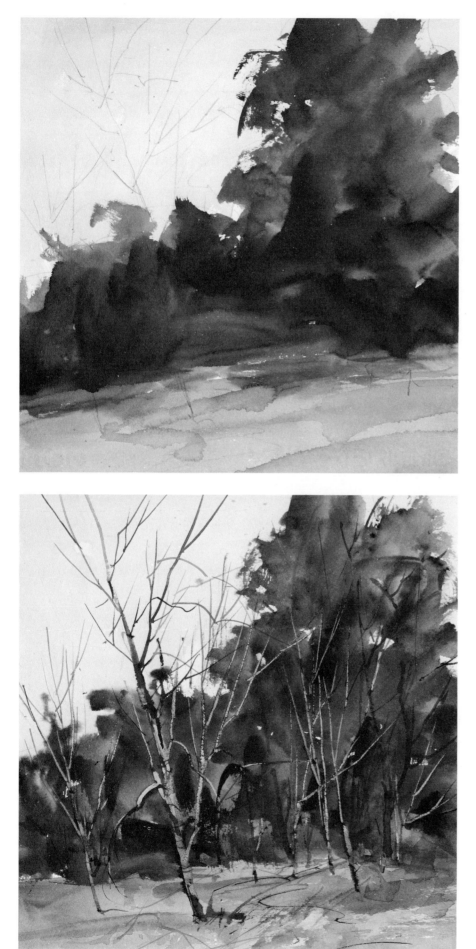

Step 1. You can also scrape *light* lines out of wet color. Once again, fill your brush with lots of liquid color and paint the big masses very quickly. Don't let them dry!

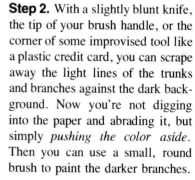

Step 2. With a slightly blunt knife, the tip of your brush handle, or the corner of some improvised tool like a plastic credit card, you can scrape away the light lines of the trunks and branches against the dark background. Now you're not digging into the paper and abrading it, but simply *pushing the color aside.* Then you can use a small, round brush to paint the darker branches.

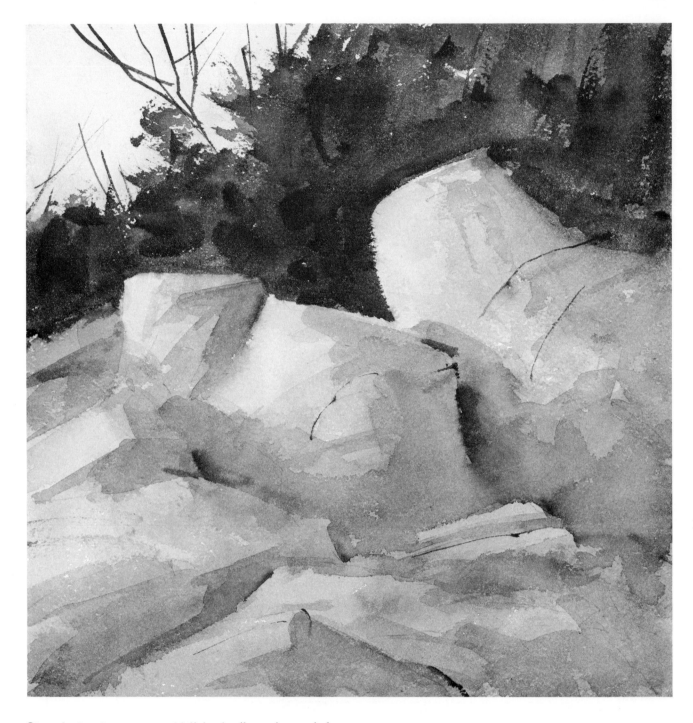

Step 1. Another way to add light details against a dark background—and to lighten broad areas—is to scratch or scrape away color when the painting is dry. Here you see the broad shapes of a rock formation and a mass of distant foliage painted in broad strokes, with very little attention to detail. The rocks need more contrast between the light and shadow areas. And the foliage needs to be enlivened with some interesting detail. When you're sure the painting is absolutely dry, reach for a razor blade or a sharp knife.

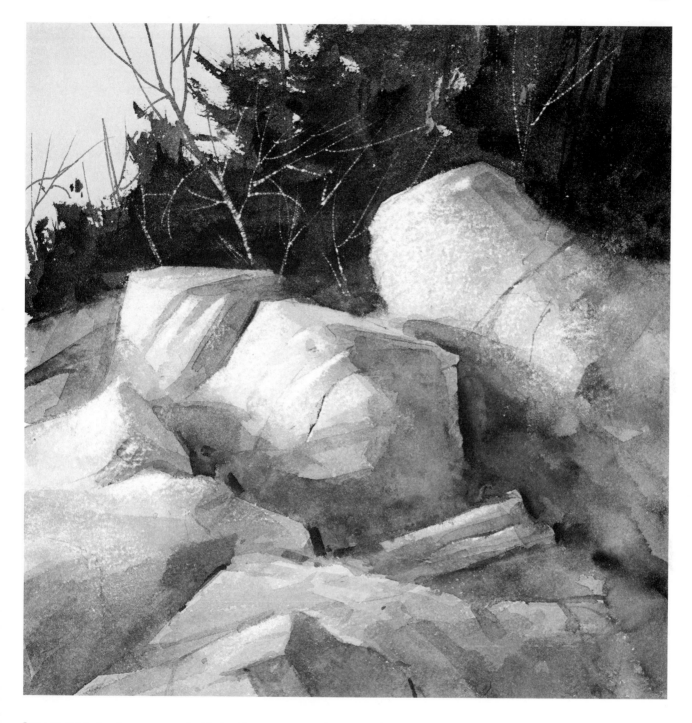

Step 2. With the sharp corner of a blade, it's easy to scratch away the light twigs and branches among the foliage at the top of the picture. If you don't scratch too hard, the blade will skip along the ridges of the paper, leaving a slightly broken white line that contains some flecks of the underlying color, like the lines you see here. If you dig in harder, you'll expose pure white. Next, the edge of the blade (not the corner) is used to scrape away the sunlit patches on the left sides of the rocks. The blade doesn't scrape the paper down to pure white, but takes off just enough color to lighten the tone and expose some irregular flecks of paper. Now you can strengthen the contrast even more by darkening the shadow sides of the rocks and adding some dark edges where one rock butts up against another.

SPONGING OUT

Step 1. This sky is terribly uninteresting. It's too pale. The one distinct cloud shape is right in the middle, like a bulls-eye. Try again.

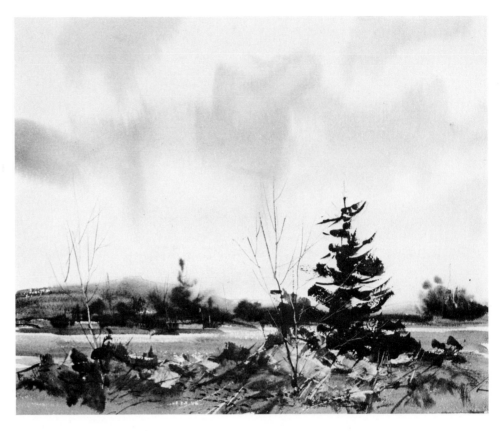

Step 2. With a silky natural sponge, you can take out most of the sky tone if you work gently. Soak the sponge until it's very soft and very wet, then gradually work across the sky with gentle strokes, wetting and removing the color. Squeeze out and rewet the sponge frequently as you work. You won't get down to bare white paper, but the sky will be light enough to repaint.

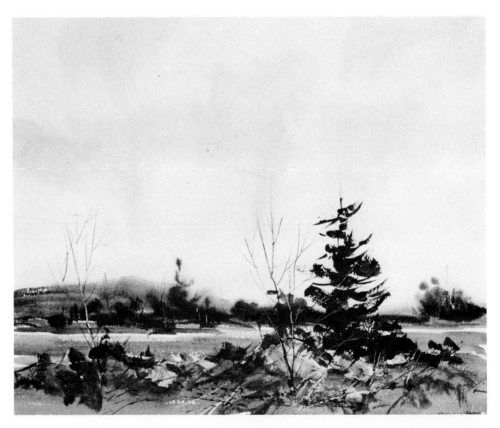

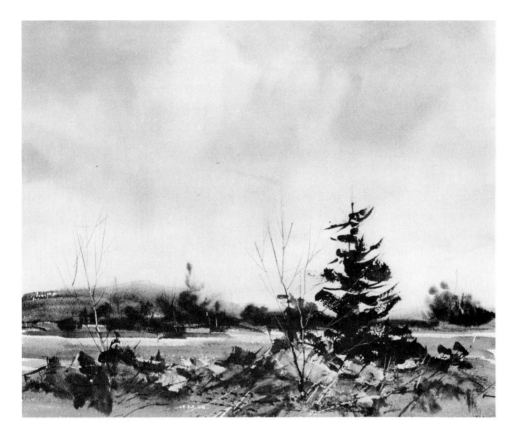

Step 3. Having sponged out a fair amount of dark color, you can let the water evaporate and go back to work on the dry paper—or you can paint right into the wetness. Here, a new sky is begun with a few strokes painted right onto the wet surface, so they begin to look like new cloud shapes.

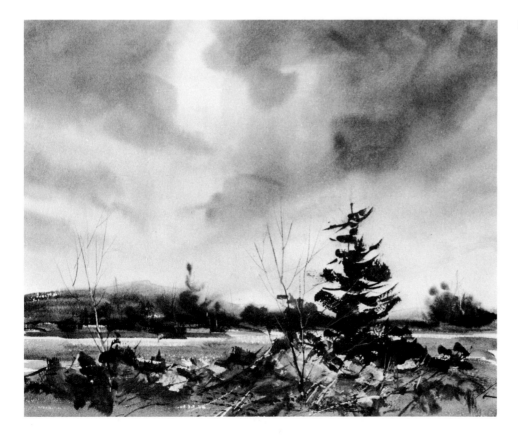

Step 4. More darks are now added to the wet surface with big, bold strokes, and new, more dramatic cloud shapes emerge. To create a few light patches where the sun seems to shine through, some of the darks are blotted away with a wad of paper toweling.

WASHING OUT

Step 1. This painting is dull because the darks are evenly scattered all over the sheet. The distant landscape looks too close because it's just as dark as the foreground. And the water lacks delicacy. How can this be corrected?

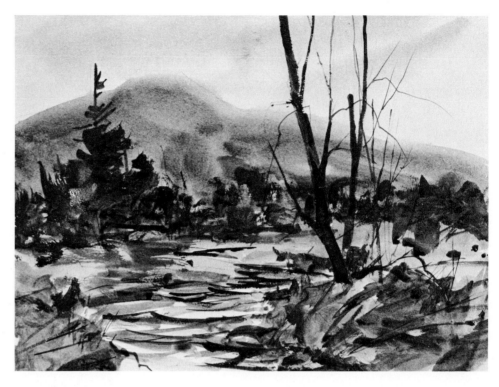

Step 2. You can take the whole painting straight to the bathtub. Fill the bottom of the tub with cold water and soak the painting until the color begins to lift off. You can speed up the process by working over the sheet gently with a natural sponge. You can also try running the sheet under the tap. You won't get off *all* the color, but you'll remove enough to try again.

Step 3. To create a sense of deeper space and atmosphere, you can leave the "ghost" of the distant mountain and paint the trees in the middle distance with light strokes. Then you can begin to strengthen the darks in the foreground.

Step 4. Now you can concentrate on repainting the foreground—darkening the tree, foliage, and nearby water just enough to make them come forward in space, while the water and trees in the middle distance stay back. Quit while you're ahead. Don't overdo it or you'll be back at Step 1.

Step 1. These trees have gotten so dark that the trunks have disappeared, and the foliage forms a monotonous mass without enough detail. How can you go about adding some lighter treetrunks to relieve the monotony. You could, of course, try scratching some light lines into the darkness. But there's another solution that you might also like to try.

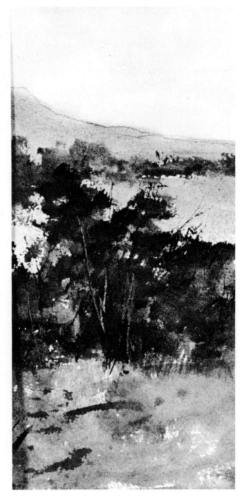

Step 2. Make a careful drawing of the shapes of the trunks on a separate sheet of sturdy white paper or thin cardboard. Then take a sharp blade and cut away the trunks, leaving gaps in the paper where the drawing of the trunks used to be. Now you've got a kind of stencil that you can place over the painting and tape down with some slender strips of masking tape—which you can see across the biggest trunk and the one to the left. The tape will hold the stencil snug against the paper.

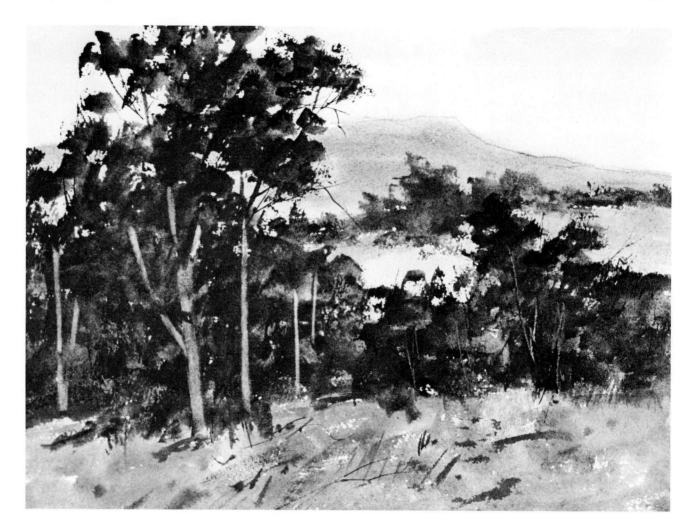

Step 3. Wet a small, stiff bristle brush—the kind used for oil painting—and carefully scrub away the dark color that shows through the gaps in the stencil. As you scrub, blot off the wet color with a wad of paper toweling. Be sure to rinse the brush frequently, so you're always working with clear water. Don't use so much water that the liquid color runs under the edges of the stencil. Use just enough water to loosen the color and then blot it up with the paper towel. When you peel away the stencil, the painting will have light lines like those you see at the left of the picture. They don't look like treetrunks just yet, but now you've got strips of lighter paper to work on. Let the corrected areas dry before you do any further work.

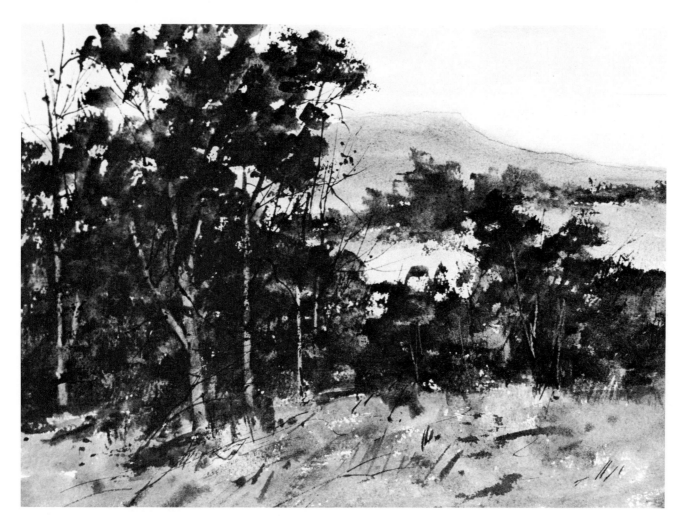

Step 4. Now you can go back to work with a small round brush and turn those pale strips into treetrunks. You can add darks around the edges of the trunks to give them exactly the right shape. You can obliterate some portions of the light strips to suggest shadows and foliage crossing the trunks. A bit of drybrushing will add texture. You can also "anchor" the trunks more firmly to the ground by suggesting some shadows below. And you can extend the new trunks upward into the sky with dark strokes. Now you have a convincing mass of trees, interrupted by lighter trunks and branches.

Step 1. The dark streaks across the center of this picture are supposed to represent distant hills, but they're too dark and they don't look distant enough.

Step 2. You can lighten the tops of the hills—making them fade away into the distance—by scrubbing them with a big, wet bristle brush. As you scrub and loosen the color, blot it away with a paper towel. Keep rinsing the brush so that it removes color rather than spreading it around. When the hills are dry, you can then paint the trees in the foreground. Now the hills look really far away.

Developing Good Habits. After the excitement of painting, it's always a letdown to have to clean up. Fortunately, you can clean up quite quickly after painting a watercolor—the job takes a lot longer if you're working in oil. It's essential to develop the right cleanup habits, not merely to keep your studio looking shipshape, but because the watercolorist's tools and equipment are particularly delicate and need special care. Here are the most important steps in your cleanup. Don't neglect them!

Sponging. After a day's painting, you'll certainly leave little pools and spatters of color in all sorts of odd places. Your drawing board or drawing table will have a fair amount of dried color around the edges, which you should sponge away with an ordinary household sponge. (Don't waste an expensive natural sponge on this task.) If you don't sponge off your drawing board and other work surfaces, there's always the danger that some of this color will dissolve and work its way onto the fresh white paper during your *next* painting session. You should also sponge off the color that's accumulated on the mixing surface of your palette, since you obviously want to start with a fresh surface the next time you paint. There's no need to wash away what's left of the little mounds of tube color around the edges of the palette; at your next working session, you can simply wet them and use them again. However, these little mounds often get covered with traces of various color mixtures; it's a good idea to wash away these mixtures with a brush, exposing the original pure color.

Washing Brushes. Your most fragile and most expensive tools are your brushes. These take very special care. At the end of the painting day, be sure to rinse each brush thoroughly in clear water—not in the muddy water in the jars. If a brush seems to be stained by some tenacious color such as phthalocyanine blue, stroke the hairs gently across a bar of soap (not laundry soap) and lather the brush in the palm of your hand with a soft, circular motion. The color will come out in the lather, except with white nylon brushes, which may stain slightly. When all your brushes have been rinsed absolutely clean, shake out the excess water and then shape each brush with your fingers. Press the round brushes into a graceful bullet shape with pointed tips. Press the flat brushes into a neat square with the hairs tapering in slightly toward the forward edge.

Storing Brushes. Place the brushes in a clean, dry, empty jar, hair end up. Leave the brushes in the jar until they're absolutely dry. You can store them in this jar unless you live in some climate where moths or other pests are a threat to natural fibers. If you're worried about moths, it's best to store the brushes in a drawer or a box. Make sure that the hairs don't press up against anything—and sprinkle mothballs or moth-killing crystals among the brushes.

Care of Paper. Watercolor paper has a delicate surface and should be carefully stored. Don't just leave a stack of unused paper out where dust can discolor it or a sweaty hand can brush up against it. Store the paper flat in a drawer, preferably in an envelope, a flat box, or a portfolio so the paper isn't battered or scraped every time it goes in or out of the drawer. Keep the paper away from moist places such as a damp basement or a leaky attic.

Care of Colors. When you're finished painting, take a damp paper towel or a cleansing tissue and wipe off the "necks" of your color tubes to clean away any traces of paint that will make it hard to remove the cap the next time you paint. Do the same inside the cap itself. There's nothing more frustrating than wrestling with that tiny cap when you're desperate for a fresh dab of color, halfway through a painting. Also wash away any paint that might cover the label on the outside of the tube, so you can quickly identify your colors. Searching for the right color among all those filthy tubes can be just as maddening as wrestling with the cap. By the way, you'll get more color out of the tube—and save money—if you always squeeze the tube from the very end and roll up the empty portion as you work.

Safety Precautions. Be especially careful about putting away sharp instruments—and always keep them in the same place. If you bought a knife with a retractable blade, as suggested earlier, be sure to retract the blade before you store the knife in the darkness of your paintbox or toolbox. You don't want that sharp blade waiting for you when you grope around for the knife. Keep razor blades in a small envelope or in a box—or just wrap a piece of tape over the sharp edge. Keep pushpins or thumbtacks in a little envelope or box—or simply push them into the edges of your drawing board. Finally, there's always a certain amount of color on your fingertips while you're painting, so don't smoke or eat while you work. Keep those colors out of your digestive tract.

Permanence. A watercolor painting, properly taken care of, should last for centuries. Although the subject of framing, in particular, would take a book in itself, here are some suggestions about the proper way to preserve finished paintings.

Permanent Materials. It's obvious that you can't paint a durable picture unless you use the right materials. All the colors recommended in this book are chemically stable, which means that they won't deteriorate with the passage of time and won't produce unstable chemical combinations when blended with one another. When you buy other colors, either to expand your palette or to replace one of these eleven colors, study the manufacturer's literature to make sure that you're buying a permanent color. All the good color manufacturers have charts which tell you, quite frankly, which colors are permanent and which colors aren't. For the same reason, it's important to buy the best mouldmade or handmade paper. Although few papers are now made of rags, the manufacturers still use the phrase "100% rag" to designate paper that is chemically pure—and that's what you should buy once you feel that your paintings are worth saving. Lower grade papers will yellow and discolor with the passage of time.

Matting. A mat (which the British call a mount) is essential protection for a watercolor. The usual mat is a sturdy sheet of white or tinted cardboard, generally about 4″ (100 mm) larger than your painting on all four sides. Into the center of this board, you cut a window slightly smaller than the painting. You then "sandwich" the painting between this mat and a second board, the same size as the mat. Thus, the edges and back of the picture are protected and only the face of the picture is exposed. When you pick up the painting, you touch the "sandwich," not the painting itself.

Boards and Tape. Unfortunately, most mat (or mount) boards are far from chemically pure, containing corrosive substances that will eventually migrate from the board to discolor your watercolor paper. If you really want your paintings to last for posterity, you've got to buy the chemically pure, museum-quality mat board, sometimes called conservation board. The ordinary mat board does come in lovely colors, but you can match these by painting the museum board with acrylic colors. Paint both sides to prevent warping. The backing board can be less expensive "rag-faced" illustration board, which is a thick sheet of chemically pure, white drawing paper made with a backing of ordinary cardboard. Too many watercolorists paste their paintings to the mat or the backing board with masking tape or Scotch tape. Don't! The adhesive stays sticky forever and will gradually discolor the painting. The best tape is the glue-coated cloth used by librarians for repairing books. Or you can make your own tape out of strips of discarded watercolor paper and white library paste.

Framing. If you're going to hang your painting, the matted picture must be placed under a sheet of glass (or plastic) and then framed. Most watercolorists prefer a simple frame—slender strips of wood or metal in muted colors that harmonize with the picture—rather than the heavier, more ornate frames in which we often see oil paintings. If you're going to cut your own mats and make your own frames, buy a good book on picture framing, which is beyond the scope of the book you're now reading. If you're going to turn the job over to a commercial framer, make sure he uses museum-quality mat board or ask him to protect your painting with concealed sheets of rag drawing paper inside the mat. Equally important, make sure that he doesn't work with masking tape or Scotch tape—which too many framers rely on for speed and convenience.

What to Avoid. Commercial mat boards come in some dazzling colors that are likely to overwhelm your painting. Whether you make your own mats or have the job done by a framer, avoid the garish colors that call more attention to themselves than to your picture. Try to find a subdued color that "stays in its place" and allows the painting to occupy center stage. Resist the temptation to glue your finished painting down to a stiff board, even if the painting is a bit wavy. The painting should hang free inside the "sandwich" of mat and backing board, hinged either to the mat or the backing by just two pieces of tape along the two top corners of the picture. When you do hang the picture, keep it away from damp walls, leaky windows, leaky ceilings, and windows that will allow direct sunlight to pour onto the picture. Any painting—whether watercolor, oil, acrylic, or pastel—will eventually lose some of its brilliance with prolonged exposure to strong sunlight.

Storing Unframed Pictures. Unframed pictures, with or without mats, should always be stored horizontally, never vertically. Standing on its end, even the heaviest watercolor paper and the stiffest mat will begin to curl. Store these just as you'd store sheets of watercolor paper: in envelopes, shallow boxes, or portfolios kept flat in a drawer or on a shelf. Take proper care of your paintings and people will enjoy them for generations to come.

PART TWO

LANDSCAPES
IN WATERCOLOR

Landscapes in Watercolor. Watercolorists paint more landscapes than any other subject. The transparency of watercolor makes the medium ideal for capturing luminous skies, the flicker of sunlight on a mass of leaves, and the crystalline shadows on a snowbank. The speed of watercolor is also a great advantage in painting outdoor subjects. As the clouds race by, as the sun moves across the sky and changes the pattern of light and shadow on those trees and snowbanks, you can capture these fleeting effects with a few bold washes and rapid brushstrokes. Speed means spontaneity: those fast, decisive strokes have a unique way of communicating the excitement of the subject and the artist's joy in painting.

Organization. You'll find that this text is organized in three sections. First, you'll find a brief review of the basic techniques of painting landscapes in watercolor. Then Claude Croney, a noted painter of outdoor subjects in watercolor, demonstrates ten complete paintings of popular landscape subjects, showing you how to put these techniques to work. Finally, there's a section on the special problems of planning and executing a successful landscape.

Wash Techniques. There are several basic ways of applying color to paper, as you may already know. The first section of *Landscapes in Watercolor* reviews these techniques by showing how they apply specifically to landscape subjects. The simplest method of applying color is a flat wash, and you'll see how to use flat washes to build up the large, solid forms of mountains. Graded washes are just a bit more difficult, and you'll see how to paint a lake in this technique. Drybrush is a particularly good way to suggest textures, so you'll see how to paint rocks in the drybrush technique. Wet-in-wet—sometimes just called the wet-paper technique—is an effective way to create forms with soft, blurry edges; you'll see how to paint a misty landscape by this method. Of course, there's no "law" that mountains should always be painted in flat washes, lakes in graded washes, rocks in the drybrush technique, and mist in the wet-paper technique. You're free to use these methods according to your own tastes and according to the requirements of the subject. There will certainly be times when you'll want to paint mountains in graded washes, perhaps when the peaks are emerging from mist. Or you may want to use the drybrush technique to capture the broken light on the ripples of a lake. There are also many possible combinations of these techniques, such as establishing the basic form of a tree in flat washes and then creating the textures of leaves and bark with drybrush.

Landscape Colors. Just before the actual painting demonstrations, you'll see a number of color sketches that will tell you more about the colors you're likely to see outdoors. You'll see comparative studies of the colors of a clear sky and an overcast sky. You'll learn about the colors of trees, rocks, hills, and meadows. And you'll be able to compare the colors of a lake, a stream, and a pond filled with intricate reflections. There are also "life-size" close-ups of sections of various paintings by Claude Croney, showing how a professional watercolorist uses color to interpret the foliage of autumn and spring, the forms of green hills, and the patterns of moving water.

Painting Demonstrations. The purpose of the ten painting demonstrations is to allow you to study every significant painting operation step-by-step. Because a watercolor proceeds so quickly and decisions must be made without hesitation, it's important to plan the picture in logical stages. In these demonstrations, each stage is captured by the camera. Croney begins with three paintings of green, growing things: deciduous trees, evergreens, and a meadow filled with grasses, weeds, and wildflowers. He then goes on to paint the large, looming forms of mountains and the more modest forms of green hills. Water is particularly tricky to paint. Croney first shows how to paint the surface of a lake, with its complex pattern of ripples, reflections, lights, and darks. He then goes on to show how to paint the action of a moving stream. Of course, snow and ice are both forms of water, so a separate demonstration is devoted to these wintry subjects. The painting demonstrations conclude with two skies: a blue, sunny sky with large, soft-edged clouds and finally the ever-popular sunset.

Special Problems. The final section begins by advising you how to select an appropriate subject for a landscape painting, which most beginners find particularly difficult. There are also some guidelines—some dos and some don'ts—for composing landscape paintings. You'll see how lighting affects various landscape subjects and how changes in the light actually change the landscape itself. You'll learn how to exploit the effects of aerial perspective to create a sense of deep space in a landscape. "Life-size" close-ups of Claude Croney's paintings will show you how to wield the brush expressively. To encourage you to study the varied forms of the natural landscape, there are studies of different kinds of rock, tree, and cloud forms. Finally, you'll learn the "three-value system," a very simple, time-tested method of designing a successful landscape.

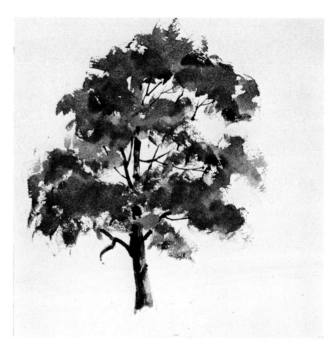

Step 1. A round brush tends to leave a more jagged, irregular stroke than a flat brush. A good way to tell the difference between the ways these two brushes work is to try painting the same tree with both. In this first stage, the broad masses of foliage are blocked in with the round brush held at an angle, so both the tip and the side press against the paper.

Step 2. Now, working with the tip of the brush, add the trunk and the branches. If it's a good one, even a very large brush comes to quite a sharp point, so you can make precise strokes.

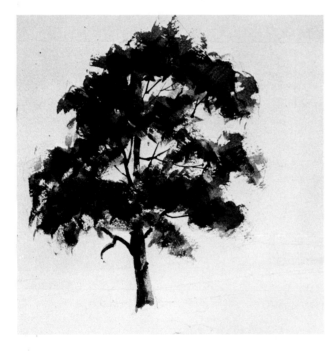

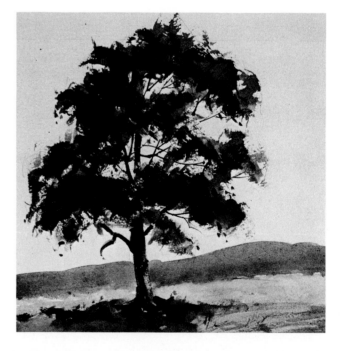

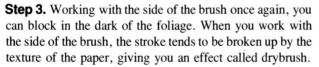

Step 3. Working with the side of the brush once again, you can block in the dark of the foliage. When you work with the side of the brush, the stroke tends to be broken up by the texture of the paper, giving you an effect called drybrush.

Step 4. Now you can add the final touches with the tip of the brush once again, adding more branches and a few flecks for leaves. And you can complete the picture by brushing in a strip of tone for the distant hill, plus some darks in the foreground to suggest a shadow under the tree.

Step 1. A flat brush tends to make broad, squarish strokes. You ought to bear this in mind when you make your preliminary pencil drawing, which should visualize the tree in big, blocky masses.

Step 2. Following the drawing rather freely, the flat brush quickly places large color areas. These have a much broader, flatter character than the foliage in the preceding demonstration, which was painted with a round brush. Because the flat brush covers so much territory, you can work very quickly.

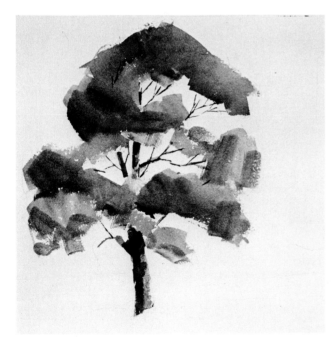

Step 3. You might not think that such a big brush would be capable of precise work, but it is. Just a touch of the forward edge of the brush will make a very crisp line, as in the branches of the tree. If you press down and give the brush a slight pull, you can make a thicker line, as in the trunk.

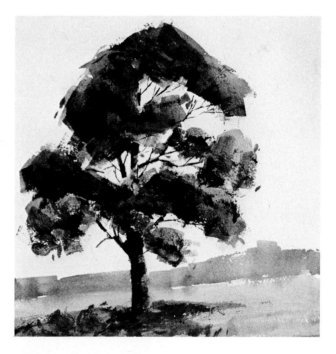

Step 4. Working with the side of the flat brush, you can produce rough-textured darks for the shadows of the foliage. The distant hills are just one sweeping stroke. And you can make the ragged shadow at the bottom of the tree by patting the brush against the paper.

Step 1. Mountains are a good subject for practicing flat washes. The big shapes are blocked in with a series of strokes, slightly overlapping one another so that they fuse together at the edges. The tone doesn't have to be smooth and even; mountains are craggy, after all, and the individual strokes can show a bit.

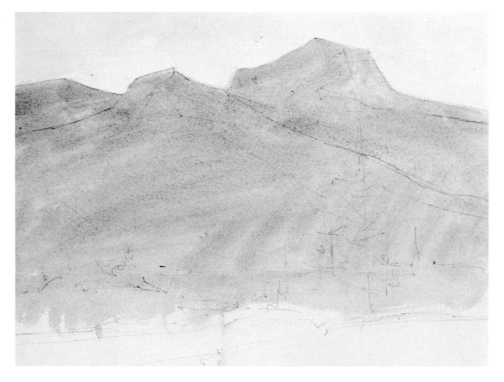

Step 2. For the shadow sides of the mountain, a darker wash is applied with free, irregular strokes. These big planes of light and shadow can be painted very effectively with a flat brush.

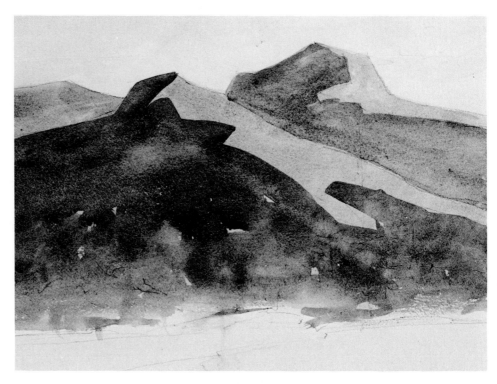

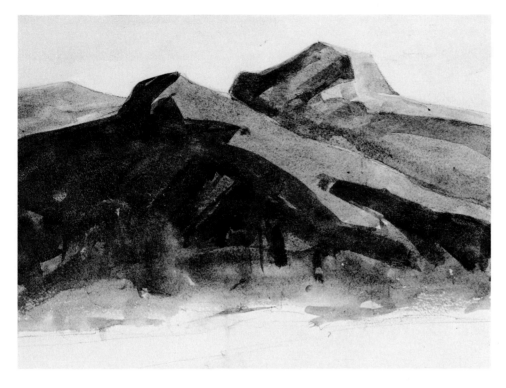

Step 3. When that shadow plane is dry, a darker shadow tone is applied to strengthen and vary that area. The shadow tone that was painted in Step 2 isn't completely covered here, but peeks through the darker tone to suggest a variety of lights and shadows.

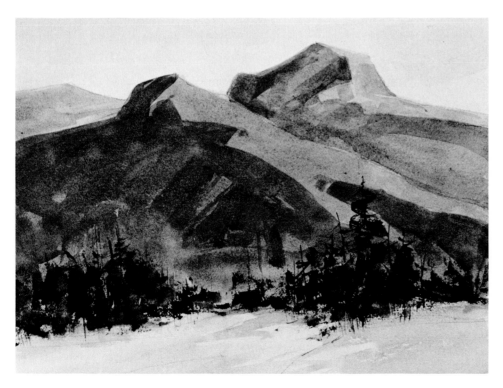

Step 4. With the light and shadow planes of the mountains completed, a still darker tone is mixed for the trees in the foreground. These are brushed in with quick, irregular strokes made by the tip of a small, round brush. To suggest snow beneath the trees, some pale strokes are added—about as dark as the wash in Step 1. The whole picture is painted in four flat tones.

Step 1. This atmospheric study of a lake begins with a wash that goes from dark to light to dark again. The sky at the top begins with some dark strokes, followed by paler strokes that blend with the dark ones and work down to the midpoint of the sheet. Then these pale strokes begin to fuse with darker strokes once again, coming down to the edge of the lake.

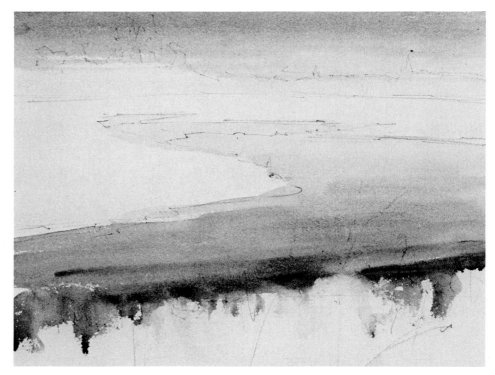

Step 2. The land mass below the sky is also a kind of graded wash, starting with dark strokes at the horizon and then gradually giving way to paler strokes in the wedge of shore at the left. The foreground grasses are roughly indicated with pale vertical strokes.

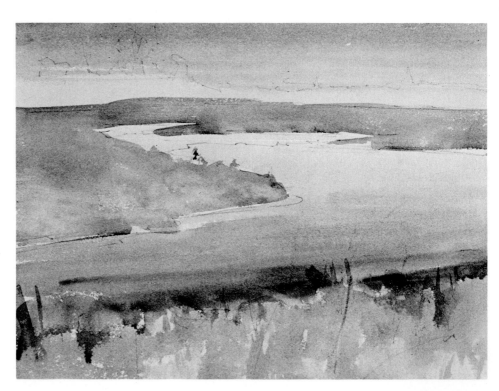

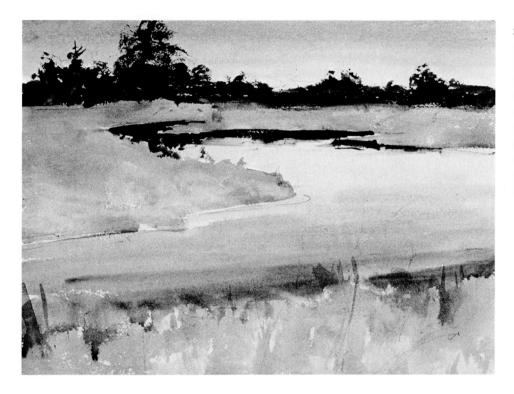

Step 3. When the darks of the trees are blocked in at the horizon, the graded wash in the sky suddenly creates a feeling of glowing light. And when the dark reflection of the trees is added just below the distant shore, the graded wash of the lake gives the impression of reflected light on the distant water.

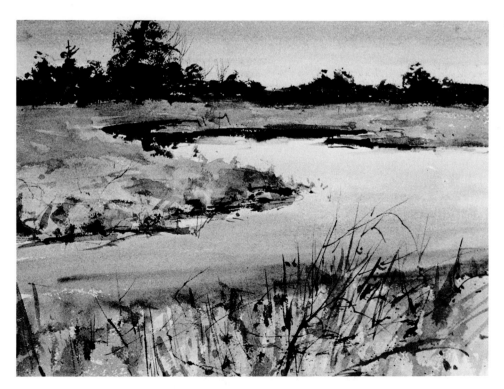

Step 4. Now the picture is completed by adding some darks along the edge of the near shoreline and adding some strokes for weeds in the immediate foreground. The graded wash in Step 1 doesn't make much sense all by itself; but with these details added, the sky and water glow with light.

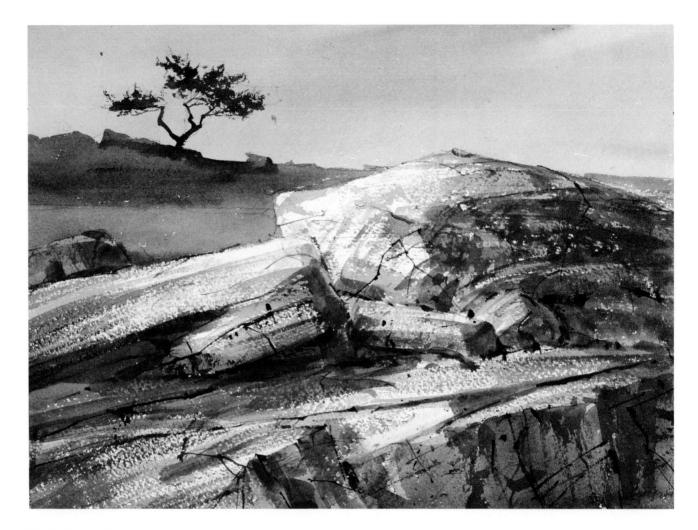

Rock Formation. The realistic texture of these rocks is created by drybrush strokes. You can start by dipping your brush into wet color and then getting rid of some of the wetness by stroking the brush across a paper towel. Or you can simply pick up a small amount of color on the brush, so it's damp rather than wet. In either case, you're working with a damp brush, dragging the side of the brush lightly over the paper. Watercolor paper has an irregular texture, with definite peaks and valleys. As the damp brush travels over the sheet, the color hits only the peaks, leaving behind the broken flecks of color you see here on the lighted tops of the rocks. If you press down harder on the brush, you deposit more color, as you'll see on the shadow sides of the rocks. The foliage of the tree on the horizon is another drybrush effect: just press down the damp brush, wiggle it a bit, and then pull it away.

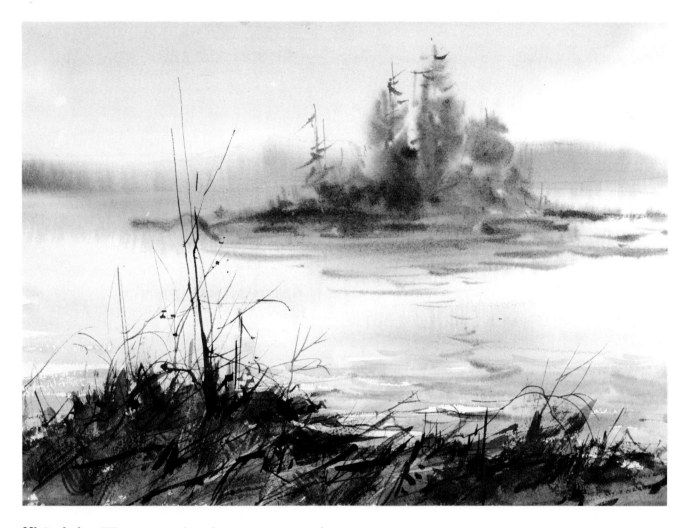

Misty Lake. When you apply color on wet paper, the strokes blur and create a magical sense of atmosphere, perfect for painting haze, mist, and fog. With practice, you'll see that a wash of pure water or wet color goes through several drying stages. At first, the liquid sits on top of the paper—not soaking in just yet—and a stroke of color will blur very rapidly in this wetness. Next, the wash begins to settle into the paper, which is still shiny, but a new stroke of color won't blur quite so much. Now, as the wet surface begins to dry out, you can still apply new strokes if the paper has just a bit of shine left: these strokes will remain fairly distinct. Look carefully at this hazy island and the distant shore beyond. The shore is very blurry, which means that the tone is applied when the paper is very wet. The larger masses of the island are more distinct than the distant shore, which means that they're applied when the wetness has begun to sink into the surface of the paper. And the crisper strokes at the tops of the distant trees and in the water are even more distinct because they're applied just before the paper loses its shine. A wet-in-wet effect is most powerful when it's contrasted with a more precise passage such as the weeds in the foreground, which are painted with sharp strokes on dry paper. It's rare to see a good picture that is painted *entirely* wet-in-wet.

Step 1. Now let's see how a rock formation is painted in drybrush. The distant landscape is painted in several flat washes. The sky is one irregular flat wash with some darker strokes added wet-in-wet. The scrubby tree is painted by pressing down a damp brush and pulling it away. Now the drybrush work begins.

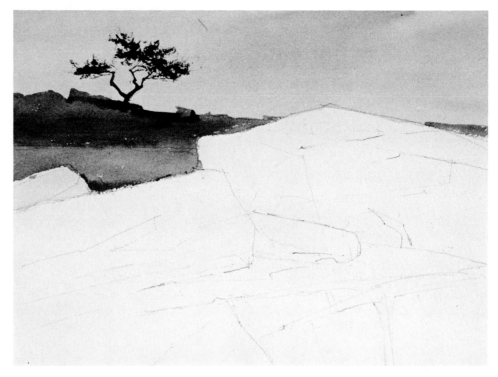

Step 2. The shadows on the rocks are painted with the quick strokes of a damp, flat brush held at an angle so the flat side hits the paper. The lighted tops of the rocks are textured by very light strokes of the brush, applicd with very little pressure and pulled along rapidly, just skimming the surface of the paper.

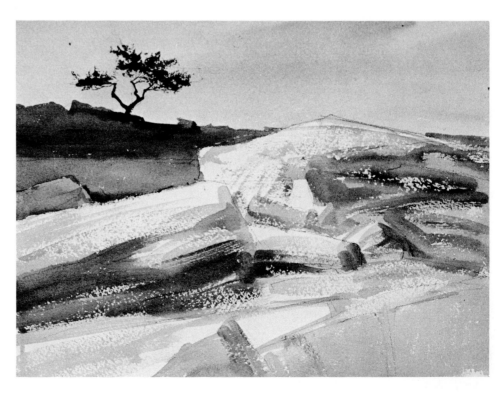

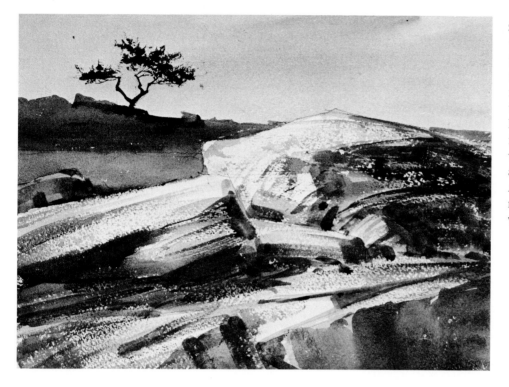

Step 3. The shadow sides of the rocks are darkened with further drybrush strokes. This time, the color on the brush is not only darker, but a bit wetter. And the brush is pressed harder against the paper, forcing the color further into the valleys. The slender strokes are made with a round brush. And the shadow in the lower right corner is a fluid flat wash.

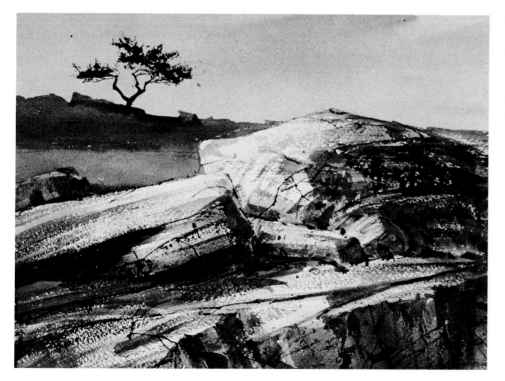

Step 4. More drybrush textures are added to the shadow on the lower right. Then the tip of a small, round brush is used to strike in slender lines for the cracks and flecks that complete the rocks.

Step 1. It's usually best to *begin* with a wet-in-wet effect and then complete the painting with strokes and washes on dry paper. In this first stage, the entire sheet is brushed with clear water. Then the distant shore, the island, and the ripples in the water are all painted into this wet surface and allowed to dry. The dark strokes are thicker color, diluted with less water.

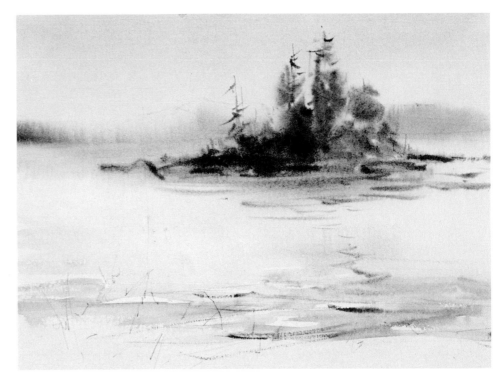

Step 2. The entire sheet is allowed to dry. Then the foreground is begun with free strokes, scraped here and there with the tip of the brush handle to suggest weeds struck by the light.

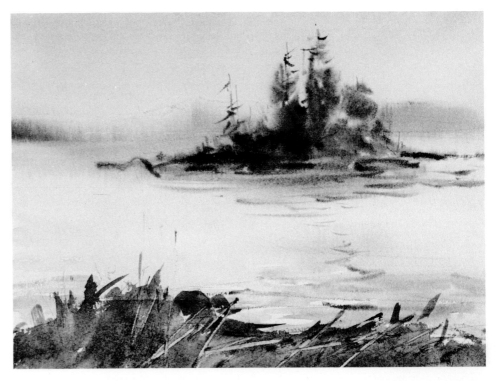

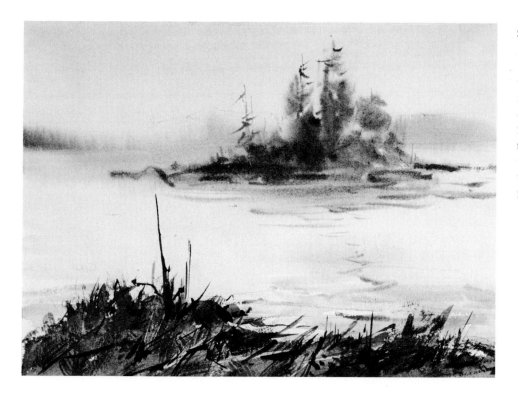

Step 3. The foreground is gradually built up with more and more crisp, dark strokes working their way across the misty blur of the lake. The contrast of the sharp-focus foreground and the blurry distance is the key to the picture—the foreground makes the wet-in-wet island look more distant and mysterious.

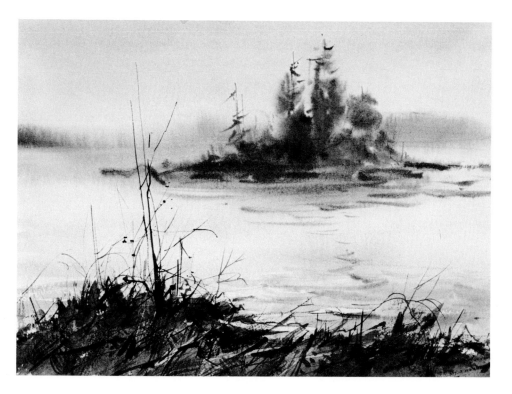

Step 4. The weeds of the foreground are completed with long, slender strokes that cut across the blurred, wet-in-wet distance, further accentuating the contrast between sharp focus and soft focus. At this point, it's possible to rewet certain areas of the island with clear water and drop in additional dark touches, which are almost invisible because they blur away into the surrounding darkness. But do this very selectively and with great care—don't rewet the whole painting.

Plan Your Mixtures. Before you start to mix any color you see in your subject, think carefully about the simplest color mixture that will do the job. Don't just dart your brush at several mounds of color on your palette and keep adding a bit of this, a bit of that, until it comes out more-or-less right. The more colors you add, the muddier the mixture is likely to be. Nor will you be able to duplicate that mixture later on if you need more color. Ideally, no mixture should contain more than three colors. Occasionally, when those three colors are *almost* what you want, but need some very subtle modification, you can add a touch of some fourth color. But two or three colors should do for most mixtures.

Greens. Certainly one of the most pervasive colors in landscape painting is green. Of course, there's no one green—but rather an infinite number of greens. The tender yellow-greens of trees in the springtime are vastly different from the deeper, richer greens of trees in midsummer. Evergreens are often a smoky bluish green or a dark green that's almost black. You have two blues on your palette, ultramarine and cerulean, and two yellows, cadmium and yellow ochre. You can create a surprising variety of greens just by mixing various blues and yellows. You can also modify the one green on your palette (Hooker's green) by adding blue or yellow or both. You'll find that Payne's gray will also act something like a blue when mixed with yellow. And the range of these mixtures can be greatly extended by adding a touch of one of your browns: burnt umber or burnt sienna. If you look closely, you'll see many brownish greens in nature. Even a faint touch of red—cadmium or alizarin crimson— will add a fascinating hint of darkness if you don't add too much. The important thing is *not* to rely totally on Hooker's green, but to regard it as one possible component in various green mixtures.

Browns. In landscapes, browns are just as common as greens—and just as varied. You do have two browns on your palette, burnt umber and burnt sienna, but these are just the beginning. Try modifying them with a bit of blue or green to produce a variety of grayish browns or greenish browns. A touch of yellow ochre will add a subtle hint of warmth, while a touch of cadmium yellow is like adding strong sunshine. Cadmium red or cadmium orange will turn your two browns coppery. But you don't even have to start with brown in order to produce brown. Any combination of blue, red, and yellow will give you an interesting brown. And these blue-red-yellow mixtures will change radically, depending upon the proportion of each color in the mixture. Two other ways to create browns are to mix one of your blues with orange or one of your reds with green. As you can see, brown is far from dull. It's one of the most diversified *families* of colors.

Painting Trees. Too many beginners paint every tree as a bright green mass of leaves and a chocolate brown trunk. It's important to look closely at the leaves and decide what shade of green you really see. Some trees, like willows, tend to have smoky, grayish-green foliage. Certain spruces are almost blue. In the tropics, many trees contain a great deal of yellow within the green. Treetrunks are just as diverse. Few trunks are really brown. The bark is often a brownish gray or grayish brown. And many treetrunks are unexpected colors, such as yellow, blue, brownish-violet, or even dusty red. When they're soaking wet after the rain, treetrunks often look black.

Painting Rocks and Soil. Just as it's easy to fall into the trap of thinking that all trees look alike, it's dangerous to assume that all rocks are gray and all soil is brown. Look closely and you'll see that rocks can be yellow, blue, green, even pink, red, or orange. And when a rock *does* turn out to be gray, that gray often has a hint of blue, green, or some unexpected color. Soil, of course, is made of the same stuff as rock, so the colors of soil are just as varied. Sand is probably the hardest ground color to paint. Don't just assume that it's always yellow, but look closely and you'll see that it's often gray or brown—or even blue after the rain, when the wetness reflects the color of the sky.

Color Schemes. Just as it's important to plan your color mixtures, you've got to plan the overall *color scheme* of a landscape. Try to concentrate your brightest colors at the center of interest, rather than spreading bright colors over the entire picture. If your focal point is a flaming autumn tree, adjust the surrounding trees so they're a bit browner and less vivid. Decide whether your picture is going to be dominated by warm color (brown, red, orange, yellow) or cool color (blue or green). If it's mainly cool color—such as a panorama of green hills, green trees, and blue sky— try to find a few warm notes for variety. A few brownish or yellowish trees will keep that green landscape from looking like a colossal salad. If warm tones dominate—as they often do in an autumn landscape or a painting of the desert—try to introduce a few cool notes, such as some evergreens or cactus. And remember that bright colors really sing out when there are subdued colors nearby.

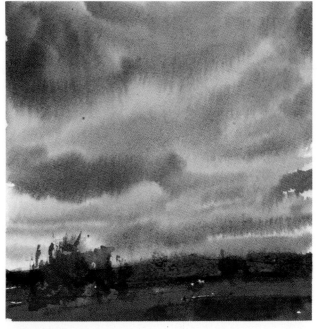

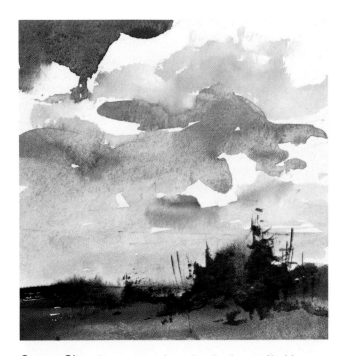

Sunny Sky. On a sunny day, the sky is usually bluest at the top, paler and warmer at the horizon. Here, the deeper blues are a mixture of ultramarine blue and cerulean blue. Lower down, the paler, warmer tone is a mixture of cerulean blue, yellow ochre, and alizarin crimson. The shadow sides of the clouds are Payne's gray and yellow ochre. The lighted sides are bare paper.

Overcast Sky. An overcast sky isn't always steely gray, but often has a warm tone because the sun is trying to force its way through the clouds. These clouds, painted on wet paper, are a mixture of Payne's gray, yellow ochre, and burnt umber. There are touches of cerulean blue where the sky appears through the clouds.

Deciduous Trees. The sunlit patches of leaves are a mixture of Hooker's green, burnt sienna, and burnt umber, dominated by the green. The shadow areas are the same mixture, with more burnt sienna and burnt umber. The grass is Hooker's green, cadmium yellow, and burnt sienna, with more green and brown in the shadows.

Evergreens. On the foreground trees, the lighter areas are Hooker's green, cadmium yellow, and burnt sienna, while the darker areas are Hooker's green, burnt umber, and ultramarine blue. The distant trees are a pale mixture of Hooker's green, burnt sienna, and ultramarine blue. The grass is cadmium yellow, Hooker's green, and cerulean blue, with more blue in the shadows.

Rocks. Avoid the temptation to paint rocks as if they're all gray or brown. They contain many subtle colors. The shadow sides of these rocks are built up with multiple strokes in various combinations of yellow ochre, burnt sienna, burnt umber, and cerulean blue. The lighted sides are bare paper with touches of yellow ochre, burnt sienna, and cerulean blue. The distant mountains, which are really paler, cooler versions of the nearby rocks, are painted in burnt sienna and cerulean blue. The dried grass in the field contains various mixtures of yellow ochre, burnt sienna, cerulean blue, and cadmium orange.

Hills. Hills covered with foliage aren't a uniform green, but contain various warm and cool colors. The underlying tone of the hills is a mixture of Hooker's green, ultramarine blue, and burnt sienna, with more burnt sienna to the left and more Hooker's green to the right. The tree strokes are various mixtures of Hooker's green, ultramarine blue, and burnt sienna. The field in the foreground is cadmium yellow, Hooker's green, and burnt sienna, with more burnt sienna to the left and more Hooker's green to the right.

Meadow. A meadow can be a rich tapestry of cool greens and warm yellows, oranges, and browns. This field was painted with various mixtures of cerulean blue, Hooker's green, cadmium yellow, yellow ochre, and burnt sienna. Hooker's green and the yellows dominate the distance, while the foreground contains both yellows and much more burnt sienna. The trees along the horizon are overlapping strokes, containing various combinations of Hooker's green, burnt umber, cerulean blue, and ultramarine blue.

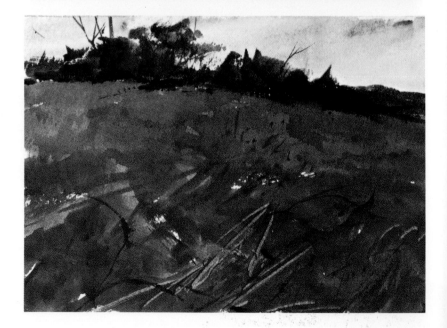

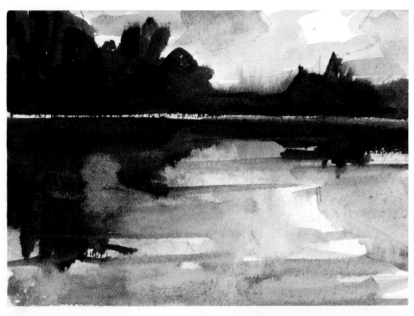

Lake. Clear water has no color of its own, but simply reflects the colors that surround it. This calm lake acts as a mirror for the colors of the sky and the shoreline. The sky is cerulean blue and yellow ochre. The trees along the shore are various combinations of Hooker's green, cadmium yellow, burnt sienna, and ultramarine blue. The same color combinations appear in the water.

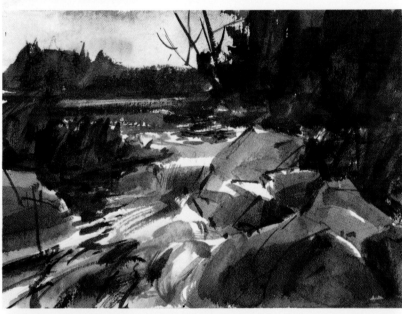

Stream. Although moving water may be interrupted by a broken pattern of lights and shadows, it's still a reflecting surface. Here, the sky is cerulean blue and a touch of yellow ochre, reflected in the cool areas of the stream. The rocks are ultramarine blue, burnt umber, and yellow ochre—a combination that is reflected in the warmer areas of the stream. The distant trees along the horizon are Hooker's green, ultramarine blue, and burnt sienna, reflected in the water at upper left.

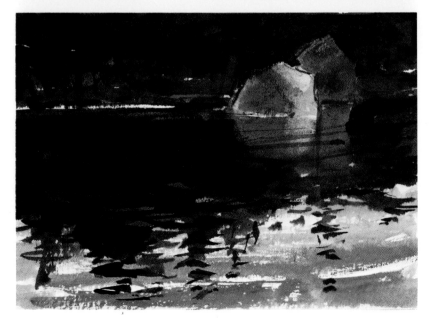

Reflections. In this close-up, you can see how the water reflects the colors of the foliage along the shore, the rocks, and the sky. The greens along the shore and in the water are Hooker's green, burnt sienna, and ultramarine blue. The rocks are yellow ochre, burnt sienna, and ultramarine blue, with the same combination in their reflections, slightly cooled by Hooker's green. Although you can't see the sky, you know that it's reflected in the blue of the water, which is cerulean blue and a little yellow ochre.

Autumn Foliage. These lively masses of foliage begin as broad strokes of a fairly light tone—various mixtures of yellow ochre, cadmium yellow, cadmium red, burnt sienna, and Hooker's green, with plenty of water. Then, while these strokes are still very wet, stronger colors are quickly dabbed in, blurring into the underlying tone. You can see where strokes of much hotter colors—burnt sienna, cadmium red, and cadmium yellow—merge with the underlying wash. You can also see where cooler tones are "floated" into the underlying wash—mixtures dominated by Hooker's green but also containing small quantities of reds and yellows. For the big, broad strokes, a very wet brush is pressed firmly against the paper. Around these broad strokes, a damp brush is skimmed lightly over the paper to create drybrush effects that suggest leaves. The trunks are short, firm strokes of wet color.

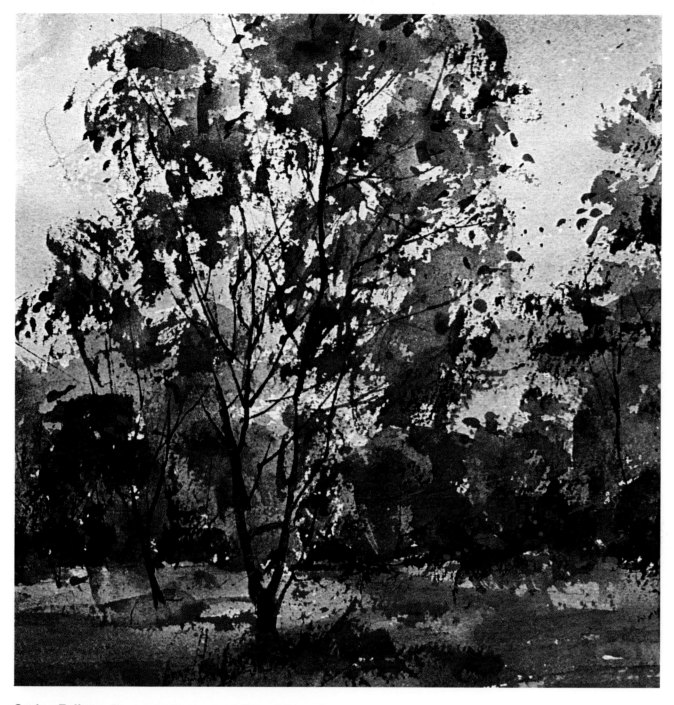

Spring Foliage. To suggest the sparse, delicate foliage of springbefore the trees are covered with heavy masses of leaves—the brush carries plenty of wet color, but *doesn't* make big, solid strokes. The brush moves gently over the surface of the paper, sometimes pressing down and sometimes just skimming. Thus, you see smaller, more irregular masses of color and lots of drybrush areas, where the brush just touches the peaks and skips over the valleys of the painting surface. Around the edges of the trees, the tip of a small brush is used to suggest a few leaves here and there. The more distant trees are painted with somewhat broader, more solid strokes, but they still contain a good deal of drybrush. To create these very delicate textures and broken strokes, try working with the side of the brush.

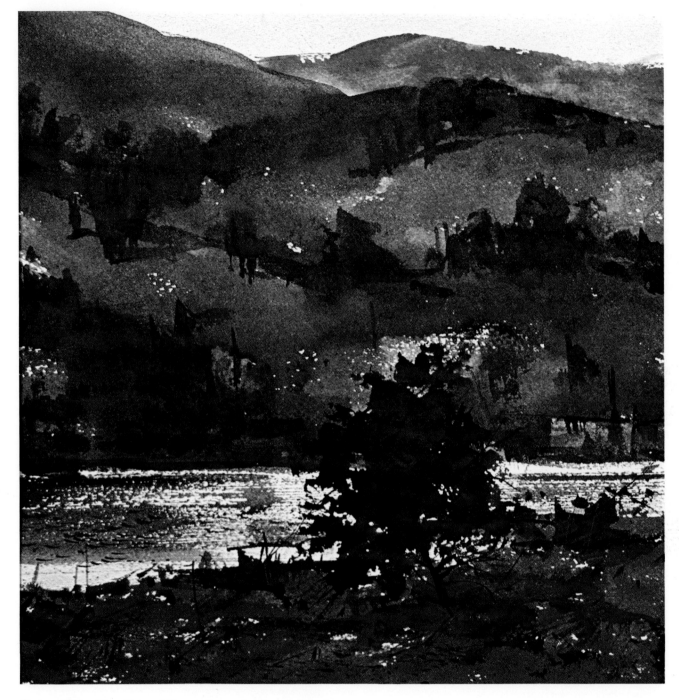

Green Hills. The distant hills are first painted with broad sweeps of a large brush carrying lots of liquid color. Then, just before this underlying wash dries—while it still has a slight shine—smaller, darker strokes are added to suggest trees. Additional tree strokes are painted in when the surface is completely dry. You can see that the earlier tree strokes tend to fuse with the underlying color of the hills, while the later strokes are quite distinct and have much more sharply defined edges. The foreground tree is painted with a very wet brush, but the strokes are ragged and have a drybrush feeling because the side of the brush is used to deposit the color.

Moving Water. In the immediate foreground, the waves of moving water are rendered with the big, long strokes of a large, very wet brush. In the middle distance, these strokes gradually become shorter and thinner—applied with the tip of the big brush or with a small brush. Above the midpoint of the picture, individual strokes disappear, and you can no longer see each ripple. Instead, you see long, horizontal drybrush strokes, made with a damp brush that simply skims along the surface of the paper. The broken texture of these strokes suggests the movement of the water and the flickering light on the ripples. Just a few dark ripples are picked out with the point of a very small brush, below the tip of the island. Along the horizon, the flash of light on the water is bare paper, with just a few very pale, horizontal drybrush strokes.

Step 1. The pencil drawing clearly defines the individual masses of foliage and the trunks of the trees to the left and indicates the general shapes of the trees along the horizon. The sky begins as a pale wash of yellow ochre into which pale strokes of cerulean blue are painted.

Step 2. The distant hills, which you can see clearly to the left, are painted with cerulean blue and cadmium red. While this tone is still wet, the trees are brushed in with Hooker's green and burnt sienna, blurring into the color of the hills.

Step 3. The field is covered with a light wash of yellow ochre and Hooker's green, followed by darker strokes of this mixture, some containing a hint of burnt sienna and others containing just a bit of ultramarine blue. Some of these darker strokes go on while the underlying wash is still wet. Others are applied after the surface is dry.

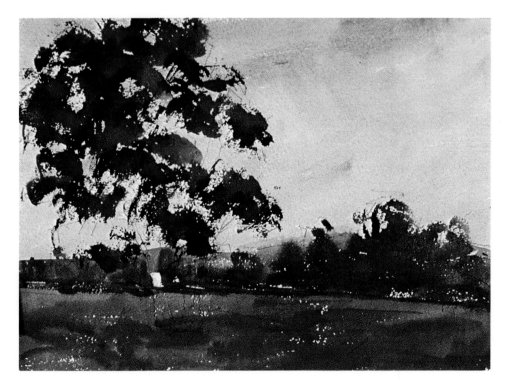

Step 4. The lighter, brighter areas of the foliage are brushed in with broad, short, curving strokes—in various combinations of cadmium yellow, yellow ochre, Hooker's green, and ultramarine blue. While these lighter strokes are still wet, the darks are brushed over and into them, so the darks and lights tend to blur together. The darks are Hooker's green, ultramarine blue, and burnt sienna.

Step 5. So far, everything has been done with big brushes. Now, a small, round brush comes into play. The trunks are painted with a dark mixture of Hooker's green and alizarin crimson. The very tip of the brush is used to paint the branches with the same mixture. At times, the brush skims very lightly over the surface of the paper so that the strokes have a dry-brush feeling.

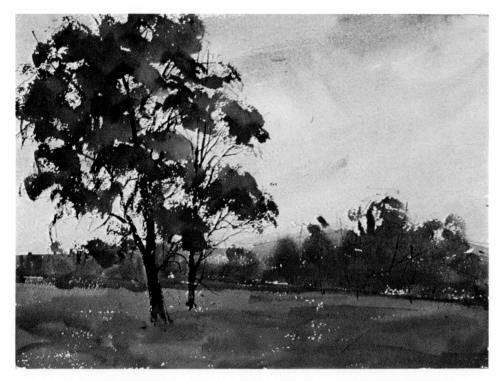

Step 6. More dark notes are added to the tree with a mixture of Hooker's green and burnt umber. The small brush is used again—often held so that the side of the brush leaves irregular patches of color on the paper. The same mixture and the same kind of strokes are used to darken the distant mass of trees, which now have a more distinct feeling of light and shadow. You can see where a few dark trunks have been suggested among the distant trees—and a few light trunks have been scraped out with the tip of the brush handle.

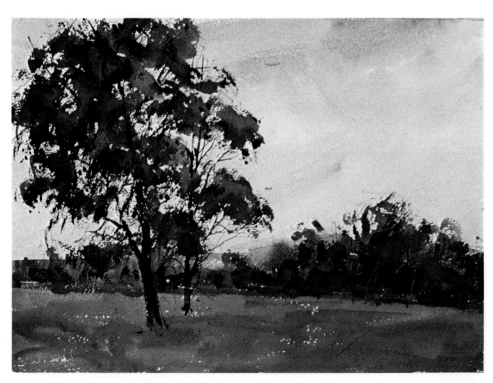

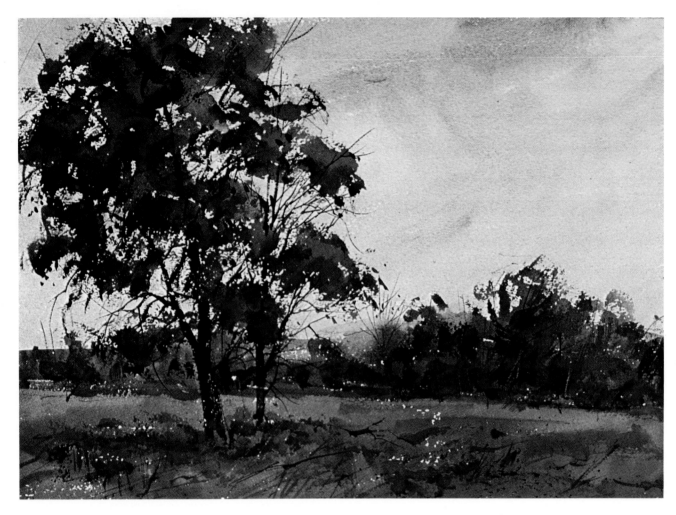

Step 7. The foreground is saved for the very end. A large brush is freely stroked across the field, sometimes depositing wet strokes and sometimes creating drybrush textures. These darks are mixtures of burnt sienna and Hooker's green. A small brush is used to build up small, rough strokes directly beneath the trees, suggesting shadows on the grass. More branches are added with the very tip of the small brush carrying a mixture of alizarin crimson and Hooker's green. A sharp blade scrapes away some flecks of light on the thicker treetrunk. The alizarin crimson and Hooker's green mixture is also used for the slender strokes that pick out individual weeds at the lower edge of the painting. Finally, a small, round brush is dipped in the alizarin crimson-Hooker's green mixture and flicked at the foreground, spattering droplets that you can see most distinctly in the lower right section. The foreground contains just enough texture and detail to suggest an intricate tangle of weeds and grasses—but not so much detail that it becomes distracting.

Step 1. The pencil drawing defines the main masses of the trees, but not too precisely—so there's plenty of freedom for impulsive brushwork later on. The sky begins with a very wet wash of yellow ochre, applied with a big, flat brush, followed by broad strokes of Payne's gray and ultramarine blue while the underlying wash is still wet. Just before the sky loses its shine, the distant trees are painted into the wetness with Hooker's green, Payne's gray, and cerulean blue, applied with a small brush.

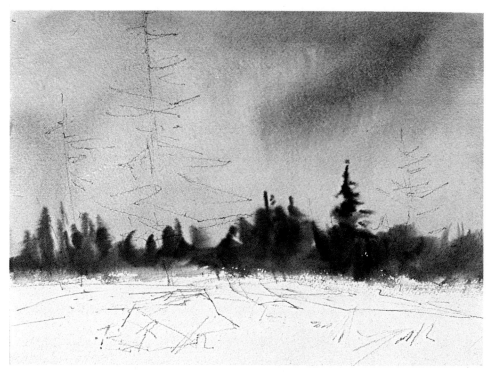

Step 2. When the sky and the distant trees are dry, two more trees are brushed in with a darker mixture of Hooker's green, Payne's gray, and cerulean blue, applied with a small, round brush. These trees strokes have a special character that reflects the way the brush is handled. The wet brush is pressed down hard at the center of the tree and then pulled quickly away to the side. Thus, the stroke is thick and dark at one end, but then tapers down to a thinner, more irregular shape as the brush moves outward.

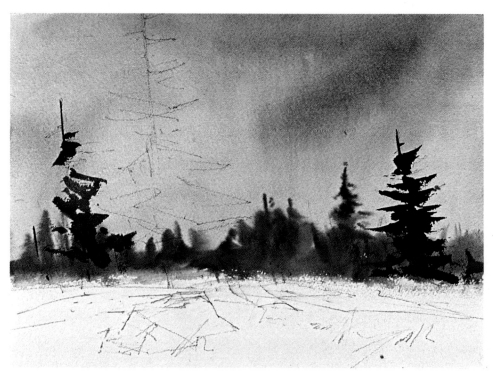

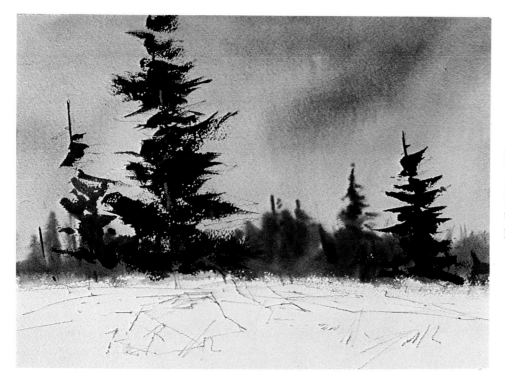

Step 3. The largest tree is now painted with a big, round brush, using the same kind of strokes as in Step 2. The lighter foliage is painted with Hooker's green, ultramarine blue, and burnt umber, then allowed to dry. The darks are painted with the same mixture, but contain more ultramarine blue. While the color is still damp, a blunt knife is used to scrape away some pale lines for the trunk.

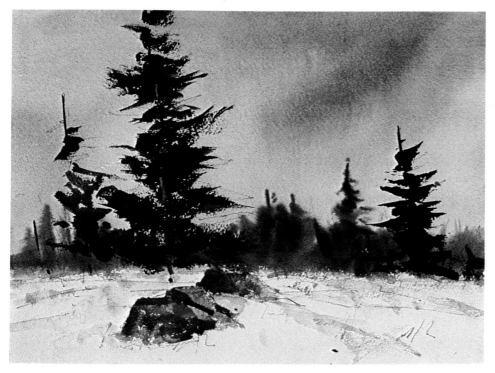

Step 4. The light and shadow planes of the rocks are both painted with Payne's gray and yellow ochre—with less water for the shadows. To suggest a few tones on the snow, a small brush glides quickly over the paper with pale strokes of ultramarine blue and burnt umber. Notice how flecks of paper are allowed to show through the shadows of the rocks, suggesting a rough texture.

Step 5. The dry grass breaking through the snow adds some warm notes to enliven a picture that is generally cool. The tip of a small, round brush is used to add drybrush strokes of cadmium orange, burnt sienna, and burnt umber. The same tone appears in the very slender strokes that suggest a few weeds—and is spattered across the foreground. These very thin strokes are a good opportunity to use the signpainter's brush called a rigger.

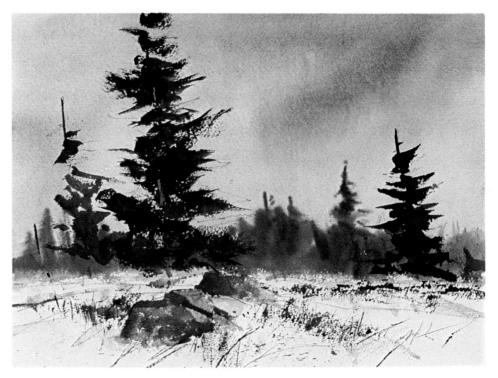

Step 6. The picture needs an additional tree to add "weight" at the center of interest. The tree is added with a dark mixture of Hooker's green, ultramarine blue, and burnt umber—using the same press-and-pull strokes that worked so well for the other trees.

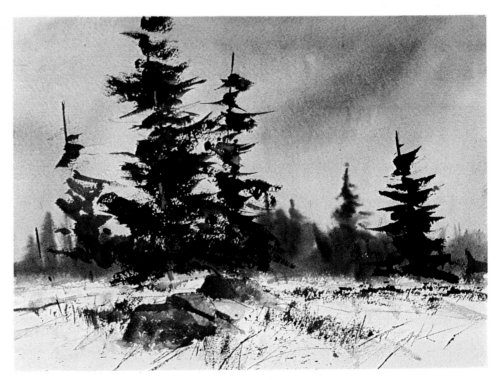

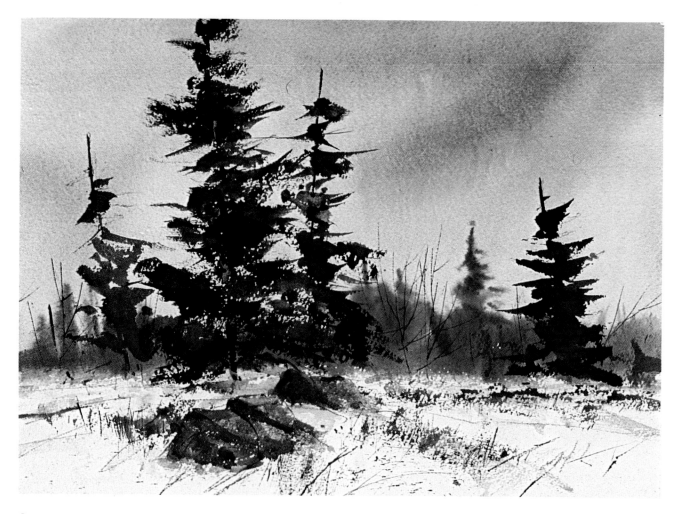

Step 7. Here's where you add those final touches that seem invisible at first glance, but do make a great difference when you look closely. A small, round brush is loaded with a dark mixture of alizarin crimson and Hooker's green. The very tip is used to add darks such as the trunks of the central trees, the cracks and additional touches of shadow on the rocks, and the skeletons of more trees along the horizon. A pale mixture of ultramarine blue and burnt umber is added just under the central tree to suggest a shadow that "anchors" the tree more firmly to the ground. Compare the finished trees and rocks with those in Step 6 and you'll see how much the picture gains by these slight touches. The big central tree is placed more firmly on the ground by its dark trunk and shadow. A few cracks and additional darks make the rocks much more solid and realistic.

Step 1. A meadow contains so much tangled detail that it's really impossible to do a very precise pencil drawing. So all you can do is indicate a few masses of light and dark, plus a few big. weeds or branches and the shapes along the horizon. The slender band of sky is painted with overlapping strokes of yellow ochre and ultramarine blue, using a large, round brush.

Step 2. When the sky is dry, the darker tone of the distant hill is painted with a small, round brush loaded with cerulean blue and cadmium red. The lower edge of this band of color is softened and blurred with a stroke of clear water, applied while the color is still wet.

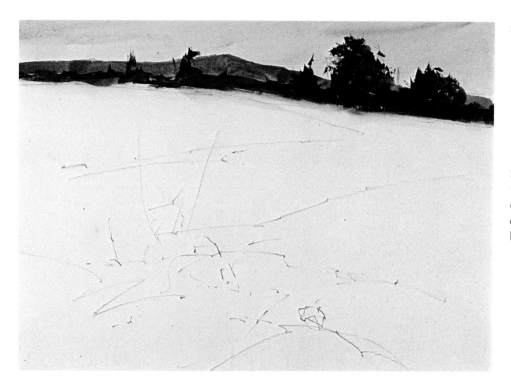

Step 3. When the hill is dry, the shapes of the distant trees are brushed over it with a small brush and a mixture of Hooker's green, burnt sienna, and cerulean blue. The strokes are quick, short, and sometimes applied with the side of the brush, giving a rough, irregular character to the trees. Once again, some of the lower edges are softened and blurred with a brushload of clear water.

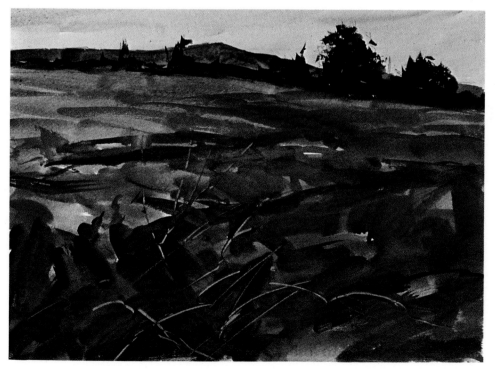

Step 4. Working with a big, round brush once again, the entire meadow is painted with casual, sweeping strokes that follow the curve of the landscape. The strokes are various mixtures of cadmium yellow, yellow ochre, Hooker's green, burnt sienna, and burnt umber—never more than three colors mixed for any one stroke. The lighter tones are added first and allowed to dry, then darker strokes are added in the foreground and allowed to blur into one another. Weeds are suggested by scratches of the brush handle or a fingernail.

Step 5. The color of the meadow needs to be strengthened. So the same mixtures are used to build up the darks of the foreground and also to darken the distant meadow, particularly in the upper left section. Do you remember how the dark bases of the trees in the upper right section were blurred with clear water? Now these trees seem to emerge softly from the meadow, growing out of their own shadows on the grass.

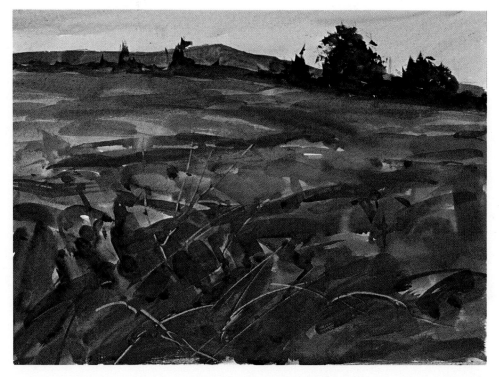

Step 6. The time has come to add some detail—very selectively. A dark mixture of alizarin crimson and Hooker's green is picked up by a small, round brush. The tip of the brush skates rapidly over the surface of the paper, suggesting twigs and blades of grass intertwined with the pale scratches made in Step 4. These details are concentrated in the foreground, not scattered over the entire field. A mixture of cadmium yellow and burnt umber is spattered among the twigs to suggest some wildflowers.

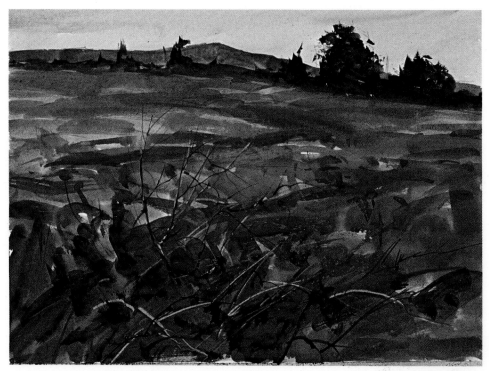

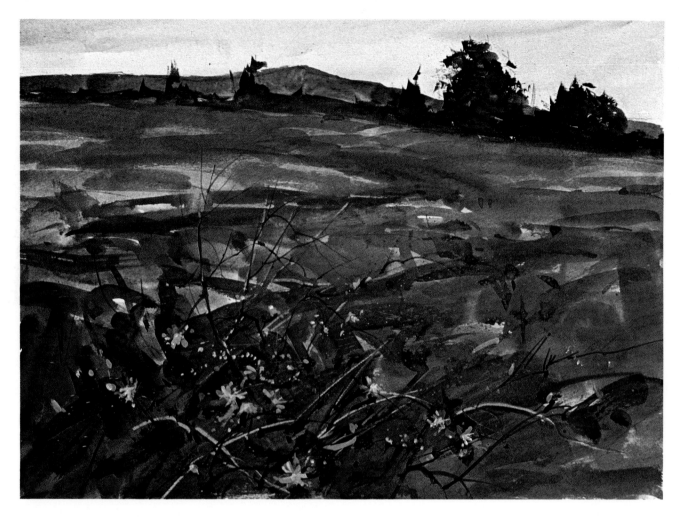

Step 7. The cluster of wildflowers is saved for the final stage. A new technique is introduced here. Because watercolor is transparent, you can't really paint pale flowers over a dark background. So this is one of those rare moments when you really need some *opaque* color. All you need is a tube of white acrylic color or a tube of Chinese white, as it's called. Mix a touch of this opaque white with your regular watercolors—preferably in a saucer or on some mixing surface that you keep away from your watercolor palette. The white will give your color just enough opacity to show up against the dark background. These flowers are mixtures of cadmium yellow, cadmium red, and alizarin crimson, with just a little opaque white. The paler strokes and the centers of the flowers obviously contain more white than the darker strokes. Only a few flowers are painted in detail. But more flowers are suggested by mere specks of color applied with the very tip of the brush. This is one of the most important lessons of landscape painting: if you have a certain amount of detail in the foreground, the viewer will imagine that the whole picture contains a lot more detail than he actually sees.

Step 1. The mountains have squarish, blocky shapes, perfect for painting with a big, flat brush. So the pencil drawing defines these shapes very clearly. The pencil lines also indicate the spiky shapes of the trees at the base of the mountains. The sky is first painted with a very pale wash of yellow ochre and cerulean blue. When this is dry, slightly darker strokes of this mixture, plus cadmium yellow, are painted over the pale background.

Step 2. The underlying pale tone of the mountains is blocked in with the broad strokes of a big, flat brush loaded with mixtures of yellow ochre, burnt sienna, and ultramarine blue. When this underlying tone is dry, the same brush is used to add darker strokes to the same mixture containing more ultramarine blue and burnt sienna. These strokes are allowed to dry and then still darker strokes are laid over them so that there is a gradual buildup of strokes from light to dark.

Step 3. A small, round brush works with quick, short, choppy strokes to paint the irregular line of trees at the base of the mountain. These strokes are a mixture of Hooker's green and burnt umber; there's no attempt to follow the original pencil drawing too precisely. Before this color dries, the lower edge is blurred by a stroke of pure water.

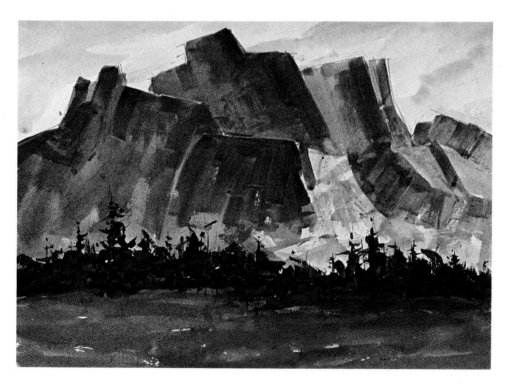

Step 4. The grass in the foreground is painted with horizontal strokes of mixtures of Hooker's green, burnt sienna, and cadmium orange. The strokes are brushed in very quickly and the surface is kept very wet, so one stroke fuses with another. Notice how the brushstrokes follow the forms in the painting. The mountains are straight, diagonal or near-vertical strokes. The foreground is painted with horizontal strokes, and the trees combine short horizontal and vertical strokes.

Step 5. The color of the mountains needs to be integrated more effectively with the rest of the picture; thus a cooler tone of cerulean blue and burnt sienna is brushed over them, darkening the bases of the mountains where they meet the row of trees. Now most of the mountains are clearly in shadow, dramatizing the sunstruck patch just to the right of center.

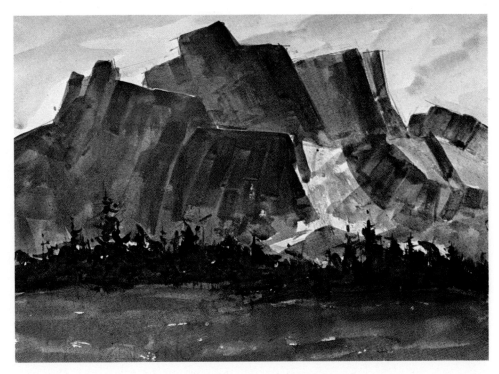

Step 6. Detail and texture are added to the foreground with a small, round brush. Quick, slender strokes are added with a mixture of burnt sienna and Hooker's green. The same mixture is spattered across the foreground. You now have the feeling that there are weeds and tufts of grass in the meadow.

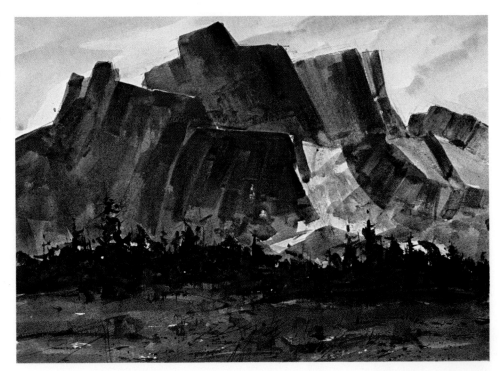

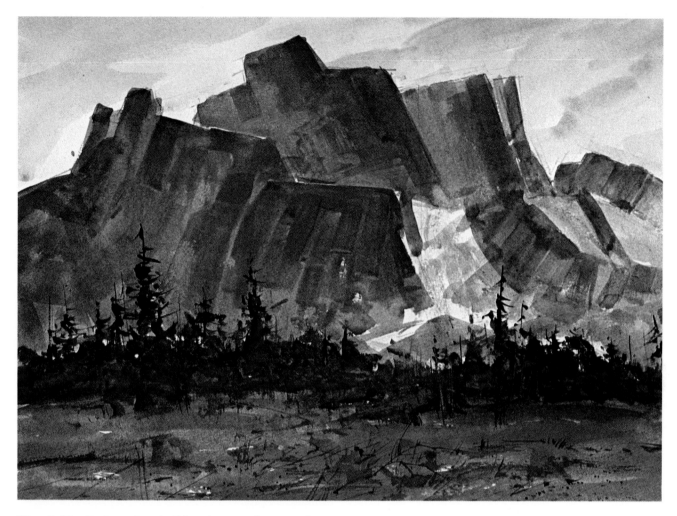

Step 7. The final step is to build up the row of trees so they seem closer, loftier, and more distinct. A dark mixture of Hooker's green and burnt umber is applied with the tip of a small brush, working in short vertical and horizontal strokes. These are the press-and-pull strokes used to paint the evergreens in an earlier demonstration. Some strokes are darker and some are lighter, creating the impression of lights and shadows among the trees. Because you now see the trees more clearly, they're closer to the foreground; by contrast, the mountains seem more distant. The picture gains a much deeper sense of space.

Step 1. The pencil drawing traces the shapes of the hilltops very carefully; defines the curves within the hills and the lines of the shore; but simply suggests the trees, leaving room for free brushwork later on. The sky begins with a pale wash of yellow ochre, followed by strokes of Payne's gray, wet-in-wet. The distant hills are painted with Hooker's green, cerulean blue, and Payne's gray.

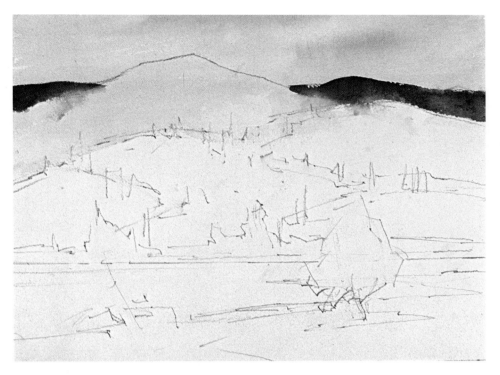

Step 2. The big shape of the hills is covered with a wash of Hooker's green, yellow ochre, and ultramarine blue. While the underlying color is still damp, darker strokes are added to suggest trees. These strokes are a mixture of Hooker's green, burnt sienna, and ultramarine blue, blurring slightly with the damp undertone. When the entire area is dry, more trees are suggested with this dark mixture.

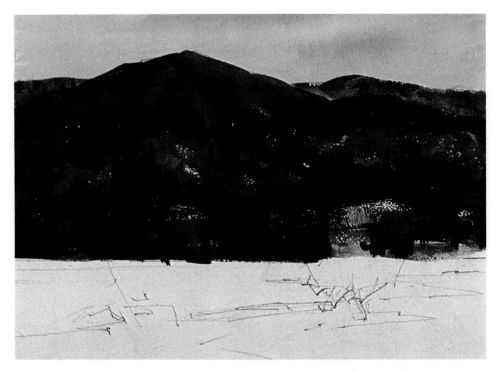

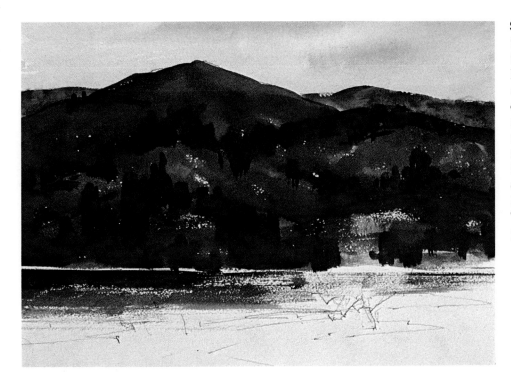

Step 3. To indicate the reflections in the water, a small, flat brush is loaded with Hooker's green, burnt umber, and ultramarine blue, then drawn across the paper with steady horizontal strokes. At the left, the color is heavy and fluid. At the right, the brush is merely damp, producing a drybrush effect that suggests light shining on the water. The light patches are bare paper.

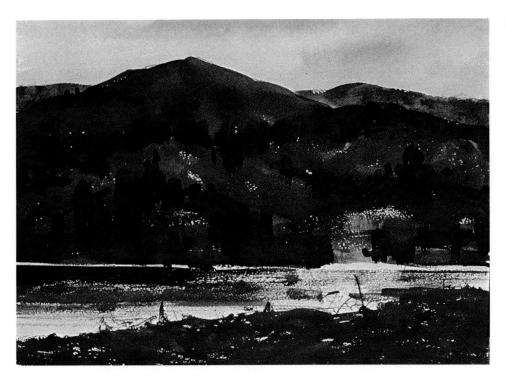

Step 4. The foreground is painted with mixtures of cadmium yellow, Hooker's green, and cadmium orange. The strokes are applied quickly, overlapping one another and flowing together. Here and there, you see touches of almost pure cadmium orange, which add some necessary warm notes to a cool picture.

Step 5. When the foreground color is dry, the tree and bushes are brushed in with a mixture of Hooker's green, burnt umber, and burnt sienna. The color is quite thick, containing just enough water to make it fluid, and the side of a small, round brush is used to create ragged, irregular strokes. A slightly paler version of this mixture—with more water—becomes the shadow under the tree.

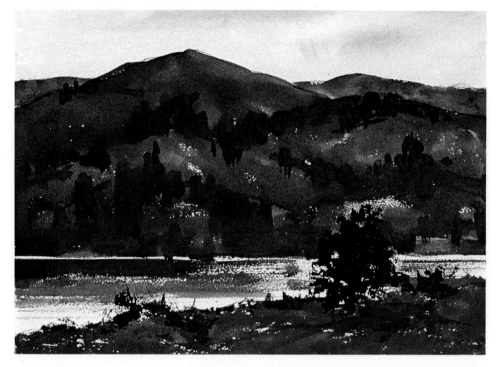

Step 6. The dark trees on the distant hill become slightly more distinct as a small, round brush adds strokes of burnt umber and Hooker's green. Some of these strokes are broad and chunky, suggesting the overall shape of a tree. Other strokes are vertical and slender, suggesting treetrunks. If you look closely, you're not really sure that you see any specific trees, but these additional dark strokes *suggest* enough to give you the feeling that the trees are really there. This same mixture is used to darken the reflection in the left side of the water.

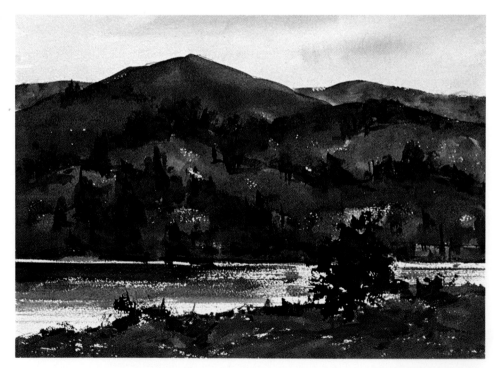

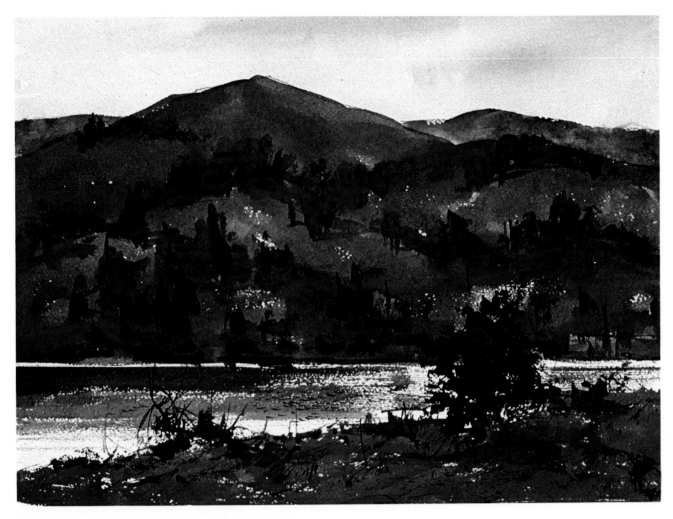

Step 7. Those last vital details are added to the grass and trees in the foreground. A small, round brush carries a mixture of alizarin crimson, Hooker's green, and burnt sienna. The tip of the brush adds a trunk and some branches to the large tree, some tangled branches to the bush in the lower left, and some slender lines to suggest twigs and weeds. You can also see more detail added to the water. A mixture of Hooker's green and burnt sienna is used to add some very tiny ripples in the water at the very center of the picture. You can also see additional drybrush work in the dark reflection under the hill at the left. The ripples don't cover the entire strip of water. There are just enough ripples to give you the feeling that the water is moving.

Step 1. Your pencil drawing can't possibly indicate every wave and ripple in the surface of the lake, so all you can do is draw a few lines to separate the dark areas from the light ones. And a few pencil lines can define the shapes along the shoreline. This sky starts with a wash of yellow ochre, which is allowed to dry. This is followed by some strokes of cerulean blue, modified by a hint of yellow ochre.

Step 2. The distant hills are painted with a wash of yellow ochre, Payne's gray, and cerulean blue. While the wash is still wet, it's blotted with a paper towel, which lightens the tone and fades it out in the right-hand side. Thus, the distant shore seems farther away and has a more atmospheric quality.

Step 3. As you can see, the whole idea is to work from top to bottom and from distance to middle distance to foreground. Now the tree-covered island is painted with strokes of Hooker's green and burnt umber. The strokes are short and rough, some darker and some lighter, some containing more Hooker's green and others containing more burnt umber. The color does not contain too much water, so the brush is damp, rather than wet, giving a ragged drybrush character to the strokes.

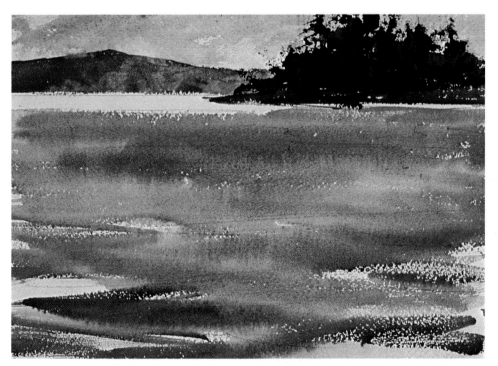

Step 4. The water is painted with a very wet wash that mingles yellow ochre, cerulean blue, ultramarine blue, and Hooker's green, all applied with a big, round brush. A pale wash of yellow ochre and cerulean blue goes onto the paper first, followed by darker mixtures that quickly spread and blur. In the foreground, you can see that the color isn't quite as fluid and the brush isn't nearly as wet, so the strokes at the very bottom of the picture are drybrush. The paint really looks wet—just like the water.

Step 5. When the colors of the water are dry, a small brush goes to work on the dark reflections under the island. These dark, horizontal drybrush strokes are a mixture of ultramarine blue, Hooker's green, and burnt umber. A few ripples and horizontal lines are drawn into the water with the tip of the brush. The dark patch in the upper left section is the same mixture, but with more water. Notice how the drybrush strokes in this section create the feeling that light is flashing on the ripples.

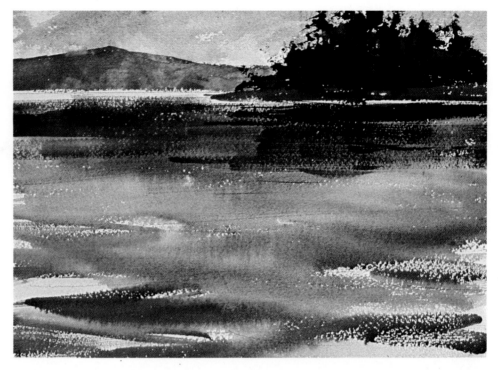

Step 6. Working downward, a small, round brush adds short, choppy, slightly curved strokes to suggest ripples. The strokes vary in length and thickness; thus they're never monotonous. The mixture is Hooker's green and ultramarine blue.

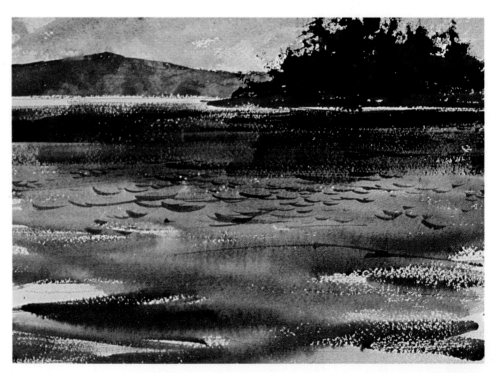

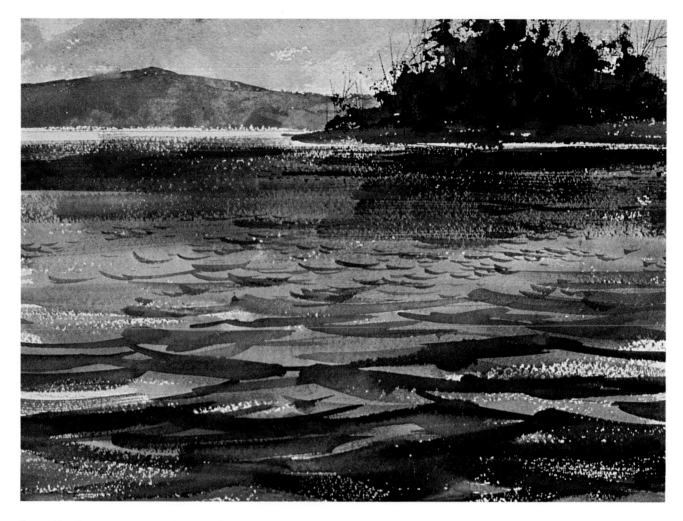

Step 7. The brushstrokes for the ripples grow longer, thicker, and darker as they approach the immediate foreground. The blend of Hooker's green and ultramarine blue is darkened by burnt umber. The smaller strokes are done with a small, round brush. Now the bigger strokes are executed by a large brush. Specks of white paper continue to peek through like sparkles of light on the water. Finally, a few branches and other details are added to the island with a mixture of burnt umber and Hooker's green.

Step 1. This painting contains so many elements that the composition is fairly complex and needs a careful pencil drawing to determine where everything goes. Thus, pencil lines locate the rocks, the fallen treetrunks, and the curving patterns of the water. The sky is a wash of yellow ochre, followed by strokes of cerulean blue applied while the underlying color is still wet.

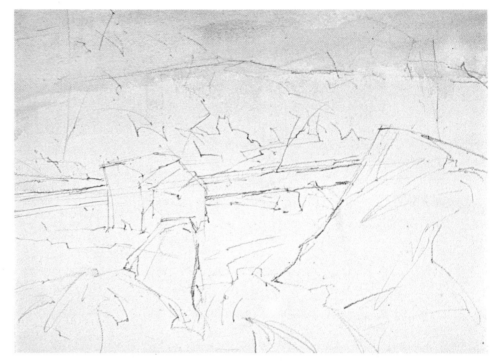

Step 2. The mountain along the horizon is a wash of ultramarine blue, alizarin crimson, and yellow ochre. As you can see, the wash isn't absolutely smooth. At some points, there's more alizarin crimson, while there are other places where you can see more yellow ochre or more ultramarine blue. The lower edge of the wash is lightened and is slightly blurred by strokes of clear water.

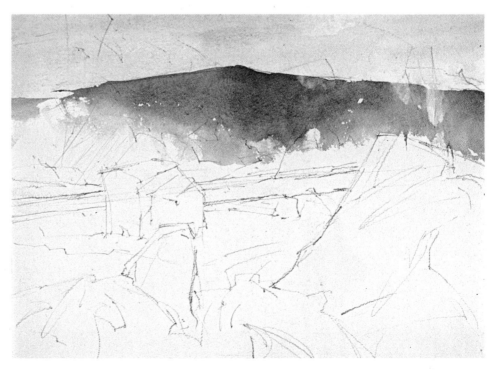

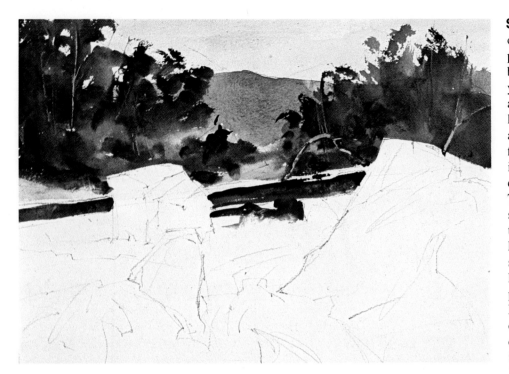

Step 3. Over the dried wash of the hills, the trees are painted with various combinations of cadmium yellow, yellow ochre, burnt umber, and Hooker's green. The lighter strokes, mainly yellow and green mixtures, go in first. Then, while the underlying strokes are still wet, the darker strokes go over them. Thus, the light and dark strokes tend to fuse. While the darks are still wet, some light trunks and branches are scraped out with a blunt knife. The dark treetrunk is painted with a blend of Hooker's green and alizarin crimson, and a bright patch of cadmium red is added while the dark tone is still wet.

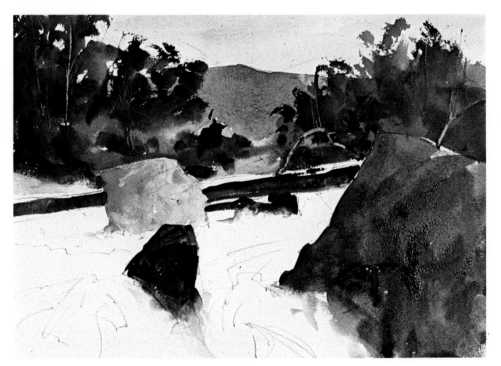

Step 4. The sunny rock is painted with fluid strokes of pure yellow ochre, blotted with a paper towel on the lighter side. The darker rocks are painted with ultramarine blue, burnt umber, and cerulean blue. Pale strokes come first, and then the dark ones are painted in while the underlying color is still wet. The lower edges of the rocks are blurred with clear water so that the solid forms seem to melt away into the running stream.

Step 5. Shadows of burnt sienna and cerulean blue are added to the sunlit rock. Then the shadows on the other rocks are deepened with ultramarine blue and burnt umber. This same mixture is used to add shadows to the distant trees with short, scrubby strokes. And the tip of a small brush adds some branches. You can also see some spatters of this mixture on the rock in the lower right.

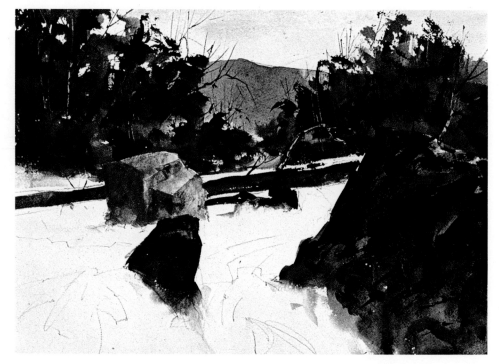

Step 6. Until now, the water area has been left as bare paper. Now the immediate foreground is covered with a very pale wash of yellow ochre, Hooker's green, and cerulean blue. While this area is still wet, the brush goes back in with dark strokes of Hooker's green and burnt umber that fuse with the underlying color, wet-in-wet. A paler version of this same mixture indicates the shadow under the fallen treetrunk. The central strip of water is still bare white paper.

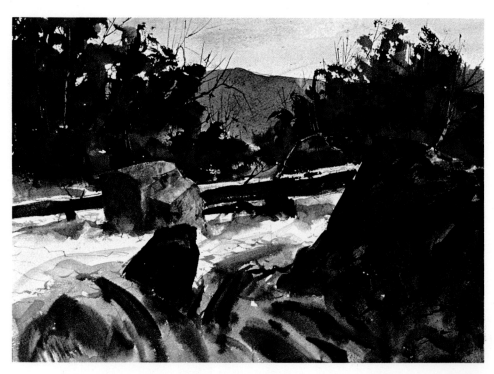

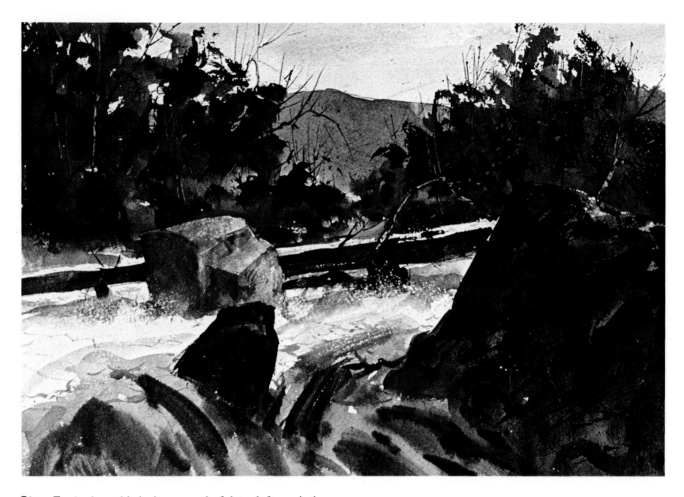

Step 7. A sharp blade is a wonderful tool for painting foam. Now the *edge* of a sharp knife or razor blade—not the tip—is lightly stroked across the area beneath the fallen trunk. The blade catches the high points of the paper and scrapes away just enough color to reveal tiny flecks of bare paper that look amazingly like foam. The knife also scrapes away a patch of light in the shadow side of the sunlit rock, so the shadow seems to contain some light reflected from the surface of the water. To enliven the trees to the right—and suggest some leaves caught in sunlight—a small, round brush spatters droplets of cadmium yellow. You can also see some small, pale strokes that suggest a few ripples in the water—a mixture of burnt umber, ultramarine blue, and a lot of water.

Step 1. A snow-covered field—which is, after all, simply water in another form—is just as difficult to draw as a lake. The best you can do is to draw the curves of the snowdrifts, the banks of the icy stream, the line of the horizon, and the shapes of the treetrunks. The sky begins as a pale wash of ultramarine blue and burnt sienna, followed by darker strokes of ultramarine blue and burnt umber, applied while the underlying color is still wet. While the sky is still damp, the distant trees are quickly put in with short strokes of burnt umber and Hooker's green.

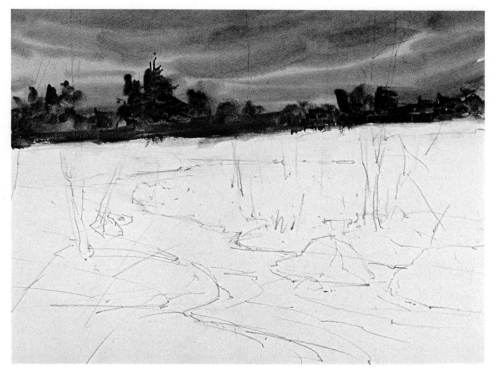

Step 2. The shadows on the snowbanks and the patches of tone on the snow are brushed in with a very pale mixture of cerulean blue and burnt sienna, and the shadows grow darker in the foreground area. Bare paper is left for the lightest areas.

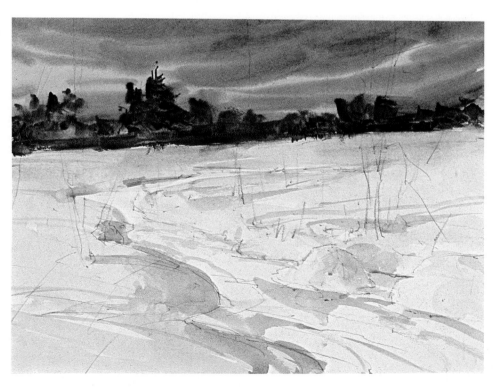

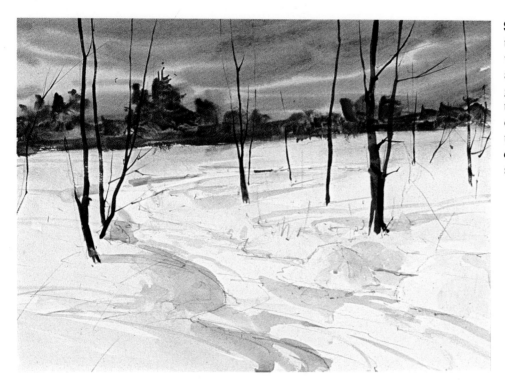

Step 3. The thickest, darkest treetrunks are added with very fluid strokes, a blend of alizarin crimson and Hooker's green. Look closely at the trunks—particularly the one on your right—and you'll see that the mixture is sometimes dominated by the green and sometimes by the red.

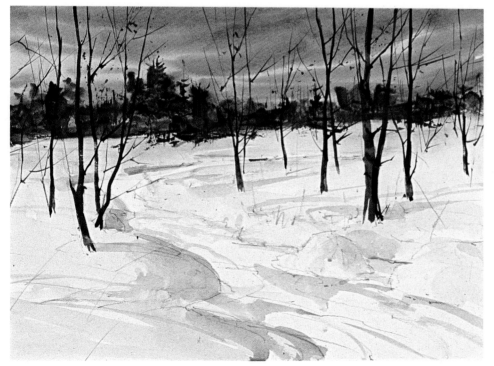

Step 4. More trees are added with the tip of a small, round brush carrying a mixture of Hooker's green and burnt umber. In the sky, you can see a light spatter of cadmium red, alizarin crimson, and Hooker's green, flicked on with the same brush. These dark droplets give you the idea that some dead leaves are still hanging from the slender branches. The distant trees are darkened with strokes of Hooker's green and burnt umber.

Step 5. The icy water, which reflects the dark tones of the sky and the surrounding trees, is now painted with curving strokes that wind from the foreground through the middle distance and back toward the horizon. The pale strokes come first; they are mixtures of Hooker's green and burnt sienna or Hooker's green and burnt umber. Then come the darker strokes, which are Hooker's green and alizarin crimson or cerulean blue and burnt umber.

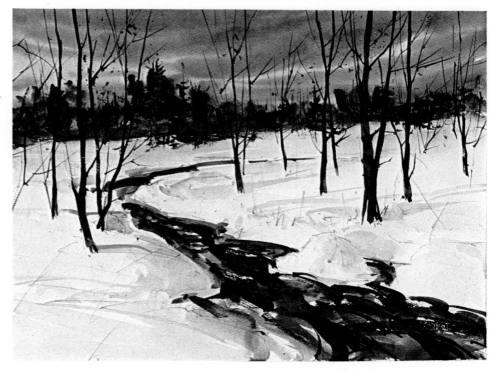

Step 6. Warmer touches are added along the banks, suggesting rocks. These are mixtures of burnt umber and cerulean blue. Touches of burnt sienna and cerulean blue are added among the treetrunks to suggest patches of dried weeds. The same mixtures are used for the thin strokes that render the stalks sticking up through the snow.

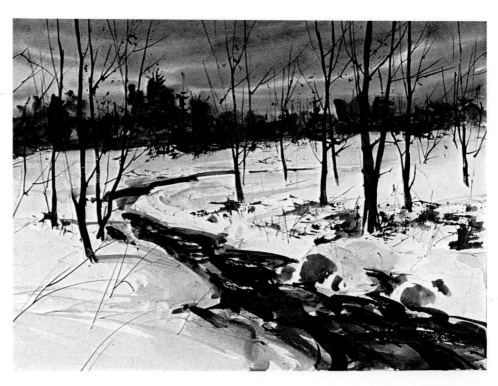

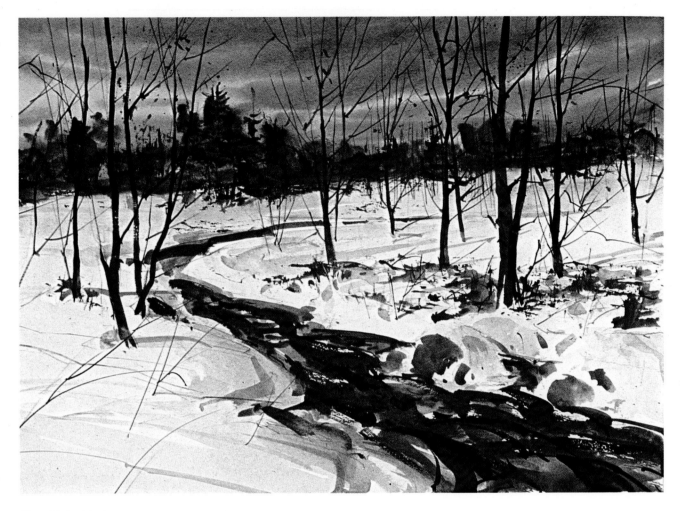

Step 7. In this final stage, the curves of the snowbanks—to the left of the frozen stream—are accentuated with curving strokes of cerulean blue and burnt sienna. This same mixture is used to add more touches of shadow beneath the trees on the right side of the stream. A few more touches of warm color—cadmium orange—enrich the dry grass among the trees. More darks and more branches are added to the tree-trunks with a mixture of alizarin crimson and Hooker's green. This snowy landscape shows how brushstrokes can mold the forms of the land. You've already seen how the direction of the strokes follows the frozen stream from the foreground into the distance. And you've noticed how the curving strokes in the foreground establish the rounded shapes of the snowbanks. But look carefully at the delicate streaks of shadow cast by the trees. These inconspicuous lines remind you that the snow isn't always flat, but some-times has a slightly diagonal pitch, which you can see in the middle of the picture, and sometimes has a distinct roll, which you can see in the lower left section. These shadows function as *contour lines*, generally leading the eye over the curves and angles of the landscape.

Step 1. It's usually best to begin a sunny sky by painting in the blue patches between the clouds. The big blue shape in the upper left section comes first—a mixture of ultramarine blue, cerulean blue, and a little yellow ochre, touched with clear water to blur a few edges. The right side of the sky is brushed with clear water. Then more strokes of the same mixture are carried from left to right above the horizon, blurring as they strike the wet paper. The strip of blue at the horizon is also painted on wet paper, which produces very soft edges.

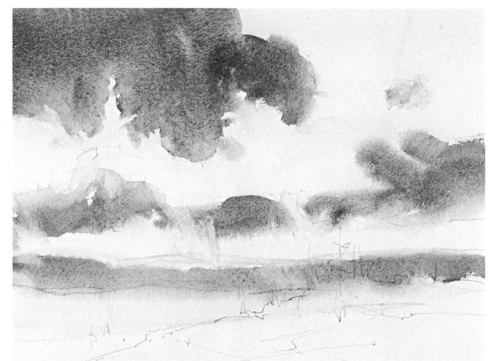

Step 2. When the blue areas are dry, the shadow sides of the clouds are brushed in with a pale wash of Payne's gray and yellow ochre. Once again, a brush carrying clear water is used to blur the edges of some of these strokes so that the shadows seem to melt away into the lighted areas of the clouds.

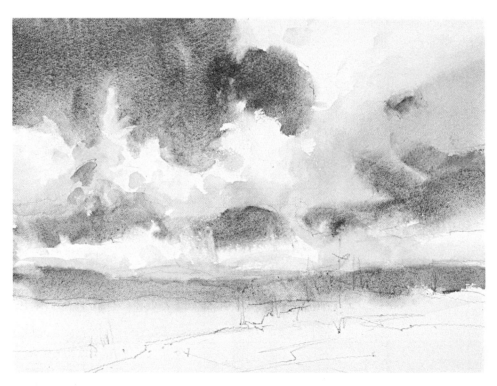

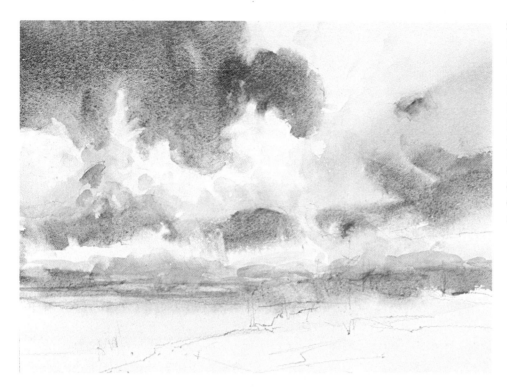

Step 3. When the shadows of the clouds are dry, more edges seem to need softening. A small bristle brush is loaded with water and used to scrub away color at various places where the edges of the clouds meet the edges of the blue sky. Then more strokes of Payne's gray and yellow ochre are added to suggest darker clouds along the horizon.

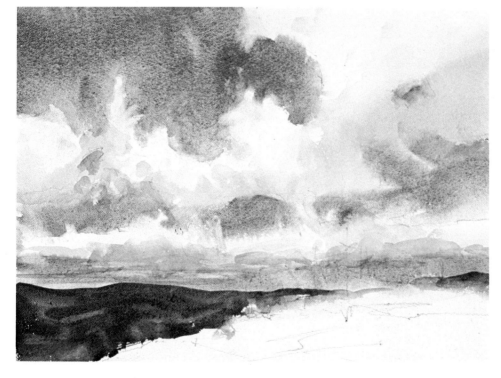

Step 4. When the sky tones are completely dry, the distant hills are painted with mixtures of ultramarine blue, cerulean blue, and burnt umber—with more burnt umber in the darker patches. Notice how strokes of clear water are used to soften some of the edges of the hills where they blend into the unpainted patch of foreground to the right.

Step 5. The hills are allowed to dry, and then the trees are painted with Hooker's green and burnt sienna, warmed here and there with a bit of cadmium red or cadmium orange. The lower masses of the trees are painted with broad strokes, while the upper trunks and branches are mere touches of the tip of the brush.

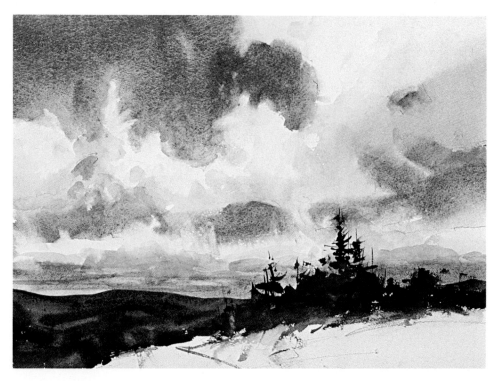

Step 6. The land in the foreground is painted with an irregular wash of Hooker's green, cadmium orange, and cadmium yellow. You can see that some areas contain more orange and some areas contain more green. A good deal of water is added in the lower right section; thus the wash becomes pale and suggests sunlight falling on the grass.

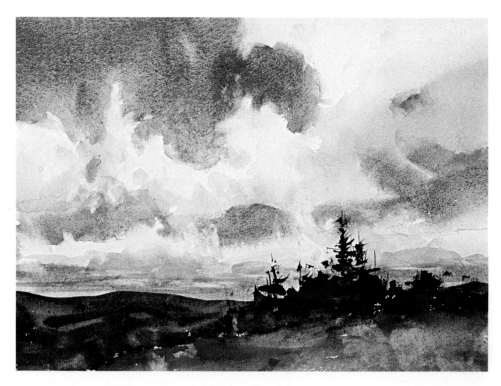

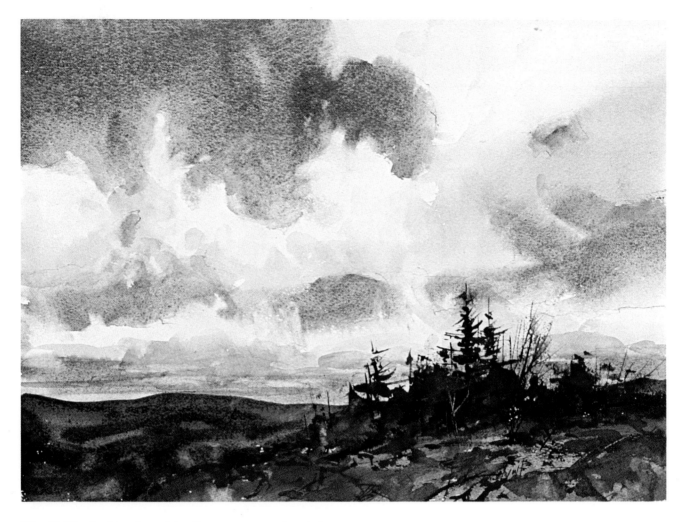

Step 7. The final touches of detail are concentrated entirely in the trees and grass in the immediate foreground. A dark blend of Hooker's green and burnt umber is used to add more detail to the trees—more trunks and branches and touches of shadow. You can see where a sharp blade is used to scratch out a light trunk beneath the tallest tree. The side of a small brush, loaded with Hooker's green and burnt sienna, is casually dragged across the grass to create darker patches. Then the tip of the brush picks up a darker mixture of Hooker's green and burnt sienna to trace some warm, ragged lines over the landscape. You don't actually see grasses, weeds, or twigs, but these strokes make you *believe* that you see them.

Step 1. Like most skies, a sunset is difficult to draw in pencil. Therefore, it's best to draw just the shapes of the landscape: the large tree to the right, the smaller trees along the horizon, and the lines of the stream. A large, flat brush is used to wet the entire sky with clear water. Then mixtures of yellow ochre, cadmium orange, burnt sienna, and cerulean blue are brushed onto the surface in long, slow strokes. The lights and darks and the warm and cool tones mingle, wet-in-wet. The sky is painted with the drawing board tilted slightly upward at the back so that the colors tend to run down.

Step 2. When the sky is dry, the background trees are painted with mixtures of cadmium orange, burnt sienna, and Hooker's green. The warmer strokes are painted first and are dominated by burnt sienna. The darks contain more Hooker's green and are painted over the wet tones of the brighter colors. The ragged strokes against the sky are made by jabbing the brush against the paper, then pulling away.

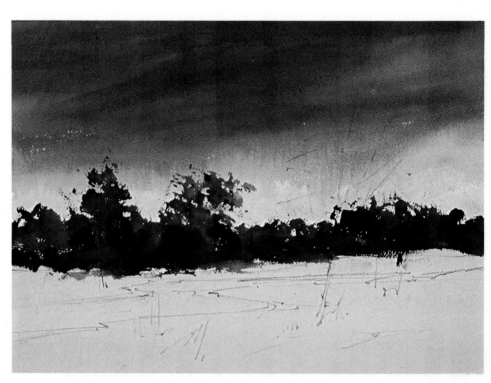

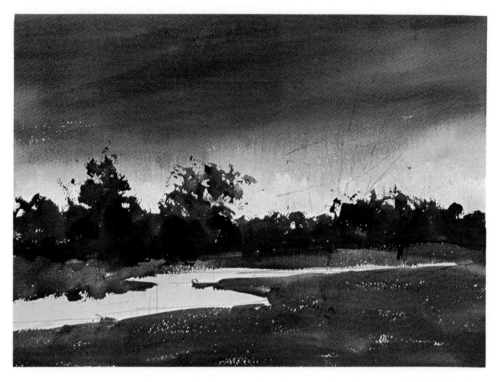

Step 3. The shapes of the land on either side of the stream are painted with mixtures of burnt sienna, Hooker's green, and cerulean blue. The immediate foreground contains more Hooker's green.

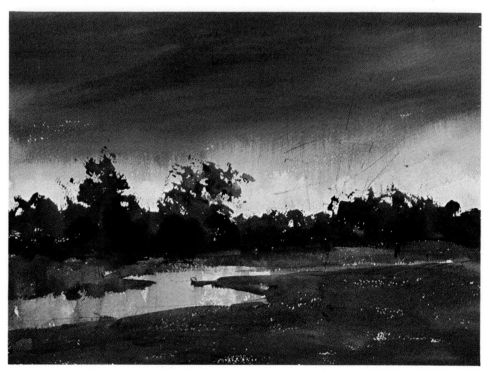

Step 4. Now the water is painted with a pale mixture of burnt sienna and cerulean blue. Notice that the strokes in the water are vertical, leaving gaps of bare paper, creating a sense of reflected darks and lights. The tone of the water is carried down over the shore to darken the left foreground.

Step 5. So far, the landscape is covered with generally warm tones—too warm to make a satisfying picture. The painting needs some strong, cool notes. The dark trees to the right are painted with short, rough strokes in a mixture of Hooker's green and burnt umber. The very ragged strokes against the sky are made by pressing the brush against the paper, pulling slightly to one side, and then pulling away. The lower tree is simply a dark, liquid mass that spreads at the bottom to suggest that it's sitting on its own shadow.

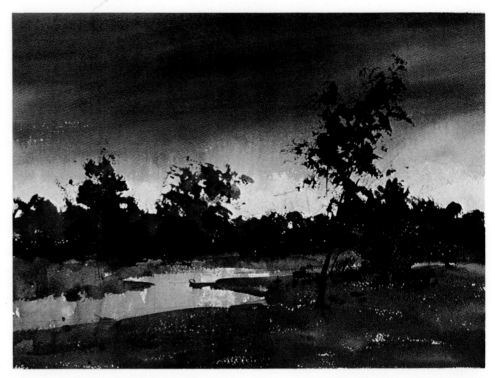

Step 6. The same mixture of burnt umber and Hooker's green is carried across the foreground with rough, irregular strokes, often made with the side of the brush. The underlying tones are allowed to break through here and there. Darker touches are added with the tip of the brush. Along the lower edge, to the right, you can see where droplets of dark color have been spattered into the wet wash. More of these darks are added to the distant trees with drybrush strokes.

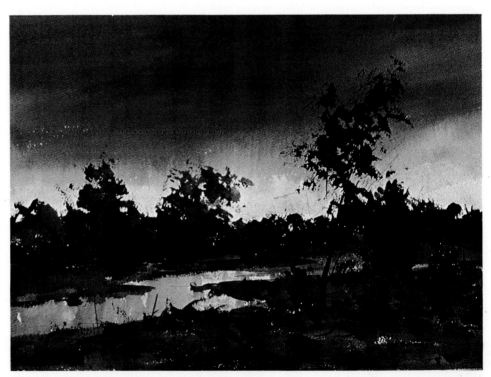

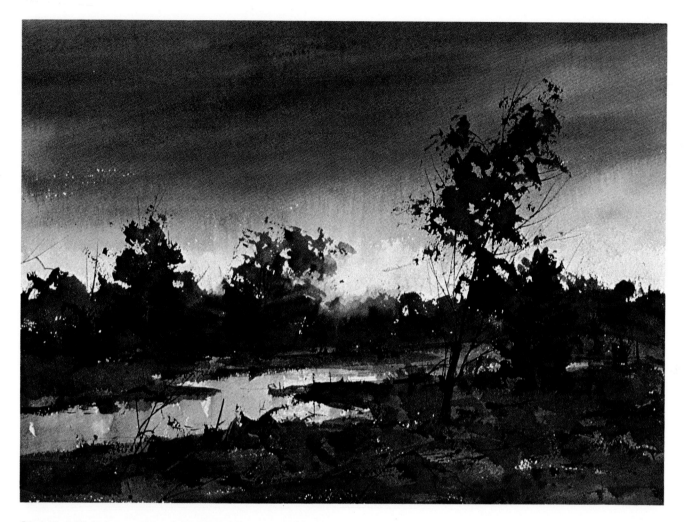

Step 7. Still darker strokes of the Hooker's green and burnt umber mixture are carried across the foreground with the tip of a small, round brush. More branches are added to the large tree, to the trees in the distance, and along the near shore. To suggest the glare of the sun going down behind the trees at the midpoint of the distant shore, a wet bristle brush is used to scrub out and soften the edges of the trees. When the color is loosened by the wet bristle brush, a paper towel is used to blot the area. The whole secret in painting a convincing sunset is *not* to overdo the hot colors. If you squint at the finished painting, you'll see that most of the colors are surprisingly dark and subdued. The whole lower half of the sky is extremely pale—just a hint of color to subdue the white paper. The only hot colors are in the upper sky, and even these bright streaks are intertwined with darker, cooler streaks. The sky looks bright precisely because it's surrounded by restrained colors.

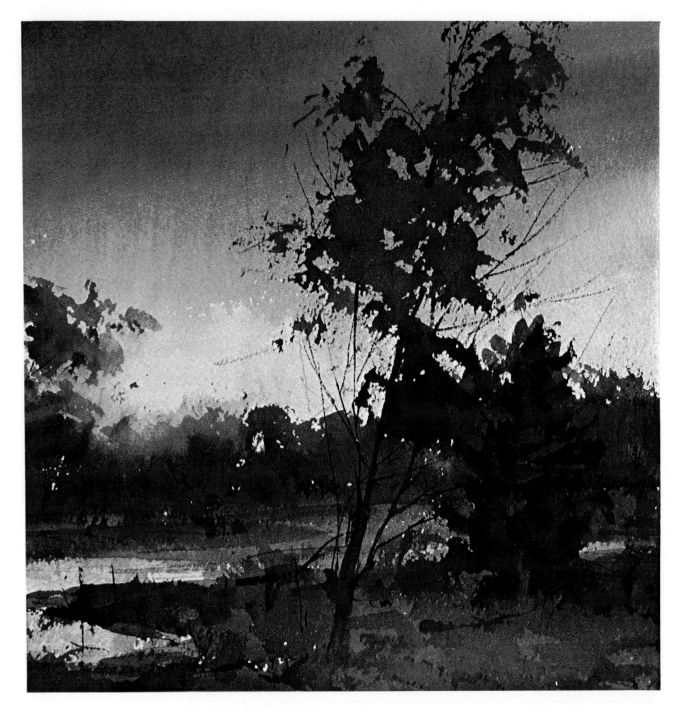

Step 7 (close-up). In this section of the finished painting, you can see the brushwork "life-size." The foliage against the sky is simply a series of flat silhouettes—patches of color without any detail. On the far shore, beside the tree at the left, it's easy to see where the tops of the lower trees have been scrubbed away to suggest the glare of the setting sun. In the sky above, the various stripes of wet color—which were brushed onto wet paper—fuse softly together.

Be Decisive. Beginning landscape painters often spend hours wandering about trying to discover the "perfect" landscape subject. By the time they find it— if they ever do—they're exhausted, and the painting day is half over. Given just so much time and energy, you'll produce a far better painting if you invest that time and energy in painting the first reasonably promising subject, even if it's not "perfect." In reality, nature almost never gives you a "perfect" picture anyhow. The professional painter knows this and always settles for an "imperfect" subject, which he transforms into a picture by moving around the trees, leaving out the smaller clouds, and adding some rocks that aren't even in the picture. So don't waste more than ten or fifteen minutes looking for your subject. As soon as you see something that *might* make a good picture, go to work.

Find Your Focal Point. Often, the simplest way to select a subject is to find some particular landscape element that appeals to you. It may just be an old tree, a few jagged rocks, a winding stream, or a hill against the sky. This motif isn't a picture in itself, but simply your center of interest, around which you *build* a picture. Once you've got your focal point or your center of interest, then you can orchestrate your picture around it. It's like writing a play around some famous performer. Now that you've got your star, you're ready to bring in the supporting cast. That old tree is probably surrounded by other trees, plus some grass, weeds, or rocks. You can now assemble a certain number of these around your center of interest to create a satisfying picture. In the same way, the dramatic shape of that hill against the sky isn't a picture in itself, but becomes the focal point of a picture when you include some surrounding hills, some trees in the foreground, and some sky above. Selecting the center of interest is just the *beginning*—but it's a good way to get started.

Contrast or Conflict. Another way to discover a subject is not to look for a single motif such as a tree or a hill, but to find some contrast or conflict within the landscape. You may just be intrigued by the contrast of dark trees against the white snow of a winter landscape; the clumsy, blocky forms of a rock formation amid the slender, graceful forms of weeds and wildflowers in a meadow; the long, low lines of the plains contrasting with the round, billowing forms of the clouds above. Of course, having found your subject, you still have to decide on your center of interest, so your painting has some focal point. Which are the

biggest trees, rocks, or clouds—or the ones with the most *interesting shapes*. If you can't *find* a center of interest ready-made, you'll have to *create* one by making it bigger or by exaggerating its odd shape.

Watch the Light. From dawn to dusk, the sun keeps moving, which means that the direction of the light keeps changing. At one moment, a subject may seem hopelessly dull. But an hour later, the light's coming from a slightly different direction, and that subject is transformed. At noon, those trees, rocks, or hills may not impress you at all because the sun is high in the sky, producing a bright, even light, with very few dramatic shadows. But in the late afternoon, with the sun low in the sky, creating strong shadows and interesting silhouettes, those dull trees, rocks, or hills may take on unexpected drama. Conversely, the delicate colors of those wildflowers may look brightest at midday and lose their fascination in late afternoon. So the key to finding a subject may be watching for the right time of day and the right light effect.

Keep It Simple. Knowing what to leave out (or take out) is just as important as deciding what to put into a painting. Nature offers you an infinite amount of detail and it's tempting to try to load it all into the picture. But you can't include everything. It makes the job of painting much harder and bewilders the viewer. Besides, watercolor doesn't lend itself to rendering a great deal of precise detail. Watercolor's a broad medium, and it's best for painting simple forms with broad strokes. So don't try to paint every treetrunk, branch, twig, and leaf in the forest. Pick out a few trunks and a few branches; try to paint the leaves as large masses of color. Don't try to paint every cloud in the sky, like a vast flock of sheep, but focus on a few large shapes, even if it means merging several small clouds into a big one—and simply leaving out a lot of others. Don't try to paint every rock on the beach; pick out a few large rocks for your center of interest, then include some smaller ones to make the big ones look bigger by contrast.

Using a Viewfinder. Many landscape painters use a very simple tool to help them decide what to paint. Take a piece of cardboard just a bit smaller than the page you're now reading. In the center of the cardboard, cut a "window" the same proportion as a half sheet of watercolor paper. Let's say 4″ × 6″ (100 mm × 150 mm). Hold this viewfinder at a convenient distance from your eye—not too close—and you'll quickly isolate all sorts of pictures within the landscape, far more pictures than you could paint in a day.

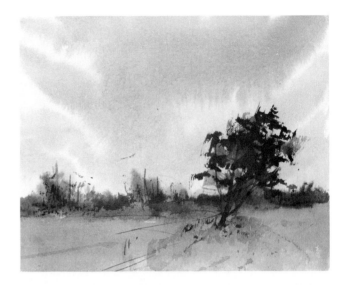

Don't place your center of interest in the dead center of the picture like a bull's-eye. And don't run the horizon straight across the middle so that it divides the picture into equal halves. This sort of symmetry makes a dull composition.

Do place the focal point of the picture off center. And place the horizon above or below the center. A good rule of thumb is to place the horizon about one-third of the way up from the bottom—as you see here—or one-third down from the top.

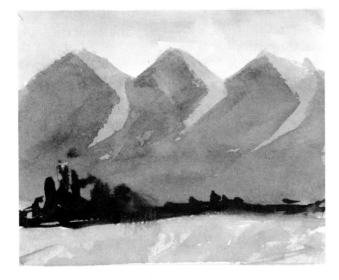

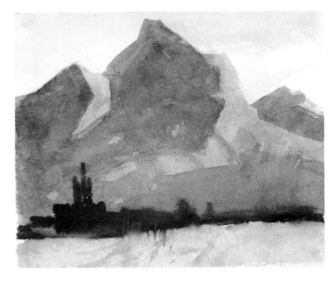

Don't make everything the same size and shape, such as these monotonous mountain peaks. Nor is it a good idea to space them out evenly, like a parade of soldiers.

Do vary the size and placement of the shapes in your painting. If you're working with three mountain peaks, make one really big, another one slightly smaller, and the third smaller still.

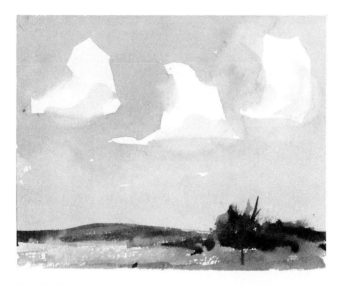

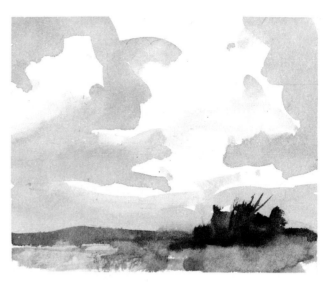

Don't fill your picture with small, scattered elements such as these tiny clouds floating in an empty sky. Like those monotonous mountain peaks, they're all about the same shape, with roughly equal spaces between them.

Do merge a couple of those small clouds into one big shape—or exaggerate one of them so that it becomes bigger. Balance the big cloud against the small one. Make the shapes of the two clouds as different as possible. And get rid of the third if you can't find a place for it.

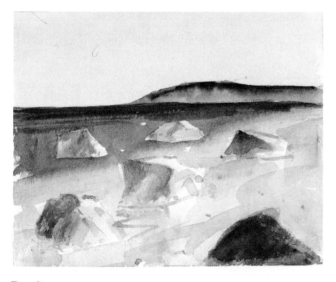

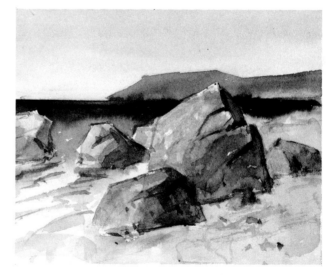

Don't scatter things across the landscape (such as these rocks) so the eye doesn't know where to look and can't find the focal point of the picture. The eye needs to know that there's one central character in the drama.

Do group those rocks, overlap them, make one really big, and make sure that the others are different sizes. Now the eye goes straight to the biggest shape. Naturally, these guidelines will apply not only to trees, peaks, clouds, and rocks, but to *any* landscape subject.

Tree in 3/4 Light. Before you begin to paint, study the subject, determine where the light is coming from, and get a clear idea of the pattern of lights and shadows. Here, the light is coming from the left side and slightly above the tree, throwing the right sides and the bottoms of the leafy masses into shadow. The tree also casts a shadow on the ground to the right.

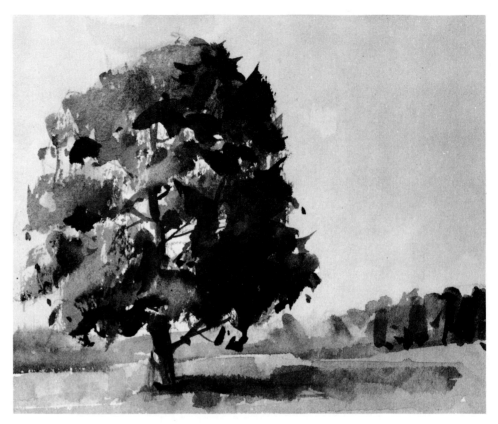

Tree in Back Light. Late in the day, when the sun is moving down toward the horizon, the light often hits things from behind and produces dark silhouettes. This back-lit tree consists entirely of dark masses, with no clear division between light and shadow. However, some of the leafy masses are a bit darker than others. Notice that the horizon is also just a dark, flat shape.

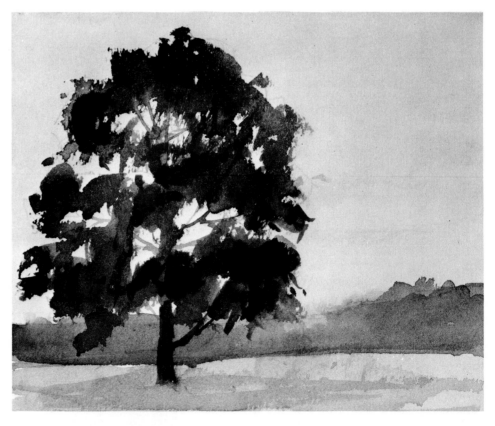

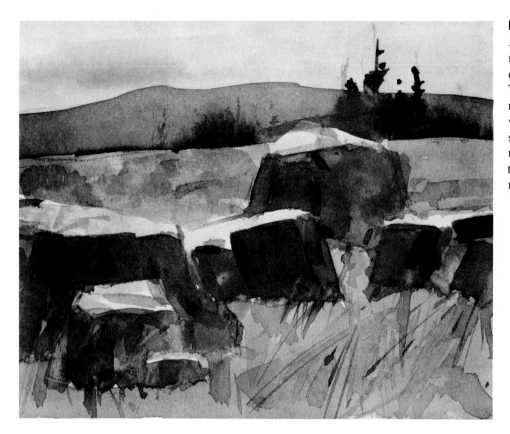

Rocks in Top Light. Around midday, the sun is directly overhead and shines down on the tops of things. Thus, the top planes of these rocks are in bright light, while the sides are in deep shadow. Try to visualize the trees on the preceding page in top light. And try to visualize these rocks in back light.

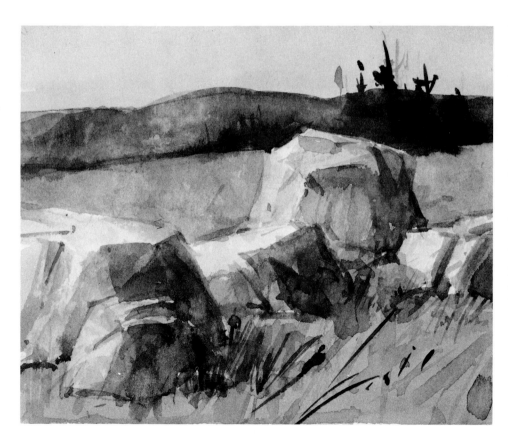

Rocks in 3/4 Light. These rocks, like the tree at the top of the facing page, are lit from the left and from slightly above. Thus, their tops and left sides are sunlit, while their right sides are in shadow. Notice that the shadows aren't quite as dark as those on the tree. That's because the light source isn't directly to the side, but just a bit in front of the rocks. It's just as important to define the direction of the light when you're painting *other* subjects, such as clouds, hills, and mountains.

Frontal Light. Exactly the same landscape can look quite different when the direction of the light changes. This snowy landscape is lit from the front. Imagine that you're facing the landscape and that the light is coming over your shoulder. Thus, the snow is pale and the distant sky is dark.

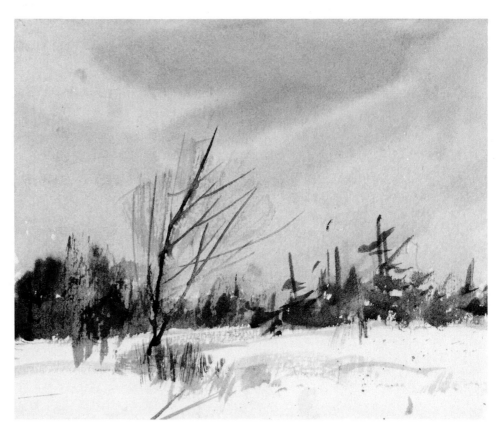

Back Light. Now the same landscape is lit from behind. The sun is sinking behind the distant trees, brightening the sky and throwing the snowy field into shadow. Decide which lighting effect you'd like to paint—or try them both.

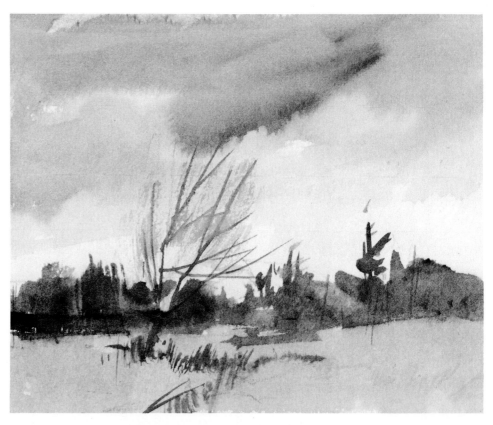

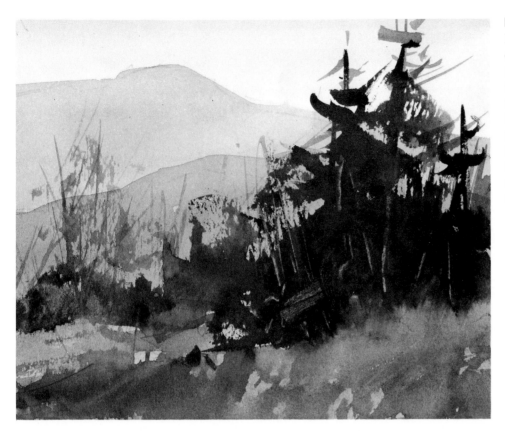

Mountainous Landscape. Near objects tend to be the darkest and most detailed, such as the trees to the right. Objects in the middle distance tend to be paler and less detailed, such as the hill and the trees to the left. Far objects tend to be palest and contain the least detail. This phenomenon is called aerial perspective.

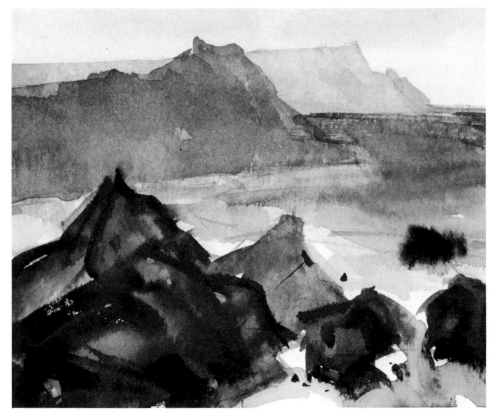

Coastal Landscape. The rocks in the foreground are darkest, and you can see lights and shadows on them. The headland beyond is just another big rock like those in the foreground, but it's paler—and the lights and shadows are less distinct. The headland on the horizon is paler still, and you can barely see any difference between the lights and shadows. By emphasizing aerial perspective, you'll give your landscapes a strong feeling of space and atmosphere.

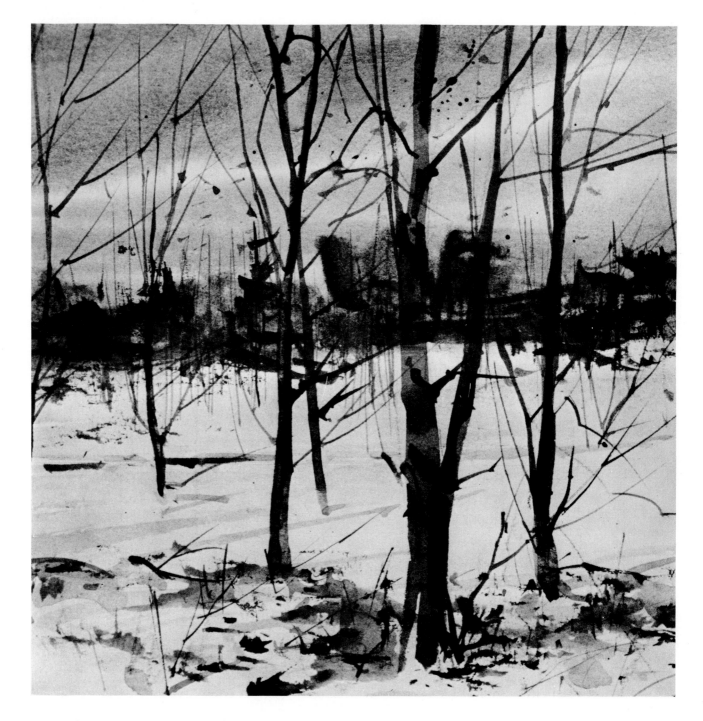

Linear Strokes. A watercolor brush can make many different kinds of lines, depending upon which part of the brush you use—and how you hold it. If you work with just the tip of the brush, you can make rhythmic, slender lines. If you press down a bit harder, more of the brush will spread out onto the paper, and you'll produce thicker lines. That's how these treetrunks and branches are painted. The thick strokes of the branches are made by pressing down firmly so that not only the tip of the brush, but also a fair amount of the body, travels across the surface. For the thinner trunks, the brush isn't pressed down quite so hard. And just the tip of the brush is used for the slender branches and twigs. The brush carries lots of very fluid color. This group of trees is essentially a series of thick and thin lines.

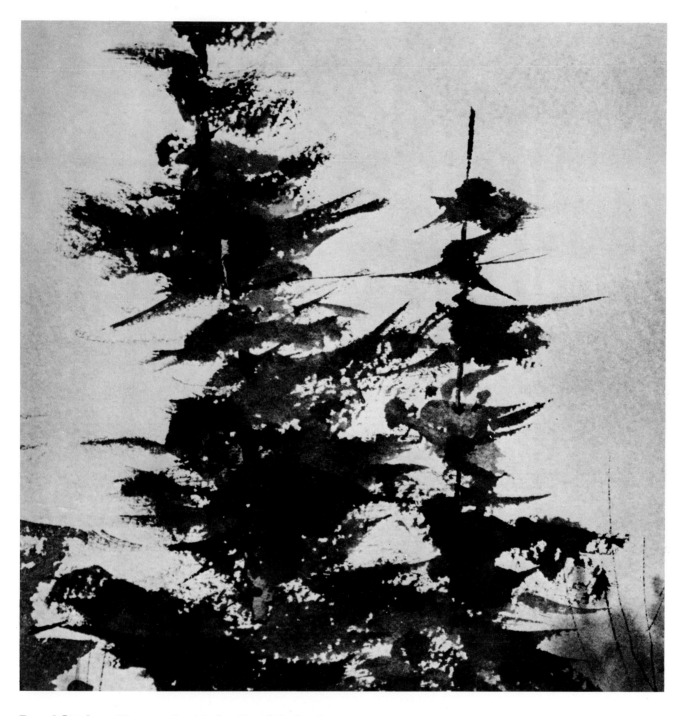

Broad Strokes. If you work with the side of the brush, holding the wooden handle at an angle or almost parallel with the surface of the paper, you can make broad, ragged strokes like the brushwork used to paint these evergreens. The strokes will be particularly broad and ragged if you pull the brush sideways. That's how the thicker strokes in this picture were made. You can also press the brush firmly against the paper, pull it away to one side, and gradually lift the brush off the surface—making a stroke that starts out thick and ends up thin, like the brushwork toward the tops of these trees. Working with the side of the brush also gives you the broken drybrush textures you see along the edges of the branches.

Blocky Forms. There's no such thing as a "typical" rock. Each has its own distinctive shape. The easiest rocks to paint are the ones that look like blocks. The tops and sides of these cubical forms are clearly defined; thus you can easily isolate the light and shadow planes. Most of the rocks in this picture have a brightly lighted top, a deep shadow plane on the right, and a middletone on the left.

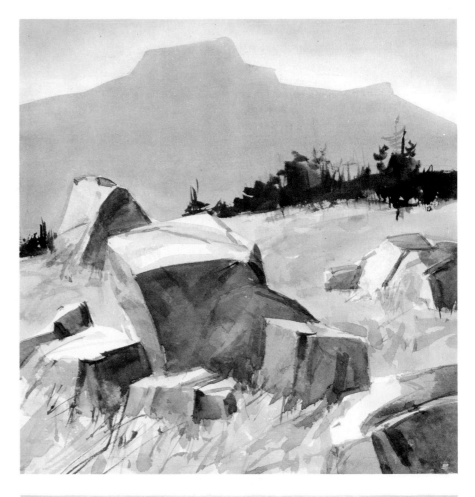

Rounded Forms. Another common geometrical form is the rounded rock, which looks like a sphere that's half buried in the earth. There's no distinct break between the light and shadow planes, but a gradual transition from light to dark. Here, the tops are brightly lit, and the sides that face you are in shadow. When you paint the shadow side, you can produce a soft transition by wetting the edge where the shadow melts into the light. You can see this clearly in the medium-size rock just below the center.

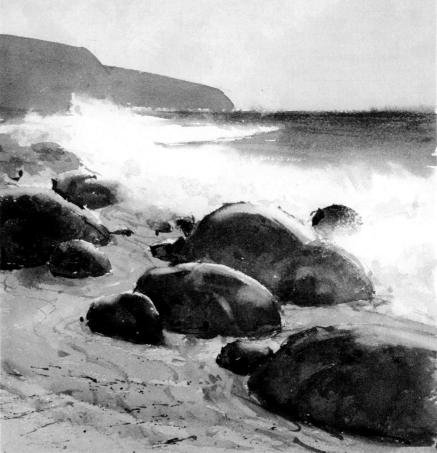

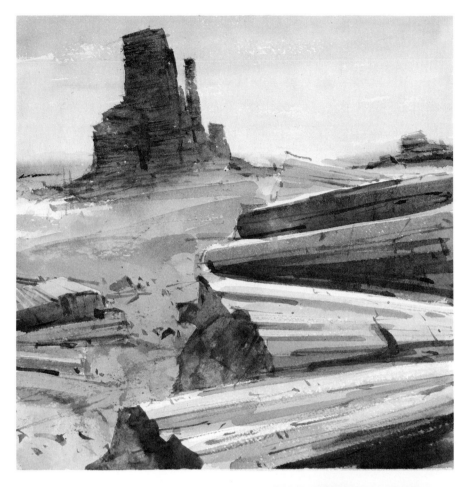

Horizontal Forms. Rocks often occur in horizontal strata, like a layer cake. The layers tend to form blocks; therefore you can paint the planes of light and shadow almost as easily as the blocky rocks on the facing page. And you'll need some lines to define the separate layers.

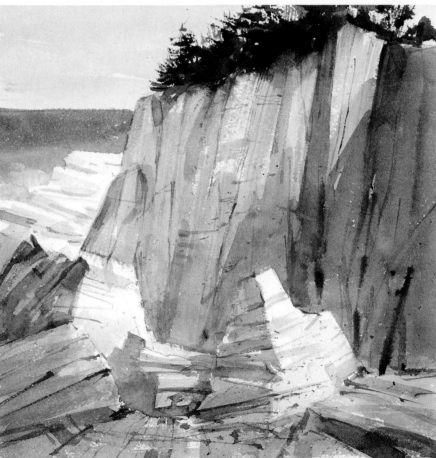

Vertical Forms. Tall rock formations often look like groups of columns or slender boxes stacked side by side. It helps to visualize them as tall, slender rectangles with light and shadow sides. You can render them very much the way you paint the layered rocks.

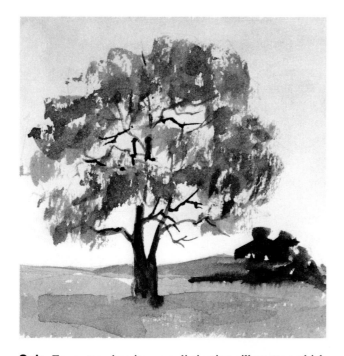

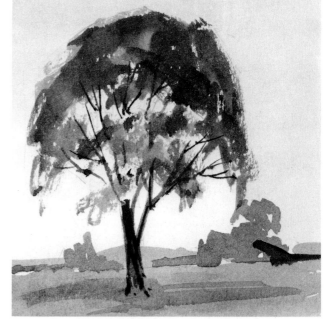

Oak. Every tree has its own distinctive silhouette, which you should try to visualize clearly before you paint. An oak has a broad, rounded shape, with big gaps between the bunches of leaves. You can see lots of sky and lots of branches in these gaps. The branches grow outward to the side.

Elm. A single domelike mass of leaves is typical of the elm. The branches grow upward and then turn slightly outward—but they never grow sideways like oak branches.

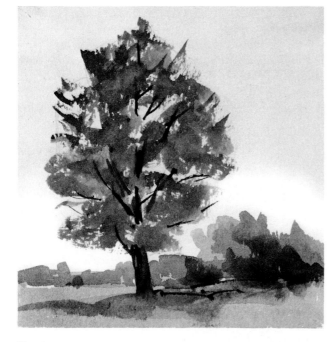

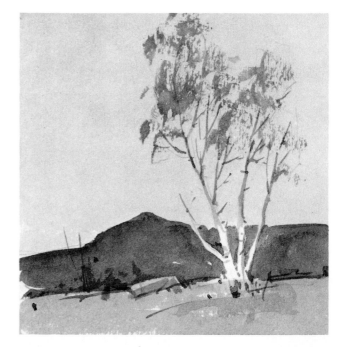

Maple. The leaves of the maple form dense, irregular clusters, among which the branches tend to be hidden. Naturally, the leaves are less dense in the spring, and you can see the branches more clearly.

Birch. Birches often appear in clumps, with multiple slender trunks that carry delicate, lacy leaves through which you can see lots of sky. Drybrush is a good technique for painting birch foliage. Not all birch trunks are as light as this one. There are also dark birches.

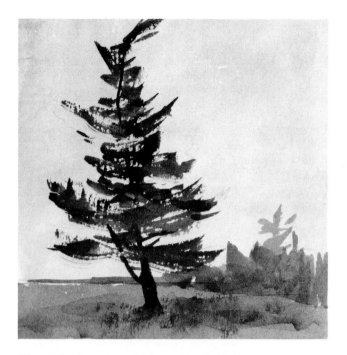

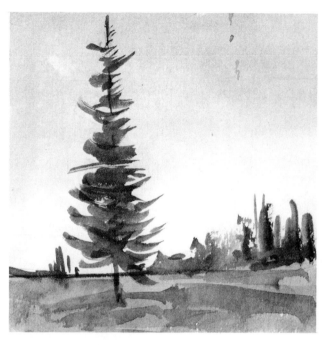

Pine. The densely packed needles of the pine grow outward in thick clusters that curve slightly upward. The silhouette is jagged and so are the shapes of sky that cut into the silhouette.

Spruce. The spruce looks somewhat like a pine at first glance, but the shape is narrower. The tree looks as if it would fit into a tall, slender cone. The masses of needles also form jagged shapes that turn upward at the end. It's hard to see the branches.

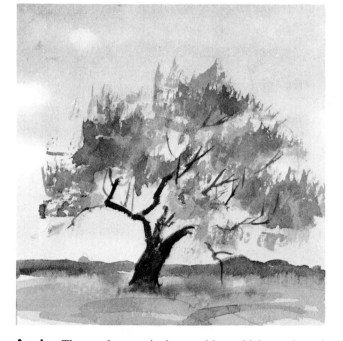

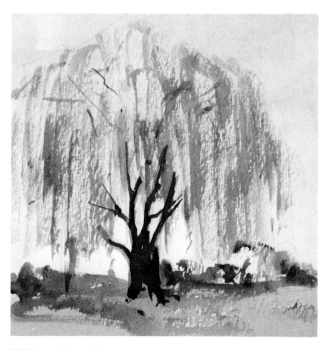

Apple. The apple tree is low, with a thick trunk and branches that often seem twisted and erratic. The tree may tilt to one side. The foliage forms irregular bunches that look lacy around the edges. There are big gaps of sky between the clusters of leaves.

Willow. The thick trunk and branches of the willow contrast with the very delicate, lacy leaves that trail downward like frothy, falling water.

Puffy Clouds. Clouds aren't mere blurs of smoke, but have distinctive, three-dimensional forms, often just as solid looking as rocks. Learn to identify the different cloud shapes, such as these cumulus clouds that are rounded at the top and generally flatter at the bottom, with clearly defined light and shadow sides.

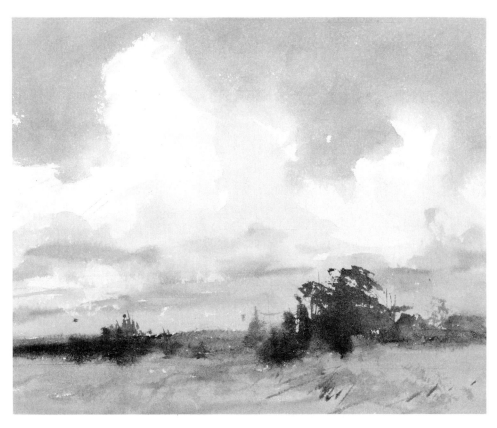

Layered Clouds. Not all clouds are round and puffy. They also occur in horizontal strata—one layer of clouds above another. It's often effective to paint such a sky wet-in-wet, as you see here. The paper is brushed with water and then the darks are brushed in with horizontal strokes. Be sure to leave light patches between. Notice that the layers are more tightly packed together at the horizon.

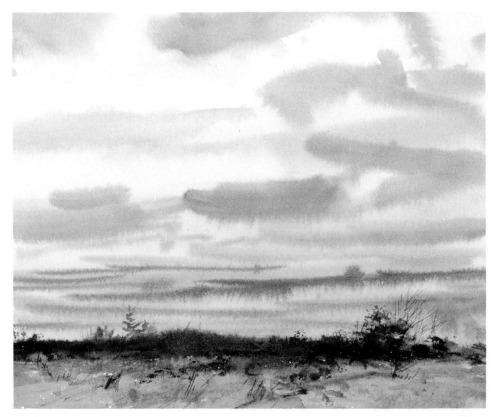

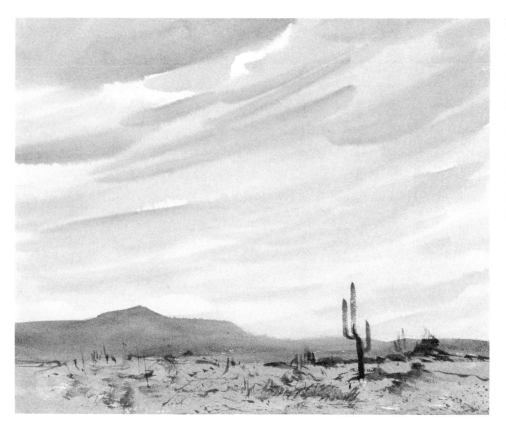

Windswept Clouds. The wind sometimes blows the clouds across the sky like laundry on a clothesline. The clouds curve and are blown upward at one end, somewhat like the layered clouds on the facing page, but with more movement. The clouds at the top are bigger because they're overhead. The clouds at the horizon are smaller because they're farther away.

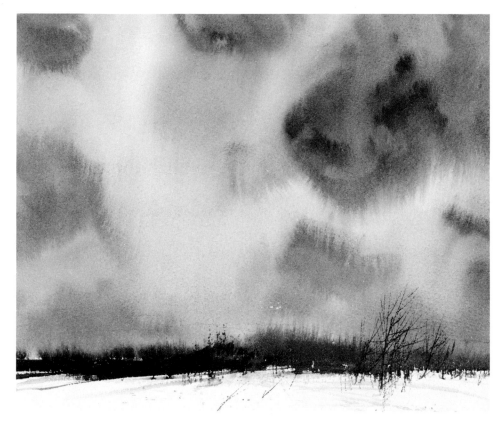

Storm Clouds. Because they roar in between you and the sun, storm clouds are frequently back lit. The sun is behind them, which is why they look dark. They have ragged edges because they're being blown across the sky by the stormy wind. This stormy sky is painted with lots of dark color on very wet paper.

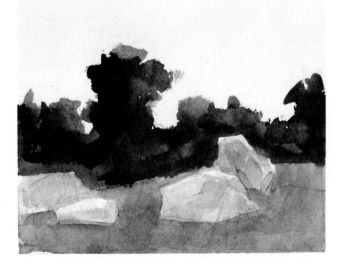

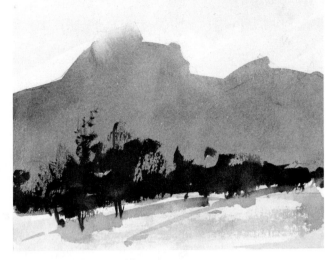

Rocks and Trees. When you plan a landscape, it's often helpful to visualize the picture in three distinct values—three different degrees of lightness or darkness—and perhaps a fourth value for the sky. Decide which is the darkest area, which is the middletone, and which is the lightest area. Here, the trees are obviously the darkest value; the ground is the middletone; and the rocks are the lighter shades. The sky is about the same tone as the rocks.

Mountainous Landscape. The lightest value is the snow in the foreground, which is repeated in the sky. The trees are the darkest value. The distant mountains are the middletone—repeated in the shadows under the trees.

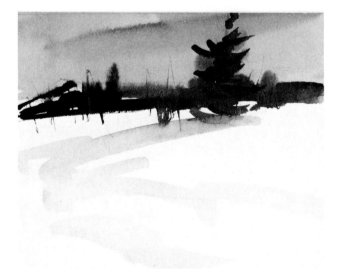

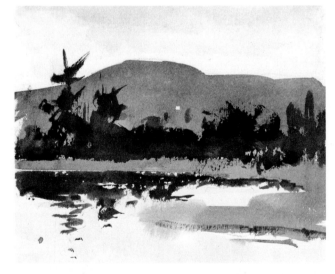

Snowy Landscape. Again, the snow is the lightest value and the trees are darkest. But now the sky is the middletone, and this middletone is repeated in the shadows on the snow. Before you start a painting, do some value sketches like these in order to plan the basic design.

Lake and Hills. The water mirrors the sky; together, they form the lightest value. The trees are darkest; this dark is repeated in their reflection. The land is the middletone. Naturally, such a sketch is a highly simplified version of the painting. It just helps you plan your washes, which will contain far more detail when you finish the painting.

PART THREE

SEASCAPES IN WATERCOLOR

Seascapes in Watercolor. Every year, as soon as the weather permits, watercolorists start walking the beaches, climbing the headlands, clambering out on the rocks of coastlines around the world. Perhaps because watercolor *is* essentially water, the medium seems right for painting glistening waves, the shining sides of wet rocks, and tidepools on sparkling sand. Of course, the classic seascape of crashing waves, flying foam, and looming rock formations is only one of the many coastal subjects you'll find in this book. Most seascapes are really coastal landscapes in which the sea itself may be incidental. So this book will show you how to paint many other things besides the sea, from rocky cliffs to rolling dunes to moonlight on the beach.

Organization. You'll find that this treatment of seascape painting in watercolor is divided roughly into three sections. First, there's a brief review of the basic techniques of watercolor—applied specifically to common seascape subjects. Then Claude Croney, a watercolorist who lives by the sea and has spent much of his life watching its changing moods, executes ten complete paintings of coastal subjects, step-by-step. The final section deals with a variety of problems that are unique to seascape painting, ranging from planning the picture to various technical tricks for painting specific subjects such as seaweed and driftwood.

Basic Techniques. The two fundamental tools of the watercolorist are round brushes and flat brushes, so you'll see an interesting comparison of the way these different brush shapes behave. You'll compare the lively curves of waves painted with round brushes and the broad shape of a shoreline painted with flat brushes. You'll also see how the basic wash techniques can be used to paint different coastal forms. The big, blocky shapes of a headland are built up in a series of flat washes, which is the simplest way to handle watercolor. Then a distant shore is developed in graded washes, which are just a bit harder. You'll see how clouds are painted on wet paper to create soft edges—the wet-in-wet technique. The rugged textures of a cliff are painted in the drybrush technique. Naturally, once you've mastered these techniques, you're free to switch them around. Clouds don't always have soft edges; there are times when you'll want to paint them in flat washes to create hard edges. A distant headland in fog might call for the wet-in-wet technique. It's also worthwhile to think of combinations of techniques: that headland can begin as a series of flat washes and then you can add detail with drybrush.

Color Sketches. Just before the step-by-step demonstrations, there are some color sketches that tell you more about the colors you'll find along the coastline. Light and weather have a great deal of influence on color, as you'll see in these sketches of a sandy beach, a headland, waves, and surf on a sunny day and then on an overcast day. You'll also compare a variety of sky colors, including a sunlit sky, a sunrise, and a storm. You'll see "life-size" close-ups of sections of Claude Croney's paintings, in which you'll observe how he handles color when he paints waves, rocks and foam, sand dunes with beach grass, and the intricate detail of weeds and water in a salt marsh.

Painting Demonstrations. The ten paintings in the step-by-step demonstrations have been selected to include the most popular coastal subjects. The first three demonstrations focus primarily on water, showing how to paint the transparent, rolling shapes of waves; the exploding form of surf striking against rocks; and pools on the beach at low tide. There's also a demonstration painting of a salt marsh, where the sea cuts in among intricate masses of marsh grass. The next three demonstrations concentrate on the effects of light and weather: moonlight on the sea, one of the most romantic of all seascape subjects; the mysterious tones of fog along the shoreline; and the violent action of a storm. Finally, Croney demonstrates how to paint the solid forms of the coast: the rugged shapes of a rocky shore; the soft, rhythmic, extremely subtle shapes of sand dunes; and finally the dramatic, sculptural form of a headland.

Special Problems. In the final section, you'll find guidance about how to select subjects to paint—which can be particularly difficult when you're facing the vast panorama of the shore and the distant sea. There are suggestions about how—and how not—to compose successful seascapes. You'll see how the direction of the light not only alters specific forms (such as rocks) but really creates totally new pictures as the light changes. You'll see how aerial perspective creates a sense of the third dimension in a coastal landscape. There are sketches of various wave forms, the most difficult of all seascape subjects. And you'll learn a variety of technical tricks for painting pebbles, seaweed, beach grass, driftwood, and other details that lend richness and authenticity to your work. Finally, you'll see how to create a simple and effective plan for a seascape painting by using the "three-value system."

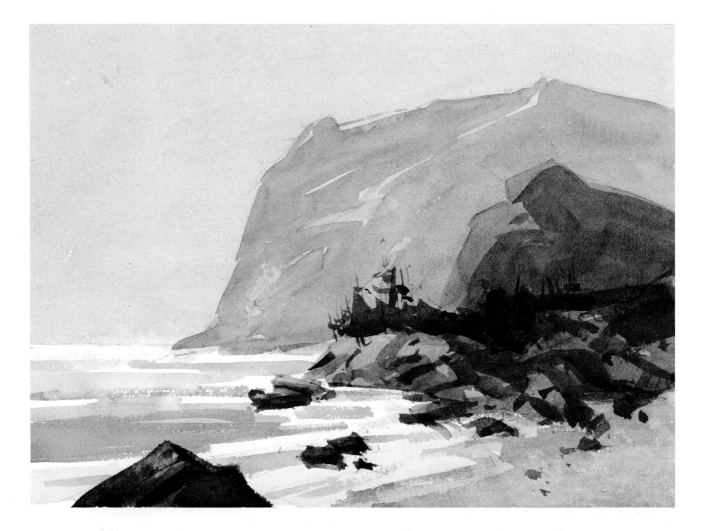

Headland and Beach. A series of flat tones, applied one over the other, can create a sense of space and atmosphere. You work from light to dark, beginning with your palest tone, letting that dry; then applying a slightly darker tone, letting that dry; and continuing, wash upon wash, until you get to your darkest darks. It's often best to work from the top of the painting to the bottom, starting with the sky; this also means that you're working from distance to foreground. In this painting, the sequence of operations is simple. First comes the pale wash of the sky. The slightly darker wash of the distant headlands is brushed over the sky. The dark rock formation to the right is brushed over the headland. And so on. Each tone is flat—which means that it's the same density from end to end, not dark at one end and light at the other. You can make an absolutely smooth tone, such as the sky, by starting from the top and overlapping wet strokes until you reach the horizon. Or you can allow the strokes to show by leaving some gaps between them, as you see in the big headland. In the rocks and water, the pale strokes go down first, are allowed to dry, and are then followed by darker strokes.

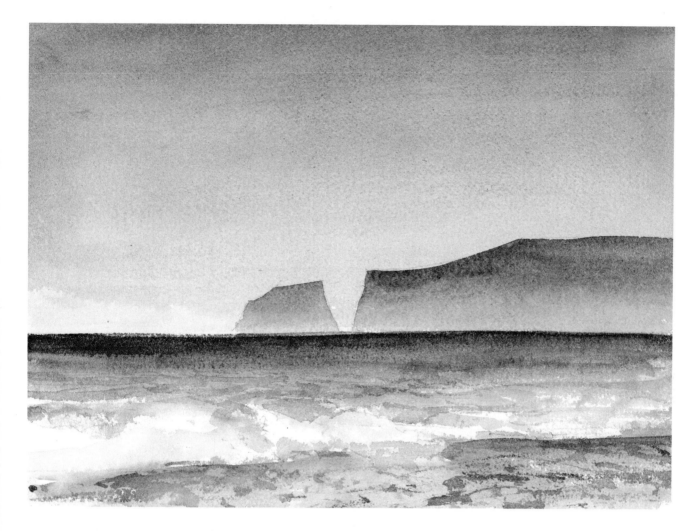

Distant Coast. Because they move from dark to light, graded washes create a marvelous sense of luminosity. Here, you sense a glow of light in the lower sky. The forms of the distant coast seem to be rising out of a mist, which makes them paler at their lower edge. Even the sea is darkest at the top and grows gradually lighter as it approaches the shore. All these graded washes are done the same way. Starting at the top of the wash, you paint a series of horizontal strokes with your biggest brush, one wet stroke slightly overlapping the one above. Each stroke contains just a little more water than the one above it. As the wet strokes fuse, they gradually shade from dark to light. Whenever you paint a large wash—whether flat or graded—it often helps to tip your drawing board up slightly at the back end so that the wet color rolls downward toward you and tends to pool at the lower edge of the last stroke. This keeps the edge of the stroke very wet so that it fuses softly with the next overlapping stroke. If too much wet color accumulates at the lower edge of the *last* stroke at the very bottom of the wash, quickly rinse out a big brush, swing it through the air or wipe it on a paper towel to get rid of most of the water, and use the damp tip as you would a sponge to soak up the excess color.

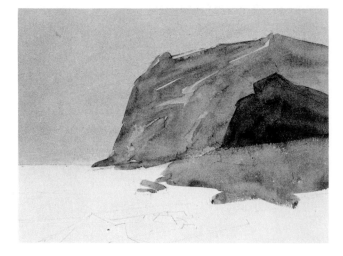

Step 1. To lay a big wash such as this sky, mix plenty of liquid color on your palette and use a large brush. Tilt your drawing board up slightly at the back. Start at the top and brush in a series of horizontal strokes, one below the other. Your strokes should overlap a bit. Work fast so that the strokes stay wet, each one fusing softly with the one above.

Step 2. When the sky wash is dry, a second, darker wash covers the entire headland and the shape of the foreground rock formation. When the second wash dries, a darker tone goes right over it; this is the shadow side of the big rock that you can see more clearly in Step 3. The strokes on the headland have gaps between them, suggesting rocky forms.

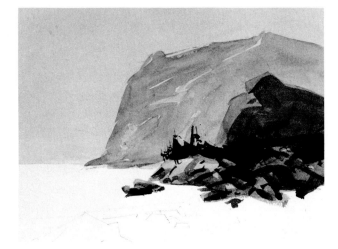

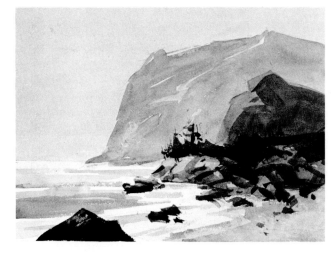

Step 3. To give the dark rock formation a lighted side, a paler tone is added at the left and brushed right across the entire shadow. Smaller rocks are defined by crisp strokes that go right over the flat wash you see in Step 2. Lighter strokes come first and are allowed to dry. Darker strokes follow and are carried upward to suggest the trees.

Step 4. The water and the beach are painted in two stages. First, a series of pale strokes is brushed in and allowed to dry. These are followed by a few darker strokes. Some strips of paper remain bare to suggest light on the water. And the dark rock in the lower left corner is added last.

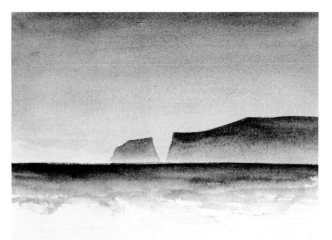

Step 1. Sky and sea are painted in the dark-to-light technique called a *graded wash*. Just as when you paint a flat wash, you paint a series of horizontal strokes, one below the other. But you add a bit more water to each succeeding stroke. The sky is painted with smooth strokes, while the sea contains rougher, shorter strokes that suggest the action of the waves.

Step 2. The two shapes of the shoreline are painted in exactly the same way, working with dark strokes at the top and lighter strokes at the bottom. To accentuate the hazy feeling along the horizon, there's a much more rapid switch from dark strokes to pale strokes—thus the transition from dark to light is more abrupt.

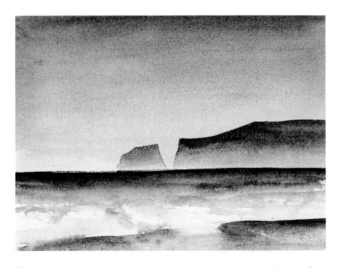

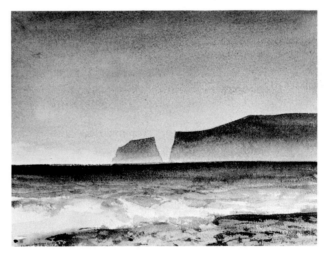

Step 3. The beach is also painted in a graded wash, starting with a dark stroke at the edge and quickly switching to paler strokes. At the middle of the beach, the tone of the sand blurs into the tone of the water. This is done by adding a stroke of clear water along the edge before the beach dries. This soft blur looks like foam rolling up over the sand.

Step 4. When all the graded washes are absolutely dry, a small brush adds lighter strokes in the water that become the pattern of waves and foam. The beach in the immediate foreground is also completed with small, irregular strokes that suggest pebbles and seaweed.

Step 1. A round brush is particularly good for making strokes that start out slender and gradually thicken. At first, you just touch the paper with the very tip of the brush and then you gradually press down harder until the full body of the brush is against the paper. That's how these dark clouds are painted. But the sky area is first brushed with clear water so that the dark strokes will blur slightly.

Step 2. To paint the distant ocean, the area is first covered with a pale flat wash. When this is dry, the sharp point of the brush is used to paint short, slightly curved strokes that suggest waves. You can see these strokes most clearly at the right. The big strokes in the sky and the flat wash of the sea are done with a large, round brush. A smaller round brush is used for the waves.

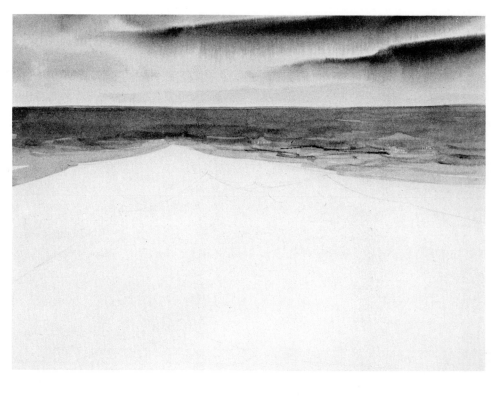

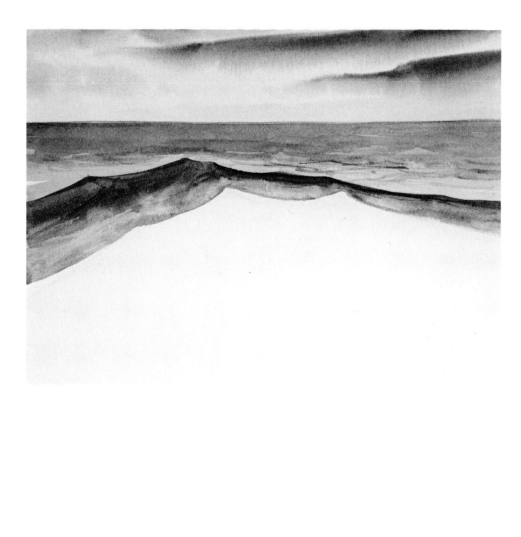

Step 3. Until now, the lower half of the paper has been left bare. Now the big wave in the middle distance is painted in a series of curving strokes—for which the shape of a round brush is perfectly suited. You can see that the top of the wave is painted with dark strokes, and the lower portion is painted with lighter strokes containing more water.

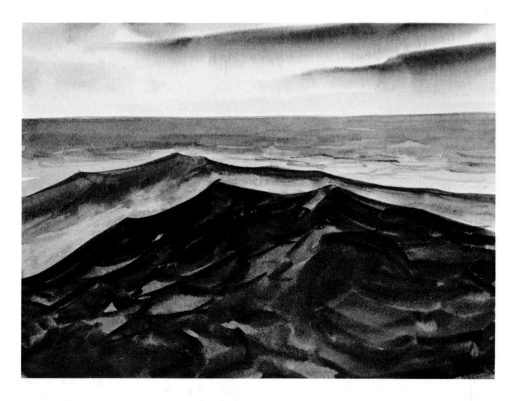

Step 4. The big wave in the foreground is now painted with a series of curving strokes, some thick and some thin, some dark and some light. The slender strokes are painted with just the tip of the brush, while the heavier strokes use the full body of the brush. The curve of the strokes expresses the action of the wave.

Step 1. It's obvious that a flat brush can make bold, broad strokes when you use the full body of the brush. But you can also use the forward edge of the brush to make very slender lines. You can see both these kinds of strokes in the dark clouds here—some are thick and others are mere streaks. The paper is first brushed with clear water so that the clouds will have soft edges.

Step 2. The flat brush will also make broad, squarish strokes that reflect the shape of the brush. You can see these in the rock formations, where each stroke stands out quite distinctly. The very edge of the brush is used to make the long horizontal strokes of the water. A few of these strokes are curved downward to suggest the action of the breaking waves.

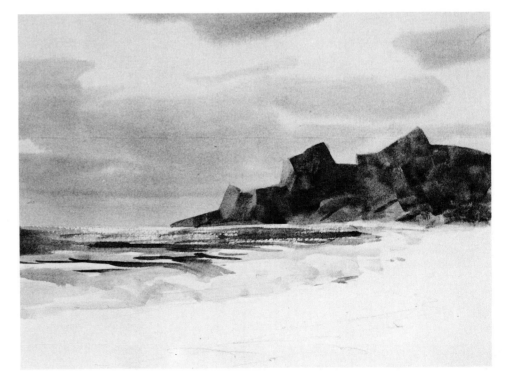

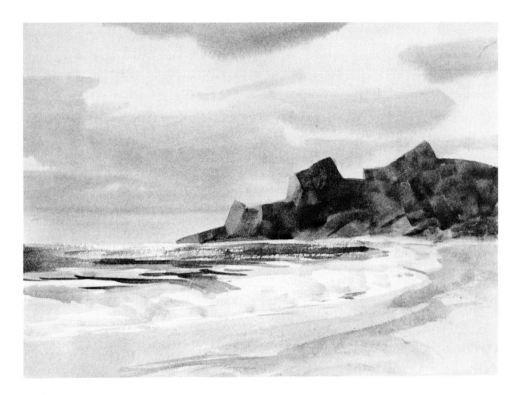

Step 3. The broad, flat shape of the brush carries a lot of color and quickly covers the beach with a flat tone. When this is dry, the brush adds curving, darker strokes over the undertone.

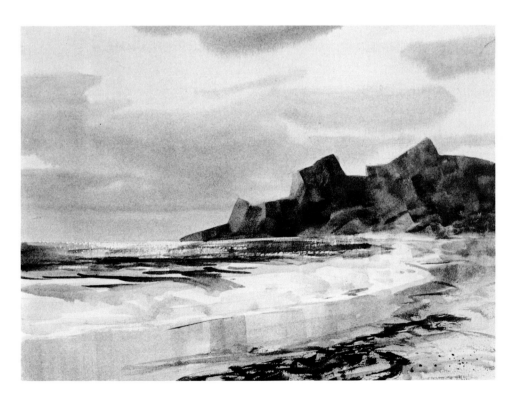

Step 4. The reflections in the wet sand are painted with short vertical strokes of a smaller flat brush—a very effective way to render water and reflections. Only the last few touches in the lower right are painted with a small, round brush. The tip of this brush is needed for the small, ragged strokes that suggest seaweed and other shoreline debris.

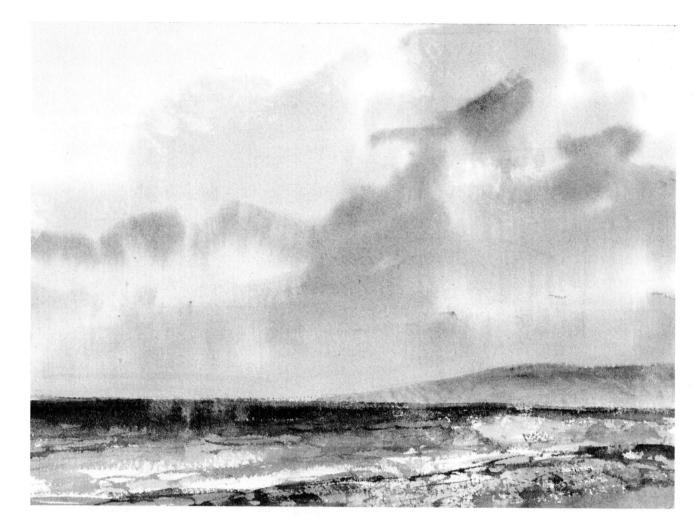

Approaching Storm Clouds. The wet-in-wet technique is particularly effective for painting large, soft shapes, such as clouds and surf. You begin by wetting the paper—either the whole sheet or just the area you're going to paint on—with clear water or with a wash of color. You can use either a large, flat brush or a soft natural sponge for this wetting operation. Then, before the wet surface loses its shine, you brush in masses of darker color with quick, bold strokes. Watercolor always dries a bit lighter than you expect. It's particularly important to work with color that looks *too dark* when you paint wet-in-wet, since the color will get a lot lighter when it blurs and spreads. In this stormy sky, lighter tones are brushed into the upper sky. Then, while the entire sky is still wet, the darker strokes are brushed into the center of the sky and down toward the horizon. Because the drawing board is tipped up at the back, the wet color tends to run downward, developing vertical streaks along the lower edges of the clouds—which makes them look even stormier. A small wad of paper toweling is used to blot up color to open light gaps between the clouds.

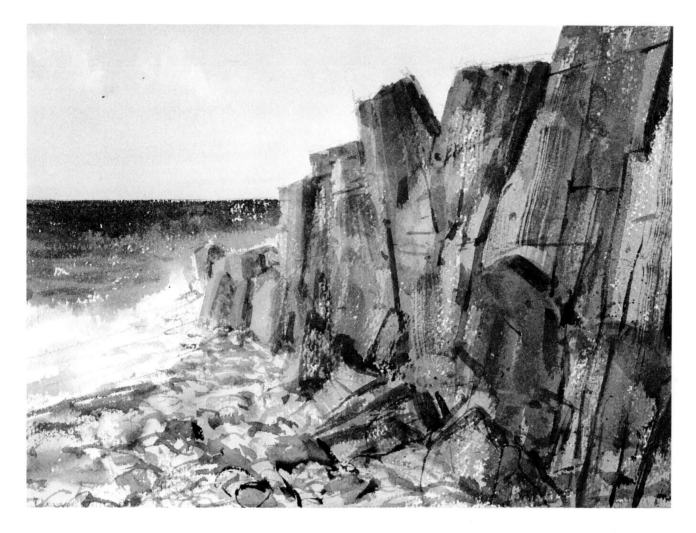

Rocky Cliff and Shore. The drybrush technique produces
rough strokes that are ideal for expressing the textures of
craggy rocks, as well as beaches strewn with pebbles and
boulders. The brush is damp, not wet, and moves quickly
over the irregular surface of the paper. A lot depends upon
how hard you press. If you skim the brush very lightly over
the paper, you deposit color just on the high points, skip-
ping past the valleys, which remain bare. If you press
harder, you force more color down into the valleys, so the
stroke is darker, but you still don't cover the paper com-
pletely. The angle of the brush also makes a big difference:
if you work with the side of the brush, the stroke is more
ragged. The whole point is to make a broken, irregular
stroke, rather than a smooth, solid stroke. The broad strokes
of this cliff are painted with a damp, flat brush. The cracks
and other details are painted with the tip of a round brush.
The pebbles and boulders on the beach are also painted with
a small, round brush, held on its side for the more ragged
strokes. Even the distant sea is painted with drybrush
strokes, executed with a flat brush.

Step 1. When you're planning to paint a wet-in-wet sky, there's not much point in drawing the shapes of the clouds. Those big blurs of color tend to go their own way, moving across the wet surface without paying any attention to your pencil lines. So just draw the horizon and a few details of the shore. Plan the location of the cloud masses in your head.

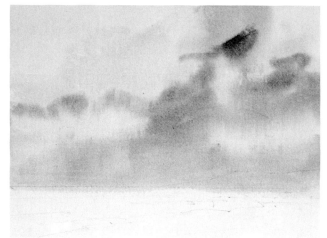

Step 2. You begin by wetting the entire cloud area, either with a big, flat brush or with a soft natural sponge. While the paper is still wet and shiny, brush in the darks of the clouds and the sky tones in between. Be sure to leave some bare paper to suggest the lighted areas of the clouds. Work with color that seems just a bit too dark. It's going to dry lighter.

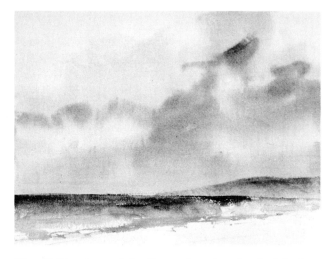

Step 3. The shape of the distant shore is painted while the sky is still damp. Thus, the top of the land has a slightly soft edge, making the shape look more remote and atmospheric. Then the entire sky area is allowed to dry. The sea is painted on dry paper, working with dark strokes at the horizon and lighter strokes toward the beach. This is an irregular graded wash.

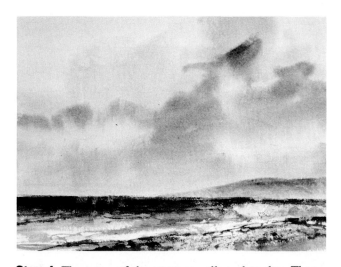

Step 4. The tones of the water are allowed to dry. Then strokes of darker color are used to strengthen the water and suggest the pattern of the waves. A pale tone is added to the beach at the lower right, allowed to dry, then textured with dark touches and drybrush strokes. The hard edge of the sea accentuates the softness of the clouds.

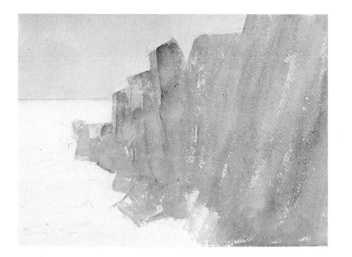

Step 1. Before working over an area with drybrush, it's a good idea to start with a solid tone. This unifies the drybrush strokes that come next. The cliff begins with an irregular flat wash, leaving some gaps between the strokes. These squarish vertical strokes, made with a flat brush, accentuate the blocky character of the cliff. The sky is also covered with a flat wash.

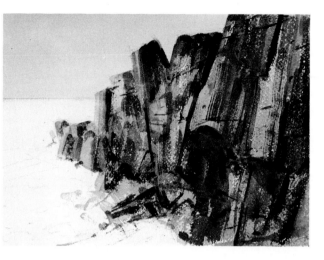

Step 2. Now the textures and details of the cliff are painted with drybrush strokes. A large, flat brush is dampened with dark color and pulled downward along the rocks, leaving broken streaks and masses of shadow. When these broad strokes are dry, a small, round brush is used to paint the cracks and other details.

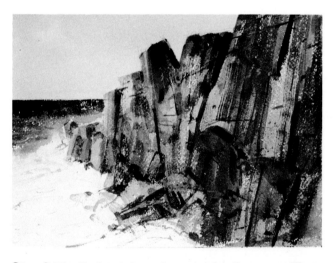

Step 3. The flat brush is used to paint the distant sea. The color is a bit wetter, and the brush is pressed down hard, forcing more paint into the rough surface of the paper. But flecks of bare paper still show through, suggesting light sparkling on the water. This is something like a graded wash, moving from dark strokes to light.

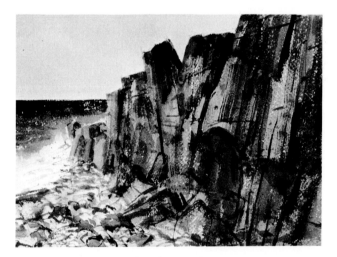

Step 4. The pebbles and fallen boulders at the foot of the cliff are painted with drybrush strokes made by a small, round brush. The side of the brush is used for the broader strokes. The tip is used for the slender, dark lines. The side of the brush is lightly skimmed over the surface, leaving behind a pattern of small flecks to create the feeling of sand.

Cool Colors. Seascapes tend to be dominated by cool colors, which means blues, greens, and grays. Within this cool color range, it's possible to achieve great variety if you know how to modify the two blues on your palette, mix interesting greens without simply relying on your tube of Hooker's green, and mix the colorful grays that are so typical of coastal subjects.

Blues. The two blues on your palette—ultramarine and cerulean—can be transformed into many shades of blue simply by adding faint touches of other colors. Just a speck of brown—burnt umber or burnt sienna—will push either of these blues a bit closer to gray. Hooker's green will obviously turn them both to greenish blue. A trace of alizarin crimson will produce purplish blues, but avoid the more powerful cadmium red light, which will demolish both blues—although you *will* get some interesting coppery darks. All these different blues will give you a rich variety of colors to use in painting skies and water.

Greens. In coastal subjects, greens most often turn up when you paint water, which means waves, tide-pools, and the inland water of the salt marsh. First try modifying the one green on your palette, Hooker's green, with the two blues to produce bluish greens. A touch of cadmium yellow light will turn Hooker's green—or one of those blue-green mixtures—into the brilliant transparent green that you often see when the sun shines through a wave. A trace of warm color, such as alizarin crimson or one of your browns, will darken one of those blue-green mixtures to give you the heavier tone that you often see where the distant sea meets the sky. It's even more important to learn how to create greens by blending your blues and yellows—or Payne's gray with one of your yellows. And each of these blue-yellow or gray-yellow mixtures can be further modified with a warm touch like one of your browns or reds.

Grays. Beginning painters often have the mistaken idea that gray is the dullest of all colors—not really a color at all. But if you look closely at nature, you'll see that grays are everywhere and are as varied as any other color. Gray isn't merely a pale version of black; it can turn out to be an extremely subdued version of any color on your palette. You should certainly learn to mix the lovely variety of grays you can get by blending blues and browns, varying the proportions of the mixture to produce cool grays (dominated by blue) and warm grays (dominated by brown). Starting with these basic blue-brown combinations, you can add a touch of any other color on your palette. Yellow ochre

will add a slightly golden tone; but you've got to be more cautious about adding cadmium yellow light, because a little goes a long way and may destroy the gray altogether. A suggestion of alizarin crimson can push a gray mixture toward violet, though be careful about adding cadmium red.

Painting Water. In painting coastal subjects, the colors of water are most difficult to capture. It's important to remember that water is a reflecting surface, which means that it picks up a lot of its color from the sky. A bright blue sky—even punctuated by some clouds—generally means that you'll see plenty of bright blue in the water too. Conversely, a gray sky means that you'll see a lot of gray in the water. Don't just make up your mind that water is "always blue" and paint bright blue waves even when the sky is overcast. Look closely at moving water and you'll see that it's never one uniform tone, but contains a variety of colors. The horizontal surfaces, facing up toward the sky, are most likely to reflect the sky color. A vertical surface, like the face of the wave rolling toward you, may be brilliant green because the sunlight is shining through it. The broken wave that spills along the beach may combine reflected color, picked up from the sky, with some sandy tones.

Painting Surf. Resist the temptation to paint surf as if it's a mass of snow white whipped cream. Remember that surf is simply water in another form, so it still reflects the colors of its surroundings. In bright sunlight, that "white" surf may have a slightly golden tone. On an overcast day, the surf is likely to be a delicate gray. And don't forget that surf has a shadow side, just as a cloud does. That shadow isn't necessarily gray, but might be gold, green, blue, or even violet—you've got to look carefully to make sure.

Color Schemes. Surrounded by so much cool color—blue, green, gray—you have to plan your color schemes so that your pictures don't become monotonous. Look for opportunities to introduce some subtle, warm notes. On a sunny day, the whites of the clouds frequently contain a hint of gold or pink. A blue sky often grows slightly warmer toward the horizon, where you're also likely to see a hint of gold or pink. There are apt to be touches of yellow sunlight on waves and surf. Those "gray" rocks often contain browns, yellows, oranges, and violets. Although sand is rarely as yellow as you think, it *is* generally tan or a subdued brownish gray, with hints of gold in bright sunlight.

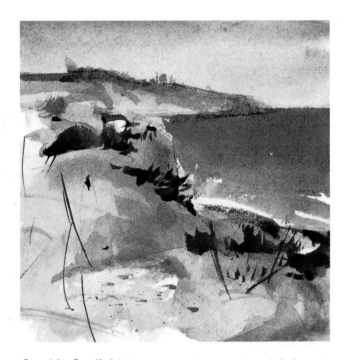

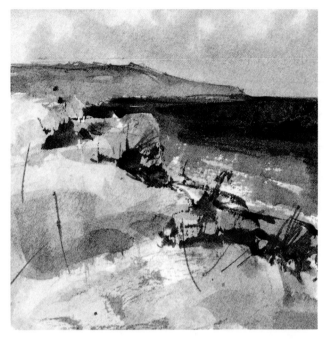

Sand in Sunlight. On a sunny day, sand certainly has a golden tone—but it's *not* as yellow as you think. This beach is painted with subdued yellow ochre—not the more brilliant cadmium yellow—with a hint of burnt sienna and some cerulean blue in the shadows. The sandy cliff in the distance is painted with the same mixtures.

Sand on Gray Day. The color of the sand changes radically on an overcast day. The golden tone turns grayish, with just a hint of warm color. The beach is painted with yellow ochre and burnt sienna once again, but with a lot of Payne's gray instead of cerulean blue. The sandy headland along the horizon contains even more Payne's gray. The colors of the sky and the sea change too.

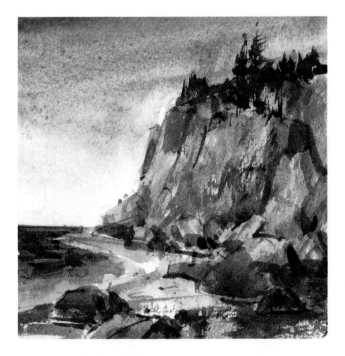

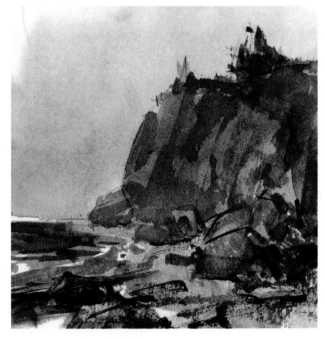

Headland in Sunlight. A headland, like a beach, looks radically different in sunshine and on a gray day. In sunlight, these rocks are painted with a mixture of yellow ochre and burnt sienna, plus some alizarin crimson in the brighter patches and some cerulean blue in the shadows. The shadowy rocks in the foreground are the same mixture, with more cerulean blue.

Headland on Gray Day. The same headland becomes a totally different color when the weather turns gray. The rocky shapes are painted with a mixture of yellow ochre, burnt sienna, and Payne's gray—with a bit more burnt sienna and Payne's gray in the shadow areas. The water also turns gray in this kind of weather and is a mixture of yellow ochre and Payne's gray.

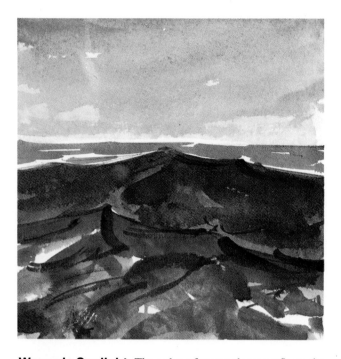

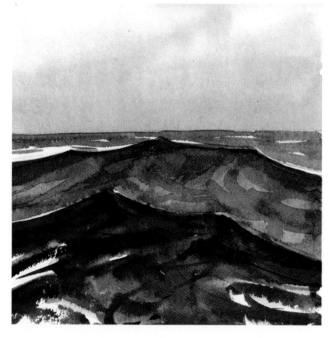

Waves in Sunlight. The color of water always reflects the sky. So the blues of a sunny sky appear in the water below. This bright sky is cerulean blue brushed over a very pale wash of cadmium yellow. The bright blues and greens of the waves are ultramarine blue, cerulean blue, and cadmium yellow. The softer tones are yellow ochre, ultramarine blue, and Hooker's green.

Waves on Gray Day. When the sky turns gray, so does the water. This sky is Payne's gray and cerulean blue brushed into a wet wash of yellow ochre. The dark strokes in the water are ultramarine blue, Hooker's green, and Payne's gray. The lighter areas are various mixtures of yellow ochre, Payne's gray, and Hooker's green.

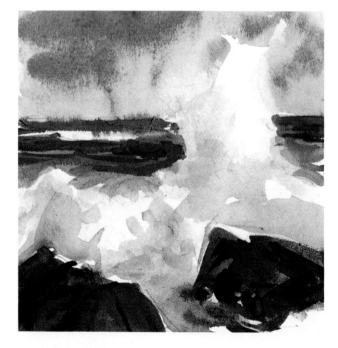

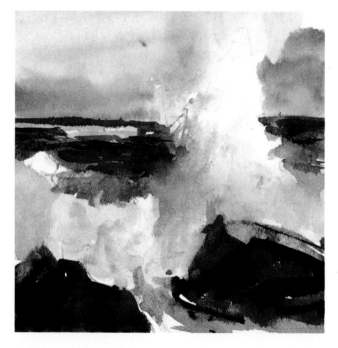

Surf in Sunlight. On a bright, sunny day, the surf and the wet, shiny rocks have a distinctly warm tone. The warm shadows on the foam are burnt sienna and cerulean blue. The lighted sides of the rocks are burnt sienna with a little cadmium red and ultramarine blue. The shadow sides of the rocks are burnt sienna, ultramarine blue, and burnt umber.

Surf on Gray Day. On an overcast day, the surf turns cooler, and the wet rocks are a more subdued tone. Now the dark tones in the foam are a pale mixture of burnt sienna and cerulean blue—with more blue. The rocks are burnt sienna, ultramarine blue, and burnt umber, with more blue in the darkest patches.

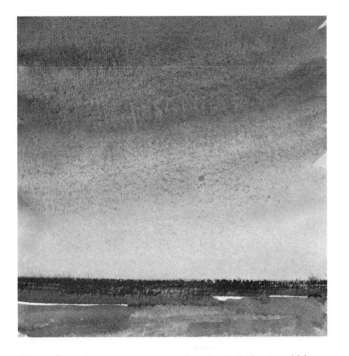

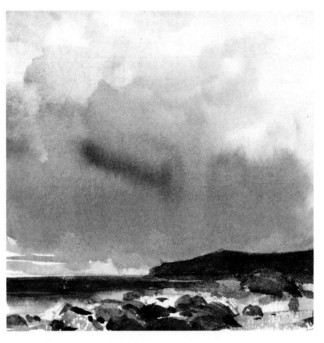

Clear Sky. On a sunny day, a blue sky is darkest and bluest at its highest point, growing paler and warmer as it approaches the horizon. This sky is painted with a lot of ultramarine blue at the very top, gradually mingling with strokes of cerulean blue, which mingle, in turn, with yellow ochre above the horizon.

Gray Sky. A gray sky often contains gaps in the clouds, through which you can glimpse the warm tones of the sun. This overcast sky begins with a pale wash of yellow ochre, followed by large strokes of Payne's gray put in while the underlying color is still wet. You can see patches of bright sky breaking through—just above the sea and in the upper right corner.

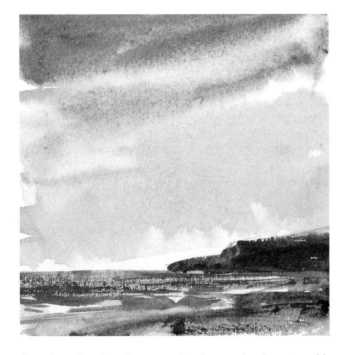

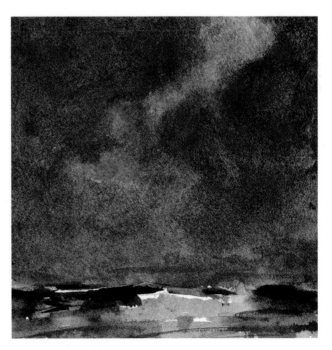

Sunrise. Streaks of warm color frequently alternate with streaks of cool color as the sun rises. It's important to keep your colors delicate—never garish. The warm tones above the horizon are a very pale mixture of burnt sienna and yellow ochre. Above the midpoint of the sky, you can see streaks of cerulean blue and a little ultramarine blue. Notice how the colors of the sky are echoed in the water.

Stormy Sky. The brooding darks of a stormy sky contain richer color than you might expect. There are often warm tones among the dark clouds and patches of cool sky breaking through. These storm clouds are painted with a mixture of burnt sienna and ultramarine blue, with touches of cerulean blue breaking through the center. The entire sky is painted wet-in-wet.

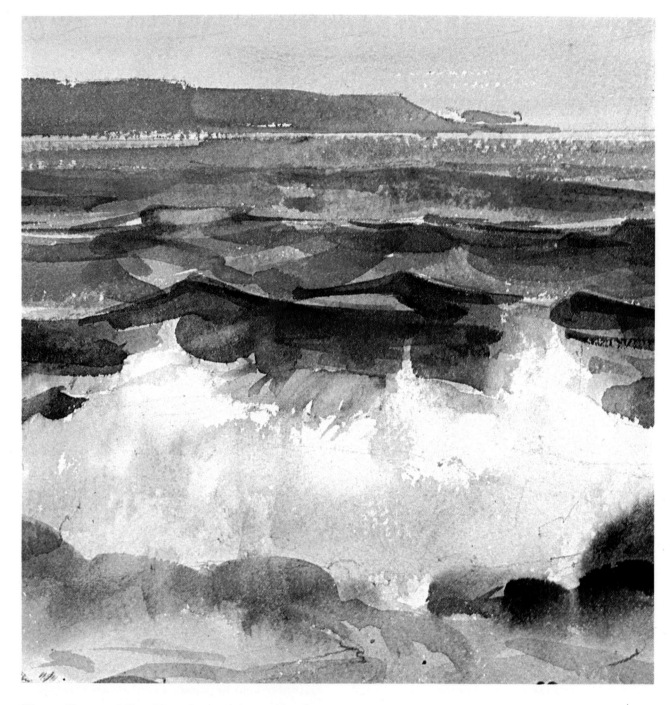

Waves Near and Far. The softness of the crashing foam in the foreground is expressed by broad, scrubby strokes made with the side of a large, round brush. The edges of the strokes are blurred with clear water. The choppy movement of the waves in the middle distance is expressed with curving, arclike strokes of the brush, some thick, some thin. At the horizon, long, straight drybrush strokes allow flecks of bare paper to shine through, suggesting the sparkle of light on the waves.

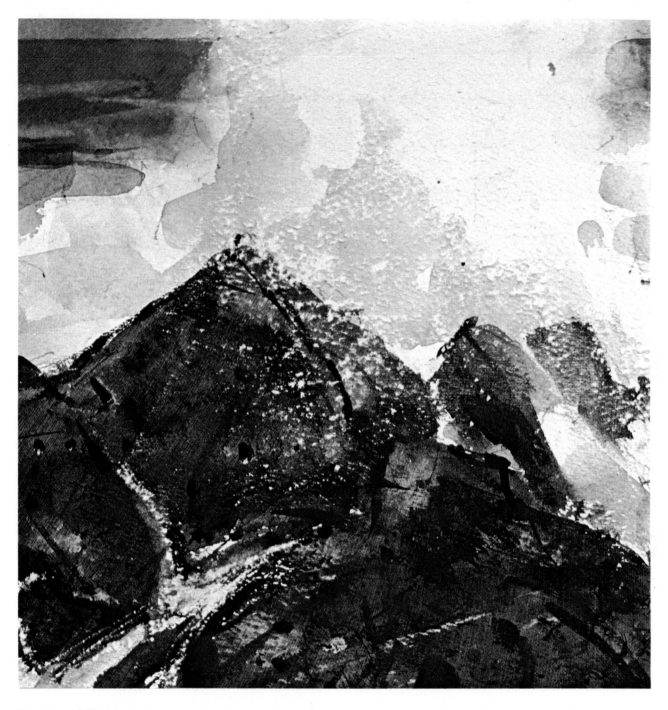

Rocks and Foam. As the waves crash against the rocks, the foam is flung upward. To capture this upward movement, the side of a large, round brush is pressed against the paper and pulled upward, leaving a ragged, broken stroke, which you can see in the shadows of the foam. The rocks begin as a flat wash and are then textured with broad dry-brush strokes made by the side of the brush. The cracks and pits in the rocks are made with the tip of a small, round brush. A sharp blade skims over the paper and scrapes away flecks of color, exposing the bare paper, which looks like flying foam.

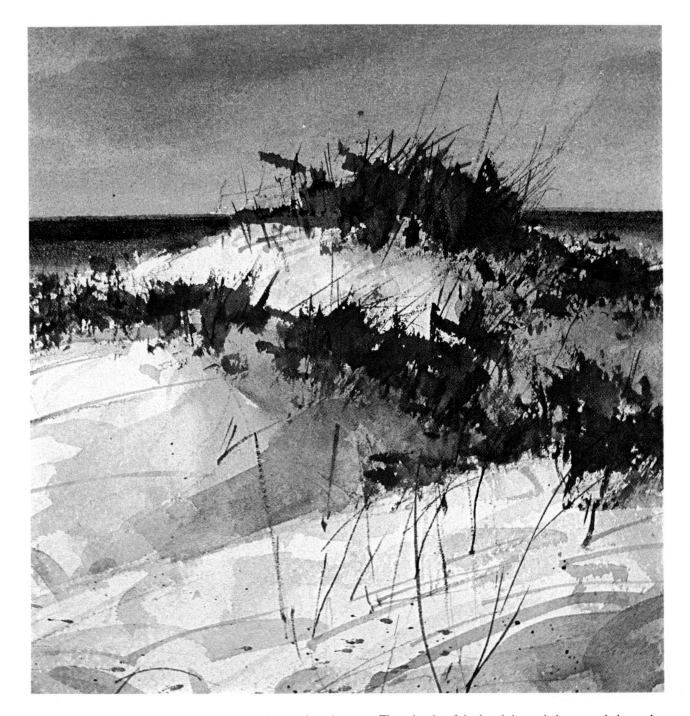

Sand and Beach Grass. The soft, subtle forms of sand dunes are particularly difficult to paint because they don't have clearly defined planes of light and shadow. However, the dunes are often crowned with vegetation which clearly defines where one dune ends and another begins. And this vegetation casts shadows that trace the curving shapes of the dunes. Here, the beach grass is painted with the side of a round brush pulled swiftly upward or slightly to the side, leaving a ragged patch of color that suggests a clump of foli-age. Then the tip of the brush is carried over and above the underlying color to represent individual stalks. You can see more of these slender strokes breaking through the sand in the foreground. The brush traces the lines of shadow that move over the dunes, following the curves of the sand. These pale strokes of shadow look casual at first glance. But when you look more closely, you'll see that they follow the contours of the dunes very carefully.

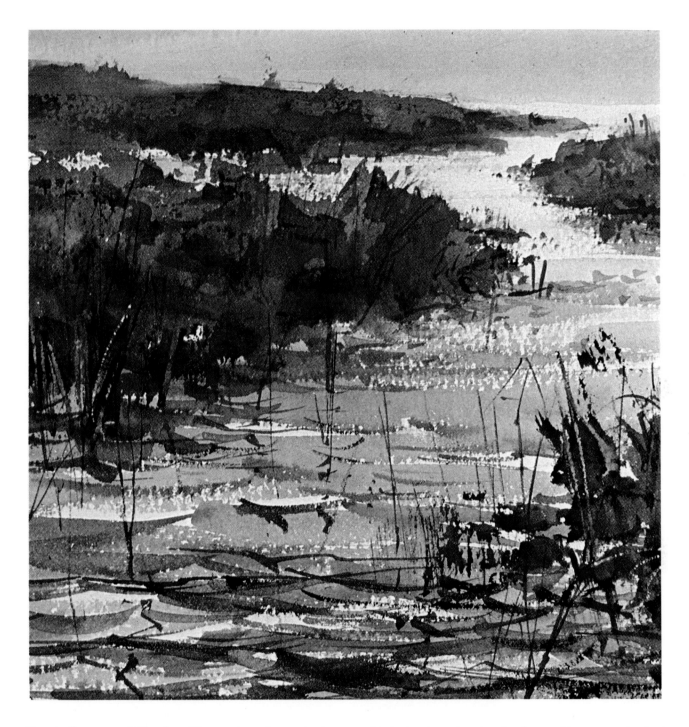

Marsh Grass and Ripples. The patches of grass in the right foreground and the middle distance are painted with ragged strokes of the side of a round brush—very much like the beach grass on the dunes. But the green mass along the horizon is painted with horizontal strokes that follow its long, narrow shape. The colors of the water are first painted broadly with thick, horizontal strokes that curve slightly to suggest the movement of the water. Wet strokes alternate with drybrush strokes, leaving flecks of bare paper that look like sparkles of light on the water. When the underlying strokes are dry, the tip of a small, round brush strikes in darker, thinner strokes that create the feeling of ripples in the immediate foreground. All the details of the water are concentrated at the lower end of the picture—implying that these details continue into the distant water, which is actually painted with just a few broad strokes.

Step 1. The preliminary pencil drawing defines the shape of the foam of the breaking wave, then traces the tops of the distant waves and the shape of the shoreline. The sky is covered with a pale wash of yellow ochre applied with a large, round brush, followed by strokes of cerulean blue. The two colors merge softly, but each retains its identity.

Step 2. A large, round brush is used to paint the water in thick, curving strokes, leaving strips of bare paper to suggest the foamy tops of the waves. A strip of white is left along the horizon to look like light shining on the water. The strokes are mixtures of yellow ochre, cerulean blue, Payne's gray, and ultramarine blue—never more than two or three colors to a mixture. The distant headland is painted with a flat wash of yellow ochre, cerulean blue, and Payne's gray.

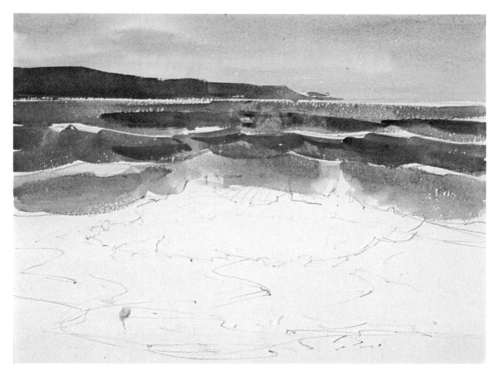

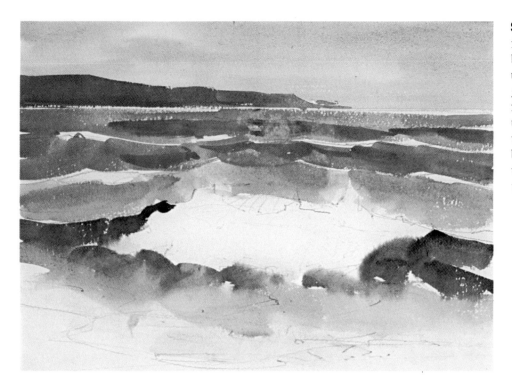

Step 3. The shape of the foam is more clearly defined by surrounding strokes of ultramarine blue, Hooker's green, and burnt umber. Before these colors are carried under the forward edges of the foam, the bare paper is brushed with clear water. So the strokes at the bottom of the wave have soft edges.

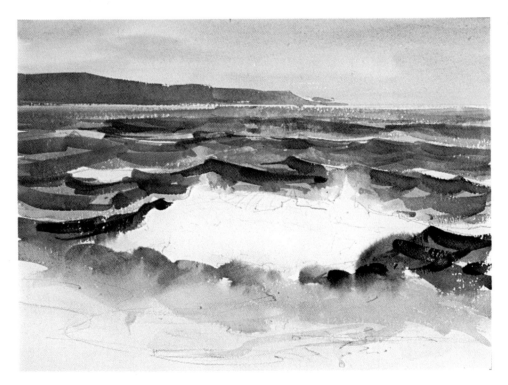

Step 4. The sea is darkened with more curving strokes of ultramarine blue, Hooker's green, and burnt umber. The darkest strokes are concentrated behind and around the foam, which now stands out as a strong, light shape.

Step 5. When the colors of the surrounding waves are dry, the shadows on the foam are brushed in with a pale wash of cerulean blue and burnt sienna, broken and softened by strokes of clear water that preserve the whiteness of the paper at the top of the foamy shape. Above and behind the breaking foam, the green top of the wave is painted with cadmium yellow, Hooker's green, and cerulean blue—the strokes curving downward to follow the movement of the wave.

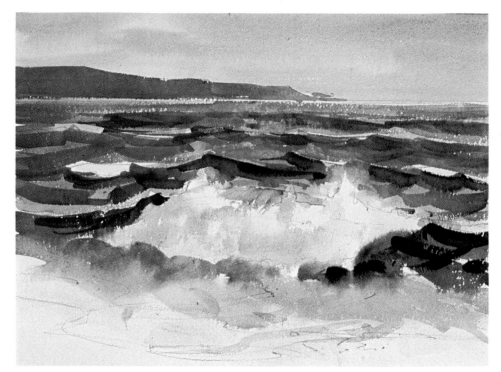

Step 6. The strip of beach at the lower edge of the painting is brushed in with mixtures of burnt sienna and cerulean blue in the light areas, burnt umber and ultramarine blue in the darks. The wet strokes blur into one another. Notice the pale patch just left of center, broken by vertical strokes, which looks like a reflection on the wet sand.

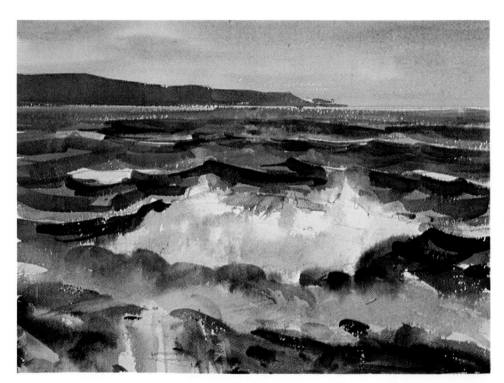

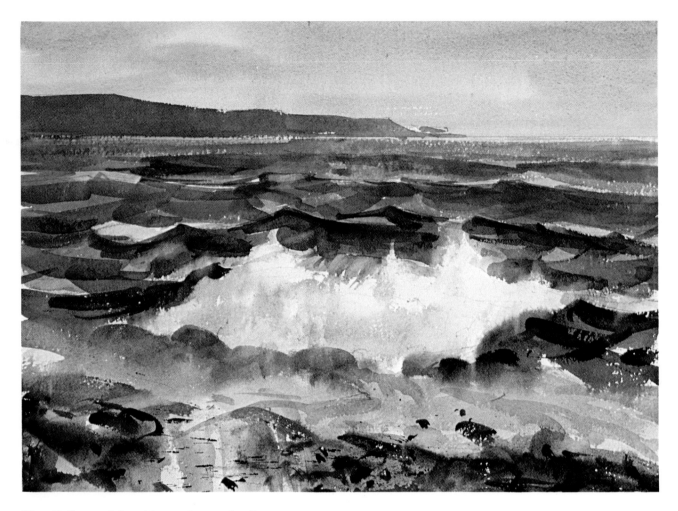

Step 7. Some of the white patches on the distant sea are a little too insistent, so they're toned down with very pale washes of yellow ochre and cerulean blue, applied with a small, round brush. Look at the bit of white at the extreme right, just above center, in Step 6; compare it with Step 7— and you'll see the difference. It's important to darken these patches so they don't distract attention from the larger white shape of the breaking wave in the foreground. The water spilling across the beach in the foreground is strengthened with pale strokes of ultramarine blue, Hooker's green, and burnt umber, which you can see just above the dark shape of the beach at the right. Then the tip of a small, round brush is used to add dark strokes and flecks that look like rocks and bits of seaweed on the beach. Notice how a few very thin strokes carry across the pale patch of sand—just left of center—which now lies flat and really looks shiny.

Step 1. The shapes of the rocks are carefully drawn in pencil, as are the shapes of the waves to the right. The horizon line is clearly established. But the burst of foam is drawn casually, since this will have soft, wet edges. The upper third of the paper is brushed with clear water, followed by strokes of yellow ochre and Payne's gray; these are carried up to the edge of the foam, where they melt softly away, leaving bare paper.

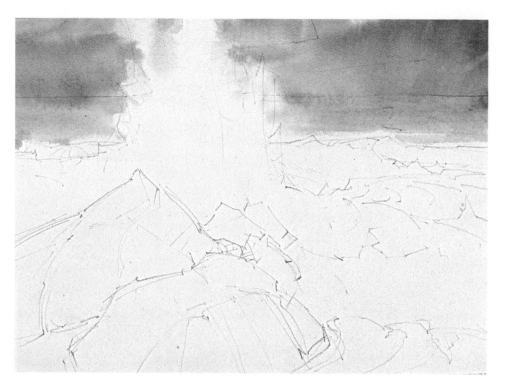

Step 2. When the sky and distant sea are dry, the water is darkened with a wash of Payne's gray and yellow ochre. This, in turn, is allowed to dry. Then, darker strokes of the same mixture are carried over the underlying color, leaving lighter strips between them.

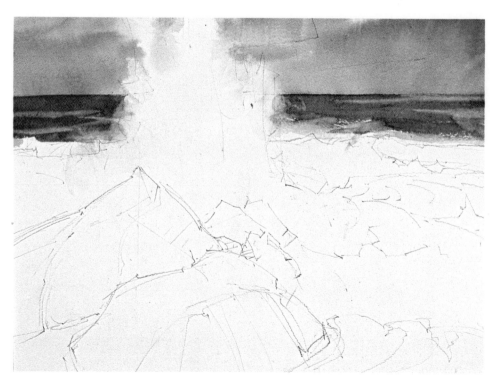

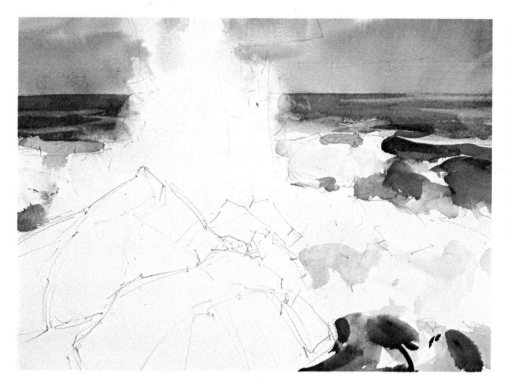

Step 3. Some pale shadows are added to the foamy shapes surrounding the big burst in the center. These are mixtures of yellow ochre, Payne's gray, and ultramarine blue, painted with a large, round brush. The darks of the waves in the middle distance and in the right foreground are painted with this same mixture containing much less water. But most of the foam is still bare paper at this stage.

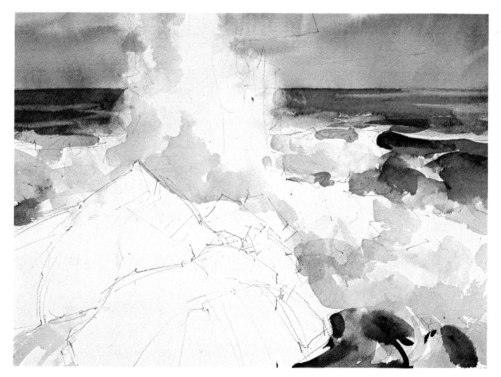

Step 4. All the major shadow areas of the foam are now painted with Payne's gray and a little yellow ochre. The strokes are short and ragged, often applied with the side of a round brush, reflecting the movement of the foam. The edges of some strokes are softened with a stroke of clear water—you can see this in the shadow to the left of the big burst of foam.

Step 5. The dark shapes of the rocks are painted with rough, rapid strokes of burnt umber, Hooker's green, and ultramarine blue. The strokes vary in tone, some containing more burnt umber and some containing more blue or green. While the paint is still damp, it's scraped with a knife blade, which leaves some lighter patches and some irregular scratches that express the rocky texture.

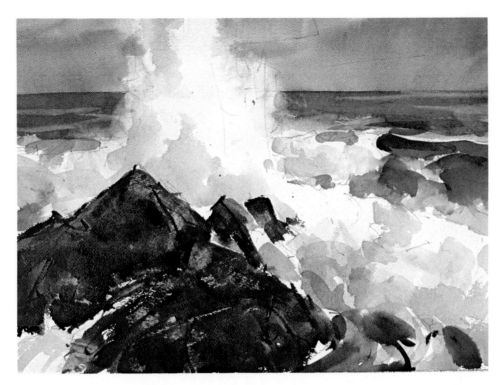

Step 6. When the rocks are dry, the tip of a small, round brush adds dark lines and dots—a mixture of alizarin crimson and Hooker's green. Now the rocks have the usual cracks and other breaks in their rough surface. A small, round brush adds some thin strokes of Payne's gray and ultramarine blue in the upper right section to define the distant waves more clearly.

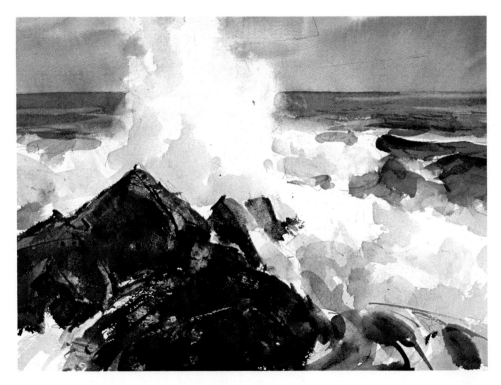

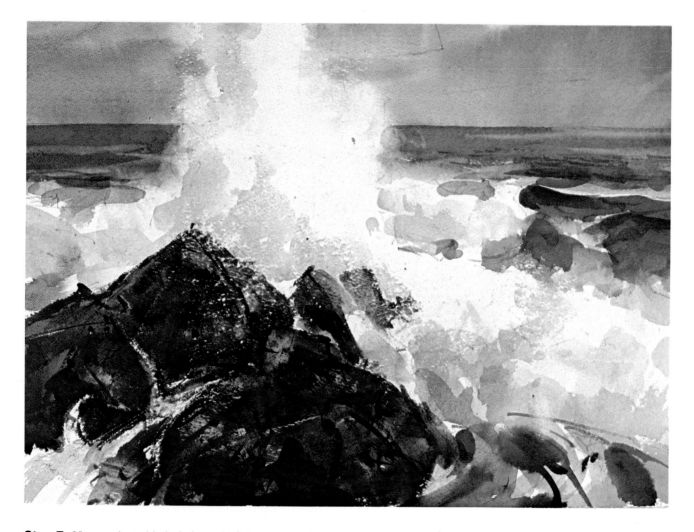

Step 7. Now a sharp blade is brought into play—not the tip, but the sharp edge. The blade is carried lightly over the surface of the rocks and the foam in the foreground, gradually lifting away some bits of color from the high points of the paper. Where these flecks of color are removed, dots of bare paper begin to show through. Now flecks of foam seem to be flying over the rocks and into the air. Notice how the tip of the blade is used to scratch a white line next to the dark crack in the rock to the extreme left, so that the crack seems deeper and more three-dimensional. When you work with a knife, it's important to know when to stop. The technique is so fascinating that you can get carried away and scrape off too much. Just a few scrapes are enough to do the job.

DEMONSTRATION 3. TIDEPOOLS

Step 1. The shapes of the tidepools left behind by the receding water are carefully drawn, and so are the big forms of the rocks and the shape on the distant horizon. This pictorial design has a lot of beautiful curves and angles that must be well defined in the drawing. The sky is covered with a wash of yellow ochre, followed by strokes of Payne's gray, applied while the yellow ochre is still wet.

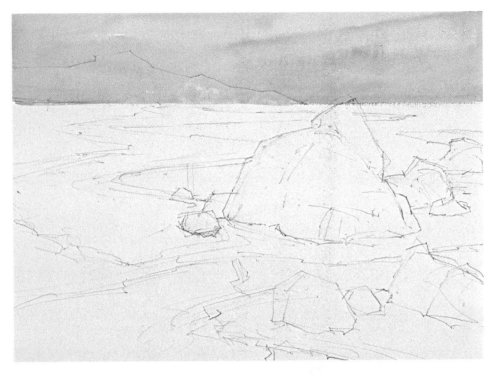

Step 2. The distant headland is painted with a darker wash of yellow ochre, cerulean blue, and Payne's gray, lightened here and there with a touch of a paper towel. This mixture is carried down into the rhythmic shapes of the beach. Notice how the mixture gradually changes as it comes toward the foreground—where there's much more yellow ochre. The rocks and water are still bare paper.

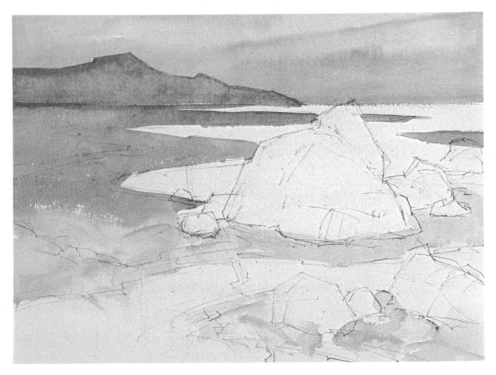

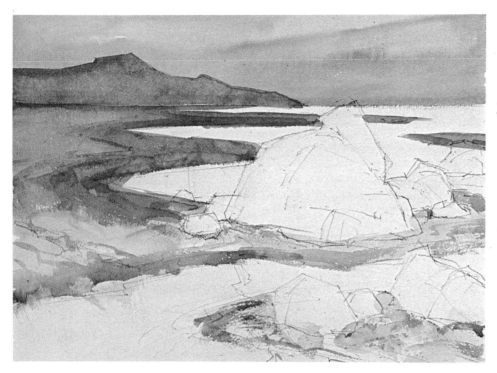

Step 3. The shapes of the sand are darkened and defined more clearly with strokes of Payne's gray, yellow ochre, and burnt sienna. The sand in the lower right section is painted with drybrush strokes to suggest a pebbly texture.

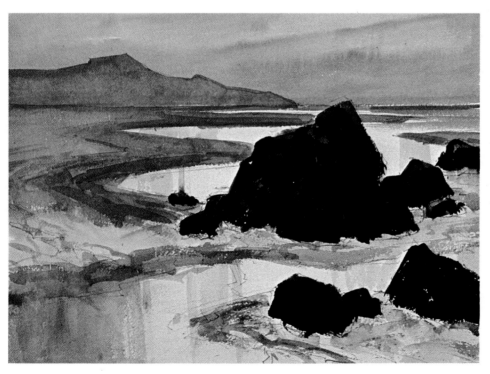

Step 4. The still water of the pools is painted with a flat brush, applying vertical strokes of Payne's gray, cerulean blue, and yellow ochre that suggest reflections from the sky and from the edge of the sand. The distant water in the upper right section is painted with horizontal strokes of the same mixture. Then the dark tones of the rocks are painted with mixtures of alizarin crimson, Hooker's green, and burnt umber, applied with overlapping strokes, some darker and some lighter. While the color is still wet, some lighter areas are scraped away with a blunt knife.

Step 5. The dark reflection of the biggest rock is painted with the same mixture of Hooker's green, alizarin crimson, and burnt umber, using a small, round brush to move carefully around the edge of the smaller rock beneath. The top and left side of the reflection are blurred with strokes of clear water. The reflections of the small rock at the extreme right and the rock at the bottom of the picture are painted with the same mixture.

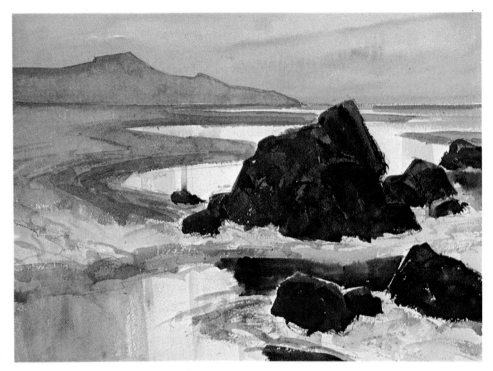

Step 6. More dark strokes are carried around the edges of the water—mixtures of Hooker's green, Payne's gray, yellow ochre, and burnt sienna. The sand beneath the biggest rock and in the lower right corner is textured with more strokes of burnt sienna and Hooker's green. The tops of the rocks are scrubbed with a wet bristle brush and blotted with a paper towel to lighten them a bit.

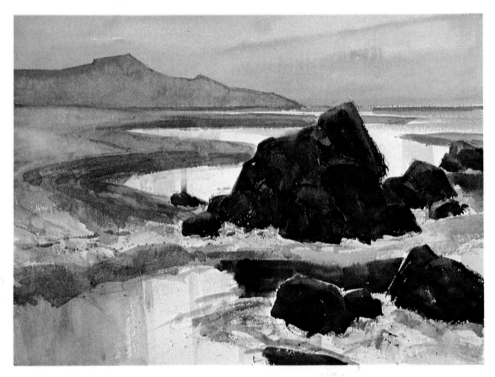

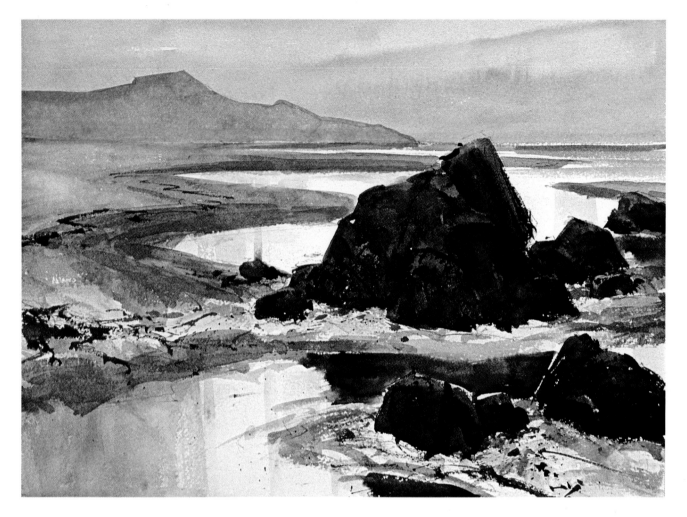

Step 7. A small, round brush is loaded with a dark mixture of cadmium red and Hooker's green. The tip of the brush adds dark strokes to finish off the rocks. The same mixture is used for dark drybrush strokes to suggest seaweed on the sand. Notice how the seaweed follows the curve of the shore into the distance. The brush is flicked at the sand, spattering dark droplets that look like pebbles and other debris. This painting is a particularly dramatic example of aerial perspective: the darkest tones, the strongest contrasts, and the most detail are in the foreground, while the palest tones and least detail are in the distance.

Step 1. The sea invades the land to form a salt marsh where thick patches of marsh grass grow to create islands and peninsulas. The shapes are ragged and spiky; therefore all you can do is indicate them very roughly with pencil lines. The important thing is to establish the overall shapes of land and water. The sky begins with a pale wash of yellow ochre and alizarin crimson, followed by strokes of cerulean blue and Payne's gray, applied while the underlying color is still wet.

Step 2. The same procedure is followed in painting the water. First, the water is covered with horizontal strokes of alizarin crimson, yellow ochre, and a bit of Payne's gray, leaving breaks between the strokes to suggest light on the water. Before this warm tone is completely dry, the darker strokes are added in the foreground and middle distance—a mixture of cerulean blue and Payne's gray. The strokes curve slightly to express the ripples of the water.

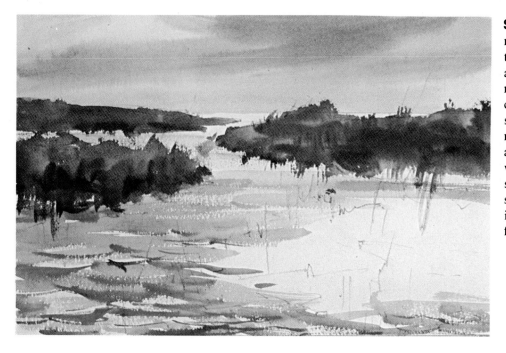

Step 3. The shapes of the marsh grass in the middle distance and along the horizon are first covered with a warm mixture of burnt sienna and cerulean blue. While this is still wet, a darker, cooler mixture of Hooker's green and burnt umber is brushed in with ragged strokes, leaving some lighter gaps. The strokes are carried downward into the water to suggest reflections.

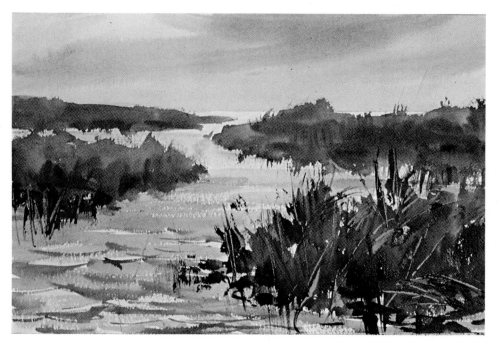

Step 4. The marsh grass in the foreground is painted with the same colors as those in Step 3, but with less water; thus the tone is darker. While the color is still damp, a blunt knife scrapes away some light lines to suggest pale stalks. You can see that the strokes of the brush vary in tone, some containing more brown and others containing more blue or green. A similar patch of grass is painted in the section at the left.

Step 5. More darks are added to the marsh grass in the distance with a mixture of Hooker's green, cerulean blue, and burnt sienna, applied with a small, round brush. Now the shapes of the marsh grass seem to have distinct lights and shadows, although these are painted very loosely.

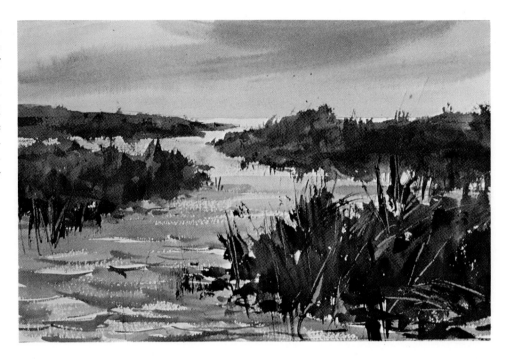

Step 6. More detail is added to the marsh grass in the right foreground, using the tip of the same small brush. (The signpainter's brush called a rigger would be useful here.) The dark lines are a mixture of Hooker's green and burnt sienna. Blades of marsh grass are added to the water, and you can even see a wiggly reflection beneath one of the stalks toward the left.

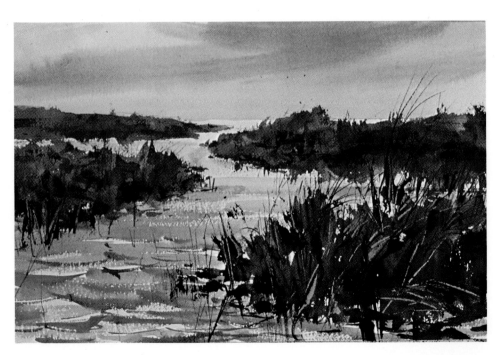

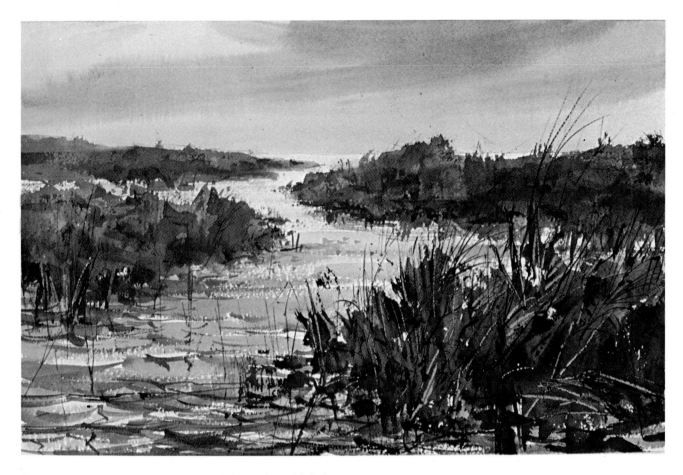

Step 7. The tip of a small, round brush is used to add dark ripples to the water in the foreground and dark reflections beneath the clump of marsh grass to the right. These curving strokes, which express the movement of the water, are a mixture of Hooker's green, Payne's gray, and burnt umber. More blades of grass are added with Hooker's green, burnt sienna, and alizarin crimson. If you look carefully at the lower left section, you'll see the reflections of the grass—slender, zigzag strokes. More light lines are scratched out of the grass to suggest individual stalks caught in sunlight. With so much intricate brushwork in the foreground, it's important to keep the shapes in the middleground simple, as you see here. And it's equally important to have a simple sky.

Step 1. Because this will be a dramatic sky, painted wet-in-wet, only a few big cloud shapes are defined in the pencil drawing—and these will certainly disappear as the color begins to flow. It's more important to define the horizon line clearly and draw the solid shapes of the rocks. The lines on the sea divide the light areas from the dark. So that the sky won't be too cold, it's covered with a warm mixture of yellow ochre and alizarin crimson.

Step 2. While the warm undertone is still wet, dark strokes of Hooker's green, ultramarine blue, and burnt sienna are flooded onto the shiny surface of the paper. The paper isn't completely covered. One large gap and some smaller ones are left for the moonlight. While the dark sky is still wet, a paper towel or a cleansing tissue can be used to blot away some dark color if it gets out of hand.

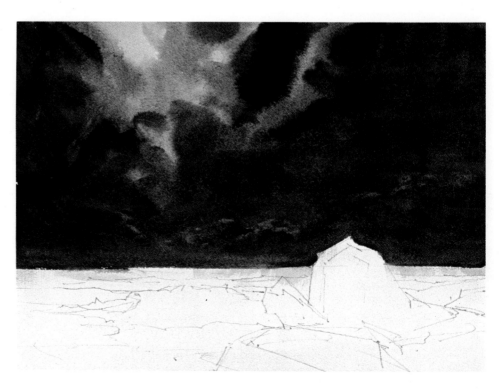

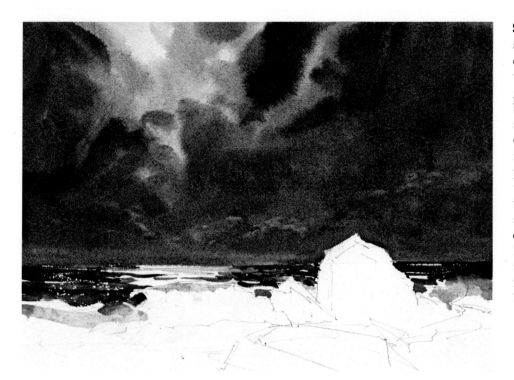

Step 3. The rich sky tone is allowed to dry. Now the darks of the water are painted with a mixture of Hooker's green, ultramarine blue, and burnt sienna. Horizontal strokes are made with the tip of a small, round brush, leaving a large gap of bare paper, plus some smaller flecks of white for the moon shining on the sea. Paler strokes of this same mixture are used to darken some parts of these light patches and are carried toward the foreground. The foam and the rocks are still bare paper.

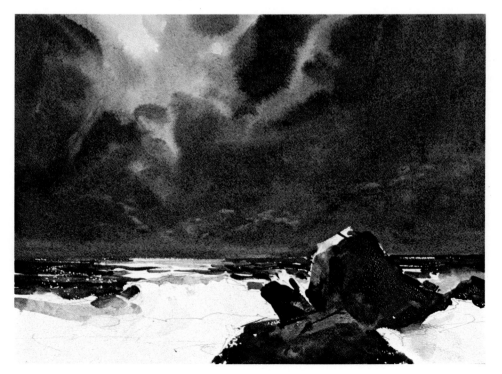

Step 4. The dark shapes of the rocks are painted with burnt umber, alizarin crimson, and Hooker's green. A lighter tone of this mixture goes on first, followed by darker strokes, some containing more brown and others containing more green. The top of the biggest rock is left untouched, suggesting a patch of moonlight.

Step 5. Now the luminous shadows of the foam in the foreground are painted with mixtures of burnt sienna, cerulean blue, and yellow ochre. The wet strokes blur into one another. A dark pool is painted next to the foreground rock with cerulean blue and burnt sienna. The top edge of the breaking wave remains bare paper, giving the impression of reflected moonlight. Notice the curving strokes in the lower right corner, suggesting the swirl of the water.

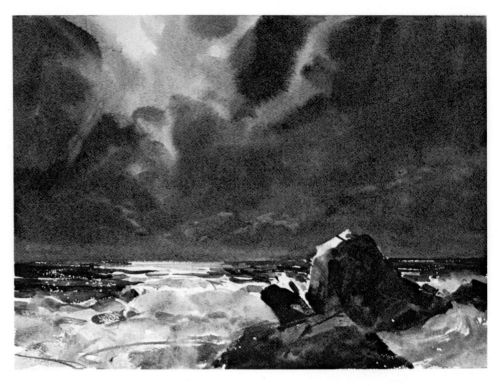

Step 6. Some light tones are scrubbed out of the dark rocks with a wet bristle brush, then blotted with a paper towel to lift off the color. The rocks are then warmed slightly with a mixture of alizarin crimson and yellow ochre, applied with a small, round brush.

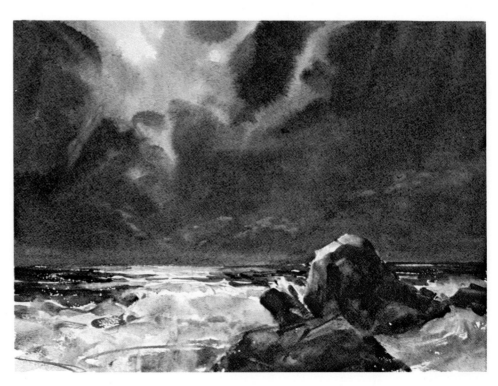

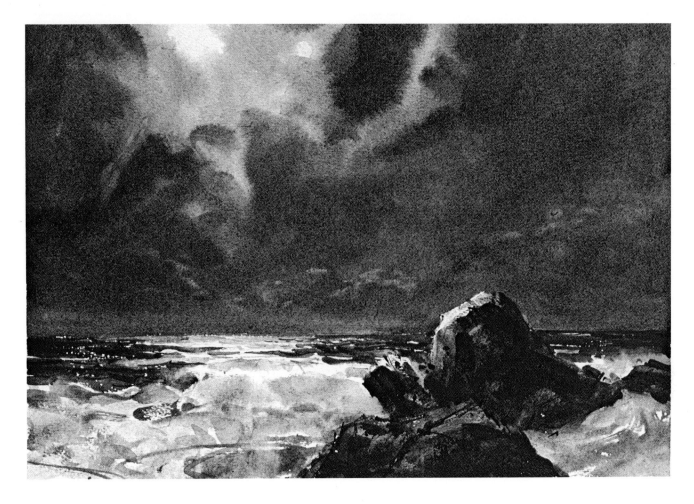

Step 7. A small, round brush picks up a mixture of alizarin crimson and Hooker's green to add more dark strokes to the rocks, sharpening their edges and making them stand out more clearly. Small strokes of this same mixture are added to the distant sea, suggesting more waves. Look carefully at the top of the foam, just below the flash of moonlight on the sea, and you can see where a wet bristle brush and a paper towel have been used to scrub away a bit more color to reveal more white paper. The moonlit top of the most prominent rock is warmed very slightly with a pale mixture of alizarin crimson and yellow ochre. You can now see this mixture very clearly in the moonlit patch on the water. It should be obvious by now that a moonlit picture isn't all just black, gray, and white, but can be full of rich color.

Step 1. The pencil lines define the distant headland, the horizon, the rocks in the foreground, and the edges of the waves moving in toward shore. The sky is completely covered with a wash of Payne's gray and yellow ochre, applied with a large, flat brush. The tone is carried over the distant headland. More water is added to the wash at the lower right, so the headland won't be too dark.

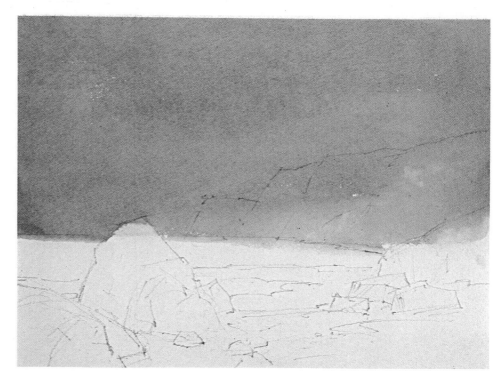

Step 2. The headland is painted with a flat wash of Payne's gray, cerulean blue, and yellow ochre, applied with a large, round brush. The tip of the brush carefully traces the shapes of the cliffs. A paler version of the same mixture is carried over the rocks to the right. You may have noticed that the sky tone covers the tip of the big rock to the left; it doesn't matter, because the rock will be painted in a very dark tone. The entire foreground is still bare paper.

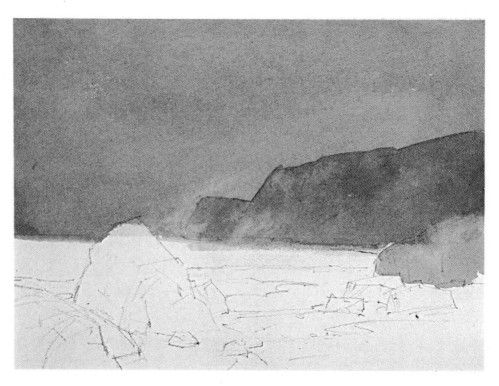

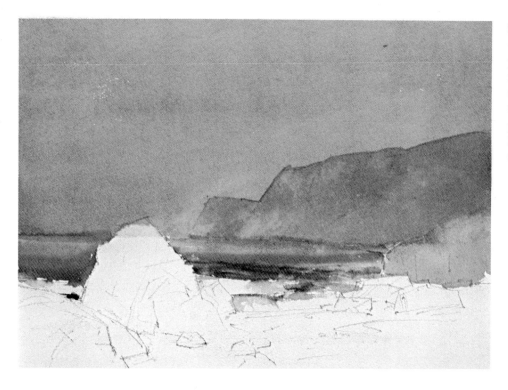

Step 3. The water is covered with a wash of Payne's gray, yellow ochre, and a little cadmium yellow, applied with a small, round brush. Before this underlying wash is completely dry, the tip of the brush adds some darker strokes of this same mixture.

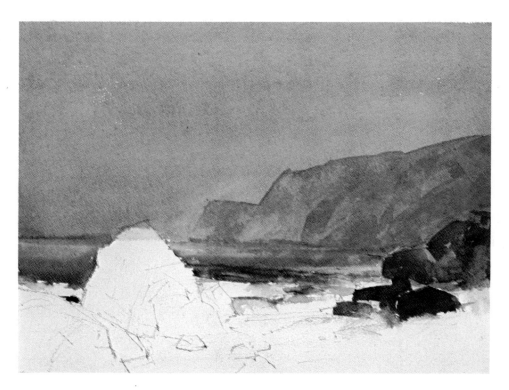

Step 4. The rocks to the right are painted in irregular flat washes of Payne's gray, Hooker's green, and burnt sienna. A small, round brush is used to paint the shapes precisely. Notice that the lower edges of the rocks have been lightly brushed with clear water here and there; thus they seem to melt away into the beach. Some free diagonal strokes are added to the distant headland to suggest shadows on the cliffs; these are a mixture of Payne's gray and yellow ochre.

Step 5. The underlying tone of the sand is painted with the same mixture of Payne's gray and yellow ochre, using a large, round brush. So far, the picture has been painted almost entirely with these two colors, as you've certainly noticed. Fog seems to cast a veil over everything, reducing it to shades of gray. But it's not a dead, steely gray. On the contrary, it's a gray that's full of subtle color.

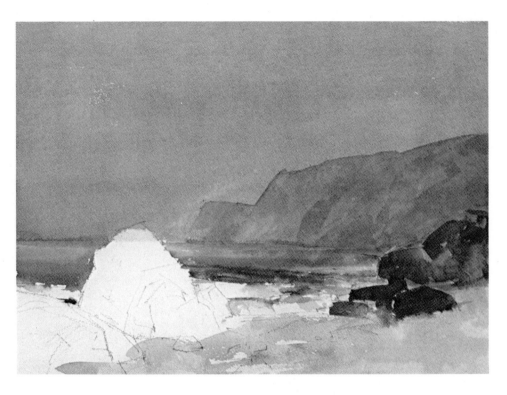

Step 6. The rocks in the lower left corner are the one really dark note in the picture. First they're covered with Payne's gray, yellow ochre, and a little Hooker's green. Then, while they're still wet, the darker notes are added with Payne's gray, Hooker's green, and burnt sienna. The rocks all flow together in a single continuous shape divided by just a few dark strokes.

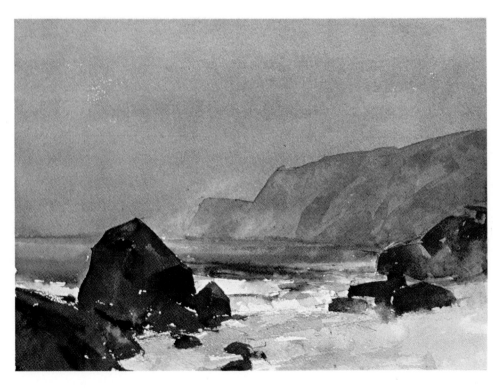

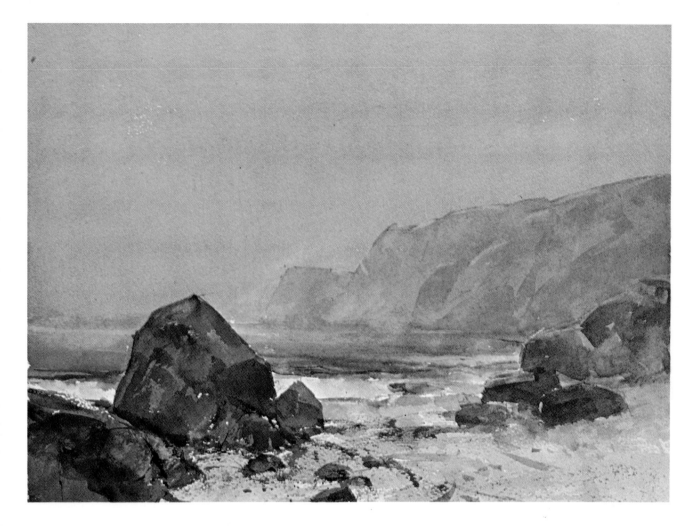

Step 7. The shapes of the rocks in the left corner are
strengthened with dark strokes of Payne's gray and burnt si-
enna, applied with a small, round brush. The shadow planes
are clearly defined. The tip of the brush adds cracks and
some dividing lines between the rocks. The lower edges of
the rocks are drybrushed; thus they seem to sink into the
sand, rather than sit on top of it. A few of these dark strokes
are added to the rocks at the right and to the edge of the dark
water. Then this mixture is drybrushed over the sand. To
make the headland melt away farther into the distance, it's
scrubbed with a wet bristle brush and then blotted with a
paper towel. The tops of the rocks at right are also scrubbed
and blotted. And the same thing is done to the water along
the horizon to the left. Now the dark rocks in the foreground
really come forward, while the distant headland fades away
into the mysterious fog.

Step 1. The pencil lines precisely delineate the rocks, horizon line, and headland. But they do nothing more than locate the dark and light masses in the sky. The strokes of the sky will obliterate the pencil lines and won't really follow them too carefully. The sky is first covered with pale mixtures of burnt sienna, yellow ochre, and cerulean blue, with some darker strokes of cerulean blue in the lower right section.

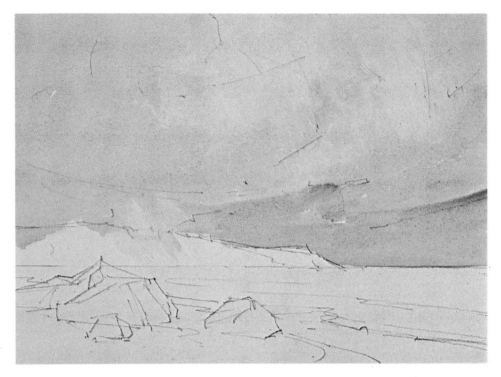

Step 2. When the underlying tone is dry, large strokes of burnt sienna and cerulean blue are swept across the sky in a curving motion that expresses the movement of the storm clouds. A pale mixture of these two colors is brushed in first. Before it's dry, the darker strokes, containing more blue, are added. Notice how a light patch is left at the top of the sky, and a strip of light is left above the horizon.

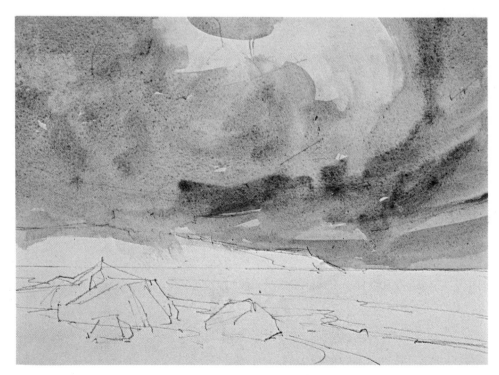

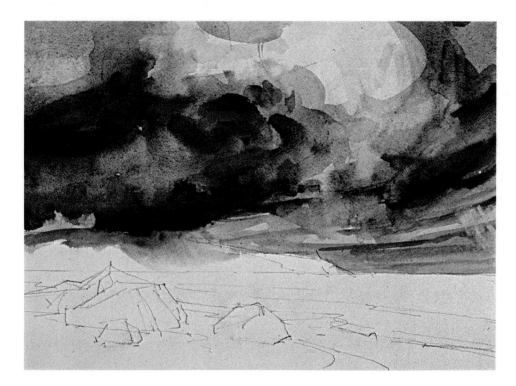

Step 3. The tones in Step 2 are allowed to dry. Now darker strokes of burnt sienna and ultramarine blue are brushed in with rapid, irregular strokes that express the turbulence of the storm clouds. Some of these strokes blur into one another, creating soft edges. Others stand alone—like those in the upper right section—and have hard edges. Some of the dark tone is carried over the distant shore.

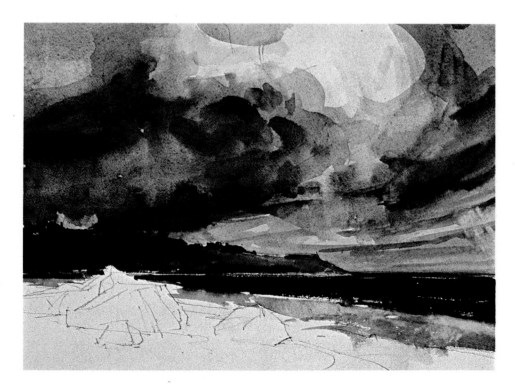

Step 4. When the sky is dry, the distant shore is painted with yellow ochre and Hooker's green in the sunlit area to the right. While this is still wet, the dark area to the left is painted with Hooker's green and burnt umber—and the two colors blur together. The water is painted with long, straight strokes of Hooker's green, ultramarine blue, and burnt umber. This same mixture is lightened with water as it approaches the shore.

Step 5. The beach is painted with burnt sienna and cerulean blue, applied in irregular strokes, some darker and some lighter. A few of these strokes are carried out into the pale tone of the water.

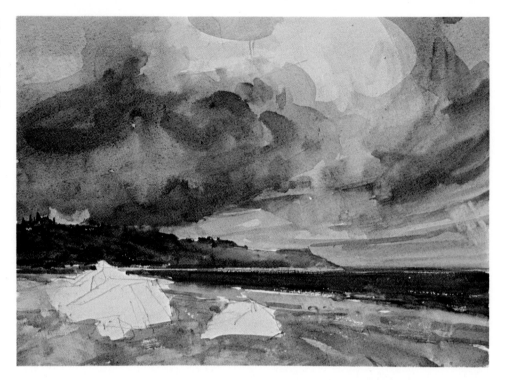

Step 6. The rocks are painted with burnt umber, ultramarine blue, and a touch of cadmium red. The darks are added before the lighter tones are completely dry so that they blend together slightly. These dark strokes contain more ultramarine blue. A few touches of the brush suggest some pebbles to the right of the rocks.

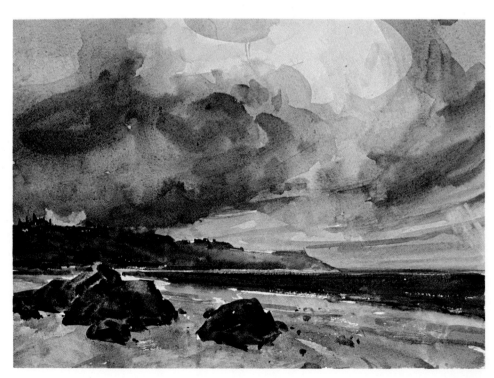

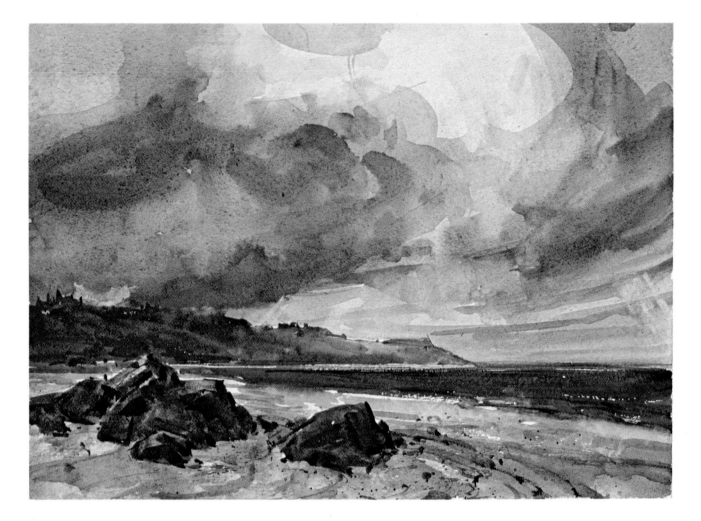

Step 7. Alizarin crimson and Hooker's green are mixed for the dark strokes that are added to the rocks in this final stage. The shadows on the rocks are more clearly defined with precise strokes, which also sharpen the edges. Pale, curving strokes of cerulean blue and burnt sienna are carried along the beach to suggest the contour of the shoreline. Droplets of this mixture are flung at the foreground and spattered across the sand to suggest pebbles. When you finish painting a dramatic sky, it's always tempting to go back and try to make a few last-minute changes. Such a sky is painted so rapidly, so intuitively, that you can always find things "wrong" with it. But you're almost certain to ruin it by going back and trying to eliminate those imperfections—which only you can see. So now is the time to stop.

Step 1. Rocks must be studied with care and then drawn with precision. You can't just invent them. Here, the pencil lines define not only the overall shapes of the rocks, but the shapes of the shadows. The sky is first brushed with a pale wash of yellow ochre. Into this wet color goes a darker mixture of Payne's gray and alizarin crimson. There's a little more crimson just above the horizon.

Step 2. The water is painted with ultramarine blue, Hooker's green, and burnt umber. The color is applied with dark, heavy strokes at the horizon, and more water is added to the mixture as it approaches the beach. Some bare paper is left in the distance to suggest light on the water. And more bare spots are left along the beach to suggest foam. The headland is first covered with a pale wash of Payne's gray and burnt sienna. When this is dry, a darker mixture of the same colors, with more Payne's gray, is painted in straight diagonal strokes to create the shadows on the cliffs.

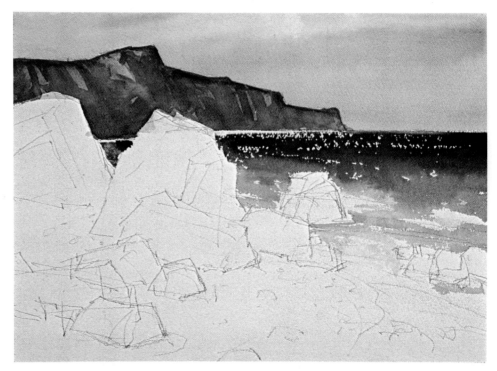

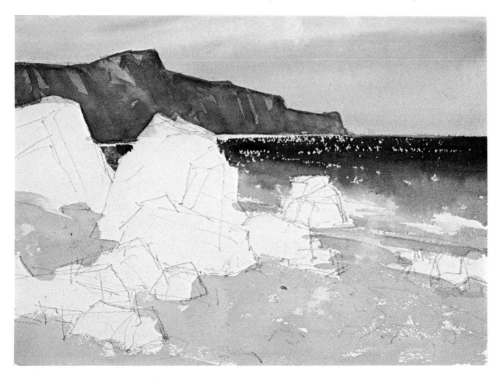

Step 3. The sand is painted with a mixture of yellow ochre and Payne's gray. It's no problem if the tone of the sand splashes over the edges of the rocks. The dark tones of the rocks will quickly cover anything underneath.

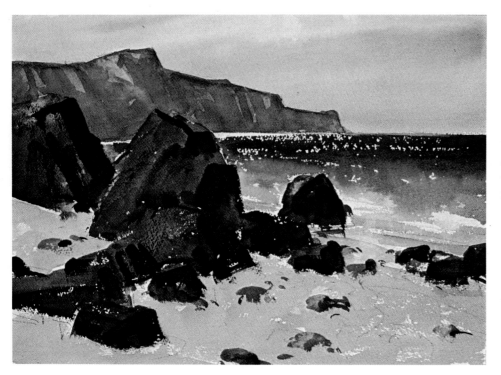

Step 4. The big rocks and some smaller stones are first covered with a mixture of Hooker's green, burnt umber, and a little cadmium red. When this undertone is dry, the dark planes are painted with ultramarine blue and burnt umber. The lower edges of the rocks are drybrushed so that they seem to be sinking into the sand.

Step 5. A paler mixture of ultramarine blue and burnt umber is used to paint rocks and pebbles of different sizes scattered across the beach. Most of these "pebbles" are nothing more than curving strokes, thin at one end and thick at the other, which you'll see if you look closely at the right foreground. Only a few larger rocks are painted completely, with a touch of dark at the right to suggest a shadow. This mixture is then spattered across the sand to suggest smaller pebbles.

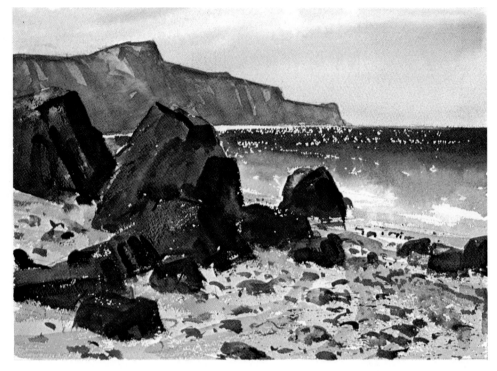

Step 6. The very tip of a small, round brush now adds dark lines to the rocks with a mixture of Hooker's green and alizarin crimson. This same mixture is used for touches of shadow beside the smaller rocks and pebbles on the beach.

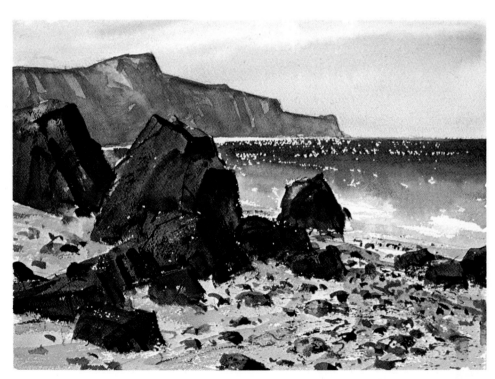

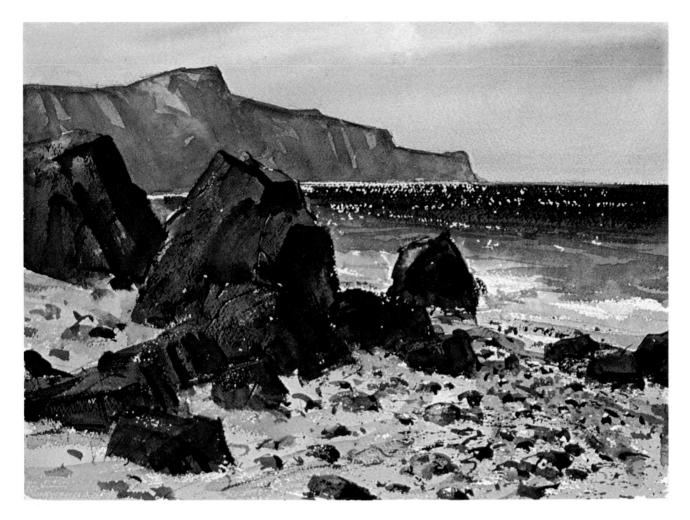

Step 7. More horizontal strokes are added to the water with a blend of Hooker's green, ultramarine blue, and burnt sienna, applied with the tip of a small, round brush. Some flecks of light are scraped off the tops of the smaller stones with a sharp blade. You also see some scraping in the lighter areas of the water, where the foam washes against the edge of the beach, and flecks of light are scraped off the tops of the big rocks. The sharp point of the blade is drawn beside some of the dark lines in the rocks, throwing the cracks into bolder relief. Here's another one of those "gray" coastal scenes—actually full of subtle color.

Step 1. The soft curves and subtle shadows of dunes are really impossible to render with lines. So all you can do is draw the shapes of the tops of the dunes, roughly locate the shadows, add a few strokes for beach grass, and then stop. A pale wash of yellow ochre, with a touch of burnt sienna, is brushed over the sky. While this is still wet, strokes of cerulean blue and Payne's gray are added. The strip of water is painted with Hooker's green, ultramarine blue, and a little burnt umber, with more water added at the bottom.

Step 2. The tones of the sand are lightly brushed in with yellow ochre, burnt sienna, and cerulean blue. A large, round brush carries soft, curving strokes over the contours of the dunes.

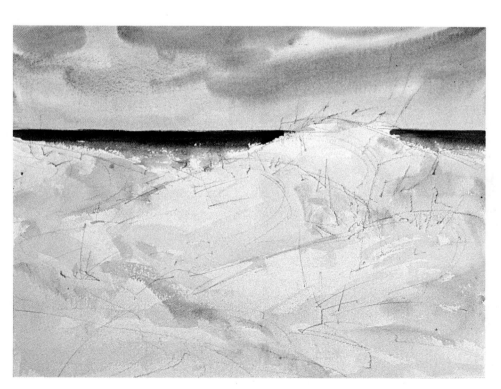

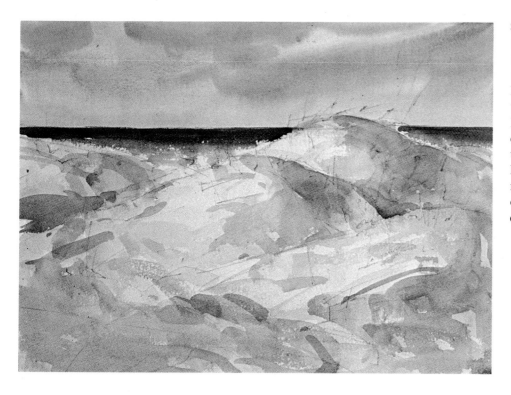

Step 3. When the first tones of the sand are dry, the forms are strengthened with darker strokes of the same mixtures. Now you can see clearly how the strokes curve, freely following the contours of the dunes. The shadow sides of the dunes are clearly established at the right of each rounded form. And a shadowy tone is carried across the entire foreground.

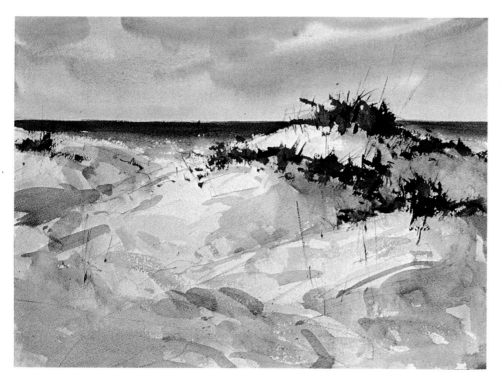

Step 4. At the tops of the dunes, clusters of beach grass are roughly brushed in with a mixture of Hooker's green and a little burnt sienna in the light areas, then Hooker's green and cadmium red for the darks. In a couple of spots, you can see touches of almost pure burnt sienna. The thicker tufts of beach grass are painted with the side of the brush, which leaves a ragged stroke. And the tip of the brush is used to indicate the slender stalks. These rows of beach grass are important because they establish the curving tops of the dunes.

Step 5. More darks are now added to the beach grass with a mixture of Hooker's green, burnt sienna, and ultramarine blue, drybrushed with the side of a round brush. More blades of beach grass are added in the foreground. And this tone is spattered diagonally across the foreground, accentuating the diagonal tilt of the dunes.

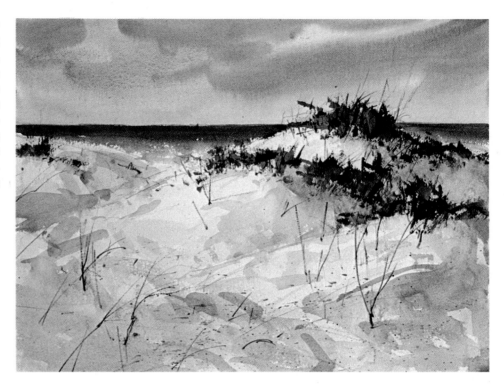

Step 6. Now the curves of the dunes can be strengthened with more shadows. These are painted with sharply defined, curving strokes of yellow ochre, burnt sienna, and cerulean blue. The strokes wind through the landscape, curving around the bases of the dunes. The shadows between the two dunes at the upper right are darkened with this mixture. And the tip of the brush is used to draw slender lines of shadow that are cast by the stalks of grass and travel down the sides of the dunes.

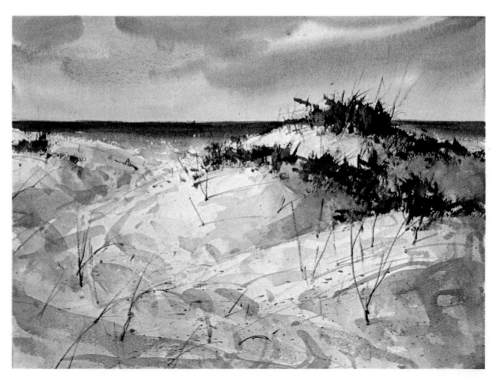

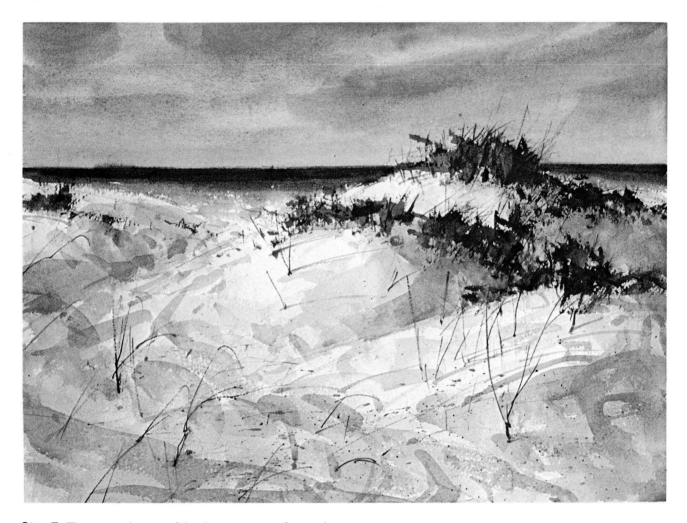

Step 7. The very pale tone of the dunes accounts for much of their beauty. But this tone needs to be accentuated by a darker background. So the sky is then brushed with clear water and deepened with cerulean blue and Payne's gray. The new colors blur together and create no hard edges. When the sky tone is dry, the water is also darkened with more Hooker's green, ultramarine blue, and burnt umber, creating a strong contrast with the sunlit top of the dune that cuts across the horizon. Sand dunes are among the most difficult coastal subjects to paint. At the very beginning, it's important to establish the direction of the light so that you have a clear idea of the location of the lighted sides and the shadow sides of the dunes. Then you must paint them with pale but decisive strokes, never losing sight of the pattern of lights and shadows.

Step 1. Pencil lines define the light and shadow planes of the rocks in the right and left foreground. The overall shape of the headland is drawn; just a few lines suggest the big shadows. The trees at the top are suggested, but not drawn precisely. The sky is covered with a very pale wash of yellow ochre, followed by some light strokes of Payne's gray and ultramarine blue, which run downward into the wet undertone.

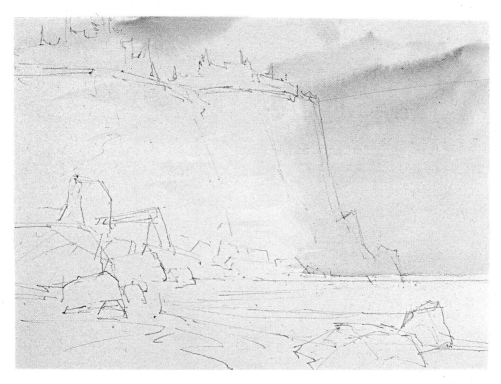

Step 2. The broad tones of the trees are painted with the side of a small, round brush that carries Hooker's green, ultramarine blue, and burnt umber. While this tone is still wet, the tip of the brush adds smaller lines for the trunks and branches.

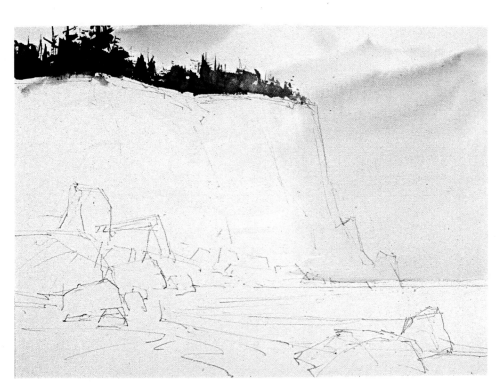

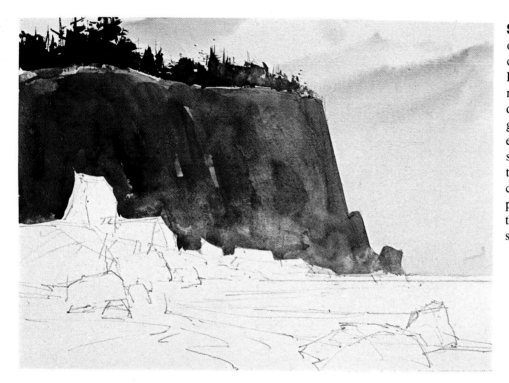

Step 3. The complete shape of the headland is roughly covered with a wash of Payne's gray and burnt sienna. While this is still wet, darker strokes of Payne's gray, burnt sienna, and Hooker's green are added to the shadows. There are gaps between the strokes, making the cliff look craggier. Some bare paper is left along the top of the cliff to suggest a glint of sunlight.

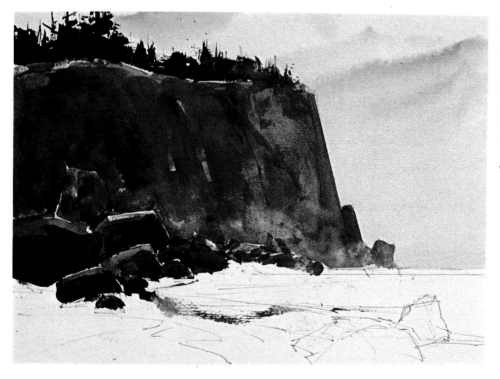

Step 4. The rocks are covered with a flat wash of Hooker's green and burnt sienna. When this is dry, the shadows are painted in with a darker tone of Hooker's green and burnt umber. Some strips of bare paper are left along the tops of the rocks, as they are on the top of the cliff.

Step 5. The water is covered with a light mixture of Hooker's green, Payne's gray, and yellow ochre, which is allowed to dry. Then the same mixture, with less water, is added with the tip of the brush, making some delicate lines for the waves, which you can see under the rocks at the center of the picture.

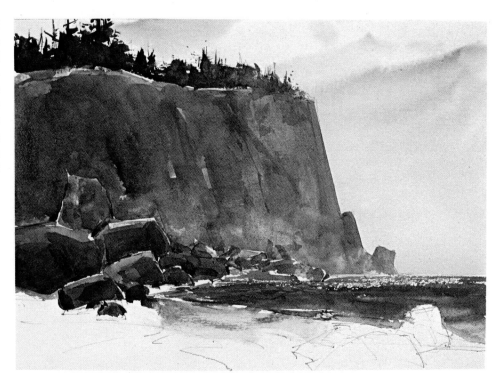

Step 6. The sand is freely brushed in with burnt sienna and Payne's gray. It's not a smooth, even tone. The sand is actually composed of darker and lighter strokes of the same mixture that blend together, wet-in-wet. The rocks in the lower right area are still bare paper.

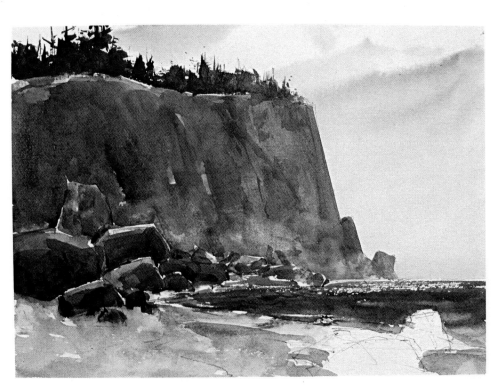

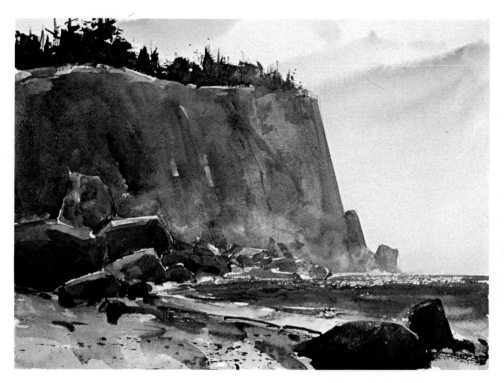

Step 7. The dark masses of the rocks in the lower right area are painted with a dense mixture of Hooker's green, burnt sienna, and cadmium red. While they're still wet, they're touched along the top with a paper towel to lighten the tones a bit. The tip of the brush handle strikes a white line between the two rocks. This same dark mixture is carried along the shoreline and spattered across the sand. Notice how the lower edge of the smaller rock is drybrushed so that it merges with the sand.

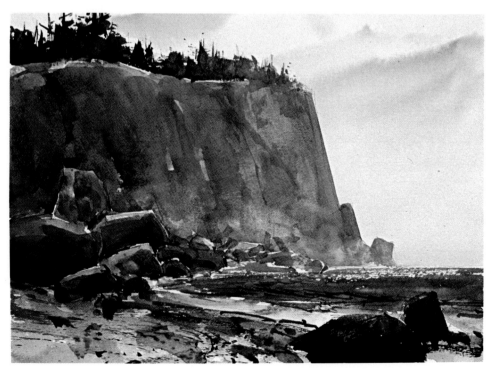

Step 8. Dark strokes are added to the rocks at the left with Hooker's green and alizarin crimson. These strokes accentuate the shadows and divide the rocks more clearly. The rocks at the right are also darkened with this mixture, and some lines are added for cracks. More dark strokes are carried along the sand, following the curve of the beach. And this mixture is used to add more lines for waves in the nearby water.

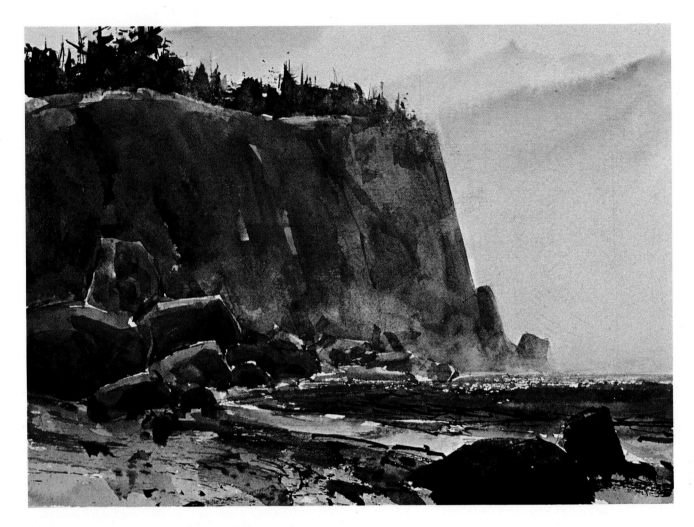

Step 9. Sometimes it really *is* worthwhile to make some last-minute alterations. The picture looks finished, but not quite. The edge of the headland is too sharp, too distinct, not mysterious enough. A large bristle brush is dipped in water and scrubbed along the forward edge of the cliff and down over the lower edge where it strikes the water. The wet color is blotted off with a paper towel. Now the end of the cliff seems to melt away into mist, and the rock at the base of the cliff almost disappears into the atmosphere. The horizon line, where sky meets water, is also scrubbed, blotted, and made more mysterious. Whenever you can, it's important to accentuate—even exaggerate—these atmospheric effects of the coastline.

How Much to Include. Standing on the beach or climbing a cliff overlooking the sea, you almost always see more than you can paint in a single picture. The panorama can go for miles, and you can't possibly include everything—though some beginners try and soon give up. You have to isolate some manageable segment of what you see. Two or three waves and a few rocks can make a simple, effective composition— and will capture the drama of the sea far more effectively than a panoramic picture with row upon row of distant waves. A single headland with a bit of curving beach in the foreground, a few rocks, and a hint of the distant shore—all these are enough to suggest the grandeur of the coastline. In short, try to construct a seascape painting out of just a few simple shapes.

What to Leave Out. You always see more than you paint, so deciding what to leave out is just as important as deciding what to put in. Even when you've finally settled on a simple arrangement of headland, beach, rocks, and a suggestion of distant shore, your painting will probably need further simplification. What if the beach is covered not only with rocks, but with seaweed, driftwood, and other debris? You can't paint them all, so you've got to leave out most of the smaller rocks and merge the remaining ones into a few simple shapes. A few scraps of seaweed are enough, and you may want to redistribute that seaweed so it traces a ragged line across the beach toward the headland, giving the eye a path to follow to your center of interest. Better take out the driftwood altogether; that fascinating, twisted shape is a distraction, and it's best to save it for another picture. Be ruthless about leaving out excess detail and any element that distracts the eye.

Redesigning the Subject. No matter how long you walk the beach, you won't find an ideal subject for a painting, with every rock, cliff, wave, and tidepool in just the right place. You must be prepared to rearrange what nature gives you and *organize* a picture. If the line of the beach looks too straight, you're free to redesign it into a graceful curve. Are the waves breaking too far up the beach? You can move them closer. Are the rocks too scattered and too far from the water? You can certainly relocate them and regroup them. Are the clouds too small and too high in the sky? Nothing prevents you from making them bigger and

moving them down toward the horizon. It's not nature's job to give you a picture. Nature simply gives you the components and it's *your* job to put them together.

Time of Day. In painting coastal subjects, *when* you paint can be just as important as *what* you paint. Experienced seascape painters like to get going early in the morning when the sun is still fairly low in the sky, creating strong patterns of light and shadow. That's when the shapes of rocks and cliffs, waves and surf look most dramatic. In the middle of the day, when the sun is directly overhead, the light is spread evenly over everything, shadows are less interesting, and even the most exciting subject often looks dull. Then things start to look interesting again in the latter part of the afternoon, when the sun is lower in the sky, very much like early morning. Late afternoon can be particularly dramatic as the sun drops toward the horizon. Now the shapes of rocks, headlands, and crashing surf are *between* you and the sun, which throws them into dark, bold silhouettes. So get going early, take a long lunch break, and then go back to work.

Changing Conditions. Nature never sits still, never strikes a pose for you. The waves keep moving; the wind blows the clouds across the sky; and the light changes from hour to hour. How can you "freeze" all the chaos and movement long enough to paint a picture? The best solution is always to make a small pencil sketch before you start to paint. The waves may keep moving and changing their shapes, but you *decide* on the shape you want and establish that shape in your pencil sketch. Halfway through the painting, those clouds may have shifted position, but they're in the right place in your pencil sketch. Having invested ten or fifteen minutes in the pencil sketch, you now have a firm idea of your picture, even if conditions change radically. You still paint from nature, of course, but you refer to the pencil sketch whenever you're in doubt. For example, let's say that the wind has reshaped your clouds. You look at the shapes in your original sketch, then look back at the changing shapes in the sky and remold them to fit the sketch.

A Note of Caution. When you're climbing out on the rocks to find the right vantage point, remember the tide! Keep an eye on the rising water and get back to the beach in plenty of time. Don't get stranded.

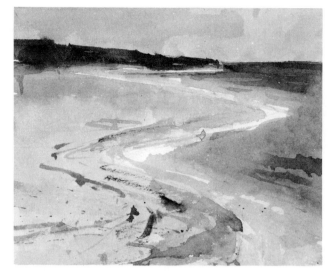

Don't lead the viewer's eye out of the picture. This shoreline swings the eye down to the lower right corner—and beyond. The dark strokes to the left of the shoreline push the eye in the same direction.

Do carry the eye into the picture. Here, the eye enters the picture at the lower edge and is carried through the center of the picture by the winding shoreline, which leads you to the distant headland. The dark strokes of seaweed follow the same path and keep the eye on the right track.

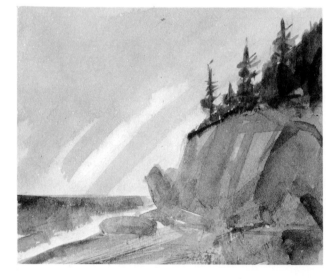

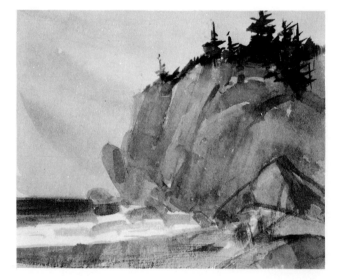

Don't split the picture into two triangular halves. If you study this landscape, you'll see that the cliffs and the shore form a triangle that starts at the upper right of the picture and ends at the lower left. The sky and sea form another triangle—the other half of the painting. It's a dull way to compose a picture.

Do divide the picture into a variety of shapes—such as the chunky block of the cliff, the horizontal strips of beach and water, and the curving wedge of the sky. Notice that the cliff extends beyond the midpoint of the picture; thus it's not divided evenly down the middle.

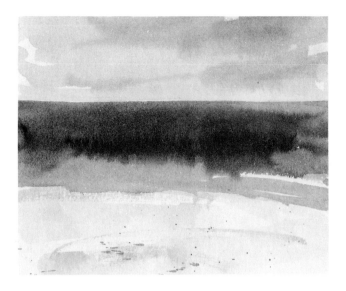

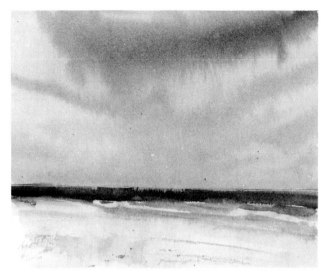

Don't divide a seascape into three equal horizontal bands for sky, water, and shore. Your pictorial design ends up looking like the monotonous stripes on a flag.

Do make sure that sky, water, and shore fill unequal spaces. This sky is twice as big as the shore. And the water is just a thin strip of darkness. Notice that the horizon is one-third up from the lower edge of the picture—always a good place to put it. Another good place is one third-down from the top.

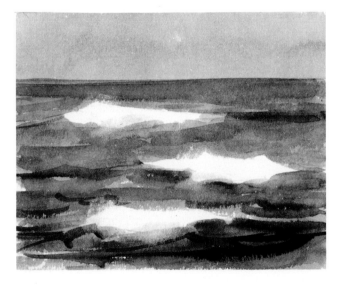

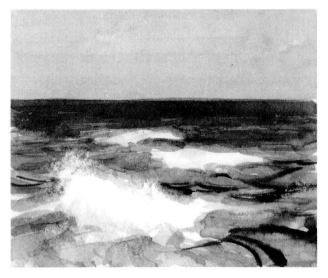

Don't make things all the same size and shape, with equal spaces in between—as these patches of foam are.

Do make them different sizes and shapes. Let one wave dominate, like the one in the foreground. Make another one smaller. And let the last be smaller still. Keep uneven spaces between them. This "rule" applies just as well to rocks, clouds, and other elements in your seascape.

Headland in Side Light.
The direction of the light determines the pattern of lights and shadows on every form, from this huge headland down to the small rocks on the beach. Here, the light is coming from the left side, brightly illuminating the planes of the cliffs that face the sea, but plunging the rest of the cliffs into shadow. Exactly the same thing happens to the blocky boulders at the foot of the cliffs, where you can see a distinct difference between the light and shadow sides.

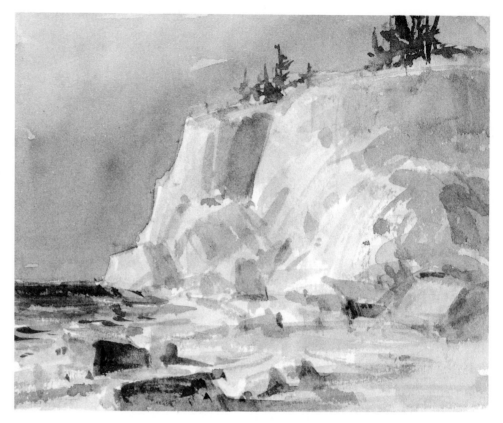

Headland in Top Light.
When the sun is high in the sky, shining directly down and catching the tops of the rocky shapes, the sides that face you are in shadow. Once again, you can see the same thing happening to the rocks at the foot of the cliff; there's a clear division between the lighted tops and the dark sides. The shadows on the foreground rocks look darker because these boulders are closer to you. Closer objects look darker, as you'll see when you get to the page on aerial perspective.

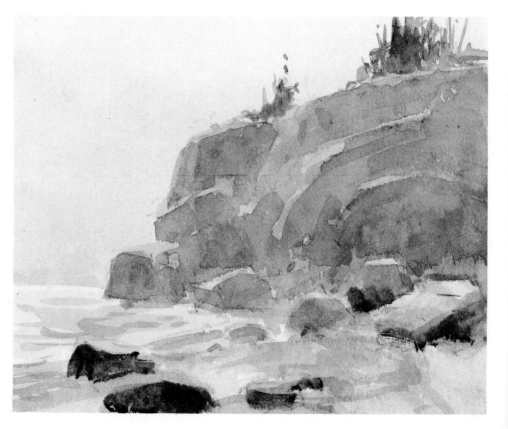

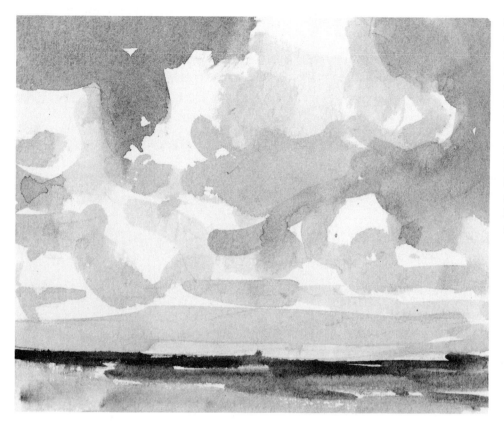

Clouds in 3/4 Light. Clouds may *look* soft and irregular, but their lights and shadows are just as clearly defined as those on rocks. So it's just as important to determine the direction of the light when you paint clouds. Here, the light is coming from the left side and slightly above— so-called 3/4 light. The tops and left sides of the clouds are brightly lit, while the bottoms and right sides are in shadow.

Clouds in Back Light. When the sun moves behind the clouds, you see only their shadow sides, so they look like dark silhouettes. The sun is also beyond the strip of land on the distant shore; therefore this too becomes a dark shape. Early in the morning and late in the afternoon, when the sun is low in the sky, these dark shapes are most dramatic.

Frontal Light. The same coastal subject can look radically different at various times of the day, depending upon the direction of the light. Here, the light is hitting the beach from the front— shining over your shoulder as you're facing the picture— which throws the sand into bright sunlight. The sky is darker than the sand.

Back Light. Now the light comes from the distant sky, beyond the dunes. The sandy shapes are in shadow and the sky is lighter. You can easily paint two different pictures of the subject—maybe more, if you come back at different times of the day.

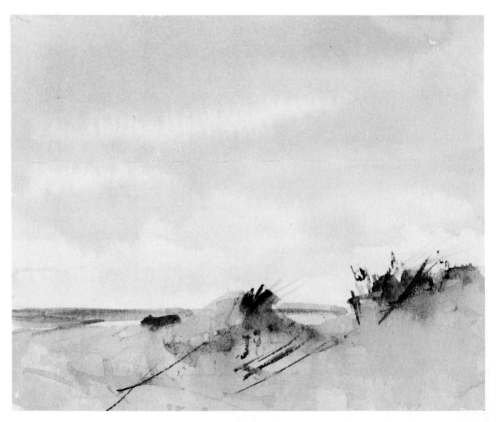

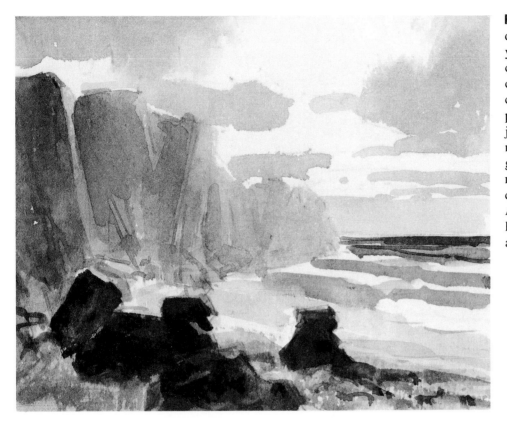

Rocky Shore. You can deepen the sense of space in your paintings if you pay careful attention to what's called *aerial perspective*. According to the "laws" of aerial perspective, the nearest objects are the darkest and the most distinct, like these foreground rocks. Objects in the middle distance, like the cliffs to the left, are paler. And the most remote objects, like the cliffs in the center, are palest.

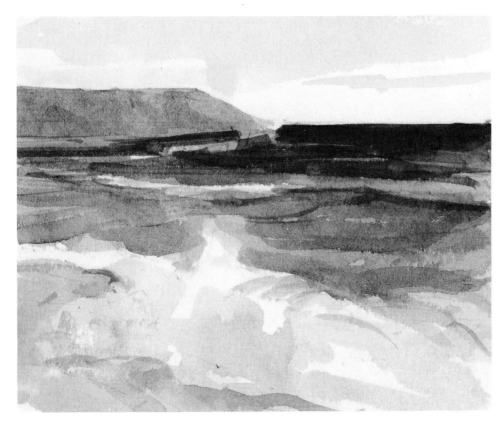

Near and Distant Waves. You've probably noticed that the sea itself can reverse the dark-to-light sequence of aerial perspective. Waves usually look darkest at the horizon and become paler as they approach the foreground. This seems to be because you see more of the lighted tops of the waves when they're close to you and more of their shadowy faces in the distance.

Swells. To paint the sea, you should be able to identify different kinds of waves. Far out from the shore, the rising and falling forms of the water are called swells. They have a beautiful, rhythmic quality, like low mountain ranges, ranked one behind the other. Swells tend to be darkest at the top.

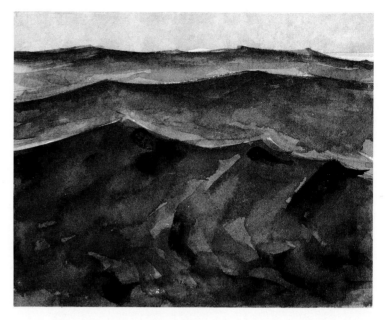

Whitecaps. Swells don't explode into foam like waves breaking on the shore, but foamy shapes often appear at the crest. These whitecaps are actually caused by the wind whipping the thin tops of the swells and sometimes carrying the foam into the air. This whitecap began as a patch of bare paper and was then scraped with a sharp blade beneath and to the left.

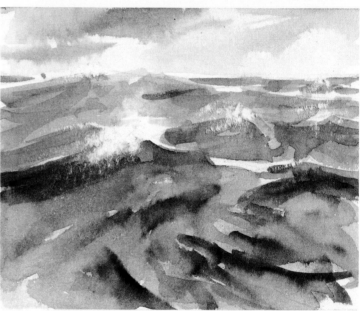

Cresting Waves. As waves approach the shore, they rise and begin to pitch forward. Their fragile edges begin to break into foam. The face of the wave becomes concave, and you begin to see deep shadows beneath the edge of the foam.

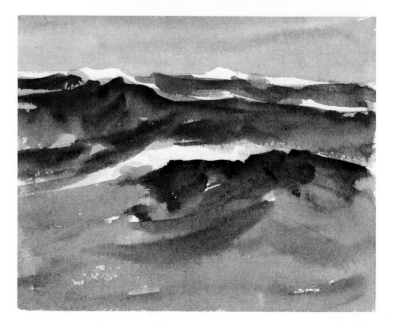

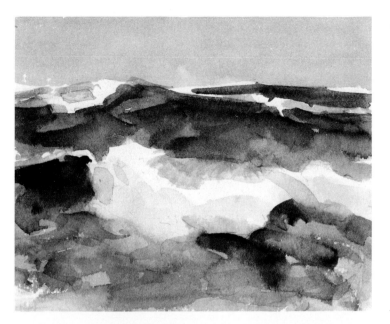

Breaking Wave. As the wave comes close to the shore, it finally rolls over on itself, and the forward edge explodes into foam. Above and behind the foam, you can often see the clear water of the wave curving toward you. The shape of the foam is usually sunlit at the top and shadowy at the front. Deep shadows form beneath the foamy shape. In the background, you can see cresting waves that haven't rolled over completely.

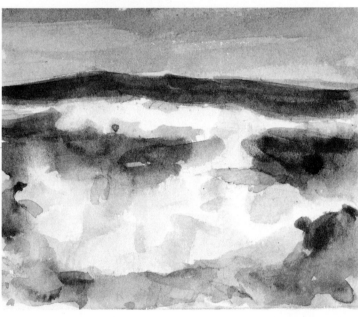

Crashing Wave. When the wave has rolled over on itself completely, it explodes into pure foam, and you can no longer see the top of the wave. Chaotic as the exploding foam may look, it's important to paint it as a solid shape—just as you paint a cloud. Look for the lights and shadows.

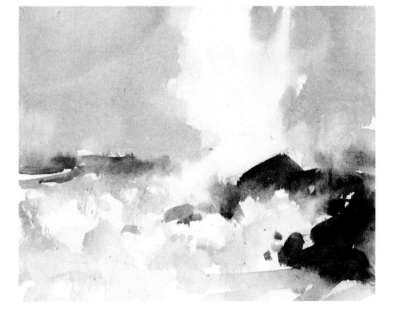

Surf on Rocks. As waves approach the shoreline, they often crash into rocks and throw plumes of spray into the sky. These masses of flying surf can assume any shape—but the point is that they *do* have shape. Focus your attention on a particular rock and watch the shape of the foam each time a wave strikes. The shape won't be exactly the same each time, but if you watch long enough, you'll be able to define the shape you want. Paint it as carefully as you render the rocks below.

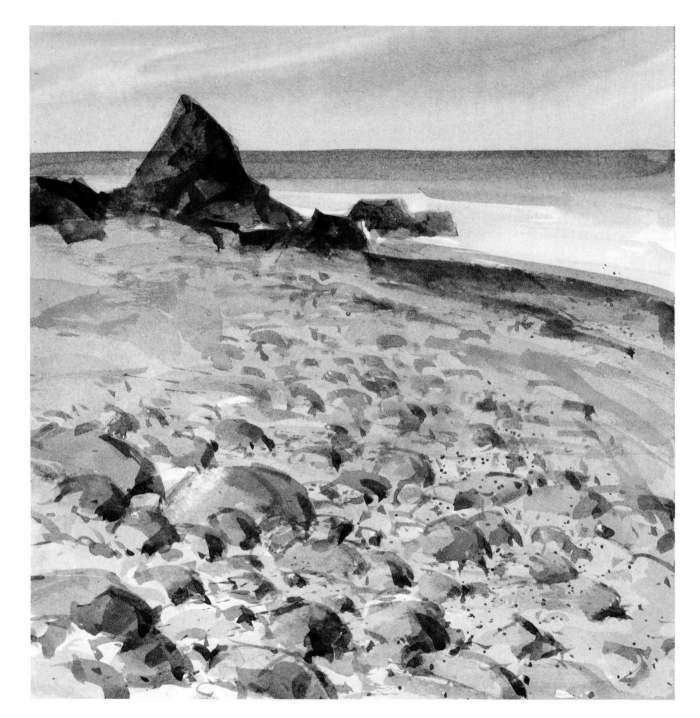

Pebbles on a Beach. The secret of painting a pebbly beach is to focus on just a few shapes. Paint these carefully, defining their lighted sides and their shadow sides. Make sure your brushstrokes follow the curve of the form. Concentrate on the pebbles in the foreground and be sure to add strong, dark strokes to emphasize the shadows. When you finish rendering a handful of pebbles, then indicate some more with the same curving strokes. Scatter these strokes among the more carefully rendered forms and they'll *all* look like pebbles. Place some strong dark touches at the shadow ends of these curving strokes to emphasize the illusion of light and shadow. And you can finish off the effect by spattering some dark flecks over the beach to suggest even smaller pebbles. One way to spatter is to dip a brush into liquid color and bang the brush against your finger or against another brush handle, held in front of the painting, so that the color flies onto the paper. You can direct the spatter more precisely if you dip an old toothbrush into wet color and spray the droplets by pulling a stick or brush handle across the bristles.

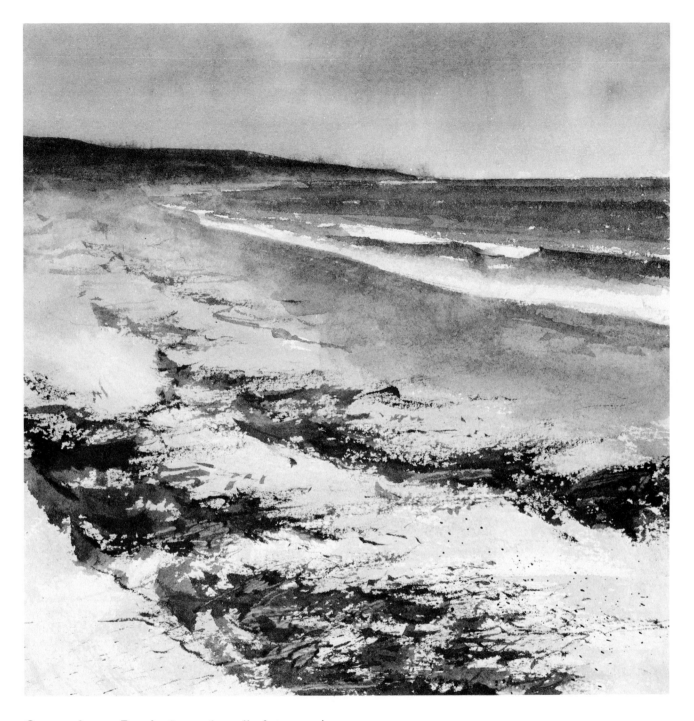

Seaweed on a Beach. Seaweed usually forms curving masses that follow the contour of the beach and run parallel with the waves. The easiest way to paint the big tangles of seaweed is with the side of a round brush—not the tip— scrubbed over the paper with short, curving strokes. These strokes will leave behind ragged marks with drybrush along the edges. You can then go back and paint individual strands and flecks of seaweed with the tip of the brush. A bit of spatter will also help. To suggest some lighter strands of seaweed, scratch the dark strokes with the tip of the brush handle (or with your fingernail) while the paint is wet. Or scratch the dry color with the point of a sharp blade.

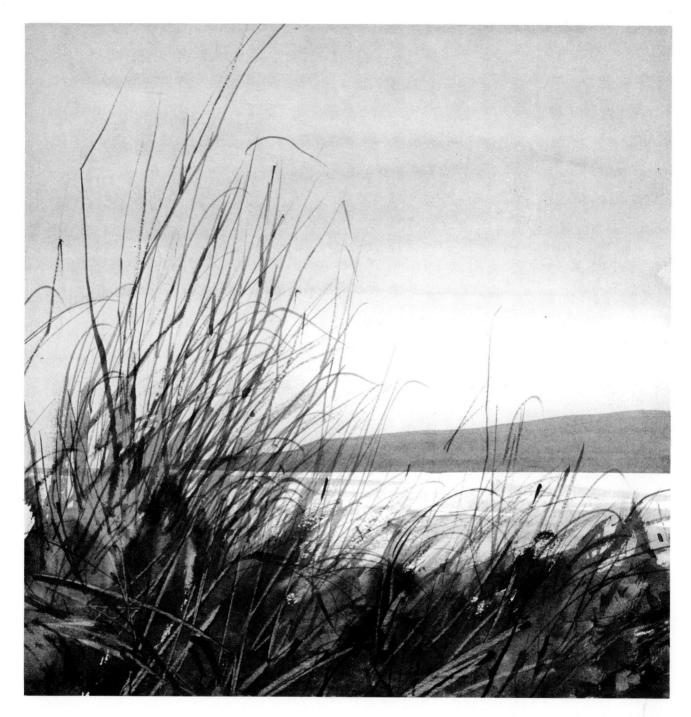

Grass and Weeds. Beautiful tangles of grass and weeds often grow along the shore, either among the dunes or in the salt marsh. Don't try to paint every blade and stalk. Here, the dark mass of weeds at the bottom of the picture is painted with broad strokes of dark color. While the color is still wet, lighter lines are scraped in with the point of the brush handle, with a fingernail, or with a blunt knife. When these strokes and scrapes are dry, you can use the tip of a small, round brush—or a signpainter's rigger—to paint the thin lines of the grass that rises into the sky. Make sure that your strokes vary in thickness and change direction slightly—don't make them all parallel. Don't get carried away and cover the whole picture with a maze of grass. Concentrate on one cluster such as the one at the left. Add a few more strokes such as those at the right. Then quit.

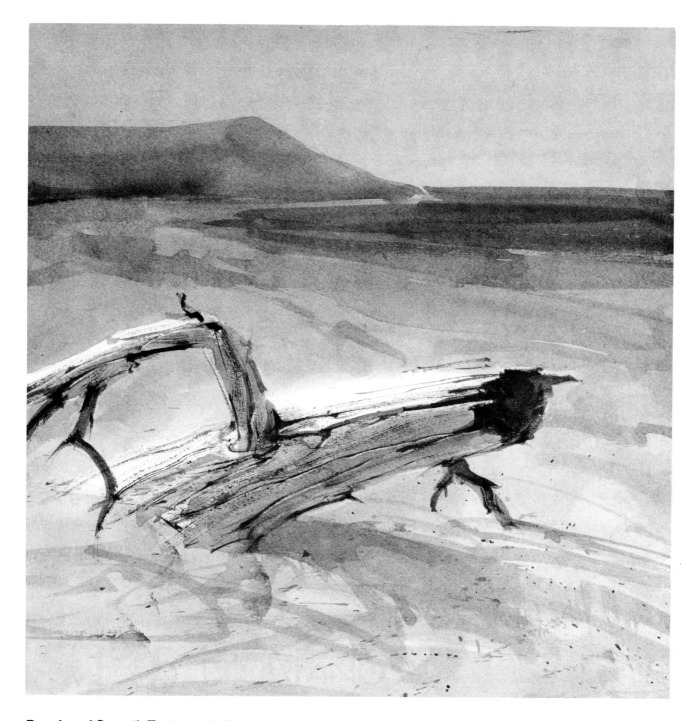

Rough and Smooth Textures. Driftwood is fascinating to paint because some parts are rough and craggy, while others are surprisingly smooth. Visualize the trunk and branches as cylinders. Paint the shadow sides of these cylinders with soft strokes that follow the direction of the form. Where the shadow curves into light, blur the edge of the wash with a stroke of clear water. Load your brush with some more color, wipe it on a paper towel so the brush is just damp, then add drybrush strokes that also follow the form. Concentrate on the rough areas and leave the smooth areas untouched. Draw some cracks with the point of the brush. When the color is dry, accentuate the cracks by scraping some white lines beside the dark strokes with the point of a sharp blade. It's important to concentrate your brushwork on the rough areas and draw just a few lines in the smooth parts.

Scraping. If the water is covered with dry color and you want to add a flash of light on the surface, try a sharp knife. Move the edge of the knife lightly over the surface to remove some color and expose some flecks of white paper. Scrape harder to remove more color until you have a ragged line of light. A ruler will help to guide the knife.

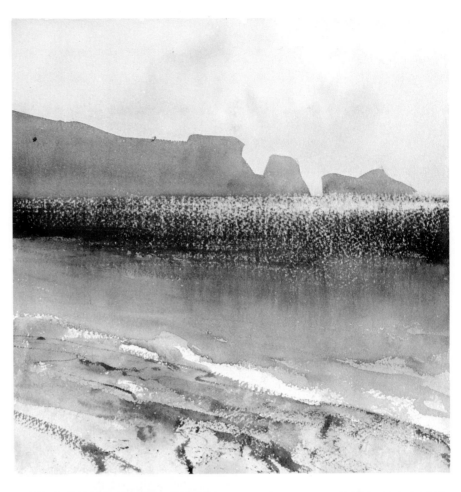

Sanding. Fine or medium-grade sandpaper will soften the edge of the white shape when you paint foam. You can carry the sandpaper over the distant sea and over the rocks to suggest flying flecks of foam.

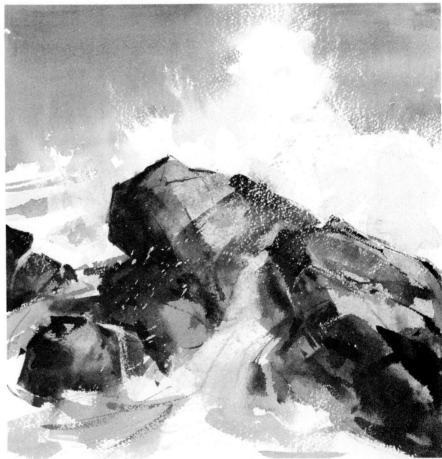

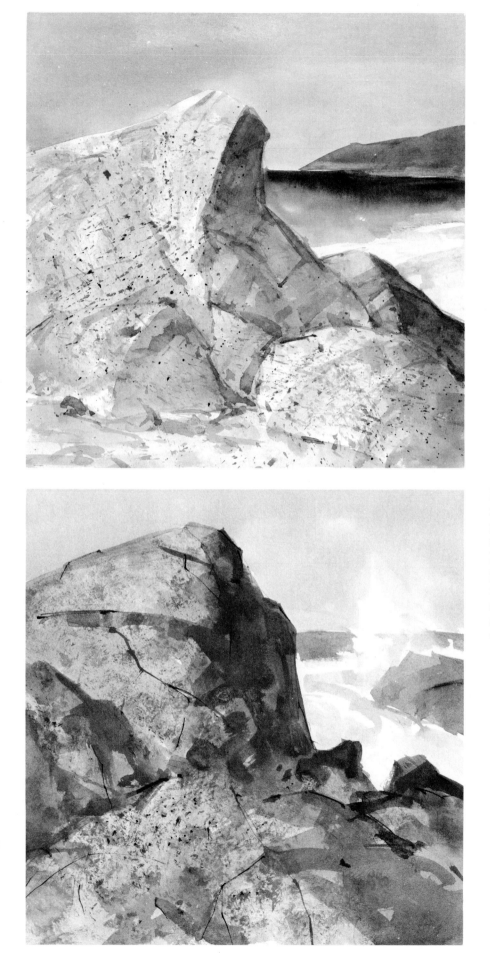

Spattering. A carefully controlled series of spatters will add texture to a rock formation. If you point the brush in the right direction, you can make the droplets climb up the side of the rock, as you see on the big rock to the left and on the smaller rock in the right corner. In both cases, the spatter was aimed diagonally from the side of the painting. At the top of the big rock, the spatter came from above.

Imprinting. Another way to create rough, random textures is to make a painting tool out of a crumpled wad of paper. Crush the paper so it has lots of wrinkles. Dip it into wet paint and press it against the painting, leaving a ragged imprint. You can see this imprint in the lighted areas of the rocks. You can also try this with a rough sponge.

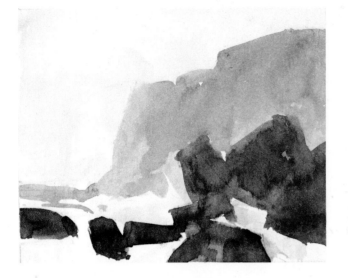

Rock and Cliff. Values are the lights and darks in your picture. Before you begin a painting, it's helpful to do a small sketch that simplifies the painting into darks, middletones, and lights. Here, the rocks are the darks; the headland is the middletone; the water and sky are the lights.

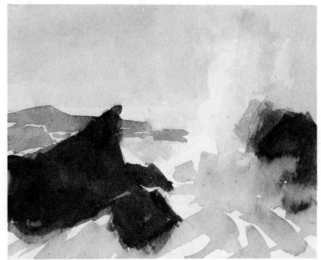

Surf and Rocks. Once again, the foreground rocks are the darks. The distant rocks and the shadows on the foreground foam are middletones. The sky and the foam are the lights.

Beach. Now the water is the darkest note, while the sky is the middletone, and the beach is the lightest area. A bit of the middletone appears on the beach. Naturally, the final painting will be much more detailed. This is just a convenient guide to organizing the picture.

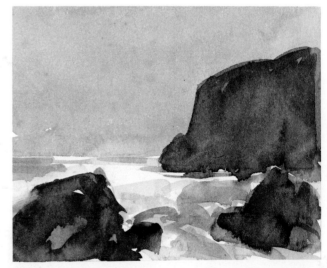

Cliff and Shore. The rocks and headland are the darks. The sky and the shadows on the water are all roughly the same middletone. The shine on the the water is the lightest note. These four sketches aren't formulas, just examples. No two subjects are the same. You've got to study the subject and create your own three-value sketch based on what you see.